Dear Friend

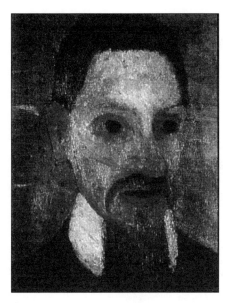

Dear Friend

RAINER MARIA RILKE AND
PAULA MODERSOHN-BECKER

ERIC TORGERSEN

Northwestern University Press

Evanston, Illinois

Northwestern University Press
Evanston, Illinois 60208-4210

Copyright © 1998 by Northwestern University Press.
Published 1998. All rights reserved.

Printed in the United States of America

ISBN 0-8101-1567-0

Library of Congress Cataloging in Publication Data

Torgersen, Eric, 1943–
Dear Friend : Rainer Maria Rilke and Paula Modersohn-Becker/Eric Torgersen.
 p. cm.
Includes bibliographical references.
ISBN 0-8101-1567-0 (alk. paper)
1. Rilke, Rainer Maria, 1875–1926—Friends and associates.
2. Modersohn-Becker, Paula, 1876–1907—Friends and associates.
3. Authors, German—20th century—Biography.
4. Artists—Germany—Biography. I. Title.
PT2635.I65Z942 1998
831'.912—dc21
[B] 98-10245
CIP

Contents

Acknowledgments

Turning up on many doorsteps in Germany on short notice, with few social graces, the wrong credentials, and no publisher, I was received again and again with courtesy, sympathy, and helpfulness. I am particularly grateful to Günter Busch, to whom I turned first and most repeatedly for counsel. Hans-Hermann Rief, of the Worpswede Archive, Haus im Schluh, was an unfailingly gracious host. Director Wolfgang Werner and Milena Schaibert, of the Paula Modersohn-Becker Stiftung, were repeatedly helpful, as was Liselotte von Reinken. To Gisela Götte, of the Clemens-Sels Museum, in Neuss, I am grateful for the opportunity to see Modersohn-Becker's portrait of Rilke at a time when it was not on exhibition, and for stimulating conversation. Christian Modersohn of the Otto Modersohn Museum and Hella Sieber-Rilke of the Rilke Archive were generous with permission to reprint copyrighted material from Otto Modersohn and Clara Rilke-Westhoff. Kind professional courtesies were also extended by the Roselius Sammlung, the Barkenhoff Stiftung, the Kunsthalle Bremen, the Hamburger Kunsthalle, the von der Heydt Museum, and the Kunstmuseum Basel.

There must be some sense in which this book is the honors thesis on Rilke that I did not write at Cornell University in 1964 for Burton Pike, the grace of whose teaching had a definitive impact on my future.

I am grateful to Central Michigan University for the sabbatical leave on which I began this project, the summer fellowship with which, earlier, I first traveled to Germany to get to know Modersohn-Becker's work, and the grant from the Faculty Research and Creative Endeavors

Committee that supported my last trip to Germany. Without the patient and resourceful support of the Interlibrary Loan Department at Park Library this work would have been inconceivable.

On the personal level, I am grateful to Uli and Petra Maaß and to Inge and Roland Hueber for their hospitality, friendship, interest, and encouragement throughout the years of work on this project. My wife, Ann Kowaleski, and our daughter, Elizabeth, have encouraged, indulged, and sustained me through eight years of work.

———

$\mathcal{O}ne$

It was a day to which he had always responded intensely, for the dead were very real to him. But All Souls' Day (November 2) 1908 was particularly memorable, for Rainer Maria Rilke spent it in his room at the Hotel Biron in Paris in the grip of a long, harrowing, and, even for him, remarkable poem.[1] In a letter to Sidonie Nádherný von Borutin, the handsome daughter of a baroness at whose estate in Prague he'd been to tea on All Souls' Day 1907, Rilke wrote the next day, with the poem at last behind him, this account of what he had done:

> An unexpected, powerful current of work had suddenly surfaced; I wrote and completed, without thinking of its remarkable relation to the day itself, a requiem for a compelling figure passed away a year ago: a woman who, from the great beginnings of her own artistic work, had fallen back, first, into her family, and from there into an unfortunate fate, and into an impersonal death, one which, in life, she had not prepared.[2]

Though Rilke's letter did not name her, the figure, indeed compelling, for whom he had written the poem was Paula Modersohn-Becker, who, on the day he'd had tea with Nádherný in Prague, had given birth to her daughter, Mathilde Modersohn. Then, eighteen days later, finally allowed to leave her bed after a long lying-in, and making the occasion festive with an elaborate coiffure, roses pinned to her dressing gown, and many lighted candles, she had collapsed and died of an embolism, saying

only, "What a pity." She was thirty-one years old, but in her short life she had created a wealth of extraordinary paintings.

Writing this poem had been so harrowing because in it—which meant, for Rilke, in a world more *true* than the external world of his room—Paula Modersohn-Becker had come back from the dead, come back to *him* with some mute plea. He had thought long and hard about death and the dead; her appearance threatened all his hard-won understanding. "O don't take away," he says in the poem on recognizing her, "the truth it's taken me so long to learn."

Because of his stature as a poet and the great power of his "Requiem for a Friend," Rilke's characterization of Paula Modersohn-Becker's life and death has had enormous influence on the way in which she and her work have been perceived in the intervening years. But the summary that he wrote for Sidonie Nádherný after finishing the poem—that in her art Modersohn-Becker had made "great beginnings," that she had then "fallen back" into her family and died an "impersonal" death—allows us, out of range of the potent spell of the poem itself, to notice how pat and how eccentric are Rilke's judgments of an artist who might well be seen very differently. Had she really made only great beginnings? What must one believe about family in order to speak of someone as having fallen back into it? What makes a death personal or impersonal? It was important to Rilke that Paula Modersohn-Becker be understood in just these ways because the assumptions that underlie these judgments were vital to his understanding of his own life and art. But was he really as sure of them as he sounds in the letter? Not only her death but her life and her art had troubled him and shaken his certainties. He had—though conventional phrases are rarely adequate to describe his responses—been in love with her once; the woman he had gone on to marry had been her dearest friend. At last, late in their friendship, he had come to recognize her remarkable achievements as a painter. But he never escaped a sense of having failed her.

Rilke had known Paula Becker—her name before she married fellow painter Otto Modersohn, eleven years her senior—since the late summer of 1900, when they'd met at the artists' colony of Worpswede, outside Bremen. He'd also met there, and married—on the rebound, it seems clear, from Paula herself—her friend, the sculptor Clara Westhoff. To Paula he had responded from the beginning with the greatest intensity, at first to her person and the way she seemed to embody some of his fondest youthful fantasies about *Mädchen,* maidens, girls—but finally,

belatedly, to her art. In the eight years of their acquaintance the force of his first rhapsodic responses to Paula as a young woman would at times be transformed into an equal but opposite force: they would clash on vital matters. Their marriages alone—his to a woman Paula loved dearly, hers to a man Rilke thought unworthy of her—made it inevit-able, but so did their fundamental assumptions about art and life. Rilke would claim the need, even the duty, to transcend marriage and familial oblig-ation in the name of his art; he had no intention of falling back into either the grim, broken family of his birth, which he had soon left behind along with his homeland, or the small family of himself, Clara Westhoff, and their daughter, Ruth. He had already left behind the group of young artists in Worpswede that had, at the time of Rilke's arrival there, begun to call itself the Family, for which Paula Becker had had high hopes. Paula hoped, too, that marriage and family in the literal sense would sustain her art. She had, as Rilke's letter after the Requiem suggests, broken free of these ties for a time, leaving her husband and stepdaughter to live and work on her own in Paris; but then, having found no way to support herself there, she had returned to Otto Modersohn and Worpswede, conceived a child, and gone on painting. Rilke, who had approved of and even conspired in her departure, blamed her death on her return, and in the Requiem he had the final word.

The Requiem was born of a pregnant silence. Though Rilke, as always, wrote a prodigious number of letters in the year between Paula's death and the writing of the poem, he avoided referring to her directly. Often, when his letters speak of death, it is unmistakably the impact of Paula's death that drives them, but with one exception—his wife had just finished a new bust of her old friend—he does not name her or tell her story. As soon as the poem was finished he broke this silence, first in the letter to Sidonie Nádherný that opens this chapter.

There is, most would agree, between the poem Rilke wrote and the story of two people that this book will be telling, a void, a vacuum, an absolute gulf, for the poem exists in an art space whose coordinates do not engage those of the historical world of the story. That this is so, no one would have insisted more vehemently than Rilke. There can be, across this void, at best only a resonance, a sympathetic vibration. Even though we find it irresistibly right to call them by the same names, knowing as well as we can this man who was a poet and this woman who was a painter is not the same as knowing the poem and the figures, one said to be living, one said to be dead, who move through it. But the

sympathetic vibration, the resonance, is deep, complex, at times unbearably ironic, always fascinating and moving.

Speaking to Paula in the poem, Rilke uses the familiar *Du*. He did not address Paula Modersohn-Becker this way in person or in letters, for he loved formality and *politesse,* but his encounter with Paula's shade in this poem is extraordinarily intimate. And *Du* is the form of address he favored in love poems, including those he wrote for Paula Becker soon after they met.

The way that Rilke tells Paula that she is wrong to come back is extraordinarily blunt: "I am right and you are wrong." The recognition that she has come with a plea, one addressed to him, is shattering:

> You're pleading. That's what pierces me
> down to the bone and rips me like a sawblade.
> Even some reproach, some grudge that you
> might bear me as a ghost, would not appall me—
> when at night I draw back to my lungs,
> my guts, the last poor chamber of my heart—
> like this pleading. What is it you want?

He describes the lengths to which he will go to permit her to rest, if she can only tell him what she is pleading *for.* If it is something left behind in a distant land that has called her back, he vows in a lengthy passage to go and retrieve it:

> I'll travel down the rivers, cross the land
> to find out all I can about old customs,
> speak to women standing in the doorways
> and watch them as they call the children in.
> I'll watch the way they put on the landscape there,
> outdoors, as they ply the ancient labors
> of field and meadow; ask to be brought before
> the king, and bribe the priests to lay me down
> before the most potent statues, leave me there
> and go and shut the temple gates behind them.
> But then, when I know enough, I'll simply watch
> the animals there till some part of their grace
> glides over into my own limbs; I'll live
> one brief existence in their eyes that hold me
> and slowly, peacefully leave me, without judgment.
> I'll ask the gardeners to name the flowers

and in the shards of their lovely names bring back
some trace of all their hundred fragrances.

Here Paula's paintings enter the poem, especially the ones to which, at
the time of their creation, Rilke had an intimate relation: still lifes, nudes
and—unheard of!—nude self-portraits from the spring and early sum-
mer of 1906. During part of this time, having left her husband and gone
to Paris with no intention of returning, she saw him almost daily in her
studio, for she was also painting his portrait.

And I'll buy fruit, the fruit in which that land
is born again, unto its very skies.
 For that is what you understood: ripe fruit.
You laid it down in bowls in front of you
and measured out, in colors, the weight of each.
Women too you saw as fruit, and children,
impelled from inside toward their destined forms.
At last you saw yourself as fruit, you took
yourself out of your clothes and brought yourself
before the mirror, then let yourself go in,
all but your gaze, so great it stayed outside
and said not: I am that; no, said: this is.
So free of curiosity at last,
your gaze, so free of owning, of such true
poverty, wanting not even yourself: holy.

In Rilkean terms, this is the highest praise, for with that gaze so free of
human desire Paula had become an exemplary artist. And she had used the
mirror, even had herself photographed in it, in painting those nude self-
portraits. In this part of his life, Rilke wrote again and again of reflections:
in mirrors, in bodies of water, more than once in Paula Becker's brown
eyes. It was his favorite way of imagining the inviolate other world of the
work of art, a world undeniably present, yet not to be entered. It offered
access to an inner reality, a reality of the heart, that Rilke thought more
true than the outer world: a reality, for example, in which, Rilke went on
insisting to his wife, the two shared a house with their daughter long after
they had left the one literal home that they would ever share.
 But after producing her exemplary works of art, Rilke's poem insists,
Paula took a fatal wrong turn: just the wrong turn that, in the historical
world, in the letter he wrote to Sidonie Nádherný upon finishing the
poem, Rilke said Paula Modersohn-Becker had taken:

But some chance happening, the last in your life,
tore you back out of your furthest progress,
back into a world where juices *will.*
Only a part of you at first, but then
day by day the reality growing around
that part began to weigh you down, until
you needed all of yourself. And so you broke
yourself, in pieces, painfully free of the law.

That *needing* had led her astray; her gaze had no longer been free of
desire, no longer been holy. Her fatal mistake, says the poem, was that,
having gone so far toward perfection in artistic creation, she tried to
achieve creation of a lower, more bodily sort: to bear a child.

Do you know how haltingly,
unwillingly your blood returned from that
peerless circulation, when you called it?
How troubled it was to take up again the mere
circulation of the body, and with what
stunned mistrust it entered the placenta
and stopped, exhausted from the long way back?

It killed her. And so she died not the one individual death that might
have grown out of her artist's life, but some common, female death:

And so you died as women used to die,
died in that warm house the old-fashioned death
of women who, when they have given birth,
would close themselves up again but cannot do it
because the darkness they have borne as well
comes back to them and forces its way in.

This notion of the individual death that flows from each particular life
is one that Rilke had met first in the work of the Danish writer Jens
Peter Jacobsen, his first great artistic master—and a shared possession, for
Paula, too, loved his work. In those nude self-portraits she made a know-
ing allusion to Jacobsen's novel *Niels Lyhne* that Rilke, if anyone, who
named this book and the Bible as the two most important books in his
life, would not have failed to recognize.

As the poem would have it, Paula had dug up the already planted
seeds of a wholly personal death and devoured them in the present for

the physical nurturance of her child. It is an image of desperation that leads to behavior deeply unnatural:

> You robbed yourself, you dug up from your heart's
> night-warm soil the still green seeds from which
> your death would grow, the one death for your life;
> like all the rest, you ate the seeds of your death
> and had in you an aftertaste of sweetness
> not your own, and so you had sweet lips;
> you whose senses, inside, were so sweet.

You had sweet lips. In any remotely conventional poem from a man to a woman, this knowledge of her lips would have come from having kissed them. Were Rilke and Paula Modersohn-Becker ever lovers? The question has a way of coming up in accounts of their lives, and it will come up here. But the deepest truth is that it does not matter much, for what was profound in their encounters took place inside them.

The fault for Paula's not having gone on toward that one death that would have grown from her life's work is not, the poem says, her own. It is not even that of the father of her child, who, the poem tells her, "pulled you from yourself." A shrewd rhetorical device: by announcing what her husband has done and claiming not to blame him for it, the poem does blame him. But through him it blames all men for failing to honor women's freedom:

> Where is the man that has the right to own?
> Who can own what cannot hold on to itself,
> only sometimes happily catches itself
> and throws itself again as a child throws a ball.
> No more than some commander may command
> the Nike on the bowsprit of a warship
> when the secret lightness of her godhead
> suddenly bears her off on bright sea-winds
> [. . .]
> For *that* is guilt, if anything is guilt:
> not to multiply a loved one's freedom
> by all the freedom we can find in ourselves.
> We have, in loving, only this one task:
> to let each other go. For holding on
> is easy for us, nothing we need learn.

For most, at least, this holding on comes easily; for Rilke, as we will see, it did not. But he was, all his life, a master of letting go. It was one of the ways in which he differed most greatly from Paula, and a central issue between them.

In a compelling dramatic turn, at the end of a poem in which he has desperately sought ways of helping Paula to rest, Rilke abruptly asks her for help. He, too, devoted to the same high goal as she, may fall back from the furthest pursuit of his art into the common life, just as she had done, and just as her spirit has now strayed back to the land of the living:

> No one has gone further. Anyone
> who has lifted up his blood to some long task
> may find that he cannot bear it any longer
> and let it fall back, lost to gravity, worthless.
> For somewhere an old enmity exists
> between our life and that great work we do.[3]
> That I may understand and speak it: help me.

This old enmity between the life and the work was a vital part of Rilke's understanding of himself and his calling—that part to which Paula's very different example posed the greatest threat. It is here most of all that the poem takes on its aspect of having the last word, of saying "I told you so," for Paula Modersohn-Becker had never wholly accepted this proposition so vital to Rilke: the duty of the artist to choose work over life. The apparent humility of the request for help that ends the poem softens this gesture but does not retract it:

> Do not come back. If you can bear it, stay
> dead among the dead. The dead have tasks.
> But help me in a way that does not distract you,
> as what is farthest off may help: inside me.

Breaking the spell of the poem's rhetoric, stepping back out of its world into the world of human lives, we sense immediately that the ghost story it tells is strangely incomplete. The hauntings in ghost stories are driven, to be sure, by unmet needs, unrighted wrongs, unresolved passions in the life of the one who has died—but also by the hungers, terrors, guilt pangs of the haunted. And in the historical world as well, in which we suspect that *haunting* is a metaphor, Rilke's saying "Paula haunts me" invites a look inside him, as well as inside Paula, for the reasons. Long after the writing of the poem, Rilke would say to Katherina

Kippenberg, the wife of his publisher and author of two books about him and his work, "She is the only one of the dead who burdens me."[4] Why did she haunt him so? What unfinished business might *he* have had with *her?*

This book takes for its subject, then, the vital business that each had with the other. If Rilke addressed Paula in his art a year after her death— and had long ago written more conventional love poems for her—Paula, at a vital turning point in her own life, in the spring of 1906, on her own in Paris, painted her strangely telling portrait of Rilke. Sitting for this portrait in Paula's studio that spring, he had been in a position to see the astonishing developments in her work in those days; and personally, too, it appears, they would interact more intensely and with fewer external limits than at any other time. By refusing to take up the sittings again after an interruption that sent them scrambling—the sudden knock on the studio door of Paula's husband, come to Paris in hopes of reclaiming her—Rilke may have signaled that the intensity of this contact, the scrutiny of those brown eyes in which once he had thrilled to see himself reflected, was more than he could bear.

There are, broadly speaking, two ways in which those who recognize Rilke's greatness have responded to it: a way of assent, especially suited to those who see him first as a great spiritual teacher, to whose wisdom it is only wise to submit; and a way of resistance, most suited to those unwilling to see him first as teacher because to do so is to place his often eccentric and problematical precepts above his art.[5] Although, as Rilke's wife, Clara Rilke-Westhoff often resisted his plans for her and their daughter, Ruth, intellectually and artistically she went the way of assent, remaining in essential ways faithful to his principles, a follower of immense and dignified loyalty, for the rest of her life. Paula Becker, who did respond deeply to Rilke, whatever the valence of the emotions he aroused in her, went the way of resistance, and so she was, once he had freed his gaze from her person and seen her art, a more essential fellow artist to Rilke than her friend Clara was. It was Paula on whom, more than any other, he molded his thinking about women as artists. Expressing in the Requiem his astonishment that she, of all women, had lost her way after death, he wrote that she had "transformed / so much more than any other woman." In his vocabulary there is no higher praise, for art, to him, was transformation.

Rilke *needed* resistance—especially from women, with whom he had the broadest and most profound, **but** also the most problematical,

affinities. He was so effortless a spellbinder and so eloquent a flatterer that to win assent from many women to his passionate views on love and other matters was all too easy for him. He left at his death a large number of female disciples in the art of love—one of whom was Sidonie Nádherný, to whom he wrote the letter that begins this chapter—though he was, at best, more a theoretician than a practitioner of this art. The chief reason why Lou Andreas-Salomé became Rilke's most indispensable lifelong friend is that again and again she resisted him, grew impatient with his self-indulgences, declined above all to play only the roles he tried to assign her in the great mythic constructs by which he lived. For the time that they knew each other, Paula, too, resisted him at many points, and so became immensely important to him: a precious and vital antagonist. And for Paula, Rilke played a similar role: he was not only a constant source of intellectual stimulation but also a vital irritant, the artistic counterpole to her husband, drawing her to Paris while Otto Modersohn called her home to Worpswede.

But Rilke's story cannot be told (nor can Paula's, for that matter) without that of Clara Westhoff; and Paula's cannot be told without that of Otto Modersohn. Complex human beings and estimable artists in their own right, they deserve our notice and repay our study. Though each is now the object of respectful critical attention, both remain greatly overshadowed by the fame of their spouses, and go on chiefly playing supporting roles in narratives of the lives of these. Nor can this book assert that this dispensation is, in the end, unjust.

By undertaking to tell, in the manner of biography, the stories of four interwoven lives over a span of nine years, I have, I hope, chosen immediacy and complexity over abstraction and analysis. But one fact remains inextricably embedded in the materials from which I have worked: that Rainer Maria Rilke and Paula Modersohn-Becker, poet and painter, man and woman, are the true poles defining the field in which this story or web of stories takes its shape.

Two

Rilke was born on December 4, 1875, into the dominant German-speaking minority in Prague, then a part of the Austro-Hungarian Empire. His father, Josef Rilke, was a military man who retired after only ten years of service. At twenty-one, in the war between Austria and Italy, he briefly had been commanding officer of the fortress at Brescia, and he had married Sophie Entz when both expected his military career to take an upward course from there. Instead, when both a recurring throat disorder and certain limitations in his makeup combined to hold him back, he retired, and thereafter held low-level positions for a railroad company.[1] Although in public a dapper ladies' man, he was disappointed with his life and had disappointed, too, his wife, who had thought herself destined for better things and felt the need to put up a front of affluence in their small, dark upstairs apartment.

Sophie Rilke had dreamed of rising from her middle-class origins; that she did not was made all the more bitter by the fact that her husband's brother, Jaroslav Rilke, extremely successful in law and public service, was rewarded with a patent of nobility. Rilke's Uncle Jaroslav had researched the origins of the Rilke family and believed that he had found a connection to the Carinthian nobility; though it was apparently not so, Rilke believed it, too. It became a vital element in the story he told himself about himself, and his lifelong fascination with the nobility seems to have been an extension of this belief and of the fantasies with which his mother consoled herself in her disappointment. A devout Catholic, Phia Rilke went to extremes with the rituals of a religiosity that overflowed into

spiritualism. Her young son René (the name Rainer came later) went through the same motions in order to please her. Later he would say that she had poured into her devotions the love that she ought to have given to him.[2]

A year before Rilke's birth, his mother had borne a daughter who lived only a few weeks. At least in part as compensation, she clothed her son in dresses well beyond the age when all young children wore them, and in fantasy games encouraged him to play for her the role of the lost daughter. Rilke incorporated these games into the mythic identity he constructed for himself as poet, where they helped to define his extraordinary relation to women. Their essence is captured in his novel *The Notebooks of Malte Laurids Brigge,* in which he created a doomed alter ego so that he might cast him off and survive him. The girl Malte plays bears Rilke's mother's name, Sophie:

> We remembered that there had been a time when Maman wished I had been a little girl and not the boy that I undeniably was. I had somehow guessed this, and the idea had occurred to me of sometimes knocking in the afternoon at Maman's door. Then, when she asked who was there, I would delightedly answer "Sophie," making my voice so dainty that it tickled my throat. And when I entered (in the little, girlish house-dress that I wore anyway, with its sleeves rolled all the way up), I really was Sophie, Maman's little Sophie, busy with her household chores, whose hair Maman had to braid, so that he wouldn't be mistaken for that naughty Malte, if he should ever come back.[3]

Discovering that, for Rilke the young poet, dead girls were a recurrent subject—one which, though it was very much in the air at the fin de siècle, he pursued with an obsessive singularity—we cannot help sensing a buried connection to the dead sister that he played for his mother in these games.

An only child, Rilke grew up at first almost completely without contact with living children. Finally sent to school when he was nearly seven, he was escorted by his mother to and from the grammar school run by the Piarist Fathers, even though it was close to their apartment, so that his contact with other children would still be kept to a minimum. These facts must have played a role in Rilke's lack of the protective exterior most children, especially only children, develop first in their contact with playmates. Delicate, vulnerable, he missed many days of school due to health problems.

Rilke's parents finally separated in 1884, when he was nine. Determined to start a new and more fulfilling life, his mother took to dressing all in black, like widowed ladies of the Hapsburg nobility. At ten René was placed in a military academy, St. Pölten, a milieu for which nothing in his earlier years had prepared him, though at times at least he seems to have accepted his father's dream for him of a military career. Though for the rest of his life he would portray his years there as an ordeal that he had barely survived—and periodically the plan surfaced of writing a novel to capture it—records show a largely successful cadet. He was promoted to a second, higher-level military school, at Mährisch-Weisskirchen, from which he was finally released due to ill health. After leaving the military academy he spent a short time at a trade school, in Linz, from which he ran away for a brief adventure with a young governess, later writing a dutiful son's remorseful letter to his mother. Soon he was able to prepare as a private student for school-leaving exams, and entered the University of Prague in 1895—the year that, far away, five young German painters who had settled in the village of Worpswede became famous almost overnight.

He had begun writing poems for his parents at the age of seven, and went on doing so throughout his youth, presenting them on their birthdays and similar occasions. Against the wishes of both Josef Rilke and his brother, René's uncle Jaroslav, who would underwrite his university studies (and provide in his will for a modest yearly stipend as long as they continued), his mother had encouraged from the first his interest in poetry. A classmate at St. Pölten described later how often, at the beginning of German class, Rilke would silently walk up to the lectern, present the instructor with a sheaf of his newest poems, and ask permission to read them aloud.[4]

Rilke's first poem was accepted for publication in 1891, and by 1893 he was publishing regularly. More than once he spent All Souls' Day in the cemeteries of Prague, writing death-tinged poems. In 1894, at nineteen, he published his first book, *Life and Songs,* which later he would exclude from even the most complete collections of his work. His first long-term love and for a time his fiancée, Valerie David-Rhonfeld, sold some of the jewelry she had inherited from her mother to finance the publication; she was the first in a series of patrons, most of them female, whom Rilke attracted all his life.

With a genius for unembarrassed self-promotion, René made himself a name as a promising young poet in the small, closed literary world of Prague. Whenever he published something of any significance, he sent

copies of it, with fawning inscriptions often in the form of little poems, to carefully selected literary eminences, each addressed as something like "honored master." (With that astonishing economy of means on which I will be remarking all through this book, he was at the same time preparing a voice in which he would one day address the first great living master of his poetic maturity, Auguste Rodin.) He founded periodicals—one of them, *Wild Chicory,* to be given away free to members of the working class—and literary societies. There are descriptions of him as literary flaneur, strolling in the most elegant getup he could manage, sometimes with a single long-stemmed iris in his hand, just as young poets might do in Paris or London. There is an account of him dressing as an Abbé to distribute copies of *Wild Chicory,* and once he signed a poem "René Caesar Rilke," though Caesar was not among his five given names. Suitably rebellious against middle-class German values, he filled his poems with Czech matter for a time. To be useful for his work, though, as everything about him had to be—that economy of means again—his fondness for thinking of himself as a Slav would have to be transformed, under the influence of Lou Andreas-Salomé, into the later conviction that Russia was his true homeland.

This is "The Young Sculptor," a poem from Rilke's second book, *Offering to the Lares* (in the Roman tradition, household gods), from 1895. It expresses the dream of fleeing Prague in favor of the outside world, and the sort of ties that might hold one back. And we see in it a motif that will become familiar: the dead girl.

I must to Rome; to our small city
Return, in glory, one year hence;
Weep not, maiden; in Rome surely
I shall carve my masterpiece.

He spoke, and set off in hot fervor
Through that world of which he'd dreamed;
And yet, his soul some inner censure
Held transfixed, it often seemed.

His restlessness soon homeward drove him;
He carved, with anguished, tear-stained face,
His poor, pale darling in her coffin,
And this—this was his masterpiece.[5]

The translation is far from adequate, but the poem has few virtues to be lost in it—perhaps only a certain gift for emotional manipulation. It is the work of an emotional and artistic adolescent, to whom the thought of beautiful dead girls could provide a delicious frisson.

One vital aspect of Rilke's sense of himself as poet that he took with him from Prague was a love of idealized medieval matter—old noble families with glorious pasts, great castles with rows of ancestral portraits, languishing maidens and the wandering singer-poets whose role it was to praise them. He was sure all his life that he was descended from just such a family, at that late stage in its history when it produced poets rather than men of action. He would do his work of praising with all his strength; in return he expected bed and board, and now and then the signs of a lady's pleasure. Before leaving Prague he had addressed to the Baroness Láska van Oestéren, a local literary light, an epistolary poem in which he confided to her his dreams of being her "court poet." To an extent that one would have thought impossible at the dawn of the twentieth century, he would, by the strength of his vision, his exquisite manners, and the confidence he drew from knowing that such a place was his by right, become something rather like a court poet to the aristocracy of his day.

Late in 1896, with another book in press, René moved to Munich, a step he would chronicle in the autobiographical novella *Ewald Tragy*. The move to a great cultural center was liberating for him; from beginnings at which even his most admiring readers find it hard to avoid smiling, he began to advance, as man and poet, in huge strides. At times, when the prodigality and shamelessness that were vital components of his genius outran his still-developing social skills, he could appear ridiculous, and even in Worpswede Paula Becker and Clara Westhoff, taken as they were with him, could share smiles at his expense.

In *Ewald Tragy* the enigmatic figure of Thalmann cuts through the superficialities of the literary café society into which the innocent and hesitant Ewald falls for a time. Rilke's model for Thalmann was novelist Jakob Wassermann, whose influence on Rilke's own life came chiefly in the form of two introductions: at Wassermann's urging he began to read the work of Jens Peter Jacobsen, especially his novel *Niels Lyhne;* and at tea at Wassermann's apartment, he met the writer Lou Andreas-Salomé. To say that Wassermann's two introductions would go on to have comparable weight in Rilke's later life is to make clear the significance that Jacobsen held for him from the first. For a long time he hoped to seek out Jacobsen in person and throw himself at his feet; by the time he

learned that this prospective master had died of tuberculosis in 1885, he had chosen a new and even greater one: Auguste Rodin. For now, though, *Niels Lyhne* was at the center of his artistic universe.

For generations of young male writers in the English-speaking world, the transformation of a child into a young aspirant to art has been achieved under the sign of James Joyce's *Portrait of the Artist as a Young Man. Niels Lyhne* was just as influential in Europe at the end of the nineteenth century: sooner or later, all earnest and artistically inclined young people read it. One reason for its appeal may be that it offered both romantic idealism that the young could still identify with, and at the same time a deliciously modern deflation of romantic ideals that gave the same young people an occasion to feel sophisticated and knowing.

Sitting down to read *Niels Lyhne*, Rilke must have begun to recognize himself in the very first chapter. That he did so at this time is unremarkable, even predictable; Rilke's response was distinguished, as were so many of his responses, not only by its intensity but by his astonishing capacity for building a world of such responses, and determinedly living in it. He would have recognized, first of all, in Niels's mother Bartholine, née Blid, the essence of the youth of his own disappointed mother:

> She had no interest in the affairs of the fields and the stables, no taste for the dairy and the kitchen—none whatever.
>
> She loved poetry.
>
> She lived on poems, dreamed poems, and put her faith in them above everything else in the world. Parents, sisters and brothers, neighbors and friends—none of them ever said a word that was worth listening to.[6]

By the next page he found his mother pitilessly portrayed not as she had dreamed of being, but as he himself had come to see her:

> When all this was sifted down, it meant little beyond a slightly morbid desire to realize herself, a longing to find herself, which she had in common with many other young girls with talents a little above the ordinary. It was only a pity that there was not in her circle a single individual of sufficient distinction to give her the measure of her own powers.

And he must also have seen the essence of the role his father, a handsome soldier when young, had played in her disappointment:

Here at least was someone from the outside world, someone who had lived in great, distant cities. . . . Here was one who had sojourned where victorious armies had tramped the roads, where tremendous battles had invested the names of villages and fields with immortal fame. . . .

He talked of painters and poets, too, and sometimes he would laud to the skies a name that she had never even heard. He showed her their pictures and read their poems to her in the garden or on the hill where they could look out over the bright waters of the fjord and the brown, billowing heath. Love made him poetic. . . .

But Jacobsen moves in half a page to the revelation of her husband's true nature:

He was tired of donning the plumage of romance and eternally spreading his wings to fly through all the heavens of sentiment and all the abysses of thought. He longed to settle peacefully on his own quiet perch and drowse, with his tired head under the soft, feathery shelter of a wing.

The progression to utter disillusion for Bartholine is brisk and pitiless:

She had merely been deceived by the very ordinary fact that his love, for a brief moment, had invested him with a fleeting glamor of soulfulness and exaltation—a very common occurrence with persons of a lower nature. . . .

Such was the state of things between man and wife when Bartholine brought forth her first child. It was a boy, and they called him Niels.

So ends Jacobsen's first chapter, and already Rilke knew that *he* was Niels Lyhne.

But in the second chapter Rilke's identification with Niels took a leap into the uncanny:

A few years after Niels was born, [his mother] had brought forth a still-born boy child, and him she chose. All that he might have been and done she served up before his brother in a confused medley of Promethean longings, Messianic courage, and Herculean might, with a naive travesty, a monstrous distortion, a world of cheap fantasies, having no more body of reality than had the tiny little skeleton mouldering in the earth of Lönborg graveyard.[7]

17

A few years before René Rilke was born, as we have seen, his mother had brought forth a girl child who had lived only a few weeks. Like young Rilke playing his lost sister, Niels gravely accepts the role his mother expects him to play: "Niels was not deceived about the moral of all these tales [of the dead brother]. He realized perfectly well that it was contemptible to be like ordinary people [such as one's father], and he was quite ready to submit to the hard fate that belonged to heroes." For Rilke, who thought the age of heroism past, it was the hard fate that belonged to poets.

It was from Jacobsen, in passages immediately following those above, that Rilke took some of his basic ideas about childhood:

> the images of that dream-born future whispered softly through Niels Lyhne's childhood, reminding him gently but ceaselessly of the fact that there was a limit set to this happy time, and presently one day it would be no more.
>
> This consciousness roused in him a craving to enjoy his childhood to the full, to suck it up through every sense, not to spill a drop, not a single one.

One way an artist could tell that he was on the right track, Rilke would tell Paula Becker one night in her studio in Worpswede, no doubt fixing her in the gaze of his legendary blue eyes, was when his work began at precisely that point in his life where his childhood had ended, giving way to adult concerns. One of the paradoxes of Rilke's attitude toward his own childhood is how utterly he treasured it while constantly refining his myths of how oppressive it was, and how it had rendered him incapable of leading anything resembling an ordinary personal and social life. Such an ordinary life, he *knew,* was incompatible with the highest demands of art, and so he must not live it. It had to be so, because only then could he accomplish his life's work. In the Requiem he was still defending his choices.

We have seen Rilke's fascination with dead girls; for the delectation of young readers of *Niels Lyhne,* not one but two beautiful young women loved by Niels waste away and die: near the beginning of the book, Niels's young aunt Edele Lyhne, and near the end, Gerda, the young woman he has finally happily married. Edele has been sent to the country because her family believes that the gay life she loves so in Copenhagen overstimulates her delicate constitution. There is truth in it: her last words are "My love to Copenhagen!" But from Jacobsen's

omniscient narrator we learn after her death of "the great artist whom she had loved secretly with her whole soul, but to whom she had been nothing, only a name that his ear knew, only one unrecognized figure in the great admiring public."[8] It makes her death, of course, that much more delicious.

Before her final decline, Edele Lyhne rejects the love of the severe and unappealing tutor, Mr. Bigum, who has, in a scene on which Niels eavesdrops, offered to abjure all his Christian beliefs if only she will have him. It is a shock and a disgrace to Niels. When he knows that Edele is dying, Niels, who at twelve loves her uncomprehendingly and helplessly, prays to God to save her, and when God does not comply, Niels rejects God: his lifelong atheism, rather than his sketchy and insubstantial life as a failed poet, becomes the chief element in his heroism, for Niels *is* a kind of hero. Although Mr. Bigum has betrayed his faith for the love of Edele, Niels vows never to betray his unbelief, and very nearly succeeds in keeping his vow. For the rest of the story Niels loses loved one after loved one; he is an inverted Job, tempted by loss after loss to turn *to* God rather than from Him. Niels has tutored his wife Gerda to accept his atheism—turning her, unintentionally, into an atheist zealot—but on her deathbed she calls for the pastor, a wish Niels willingly grants, though he will permit himself no such exception on his own death. When, immediately after his wife's death, his young son is dying, he fails for a single time to keep his vow, and prays, but to no avail; in the five pages remaining, Niels, having lost the only happiness he has known, enlists in the army, is shot through the lungs, and dies alone and unrepentant, although his attending physician, a fellow atheist from his university days, urges him to call for the pastor. He does not, and this is his heroism. The last sentence of *Niels Lyhne* is, "And at last he died the death—the difficult death."

From this notion of the heroism of Niels in choosing to die the death that follows from his chosen life—and from similar references elsewhere in Jacobsen—Rilke developed a principle we have already seen in the Requiem: the need for one to die one's own individual death. His most forceful statement of this idea after the Requiem would be *The Notebooks of Malte Laurids Brigge,* his only novel, conceived and written under the sign of *Niels Lyhne.* Like Niels, Malte is a failed artist, and, in Jacobsen's honor, a Dane. At the beginning of a six-page account of the death of his grandfather, Chamberlain Christoph Detlev Brigge, Malte writes: "Then, you knew (or perhaps you sensed it) that you had your death *inside* you as a fruit has its core. The children had a small one in them and the grownups had a large one. The women had it in their

womb and the men in their chest."[9] *The women had it in their womb:* Paula's death was Rilke's prime instance of this conviction. Even as his own death approached, Rilke remained faithful to Niels Lyhne's example. He wrote in his will that he wanted no priestly intervention at his deathbed: "to the movement of my soul, toward the open, any spiritual intermediary would be offensive and repugnant."[10]

When Jakob Wassermann introduced Rilke to Lou Andreas-Salomé, she was fourteen years older than he was and far more renowned; she had already published two novels and the first biography of Nietzsche (who had once proposed to her—as had whole cohorts of other men—and been rejected). Rilke's attention had been called to her essay "Jesus the Jew," which seemed to contain ideas similar to those in his recently completed "Visions of Christ." After their meeting Rilke sent Salomé a note informing her that in reading "Jesus the Jew" he had already spent many an evening with her, proclaiming that in perceiving the essential sympathy between their works he had "felt like one whose great dreams had come true," and offering to read the "Visions of Christ" to her in person at her earliest convenience.[11] He had used the same opening gambit in Prague in his campaign to cultivate Baroness Láska van Oestéren.

Salomé, whose earliest convenience proved to be five days later, believed that she recognized the scrawled handwriting of the note and that Rilke had already sent her, anonymously, admiring letters and poems. At twenty-one, in the spring of 1897, he threw himself at this distinguished writer in her mid-thirties, greatly experienced at fending off importunate men, with such extravagant and eloquent abandon that by summer they were lovers. Salomé had for ten years been married to Professor F. C. Andreas, but had never allowed him to consummate the marriage, which had been entered into under emotional duress and preserved by his refusal to grant her a divorce. Though Lou hinted in her memoirs that Rilke may actually have been her first lover, as he seems to have believed for a time, her biographers typically don't believe it.[12] Rilke spent the summer with the Andreases, represented to the professor as a merely literary disciple, at Wolfratshausen, in the Isar valley, even sharing their house. Lou taught him to walk barefoot in the fields and forests in the early morning—a health fad of the day—and he showered her with love letters and poems. Under her guidance he began to study Renaissance painting. When the Andreases went on to Berlin, Rilke went, too.

For a time the affair was idyllic and intense. Lou played a vital role in shaping the emerging persona that would carry him on to greatness. She persuaded him that a young man who had once played at being a girl to

please his mother was ill served by the ambiguous name René Maria, at which point he became Rainer; she even seems to have brought about a change in his handwriting, from a youthful scrawl to the precise, elegant script that was a source of pride to the man.[13] After a while, though, certain traits in Rilke began to alarm Lou. She constantly had to force discretion on him. His moods were highly volatile; his ecstasies could be followed by dark despairs, from which he looked to her to give him release. She worried at times that he might be a potential suicide. Even in better times he often appeared to need her more as a mother than as a mistress. When the prodigality of his offerings and their attendant demands began to exhaust her, she encouraged him to go away to Italy—first to Florence, then on to Viareggio—to continue his art studies, and required of him a notebook record of his discoveries, with an eye toward teaching him to be less subjective and emotional. Some biographers speculate from circumstantial evidence that Lou may have been pregnant by Rilke at this time, and infer from his letters that he hoped it was so; if she was, the child was not carried to term.[14]

It was in Florence that Rilke began writing for Lou his cycle of delicate, interwoven *Mädchenlieder:* songs of girls, we will call them, but in German virginity is an explicit part of the designation. What Rilke loved most to celebrate about girls is the moment of sexual awakening, in which he saw through his young and bewitched male eyes a profound and mysterious subjectivity:

You Girls are just like gardens
on an April night:
the springtime off on its journeys
but no end yet in sight.

★ ★ ★ ★

You Girls are just like boats
still tied up at the shore
of the hours, and thus it is
that you remain so pale;
without a thought you would
give yourselves to the wind:
for your dream is the pond.
Sometimes an offshore breeze
takes you and carries you till

it fully extends your chains,
and then you love it well:
sisters, now we are swans
who pull on the golden reins
of a fairy-tale mussel-shell.

★ ★ ★ ★

All the streets now lead
directly into gold:
the daughters in the doorways
all would have it so.

They take no leave from the old
and yet: they wander far;
how lightly and how freely,
how differently they hold
to one another now,
and in what different folds
around their shining forms
their dresses glide.[15]

It was in Florence that Rilke met another young man with a head full
of dreams of girls: the painter, designer, and graphic artist Heinrich
Vogeler, who would one day bring him to Worpswede. One source of
the significance of Florence for both young men was Botticelli, whose
ravishing images of young women they could appropriate for their fan-
tasies. At the time of their meeting, Vogeler, three years older, was better
known. The two men were invited separately to a *Herrenabend*—a male
social evening—at the Pension Benoit, where Rilke had rooms, and a
roof garden with roses in bloom, on the top floor. Each noticed the other
although they were not introduced, Rilke noting Vogeler's silent and
wide-eyed way of taking in the events. Something of a dandy, Vogeler
must have been in costume as well. Rilke made on Vogeler the impres-
sion of a monk, who always held his hands rather higher than usual, as if
prepared to pray—or so he would write almost fifty years later, perhaps
under the influence of Rilke's own self-dramatizations.[16] Rilke's "soft,
woolly young beard, like that of cloister-brothers whose chin and cheeks
have never felt a razor," added to the impression. Rilke invited the assem-
bled men to the terrace of his apartment, for its roses and view of the city.

The anonymous Vogeler silently shook the anonymous Rilke's hand upon leaving, but the exquisite young men did not speak. Each inquired as to the other's name when the evening ended, and Rilke tried unsuccessfully to contact Vogeler before Vogeler left Florence.

The two men began to correspond, and six months later Vogeler visited Rilke in Schmargendorf, near Berlin, where he was staying to be near Lou. Then Vogeler invited Rilke to visit him. Rilke made a brief visit near the end of 1898, sharing dinner on Christmas Eve with the Vogeler family in Bremen, a setting that impressed him with its elegance and the ease and warmth of the family's hospitality. On Christmas morning they drove out to Vogeler's white house in Worpswede, the Barkenhoff, the locus of all his dreams and, with his own chosen peasant girl, Martha Schröder, a central icon of his painting. Vogeler was already a distinguished designer in the mode of art nouveau or, in its German incarnation, *Jugendstil*. In a letter to his mother, knowing it was the sort of thing she would appreciate, Rilke wrote of how each stone of the house, and every object in it, was of Vogeler's choosing or design.[17] Although he could be unkind in describing his mother to others, for a long time he wrote her dutiful, filial letters in which he described richly, for her delectation, those aspects of his new life (the salons to which he had gained entry, the eminent personages among whom he often moved) that he knew would please her.

Book design was a Vogeler forte; it was arranged that he would do decorations for Rilke's forthcoming book of poems, *In My Honor*. The apparent egotism of the title is misleading; in Rilke's original conception the book was to be followed by *In Your Honor,* a volume of his love poems for Lou. Lou not only forbade him to publish it but ordered him to turn over the manuscript; he complied, and not all the poems in it have survived.

It was after this brief visit that Rilke—who would spend much of his life as a guest, and early mastered the art of pleasing a host or, more often, a hostess—composed and sent to Vogeler a *Hausspruch,* or house-charm, that Vogeler had carved into the Barkenhoff lintel:

Let light be its lot.
If the Master be but the heart and the hand
Of the building, then like the lindens of the land
His house too grows shadowed and great.[18]

Vogeler invited him to come back to the Barkenhoff and stay longer, but only after two trips to Russia with Lou Andreas-Salomé would he do so.

In Viareggio, in May 1899, a diary entry about the oppressiveness of parents (who "should never want to teach us life, because they teach us *their* life") became an early speculation about women, motherhood, and art, a nexus Rilke always found problematical. His first thoughts are quite conventional: "Mothers, to be sure, are like artists. The artist's struggle is to find himself. Woman fulfills herself in the child." For the woman already an artist, bearing a child would be the end of art: "A woman who is an artist would no longer create if she became a mother. She has placed her goal outside herself, and may from this point on in the deepest sense live art." He goes on to make an unconvincing case that living art rather than making it makes the woman richer, for she can be a prophetess who, by her love, manifests to the (male) artist the glory of the goal.[19]

When, on returning from Italy, Rilke brought Lou the journal that she had assigned him to keep, she pronounced herself satisfied, but Rilke found a way to find her reception of it, and of him, crushing. He felt that they had fallen immediately into a pattern already established between them, in which he played the ever-complaining child, Lou the indulgent mother.

> This time *I* wanted to be the rich one, the one who gave, the one bearing goods, the Master, and you were to come, led by my caring and love, and savor my hospitality. And there I was again, to you, only the littlest beggar at the furthest threshhold of your being, which rests on such broad and sturdy columns.[20]

Intellectually, too, he found her—with justification, as she was better educated, better disciplined, and more experienced—superior: "*Again and again you are ahead of me.* I struggle where you have long since won victories, that's why I am sometimes so small before you."

It was not the sort of thing that Lou wanted to hear from him, but they recovered. Lou again influenced the direction of Rilke's intellectual growth definitively by proposing that he study Russian language and culture; perhaps as a reward, plans were made for a visit to Russia. On this first trip they would visit Moscow and then St. Petersburg, where Lou had grown up, the daughter of a Russian general and a mother of north German and Danish descent. For Lou, the trip, in the company not only of Rilke but of her husband, was an actual homecoming; it convinced Rilke that he had found his spiritual home. The emotions aroused in them by each other and by Russia seem to have merged in an experience they both found intense and profound. They arrived in

Moscow in time for the celebration of Easter, a vivid event that impressed Rilke, in particular, with traditional Russian spirituality. And they spent an afternoon with Tolstoy, who disapproved of their eager identification with what he saw as backward superstitions, but who nevertheless was Tolstoy, and a hero to them both. St. Petersburg, when they got there, was preparing for the centennial of Pushkin's birth, a great nationwide celebration, and Rilke was further impressed that in Russia the birth of a poet could be celebrated so universally.

In Berlin in the fall of 1899, after their return, Rilke wrote "The Book of the Monastic Life," the first part of *The Book of Hours,* creating for it the persona of a Russian monk, though he would allow this persona to disappear from the second and third parts. The book is a product of his love for Lou, and of their first Russian trip. At Christmas of that year, which Rilke spent in Prague, *In My Honor,* with Vogeler's decorations, was published. A second collaboration, on the prose *Stories of God,* was in process.

It was in the fall of 1899, too, in one stormy autumn evening, that Rilke wrote the first draft of what would become *The Lay of the Love and Death of Cornet Christoph Rilke,* an anomaly in his work and later his best seller. Based on events of which he had read in the chronicles of the noble family from which he claimed descent, and clothed in the medieval dress of which he was so fond, it tells the story of a young man who, in a single night, finds both sexual initiation and death in battle. It is a youthful and extravagant treatment of a theme, the confluence of love and death, that would much later come to suffuse his experience of the death of Paula Modersohn-Becker.

Soon the lovers began to prepare for a second, longer trip, this time without Andreas along, to encompass much more of the country. Rilke plunged ever deeper into Russian studies under Lou's guidance; when they spent the summer of 1899 as guests of Frieda von Bülow, their hostess would complain that she saw almost nothing of them until the evenings, when they were so exhausted by each day's study that they made poor company. Lou's biographer H. F. Peters describes the extraordinary intensity of Rilke's devotion to Russian things, at the point at which this intensity began to alarm Lou, in a way that will be significant when we examine his effect on Clara Westhoff: "Russia was her country, but in less than a year Rilke had almost appropriated it."[21] Lou, in the end, was too strong to allow Rilke to make Russia *his* subject, even if his intent was then to present it to her as his gift. Others Rilke met later would lack such strength.

The second trip, begun in the spring of 1900, was a series of disappointments for Rilke. Lou was rediscovering her homeland, and in this process Rilke had only a minor role to play. They had tired themselves out, and she had tired of him, during their unceasing preparations. The length of the trip itself, from early May to late August, was too great, and the distances they tried to cover were inherently exhausting. Their second, unannounced visit to Tolstoy was a minor disaster. Becoming distraught, Rilke wrote little during the trip, and brooded about his failure to make use of it for poetry. The trip culminated, in August, with Lou going on alone to be with her family at their summer house in Finland, and Rilke left miserably on his own in St. Petersburg, desperate for her return. He wrote her a wretched, abject, reproachful letter that enraged her so much that she tore it up, and then an apology that pleased her little better. She stayed away until it was time for them to return, and in her mind the end of the affair was at hand.

Leaving Prague, Rilke had rejected his homeland as unacceptable; leaving home, he had rejected his family as equally so. He would reconstruct himself to suit the requirements of his calling. Russia would be his new homeland—yet now, losing Lou, he had lost the one through whom he could experience it. He suspected that he would always be a wanderer. He doubted that he would ever have a family.

Although he traveled back to Berlin in Lou's company, Rilke set out the next day for Worpswede, where Vogeler was expecting him. His intense encounter with Lou had been the major epoch of his life so far, an initiation into the possibilities of artistic, emotional, sexual adulthood. Exalted beyond limit at its heights, miserable at its collapse, near bursting with sensations suddenly deprived of their object, he arrived in Worpswede ripe for transformation. There, in an idyllic setting, he found a circle of earnest, gifted young artists who called themselves the Family. Two of them, to his astonishment and delight, were also lovely *Mädchen:* the girls of his fondest romantic dreams. Paula Becker and Clara Westhoff embodied these dreams more convincingly than Lou, now nearing forty, could do, and he could play to them shamelessly in ways that Lou would not have stood for. As his Worpswede journal progresses, it becomes clear that one of them, "the blonde painter," has caught his fancy in a particularly stimulating way.

Three

Paula Becker was born on February 8, 1876, just two months after Rilke, in Dresden, where her father was a civil engineer for the Berlin-Dresden Railroad. Of her early life there, only one event claims mention: when she was ten, and playing with other children in a sand pit, the collapse of a hill of sand buried the children; all were rescued but Paula's cousin Cora Parizot, who was killed. This early encounter with death may have played a role in giving death its prominence in Paula's thoughts, and thus in her letters and journals. She knew, in a way in which young people ordinarily do not, that a young life can be cut off at any time, and she entertained periodically the thought that it might happen to her.

When Paula was twelve her father moved his family to Bremen to take a position as administrator of railroads for the city. In 1895, though, he was forced into early retirement by the closing of the Office for the Management of Railroads, a development for which he blamed himself. He tried unsuccessfully to find another position, and brooded about his ability to support his large family on his pension. When Paula showed him her early artistic attempts, his responses were didactic and critical. He couldn't help it, and sometimes his letters contain apologies. He thought of himself as a man of the world: he was born in Odessa, where his father had been rector of a university, and his letters to Paula in Paris contain reminders that he, too, had been to Paris and knew French. He was educated, a reader and thinker, a liberal when young, and could articulate forcefully the received progressive attitudes of the day; in matters of art, though, his was the voice within the Becker family for

precisely the conventional nineteenth-century wisdom that Paula would struggle against. Whether or not his depressive severity, referred to openly within the family, was an early cause, Paula would become increasingly secretive about her work, while at the same time, in fruitless contradiction, deeply craving recognition.

"I do not believe that you will become an artist of the first rank, blessed by God," Woldemar Becker wrote his daughter in May 1896, when she was twenty. "That would have already become obvious by now; but you do have, perhaps, a sweet talent for drawing which can be useful to you in the future, and you must try to develop it." He went on to say that above all she must rise above the level of the dilettante, "the curse of our women's education today." Intellectually he was, if anything, more sympathetic to feminism than Paula herself. In 1897 Paula sent home from Berlin an account of a lecture on Goethe and women's emancipation, which she pronounced well delivered and sensible. "Nevertheless," she went on to say, "some other modern women have an indulgent, rather scornful way of speaking about men as if they were greedy children. And as soon as I hear them speak, I am immediately on the men's side." The letter ended, "I guess little Paula is going to let the great men of the world carry on and I'll continue to trust in their authority. Still, I have to laugh at myself and the world."

Paula's mother, Mathilde Becker, was more supportive of her daughter's efforts, though more out of kindness than conviction, for her daughter's progress away from the conventional puzzled and troubled her, too. At one point, while her husband was away in Saxony looking for another job, she arranged without his knowledge for Paula to study painting in Berlin. There was more to it than simply signing her daughter up; she arranged for Paula to stay with her Uncle Wulf in Berlin, successfully sought a reduction in the tuition, and faced her discouraged husband with the news when he came home empty handed. Then she took in an American boarder to help with the expense.

The first documents we have from Paula's hand, in 1892, are her letters home from England, where she was staying with her Aunt Marie Hill in order to learn English and the homemaking skills expected of a young woman. Though her letters dutifully list her accomplishments at sewing and butter churning, there are hints from early on that her aunt found her an unsatisfactory pupil, unwilling to accept direction. She was already trying her hand at drawing at this time; in late October 1892 her aunt enrolled her in drawing lessons in London. By early December, though, never quite able to come to terms with her strong-willed charge,

Aunt Marie had given her the choice of entering an English boarding school or returning home; suffering from fainting spells, she went home for Christmas and did not return. Periods of poor health would appear from time to time through the rest of her life.

One letter to Aunt Marie, in May 1893—she had returned home, but was still just seventeen—is a strikingly candid, self-possessed, and unrepentant account of her side of the story:

> You think I am extremely egoistic. I have so often puzzled over that and tried so hard to locate this terrible egotism of mine. I cannot find it. What I have discovered is that I very much want to be in control and that I have gotten used to directing my own life.

Her mother, she said, had always praised her, whereas nothing she did had seemed to please her aunt. "Would you suppose that I would put up with everything, considering my past? Could this 'spoiled' child get used to such a whole new situation?" Near the end she wrote, "My pride is my best possession. I will not put up with humiliations." Later in life she would defend herself against accusations of egotism from members of her family, and from Otto Modersohn. They were genuinely troubling to her, but she also understood that this quality, for which other names than *egotism* can be imagined, was the guarantor of her determination to make art. Her journals and letters reveal that she had this dream from early on: to become someone, to make something of her life, through her art.

The character of this life is distorted by exclusive focus on its darker tones. At times, and both early and late there were many, when her determination to make art was unthreatened, her letters and journals reveal first a girl and then a woman by nature high spirited, funny, affectionate, gregarious, uncomplaining. She made friends easily, loved to dance and skate, and could usually muster a light touch in response to her father's, or Otto Modersohn's, solemnities.

In 1893 Paula entered teacher training, which she would complete successfully in September 1895, at age nineteen. This course of study was required of her by her parents, as it had been of her older sister, Milly, in order to give her one of the few sources of financial independence open to women—and an alternative to marriage, for Woldemar Becker sometimes worried that his daughters, especially Paula, would not marry.

After she finished, Paula was granted a reprieve from immediate job seeking as a result of another bout of ill health. In April 1896 she went

for her first two months in Berlin, to study at the drawing and painting school of the Society of Berlin Women Artists—the course of study her mother had arranged behind her father's back. In October of that year she returned for further study; one letter home from this second stay reflects the strong will we have already seen in her, this time in relation to her art, as it describes one of her teachers:

> He is the typical social butterfly in school with his "pretty miss" here and his "pretty miss" there, and while he goes on chatting with you he has painted half your picture for you. So I told him that I was going to finish my own picture next time, my third one. He was half impressed by that and half irked, too.

For the first time, now, she had a female teacher, Jeanna Bauck, who made a strong impression on her. Taking the course of her development into her own hands, Paula decided while working under Bauck to change her emphasis from landscape painting to portraiture; she would hold to this course for the rest of her life. Her father fretted in one of his letters that there wasn't as much money to be made in portraits as in landscapes, and once he simply insisted that at the end of the term she would have to stop and take a job for a year. Responding with a stiff upper lip to his edict ("In my free time I can draw, so that my hands won't lose their touch"), she had the nerve and kindness to hold up a mirror to him:

> Father, promise me one thing. Don't sit at your desk, staring into space or at that picture of your father. That is the one way to invite worries in and then they will cover the eyes of your soul with their dark wings. Don't let them do it. Let your poor soul enjoy the few rays of autumn sun still left—it needs them.

In the summer of 1897 Paula went with a female companion for what were to be two weeks of living and painting in the Worpswede colony, only some twenty kilometers from Bremen and already well known; in the end, the stay lasted more than a month. In her journal Paula responded ecstatically:

> Worpswede, Worpswede, Worpswede! My Sunken Bell mood![1] Birches, birches, pine trees, and old willows. Beautiful brown moors—exquisite brown! The canals with their black reflections, black as asphalt. The Hamme, with its dark sails—a wonderland, a land of the gods. I pity this beautiful part of the earth—the people

who live here don't seem to know how beautiful it is. . . . No, Paula Becker, better take a little pity on yourself for not living here. Oh, not even that; you are alive, you are happy, your life is intense, and it all means that you are painting. Oh, if it weren't for the painting!

Faithful to her calling to portraiture, she went on to make word-sketches of the painters who had made Worpswede famous. She took a particular liking to the stylish young dreamer Heinrich Vogeler:

> The second in this circle is little Vogeler, a charming fellow born under a lucky star. He is my real favorite. He's not really the realistic man that Mackensen is; he lives in his own world. He carries Walther von der Vogelweide and *Des Knaben Wunderhorn*[2] around with him in his pocket. . . . In the corner of his studio is a guitar, propped against the wall. He plays all the old tunes on it. And when he is playing, it is marvelous to see how his large eyes seem to be dreaming the music.

The strong impression made on Paula by Otto Modersohn, to whose work she had already responded positively after seeing it in Bremen in 1895, is unmistakable:

> I've seen him only once and then just for a short time—and I did not get a real sense of him. All I remember is something tall, in a brown suit, and with a reddish beard. There is something soft and sympathetic in his eyes. His landscapes, the ones I saw exhibited there, have a deep, deep mood about them—a hot, brooding autumn sun—or a mysterious, sweet evening light. I should like to get to know him, this Modersohn.

In a letter home from this time, Paula conveys in even more vivid terms what Worpswede could mean to a young person, perhaps particularly to a young woman, since among the young Worpsweders certain kinds of behavioral freedom unavailable in Bremen society are evident:

> This morning I decided to leave my brushes at home and give them a rest. I strapped a rucksack to my back, packed a lunch, took along Goethe's poems, and walked to the moors, past lonely farmsteads surrounded by pine trees, through the unbelievably green meadows along the Hamme, through heathland covered with red heather, past slender nodding birches. Whenever I got to a spot that I thought must be the most beautiful one, I lay down and watched the clouds.

Not only could a young woman of the middle class roam the country-side alone and unafraid; young women and young men could roam it together, unchaperoned.

After that summer Paula returned to her studies in Berlin, but she dreamed of returning to Worpswede. In the winter her father, his funds depleted, insisted that by June she get a job, but in rapid succession two financial windfalls from members of the extended family enabled her first to keep studying in Berlin, and then, in early September 1898, to realize her dream by going back to Worpswede to study with Fritz Mackensen.

In the summer before her return, though, Paula accepted an invitation for an extended salmon fishing trip in Norway with her Uncle Wulf von Bültzingslöwen, and it was on that trip that she first read Jacobsen, to whom she responded as eagerly as Rilke. Often she sought out idyllic spots in spectacular natural settings and gave herself up to books and to reverie. She had brought along a volume of Jacobsen's stories and had begun to copy passages into the commonplace book she kept, and then her parents sent her his two novels, *Maria Grubbe* and *Niels Lyhne*. Of *Maria Grubbe* she wrote this in a letter home:

> I read it very, very slowly, intoxicating myself with small doses, partly under my buckthorn tree and partly at my little cliff near the waterfall—another of my favorite places. I can sit there completely quiet and tiny, surrounded by the roar and passion of the elements, and still feel only the power of the book.

She expressed, too, her determination to put off reading *Niels Lyhne* for a few days, in order to savor it more fully.

One note that Jacobsen the naturalist often struck that Paula, too, could be affected by was a nature-lyricism not far from that in many Worpswede paintings, including Otto Modersohn's. In the following passage, Niels Lyhne recalls at sunset, back in his room, a day spent walking in the countryside:

> He closed his eyes, and still he felt how his body drank the light, and his nerves vibrated with it. Every breath he drew of the cool, intoxicating air sent his blood rushing more wildly through the quivering, helpless veins. He felt as though all the teeming, budding, growing, germinating forces of spring were mysteriously striving to vent themselves through him in a mighty cry, and he thirsted for this cry, listened for it, till his listening grew into a vague, turgid longing.[3]

Under her buckthorn tree in Norway, and under Jacobsen's spell, Paula wrote this Jacobsen pastiche in her journal:

The buckthorn was in blossom and that was the prettiest thing about it. Its scent filled the soft air and covered me in a dream, tenderly, and sang to my soul a tale of times before I ever was, and of times when I shall be no more. And I had a strange and sweet sensation. I thought of nothing. But all my senses were alive, every fiber. I lay that way for a long time. And then I came back to myself again, to the wind and to the sun and to the happy buzzing of the insects all around me.

Jacobsen brought Paula's Worpswede dreams to new heights of intensity. This is part of the letter she wrote to her aunt Cora von Bültzingslöwen on the first evening she spent there:

All around about me the precious quiet of evening and the pungent smell of hay in the air. Above me the starry sky. Such sweet inner peace fills me and gently takes possession of every fiber of my whole being and existence. And one surrenders to her, great Mother Nature, fully and completely and without reservation. And says with open arms, "Take me."

Before a handful of young painters chose it for their idyll, Worpswede was a small, unglamorous village of peasants, mostly, who wrung a meager living from small-scale farming and the cutting of peat in the moorland for sale as fuel. What convinced the young art student Fritz Mackensen as early as 1884 that the village promised riches to painters was a lowland landscape not quite like any that painters had ever celebrated; huge, cloud-filled, constantly changing skies; and a distinctive quality of light, usually credited to the large amount of moisture in the air. The village proper stood on the side of large hill called the Weyerberg, an old sand dune from an epoch in which the North Sea had reached what was now far inland. The flat heather and moorlands, including the great Devil's Moor, extended from the Weyerberg for miles. There were windmills and thatched huts, long, straight avenues lined with birches, and narrow canals leading to the meandering River Hamme, traversed by the even narrower boats on which peat was transported to Bremen. The flat and saturated land was subject to floods that could stretch for miles, turning the Weyerberg into an island in a shallow sea; in the winter one could traverse the whole region by skating on the canals. In the moor the water itself was black, and

so were the boats, even the sails of which were tarred to resist the damp weather. For a time each year the blooming of the heather added a vivid wash of color.

Mackensen himself was most interested in the peasants, who seemed to him as weathered and elemental as their surroundings. He saw them as pious, long suffering, even noble—an inspiration and a caution to the middle class. When, in 1887, he spent a day amid a peasant congregation, listening to a series of preachers at an outdoor prayer service on the moor, he began to make sketches for an enormous painting of the scene, which would bind him to the place and make his fortune.

By the time that Mackensen and Otto Modersohn completed their studies at the Düsseldorf Academy, in 1887, they had become fast friends; they went on long sketching trips together and, when apart, corresponded eagerly. In 1889 Mackensen finally persuaded Modersohn to come to Worpswede for a summer of painting; the number was raised to three by the arrival of Hans am Ende, a friend of Mackensen's from Munich. The enthusiasm of all three for what they found there led to an impulsive decision to stay on through the winter. The spirit of the founding of the colony—for this is what the decision is usually taken to amount to—was captured in Otto's journal: "Away with academies, down with professors and teachers, Nature will be our teacher."[4] They were consciously leaving behind the cities, too, and the ills spawned by the industrial revolution. Sensibly, they kept on visiting cities to look at art; all three went to Paris for the Centennial Exposition of 1889. But they recorded the horrors of modern urban life in their journals, and in the end they all established permanent homes in the village. In the next few years they were joined by three more students from Düsseldorf: first Carl Vinnen (who, though he did not live in Worpswede, sometimes exhibited with them, and joined the association they formed); then Fritz Overbeck, and finally Heinrich Vogeler, the youngest and the last to join.

The painting Mackensen undertook after seeing the prayer service on the moor was nearly nine feet high and thirteen feet wide. Though hinged in the middle to fold flat, it was too large to bring indoors, and so it stood for more than a year against the Worpswede churchyard wall, inadequately supported and protected by a stand of Mackensen's construction. There are stories of him running to secure it when a storm threatened—once, all the way from Bremen.[5] Another of Mackensen's early works was shocking to some in Bremen for its subject: a peasant woman in the fields, sitting on a peat cart and nursing her baby. To modern eyes it seems less naturalistic, more sentimental than it did when it was

new. But the young liked it, at least in part because it scandalized the old. These paintings of Mackensen's were the first elements of Worpswede's reputation, which had, at least, reached Bremen; they gave the place, in the eyes of the new generation of painting students that soon arrived there, its initial cachet.

Otto Modersohn was a passionate naturalist, with collections of butterflies, insects, dried plants, and stuffed birds; Worpswede, for him, meant Nature (as it did at first for Paula Becker), and his early journals are filled with fierce declarations of loyalty to her. Intense, earnest, sometimes withdrawn, he was a tireless sketcher of landscapes and natural objects. He was tall, wore glasses and a full reddish beard, often smoked a pipe; Paula's pet name for him, taken from a figure of German legend, would be "King Red." He had something of a professorial air, and was sometimes the object of fond caricatures. His earnestness made him appear to his fellow bachelor artists a bit of a stick-in-the-mud.

Modersohn put endless effort into composing and recomposing, in his journal, what he called his "Ideal," in which nature always played the central role. This, from 1890, is one early formulation:

> An art that reaches out almost beyond optical vision, that aspires to the substance, the uniqueness of things, is my Ideal. The effect must be elemental, it must seize on objects with vehemence and erect documents of Nature. I value most highly the description of Nature in its simplicity with the greatest possible objectivity, without additions, since Nature surely possesses a more original power than the most assiduous conscious efforts of men.[6]

In the beginning, their correspondence shows, Fritz Mackensen and Otto Modersohn saw themselves as uniquely like-minded, and promised each other to submit to stern mutual criticism in the pursuit of common goals. It was Otto who began privately to think of himself as essentially different—and better. Though anyone who has ever *been* a young artist knows how easily such thoughts come, in Otto's case they grew into a private obsession he vented by lining the others up, again and again, in the pages of his journal—Mackensen, am Ende, Vinnen, Overbeck, Vogeler—and writing them off as insignificant, sometimes excepting his best friend, Overbeck. Each time that he repeated this ritual of dismissal he expressed his determination to keep such thoughts to himself, to behave toward the others with outward correctness while withdrawing inwardly from all but Overbeck. At the same time, both jockey and horse, he lashed himself on toward his own goal of greatness, again and

again dismissing an old version of himself as flawed while proclaiming the birth of the new one that he was certain, this time, was the right one—until its time came to be dismissed as well.

A great deal of suffering was Otto Modersohn's lot, and the ferocity of some of his obsessions cannot be understood unless it is taken into account. Our sense of the painful course of his first marriage, to the tubercular Helene Schröder, is heightened by the knowledge that Helene had first been stricken not long after Otto met her, and that not long after that, in 1892, he had met another young woman and become, at the least, utterly infatuated. He had already given Helene cause to hope for marriage, but for a time at least Sophie, slender and blonde (whom he called in his journal "the pure fairy-tale princess, a sylph, a slender little fay") had come to him like a dream come true, not only his ideal imagined wife but a muse who inspired him to new heights in his work.[7] Otto grappled with this ethical dilemma with the same intensity as he grappled with his ever refined artistic principles, and that the outcome was marriage in 1897 to the doomed Helene reflects something definitive about his character.

Conscientious to a fault, he was determined to postpone the marriage until he had achieved a large enough income from his work to provide a suitable home. The sacrifice of what might have been their best years together had baleful consequences for the marriage when it finally came. In this passage from his journal of September 27, 1900, some two weeks after his secret engagement to Paula Becker, Otto looked back over it:

> Through the heavy, hopeless suffering of my Helene my soul was made narrow, oppressed; under these continuous cares my loving, both physical and psychological, suffered greatly. Nothing of fresh, joyful daring, of the urge to act, of love that carries one along with it. . . . One lived from day to day, never dared think of the future, of which one knew that it would bring misfortune.[8]

Otto must have known, too, that bearing their daughter Elsbeth had taxed Helene Modersohn's strength, and perhaps shortened her life; it would have been in his nature to reproach himself. He entered his marriage to Paula with this guilt along with that of having fallen in love with her, already, in Helene's last days, and not having been at Helene's side when death finally came, in large part because Paula had lured him to Paris.

Heinrich Vogeler, eleven years younger than Otto, was the son of a wealthy Bremen merchant. Rebellious at school, he filled notebooks

with sharp caricatures of the teachers. He entered the Düsseldorf Academy in the fall of 1990, three years after Mackensen and Modersohn had completed their studies there, but he came to know them through his friend Fritz Overbeck. Overbeck had gone to Worpswede in 1893, and Vogeler followed in 1894, at the age of twenty-one. The others were impressed with his facility and the range of his undertakings, and by inviting him to take part in their first group show, in Bremen, they made him one of them. Vogeler had adopted the fashionable public pose of the dandy, always in costume when he appeared in public, affecting most often a frock coat of Biedermeier cut, and sometimes a beret. It was a manner that Otto Modersohn mistrusted at first; in 1894 he described the newly arrived Vogeler in his journal as "coquettish, affected as a human being and as an artist."[9]

Mackensen, Modersohn, and the other former Düsseldorf students had all been members of a club called Tartarus. They had gathered to drink, to be young, male, earnest, irreverent artists together, and to vent their frustration with their teachers and the conservative curriculum. They brought the spirit of Tartarus with them to Worpswede, where it shows in the early photographs they loved striking poses for: lined up, each holding aloft a tiny, silly-looking flower, behind the broad back of a popular poet who had come to town; thrusting their grinning faces into the spaces between rungs of a ladder or the frames of a window.

Martha Schröder was a peasant girl, the youngest of the thirteen children born to the Worpswede schoolmaster and his wife, who was widowed immediately after. In Vogeler's telling of the story, he first caught sight of her almost immediately upon arriving in Worpswede.[10] Mackensen, am Ende, and Overbeck had taken him first to roust Otto Modersohn from his studio. Then all five had gone to the churchyard, where Mackensen's magnum opus stood against the wall, and turned it around for Vogeler to have a look. Then they had ascended the Weyerberg and arrived at the Findorff monument, an obelisk of red granite dedicated to the man who had first drained the moors and opened the area to widespread settlement. In their salad days the young painters loved to climb it, and on this day Fritz Overbeck began to declaim from its pinnacle the verses of a poet whom they called "the Silesian nightingale" for the groaning awfulness of her work. At that moment a fourteen-year-old blonde girl, her hair in a single braid wrapped around her head, emerged from the woods, a tame magpie on her hand, a young child at her side. Mackensen, who boarded with the Schröders, called her over; Vogeler was struck immediately not only by her beauty but by what

he took to be her simplicity, her utter freedom from self-consciousness and concern for making an impression. He began to paint her repeatedly, often in medieval costume in scenes in which he represented himself as a young knight; in both manner and matter these paintings owed an unmistakable debt to the Pre-Raphaelites. In life as well as in art, he courted his chosen girl from the first, in defiance of conventions about social class that made their eventual union controversial. He undertook a Pygmalion-like project of seeing to her education and upbringing so that some day she might be prepared to take her place at the center of the little world he planned to create for the two of them.

With money he inherited when his father died, Vogeler bought an old farmhouse with thatched roof overlooking the highway just outside the village. At first he had to sleep under an umbrella to keep dry on rainy nights, but before long he had begun to transform it, doing much of the work himself, and would not rest until the house and ever more elaborate grounds were in every detail his own creation, a *Gesamtkunstwerk* exemplary by the intellectual fashions of the day. Between the house and the highway below, Vogeler planted a grove of young birches—*Birken,* or *Barken* in the Plattdeutsch of the region—from which the house took its name: the Barkenhoff. Vogeler was literally, shovel in hand, in the act of planting the birch grove when the young Bremen poet Rudolf Alexander Schröder appeared to recruit him for the new journal of art and literature, *Die Insel,* that he had founded in Munich in collaboration with his cousin Alfred Walter Heymel.[11] Schröder offered to rent a studio for Vogeler in Munich if he would go there to take over the art direction of the magazine. He accepted, and this position made his fortune; the journal's regular contributors included Hugo von Hofmannsthal, Franz Blei, Julius Meier-Graefe, Richard Dehmel, Maurice Maeterlinck, and the sculptor Georges Minne. In such company, he rapidly gained a reputation not only nationally but across Europe. When Aubrey Beardsley died, in 1898, the English magazine *The Studio* named Vogeler the most likely artist to take his place.

But Vogeler had darker moods in which he lost confidence in the dreamworld he was creating at the Barkenhoff. He sometimes disappeared from the social events he was so fond of sponsoring there, to be found somewhere later, alone and brooding. He pinned all his hopes on his love for Martha Schröder and her love for him; much later, both of them would pay the price.

Eighteen ninety-five, the year the original Worpsweders suddenly became famous, started out badly for them; their first rather modest

group show, at the Kunsthalle in Bremen, got bad reviews. It was a sign that, at first, their work *was* new and unconventional, at least for Bremen, a center of commerce but not of artistic innovation. They painted, in the open air, scenes of peasant life rather than historical or allegorical subjects, and landscapes that could be seen as flat and uninspiring compared to the majestic mountain scenes, dotted with ruins, favored by German romanticism. By the reigning tastemakers in Bremen they were called "apostles of ugliness" for their trouble.[12] Young people responded, though: Paula Becker, who was nineteen, saw the show in April, and wrote enthusiastically to her older brother, Kurt, singling out Mackensen and Modersohn for praise, and Vogeler, whose Pre-Raphaelite models she recognized, for amused skepticism.

For all its poor reception in Bremen, the exhibition was seen by the president of the Munich Artists' Guild. The fact that he offered them a room to themselves in the great annual international show at the Glass Palace in Munich the same year gave the Worpsweders, and Bremen Kunsthalle director Gustav Pauli, who had made the show possible, great satisfaction. Then a telegram arrived with the news of Mackensen's gold medal for *Prayer Service on the Moor* and the purchase of Otto's *Storm on the Moor* for the New Pinakothek in Munich. They had come out of nowhere and achieved a stunning coup.

In the far more enlightened Munich, the work of the Worpsweders was already in the mainstream; five years earlier the Glasgow Boys, a group of painters with similar interests from the colony at Cockburnspath, Scotland, had shown in the Glass Palace to great acclaim; further back lay the colony at Barbizon. The shows at the Glass Palace were the pinnacle of conventional taste; having arrived there, the Worpsweders could scarcely be called insurgents. It was inevitable that sooner or later the tastes of the burghers of Bremen would broaden to embrace them.

For they were, on the European rather than merely the German scale, provincial latecomers, fighting battles won by French painters a generation or more earlier. Worpswede was founded at the end of the period when colonies were a new and significant development; even in Germany the secession movements of almost the same time opened paths that led in far more radical directions, while from the perspective of Paris, Worpswede, if noticed, would have seemed provincial and passé from the moment of its birth.

In Germany in 1895, though, they were newly famous, and fame brought with it a market for their work. For Otto Modersohn, the two sales he made that year gave him reason to hope that the annual income

he needed to make a home for himself and Helene Schröder would soon be at hand; in 1897 they were married.

In the long run Fritz Mackensen proved to expect a greater collective artistic unity in the colony than Otto, who was too much a stickler for principle to keep silent. In July 1889 Otto left the association they had formed, outlining his reasons in a letter to the other members. Vogeler and Overbeck joined Modersohn in supporting the dissolution; Mackensen, am Ende, and Vinnen opposed it. There were now, among the Worpsweders, increasingly irreconcilable progressive (Vogeler, Modersohn, Overbeck) and conservative (Mackensen, am Ende, Vinnen) factions. In a stalemate, the association was dissolved.

The declining health of Helene Modersohn combined with the tensions in the group and Otto's own tendency toward brooding to lead him into an increasingly secluded life. Depressed, he was thinking of leaving Worpswede altogether.

Fame brought more than financial reward and personal conflict to Worpswede. It attracted large numbers of painting students, many of them young women, to whom the academies that the Worpsweders themselves had attended were still closed. Women could attend private painting schools, but these were more expensive and, especially if they were exclusively for women, less prestigious. First Clara Westhoff and then Paula Becker, each of whom had already attended such a school, came from Bremen to study with the newly famous Fritz Mackensen.

Clara Westhoff, like Heinrich Vogeler, was born to a Bremen merchant family. She showed an interest in art while very young; her desire for serious art study met with less parental skepticism than Vogeler's or Paula Becker's. But she understood early on that her gender would complicate her search; she was vehement, as Paula Becker was not, in expressing her disapproval of this state of affairs, and willing to press publicly for change, accepting the unflattering names for women who did so. She didn't mind it being known, she wrote her parents at seventeen, "that I've become a *Malweib* . . . a true-blue emancipated fin-de-siècle woman."[13] There is no good English translation for *Malweib,* the thoroughly pejorative term of the day for the stereotype of the female would-be artist; there were caricatures—unattractive, man-hungry, and ridiculous—in the satirical magazines. "Painter broad" would convey a bit of the flavor.

Another genetic factor conspired with her gender to influence the way people received Clara Westhoff: she was a sturdy six feet tall, dark-haired and dark-eyed, her features quite sharply drawn and emphatic.

Though reticent in speech, she had great bodily energy, not readily contained within conventional female clothing and demeanor, and Paula Becker was not the only one to include in her fond descriptions of the young Clara a sense that she was always knocking something over, or seeming just about to. In Munich, a young sculpture student made a larger-than-life portrait bust of her that her family called "the goddess-bust" for its heroic aspect and proportions; she was always being called an Amazon or compared to the goddess Diana. In the early, still Tartarus-tinged days of her first stay in Worpswede, when the planned visit of the folk storyteller Hermann Allmers to the colony was postponed, and the artists, for a lark, composed a florid fictional account of it for a Bremen newspaper (with the poet making his triumphal entrance into the village on a farm cart drawn by oxen with gilded horns), it was Clara who bicycled the twenty-odd kilometers to deliver the dispatch to Bremen in time for the next edition. On another occasion, Vogeler, Clara, and fellow painting student Marie Bock took a bicycle trip to the North Sea coast and the island of Rømø; there, on the deck of a ship stranded at low tide, Clara had danced with the sailors in the hot noon sun until her feet were covered with blisters and she had to be carried back to the inn where they were staying.[14]

At the Fehr/Schmid-Reutte painting school she concentrated mostly on figure drawing, seen as a necessary step for aspiring painters; there are earnest letters home expressing both a desire to go to the countryside and paint and at the same time a determination not to do so too soon, before two good years of drawing had laid the groundwork. Though her letters express a good deal of satisfaction with the school, whose students were mostly but not exclusively women, she could also, while still just short of nineteen, write this: "All you have to do is think about how cheaply the men study [in the state-supported academies] and you get furious. Fehr is sly. . . . He's sure of us, because where else would we poor suckers turn?"[15] She took the lead in petitioning that at least the Munich Academy's free evening classes in anatomy be opened up to women, but the authorities, citing how few other women came to her support, turned down the petition.

As a cultural center rivaled only by Berlin, Munich was an art education in itself, with the annual shows at the Glass Palace, the prints and paintings in the collection of the Pinakothek, the secession shows, and distinguished private galleries like the Schack. A satellite of Munich was the artists' colony at Dachau, contemporary with Worpswede but much larger. Periodicals, which in their design and illustration did much to spread

new art impulses as well as literary ones, flourished as well. In addition to *Jugend,* for which *Jugendstil* was named, there was *Simplizissimus;* both were weeklies founded in 1896, while Clara was there, and she would have read the debut issues eagerly. Vogeler, too, was in Munich in 1897, having taken up his duties for *Die Insel,* the new monthly, and Clara visited him late that year in his studio, before she moved to Worpswede. They were not quite strangers; Vogeler had seen Clara as a gangling adolescent in his youngest sister's dance class. (Vogeler and Paula Becker, too, had crossed paths as young people in Bremen.) Rilke arrived in Munich from Prague at the end of 1896, but there is no evidence that he met Vogeler or Clara then. Both would have known his name, though, as by 1897 Rilke was publishing widely, and had work both in *Jugend* and *Simplizissimus.*

It was natural for Clara to decide to go next to Worpswede, and to study with Mackensen, the most sought-after of its teachers. Vogeler encouraged her, and Clara moved to the village in the spring of 1898. As she had done from Munich, and as Paula, too, would do, both out of a very real youthful enthusiasm and in order to propitiate the household gods, Clara sent home glowing accounts of Worpswede and of Mackensen's tutelage, not mentioning a romantic interlude with her teacher, a well-known ladies' man, that Vogeler described with fierce disapproval in his memoirs.[16] Of this typical and complicating interaction it can at least be said that Clara's development continued rapidly through and beyond it. Clara credited Mackensen, for whom, like Paula, she did at first naturalistic drawings of peasant models, nearly indistinguishable from her teacher's, with discovering and nurturing her gift for sculpture. He spoke to her parents in support of her decision to devote her life to a medium viewed as particularly unsuitable for women, but one in which her stature and strength could be seen for once as advantages.

Clara's career took a large step forward when Mackensen arranged for her bust of an old woman to be shown in the spring of 1899 at a major exhibition in Dresden, where, besides the Worpsweders, the distinguished sculptor, painter, and printmaker Max Klinger was showing. Mackensen had already begun to lay the groundwork for Clara's being taken on by Klinger as a pupil; he made sure that Klinger saw her work, and Klinger, whose reservations about female sculptors were both typical and public, praised it. Klinger did invite Clara to his atelier in Leipzig, make a studio there available to her, and offer her instruction and critique; she stayed there six weeks. On her arrival, though, she was greeted by a test of her mettle: he placed her in a small room with a plaster cast of a hand, a block of marble, and a set of stone-carving tools,

instructing her to carve the hand out of the block. Then, by the account of one of Klinger's friends, he forgot about her. Happening into the room again in the evening, he found her asleep, exhausted, on the floor, but the carving of the marble hand was finished. In her first letter home, careful not to worry her parents, she wrote only that Klinger had placed a piece of marble at her disposal, as if this were a gesture of confidence; a few days later she acknowledged that he had meant to scare her away, to prove that she was not strong or determined enough for the work. She had impressed him; he is reported to have said, in real if stereotypical admiration, "She attacks the marble like a man."[17]

On Klinger's advice, Clara decided not to return to Worpswede, no place for sculptors; from a list of alternatives she chose Paris, planning to attend the private Académie Julian, but moved most of all by the presence in Paris of Rodin, to whom Klinger provided her a letter of introduction.

In November 1899, before leaving for Paris in December, Clara paid a kind of tribute exacted by her father in return for support of her trip: she made a portrait bust of her grandmother, Laura Westhoff. By nature eager to the point of being impetuous, her head already full of dreams of Paris, she did not find it easy to return to this plane, to make art that would meet the conventional expectations of her family. We know this because she later confessed these feelings to Rilke, who in his uncanny way gave her own experience back to her, transformed, in a letter from October 1900. The naturalistic work she produced, its painfully heightened texture reflecting her model's great age, is unlikely to have pleased her family after all. Her duty done, though, Clara went on to Paris, where her friend Paula Becker would soon arrive.

When Paula Becker arrived for her second stay in Worpswede, Clara Westhoff made an immediate impression on her that soon led to a firm friendship. She wrote this in her journal after visiting Clara in her studio and watching her put finishing touches on a bust of an old woman: "I admired the girl, the way she stood next to her sculpture and added little touches to it. I should like to have her as a friend. She is grand and splendid to look at—and that's the way she is as a person and as an artist." Clara, in retrospect, described their first meeting this way:

There sat Paula Becker in my studio in her painting smock, without a hat, on the podium meant for my models. . . . She was holding on her lap a copper kettle which she had had repaired . . . and she sat there and watched me work. The kettle had the color of her

43

beautiful and abundant hair, which was parted in the middle and loosely brushed back and swept up in three great rolls at the nape of her neck. In its full weight her hair functioned as a counterpart to her light and sparkling face with its prettily curved and finely drawn nose. She would raise her face with an expression of enjoyment . . . and from it her dark and brilliant brown eyes looked at one intelligently and merrily.[18]

In 1899 Clara made a portrait bust of her new friend that would be among the first works she would show publicly. At times the two young women worked from the same model. They went punting together on the Hamme, swimming and putting flowers in their hair; Clara, Paula noted, did all the work. Paula's first gift to Clara was a copy of *Niels Lyhne,* which she had decorated with flowers.

But Clara Westhoff was not the only one on whom Paula made a vivid impression in Worpswede. In his journal, missing Paula when she was away at a cooking school in Berlin before their wedding, Otto Modersohn tried with a painter's eye for detail to capture her presence:

The impressions we had of her when she first visited us were of liveliness and agility. Her head, with its mass of chestnut brown hair, she tilted gracefully from one side to the other, and there was an occasional burst of cheerful laughter. Whenever she walked by our home, with an old woman from the poorhouse [on her way to her studio with a model] I delighted in her youthful, refreshing appearance—the way she led the woman by the arm, the intriguing way she walked, the way her feet would touch the ground, toes first.[19]

Summoning Paula's typically lively manner, fellow painting student Ottilie Reyländer tells the story of when a visiting writer, after a party in honor of Carl Vinnen, had climbed up the Findorff monument with a torch in his hand and dared the others to come up: "And then everybody tried to reach him; he called it 'the struggle for the light.' Paula Becker was the first one up. From the highest point, where there was no room for anyone else, she shouted down, 'Rabble up here, more rabble down there!'"[20]

Paula struggled with equal determination to move upward in her work. In November 1898 she read the journals of Marie Bashkirtseff, a young Russian woman studying painting in Paris, whose writings

brought her fame after an early death put an end to her art. In her jour-
nal Paula scolded herself for having wasted her first twenty years. "I say
as [Bashkirtseff] does," she wrote, "if only I could accomplish something!"

Paula adopted a pattern of using models from the poorhouse, who
welcomed the work and didn't cost much, for she was forced to get along
on little money. Among the most vivid were "Anna Dreebeen" ("three-
legged Anna"), a dwarfed and deformed woman who walked with a
stick; old "Olheit," Adelheid Böttcher, whose fame as "the witch of the
heath" had reached Paula in Bremen before she ever went to Worpswede;
and "von Bredow," an aging drinker and former seaman to whose name
von had been ironically affixed in response to the gossip around
Worpswede that he had been born into the nobility. Often she chose
young peasant mothers and their children, for mothers and children were
among her most frequently recurring subjects. Like Clara's, her early nat-
uralistic drawings resemble those of their teacher Mackensen.

But Paula proved herself no more willing to accept direction from
Mackensen than seven years earlier from her Aunt Marie. Mackensen
kept referring her back to nature, while her own impulse was to simpli-
fy and to work toward monumentality. Ottilie Reyländer much later
wrote this account of their interaction:

> Mackensen was making corrections and asked her with a penetrat-
> ing glance whether what she had produced there was something
> she really saw in the nature of reality. Her answer was remarkable:
> an instant 'Yes' and then, hesitating, 'No' as she gazed into the dis-
> tance. . . . Even as early as this, I would often hear her express views
> which were totally out of harmony with those of our master.[21]

If, on this occasion, Paula made a reluctant *pro forma* concession, it was
not in her nature to turn against her own instincts, and she went on in
the direction in which she felt herself drawn. (Once, later, she set herself
directly against Mackensen: her 1903 *Mother and Child,* which shows a
peasant woman in the fields nursing an infant, is clearly her own version
of Mackensen's famed painting of the same subject.) The peasants gave
her memorable images, which increasingly she rendered without
Mackensen's sentimentality; from the beginning she had to defend her-
self against the charge that she favored ugliness over beauty. On separate
occasions both her father and her mother urged her to find more uplift-
ing models.

In Worpswede, in March 1899, Paula Becker reread *Niels Lyhne:*

It intoxicates all my senses. It is as if my soul were wandering at the height of day through an avenue of linden trees in blossom. The fragrance is almost too much for me. . . . Jacobsen. I can feel him in all my nerves, in my wrists, the tips of my fingers, my lips. It envelops me. I read him physically.

In her commonplace book she copied this time a passage that Jacobsen placed in the mouth of Mrs. Boye, whom Niels has loved without ever quite becoming her lover, as explanation of her having left her artistic life and friends behind for the safety of a conventional marriage: "We women can perhaps tear ourselves away for a while whenever someone has entered our lives and opens our eyes to the need for freedom that dwells in us. But we do not endure."[22] There was in *Niels Lyhne,* then, the figure of a woman who fell back, as Rilke later would claim that Paula had fallen back.

Before long, Paula's progress was such that the question arose of when she ought to begin to show her work publicly. Vogeler tried as early as 1898 to arrange for her work to be shown at the Bremen Kunsthalle, but its director, Gustav Pauli, a firm supporter of the Worpsweders against their critics in Bremen, urged him to wait until she was better prepared. Perhaps unfortunately, the wait did not last long: just before Christmas 1899, at age twenty-three, Paula showed at the Kunsthalle two landscape studies and several drawings, along with work by another student, Marie Bock.

Arthur Fitger was the reigning arbiter of conventional taste in Bremen. His academic traditionalism was just what the original Worpsweders had joined to oppose, and he was in return implacably hostile to all that they represented. He was not above striking at them, and at Pauli, through this modest showing by their two young students. The stately pace of his prose makes it difficult to excerpt, but his review begins this way:

Unfortunately we must begin today's notices with an expression of deep regret at the fact that such unqualified work as the so-called studies of Marie Bock and Paula Boecker [*sic*] has succeeded in finding its way into the exhibition rooms of our Kunsthalle. . . . That something like this could be possible is most regrettable. The vocabulary of pure speech is not adequate to discuss the work of the two above-named ladies, and we are reluctant to make use of impure speech.

A week earlier, Fitger had reviewed more gently two busts (one of which was her bust of Paula) and a relief by Clara Westhoff. After conceding her "pronounced talent," he went on to say, in effect, that for a young woman, Clara had a lot of nerve:

> The artist is, as we have heard, still a very young woman; for this reason her art seems to us rather excessively impertinent. Impertinence is becoming only to very small children; afterwards, a tender shyness clothes young women, in particular, more becomingly, until in riper years the childish impertinence may reappear as the intrepidness of youth, and enchant every heart.[23]

Carl Vinnen answered both of Fitger's pronouncements in a rival newspaper's Christmas Eve edition, referring first to the attack on Paula and Marie Bock:

> And for whom was this Olympian thunder meant, at whom was this artillery of violent rage aimed . . . ? Alas, it was only two young women pupils from Worpswede, whose entire crime consisted of exhibiting below-average and immature schoolwork and for whom—which only exacerbated the problem—the administration of the Kunsthalle had chivalrously set aside one of their side galleries. The poor Worpswede ladies!

He then pointed out in Clara's defense that the very work she had exhibited had impressed the illustrious Max Klinger enough to cause him to take her on as a student.

Paula could hardly have taken comfort from Vinnen's response, even though he'd sent her, along with a copy of it, an awkward, half-apologetic note in which he stood by his judgment of her work while praising her promise, and tried to sound gallant in defense of "our ladies of Worpswede."[24] Vinnen must have augmented—and from a Worpswede source—the confirmation Fitger's attack had given Paula's father in his essential pessimism about her future as an artist. The whole affair may be another source of Paula's secretiveness about her work: Kunsthalle director Pauli believed that it wounded her severely, turning her away, with fateful effect, from a public whose response she desperately needed.[25]

Fortunately, Paula's stay in Paris, dreamed of since the days of her studies in Berlin, had been agreed upon in advance of Fitger's review. Her friend Clara Westhoff was already there, and Paula had arranged for an adjoining room in the same hotel.

Four

There were two schools of thought, among nations adhering to the Gregorian calendar, about which year constituted the beginning of the twentieth century: 1900 or 1901. In Germany, by decree of the kaiser, the first year was 1900. And it was on December 31, 1899, that Paula Becker, thrilled at the thought and bursting with hope, left Bremen by train for the seventeen-hour trip to Paris; by the time she had arrived, so had the new century. She would enroll at the Académie Colarossi, a private painting school catering mostly to foreigners. Though Clara Westhoff would attend not Colarossi but the Académie Julian, they would attend the same free anatomy and life-drawing classes, largely unavailable to women in Germany, two nights a week at the École des Beaux Arts.

The day before leaving, Paula had written a letter to Otto Modersohn. Her head was swirling, she said, listing obvious components of the swirl such as packing and goodbyes, but also "talking about Fitger!!!" To her New Year's wishes for the Modersohns she added, "And in the new century when I am in Paris, the great pit of sin, I shall often think of your sweet and peaceful little house."

After Paula arrived, exhausted, late in the evening of New Year's Day, and lay down to sleep, she was awakened by Clara's knock, and the two friends talked until morning. She related this in a letter home a few days later, and must have been shocked when, in his reply, her father advised her to distance herself from Clara: "You are permitting yourself, without noticing it, to be influenced by her stronger personality."

Clearly, Herr Becker's perception of Clara Westhoff was influenced by her imposing physical presence. But the worst thing about her, as he saw it, was that she was an eager pursuer of all that was modern in art, a subject about which Herr Becker had decided opinions:

> In my opinion your stay in Worpswede, where all of you were subjected only to reciprocal criticism, was a bit fatal for you because everyone entered into a kind of life that may perhaps have been understandable among you "prophets" and even beautiful, but that for other mortals was just a little hard to digest. . . . The more you can shake off Worpswede and the less stock you put by that foolish word "modern," the more progress you will make.

Though later she would pretend for the sake of her father's peace of mind that she and Clara were "trying hard to ignore each other's existence," she answered him with her typical firmness:

> Your two letters did depress me a little. They made you sound so thoroughly dissatisfied with me. I, too, can see no end to the whole thing. I must calmly follow my path, and when I get to where I can accomplish something, things will be better. None of you, to be sure, seems to have much faith in me. But I do.

There was in truth little prospect that Paula's father could have suppressed either her friendship with Clara or her growing interest in the most modern art of the day, of which Paris was the indisputable, indispensable center.

Clara made Paula's birthday, February 8, especially festive for her friend, and Paula did not conceal this from her parents:

> Clara Westhoff played a little lullaby for me on her Pan's flute at my chamber door. Then handed me a budding hyacinth in a pretty green bulb glass, an enormous orange, and an intoxicating bouquet of violets. We had coffee together. And this evening, after life-drawing class, the main celebration with half a bottle of champagne!!

Often, after working hard all week, Paula and Clara took weekend excursions outside the city, to places like Versailles and the village of Vélizy. With a group of other young German artists they went in for boating, dancing, and even some nostalgic singing of German songs. For an elaborate costume party ("private, German, twelve people") the young ladies made a hundred sandwiches, and strawberry and almond

puddings, and the young gentlemen painted friezes on walls they'd covered with paper. There was wine punch, candlelight, and dancing to the guitar and mandolin; they walked home at dawn, still wearing their costumes, and after morning classes they held a hangover breakfast at noon.

One letter of Paula's mentions the additon to the group of a painter named Emil Hansen, who would go on to fame as Emil Nolde. He did not become a regular member of the group as Paula expected, but the passing sketch in his memoirs is evocative:

> One noon I met two strange young German women. One of them, Paula Becker, a painter, was small, full of questions; the other, Clara Westhoff, was tall and reticent. I never saw either of them again. But not long afterward the sculptress became the wife of the poet Rainer Maria Rilke. The painter became the wife of the painter Modersohn. During the span of a few years she painted beautifully conceived and humanly touching pictures.[1]

Paula's journals from this visit record mostly moods, romantic daydreams, artistic aspirations couched in the most general terms; it was such passages that first propelled her published letters and journals to their popularity as a gift book in the twenties. This entry from mid-April is typical:

> Now I'm beginning to awaken as a human being. I'm becoming a woman. The child in me is beginning to recognize life, the purpose of a woman; and it awaits fulfillment. It will be beautiful, full of wonder. I walk along the boulevards and crowds of people pass by and something inside me cries out, "I still have such beautiful things before me. None of you, not one, has such things." And then it cries, "When will it come? Soon?" And then up speaks art, insisting on two more serious, undivided years of work.

Working unstintingly, Paula was a great success in her studies, once being chosen by all four instructors at Colarossi as the winner of the *concours*. In the second half of April she fought through a period of depression associated with an unsolved problem in her work. "A month ago I was sure of what I wanted," she wrote. "Inside me I saw it out there, walked around with it like a queen, and was blissful. Now the veils have fallen again, grey veils, hiding the whole idea from me. I stand like a beggar at the door, shivering in the cold, pleading to be let in." At the end of the month she wrote, "I have been depressed for days. Profoundly sad and solemn. I think the time is coming for struggle and uncertainty. It comes

into every serious and beautiful life. I knew all along that it had to come. I've been expecting it. I am not afraid of it." This depression was serious enough to show in her letters home, arousing her parents' concern. Her father, sensibly, sent money, for she had not been able to eat as well as she should have, nor to heat her room adequately through the Paris winter.

From Paula's first Paris stay there is at at best only one ambiguous remark in a letter to her parents ("new perspectives have opened up for me, completions and clarifications of what I've done in the past") to show that even early in 1900 the most modern work was affecting her.[2] But she mentions more than once getting to know Montmartre, where much of the groundbreaking modern work was taking shape, and would find its most supportive reception in the gallery of Ambroise Vollard, which Paula found and visited more than once. Vollard had been showing Cézanne, still not widely known (and then more for his eccentricity and misanthropy than for his art), since 1895, and in the late 1890s he had shown van Gogh, Gauguin, Maillol, and even Picasso. In 1900 he mounted a major Cézanne retrospective that included thirty paintings. Paula discovered Cézanne at Vollard's, and we have Clara's account of her friend's eagerness to share the discovery:

> One day she insisted that I accompany her on a walk to the Right Bank, so that she could show me something special there. She led me to the art dealer Vollard. And in his shop, since we were left to our own devices, she began to turn the pictures around that were standing against the wall, and to choose with great self-assurance a few of them that were of an altogether new simplicity and seemed to be close to her nature. They were pictures by Cézanne which we saw there for the first time. We did not even know his name. In her own way, Paula had discovered him and this discovery was an unexpected confirmation of her own artistic search. Later I was surprised not to have found anything about this in her letters.[3]

Only a few years later would Gertrude and Leo Stein, those distinguished early patrons of the modern movement, make their own discovery of Cézanne, also at Vollard's.

Paula was, as we have seen, secretive about her work, and this secretiveness extended to its deepest sources. Taking Clara to see Cézanne was a confidence shared with her best friend. In the account just cited, Clara goes on to suggest, "Perhaps it was impossible for her to articulate these things in a comprehensible way—indeed, this experience was

perhaps so inexpressible that it could only be transformed in her work." In her letters to Otto and to her family she wrote most about two far more conventional Frenchmen, Charles Cottet and Lucien Simon. She was serious about them—she visited Cottet in his studio, and he returned the call, though he found her not at home—but these were the enthusiasms she could talk about.

At times Paris overwhelmed both Paula and Clara; their letters express horror at the juxtapositions of opulent wealth and wretched poverty. Paula's first comments on the French and the German character are equivocal: the French had their *joie de vivre,* the Germans their moral earnestness. As time passed she was progressively more taken with the French; sometimes the credit given Germans in Paula's assessments seems perfunctory. This is her comment in a letter to Otto Modersohn and his wife at the beginning of May:

> Now I can feel how we in Germany are far from being liberated, that we do not rise above things, that we still cling too much to the past. I sense this now about [German impressionist Max] Liebermann, Mackensen and consorts. All of them are still stuck too much in the conventional. All of our German art is.

To her parents she wrote, after praise of Cottet and Simon, "Beside them we Germans seem a little bourgeois and Philistine. Lots of zeal and enthusiasm, and too little real study." In response to Paula's question about how he liked Monet, Otto added to his negative response this comment: "In general, I like to look at French art, old and new, even if in the long run it makes one return all the more emphatically to one's own work. For it is a great pleasure to be a German, to feel German, to think German."

Though she would dutifully take formal instruction, as Klinger had urged, what Clara Westhoff looked forward to most eagerly in Paris was the chance to meet Rodin. She called at his studio in Paris, presenting Klinger's letter; years later, in a lecture she sometimes gave on Rodin, she recalled a small incident from that first visit:

> He greeted me in a friendly and attentive way and said, gesturing with his hand around the room filled with his work, that I should just look around. . . . But once, as I looked over toward him, he was holding in his hand a small piece made of plaster, which he had just picked up from the rack on which it had been standing, turning it

this way and that before the eyes of his visitors and giving bits of commentary. When he noticed that I was watching and listening, he turned to me with a kind look and placed the small, fragile thing in my hand. . . . This modest little gesture led me, in a kind, unambiguous, trusting way, into his world, which from then on was open to me.[4]

Reporting to her parents on her visits to Rodin as she had on her visits to Klinger—with an eye to reassuring them of the value of her stay in Paris—Clara strikes unself-consciously the note of the awed pupil before the revered master, and puts the best face on what must have been a disappointment:

Today I was in Rodin's studio again. He was very sweet to me, and showed me all kinds of things he was working on at the moment. Unfortunately I won't be able to work alongside the men, for a thousand reasons which he explained to me. But he was very kind, and I hope that he will take an interest in me, and then I'll ask him sometime to look at my work in my studio.[5]

That March Rodin would briefly open, with his associates Bourdelle and Desbois, the Institut Rodin, a school for sculptors, and Clara would become one of its students. There were separate classes for men and women, as there were at the academies Paula and Clara attended. While most of the instruction came from Bourdelle and Desbois, the master himself did get to know her work, and gave her criticism and encouragement.

One prospect anyone arriving in Paris at the dawn of the new century had to look forward to was the Universal Exposition of 1900, under construction since 1896 in the heart of the city. Despite delays caused by the muddy spring, it would open as scheduled, with many of the displays still unfinished, in April. In less than a year it would be seen by over fifty million people. The first stages of the Paris Metro had been completed in time for the opening. The Eiffel Tower was given a fresh coat of golden yellow paint, and next to it a gigantic globe was being built. A new bridge was built across the Seine, the first to span the river in a single arch, and on either side of the street leading up to it stood the new Grand Palais and Petit Palais, which housed the art exhibitions. On the Right Bank stood a kind of Old Paris theme park, with gabled and towered houses peopled by actors in costume; on the Left Bank was the Rue des Nations, where foreign countries had erected often huge and pre-

tentious displays. There was a fearsome three-speed moving sidewalk and a Ferris wheel that could hold twenty-six hundred people. The enormous generators that supplied the exposition's power were an exhibit in themselves, in the Hall of Dynamos, which fascinated and troubled Henry Adams; the exterior of what was called the Palace of Electricity became, at night, a large, gaudy fairy palace.

There were two enormous painting exhibitions. In the Grand Palais, "modern painting of all nations" from the last ten years was shown. The French reserved half of the space for themselves yet managed, by leaving the judging to officals of the École des Beaux Arts, to avoid letting out the secret that the foundations of modern art as we know it were being laid, chiefly in Paris, at that very time. There were not even any impressionists. The British showed Millais, Burne-Jones, Beardsley; the Austrians showed Klimt; the Belgians, Khnopff and Ensor. America showed Whistler, Sargent, Homer; the Germans, nothing from Worpswede.

The second exhibition, housed in the Petit Palais but by no means small, presented an impressive collection of French art from 1800 to 1889 that would draw Paula Becker back to it more than once. From early in the preceding century there were David, Ingres, Delacroix, Géricault. There were Manet, Courbet, Corot, Millet, Gustave Moreau; many Monets, Renoirs, and Pissaros, and even small doses of Seurat, Gauguin, and Cézanne. Though these high points make it sound impressive enough, the most modern work was often hung in out-of-the-way corners, and the consensus among young artists in Paris was that the real tone was set by the volume of numbingly conventional academic work engulfing it. Paula, though, too newly arrived to be blasé, was ecstatic.

The work of Rodin, still controversial despite his fame and advancing years, had been denied a place in the sculpture hall of the Grand Palais. Instead, Rodin had a large pavilion built on a triangular plot of land at the Place de l'Alma, the same spot where, at the time of the exposition of 1867, Courbet and Manet had mounted their own independent exhibitions. In it he placed the largest collection of his work that had ever been shown in one place: 165 sculptures, the nearly complete *Gates of Hell* in plaster, shown for the first time anywhere, and in a side room a large selection of his drawings as well as photographs of his work. Some of Rodin's recent drawings exhibited, with their seemingly inartistic poses, a frankly sexual interest in the bodies of his models that was shocking to many even in Paris. On later visits Paula would write ecstatically of these drawings in her letters to Otto Modersohn. Rodin

had gone into debt to finance his exhibition, but in the end it paid off handsomely in sales, and after the Exposition he had the entire structure transported to his new country home at Meudon.

With Clara and Paula in Paris, letters were exchanged in all directions with those remaining in Worpswede. One day in April, Vogeler, in the grip of one of his periodic moods of discouragement, sent an engagingly candid letter to Paula. He began with grumblings about how the Worpsweders had lost their sense of community, and turned to faulting himself as "the greatest braggart of them all." Of Otto Modersohn he wrote, "Modersohn is very nice but completely blind to the terrible condition of his poor wife." Near the end of the letter, obviously embarrassed at how far he'd let himself go, he blurted out praise of Paula's work: "you've changed enormously for the better. You're so free of the old-fashioned poetic trappings."

Paula, moved by these confidences, wrote him a generous and encouraging answer. And with unmistakable feeling she came to Otto's defense: "We don't know whether the man is completely blind to the awful things that must be affecting him. He has a pure, delicate, sensitive soul. In all his simplicity, there is something great. The self-control that he has about his wife is rare in men."

Paula's correspondence with Otto himself began to take on, in spite of itself, a warmth that tested the outer limits of propriety. As early as January 17, after ecstatic descriptions of the art she'd seen in the Louvre, she wrote, "I have so often wished that you were here, Herr Modersohn, and really felt it to be an injustice for me to be seeing all of this, and not you." By the beginning of May, when Paula had seen the art at the exposition, the clash between her interest in Otto and her sense of propriety becomes, but for the gravity of an event they could not have seen coming, almost comical:

> You simply *must* come here. You *may* not let this chance pass by. . . . *Dear* Frau Modersohn, can you come along? . . . How is your strength after this cold, horrid winter which brought influenza and sickness everywhere? Can you manage such a long trip so soon again? And even if you couldn't manage it, send your husband away by himself. Naturally he won't want to go without you, but be unrelenting and stern. Do not give in to him. One week will suffice. And then he will come home to you again full of new impressions.

In the same letter, one whose great length she felt she had to justify, Paula had shared her judgment that German painters were too conventional

and stuck in the past. She went on to say that Otto himself was an exception: "Do you know you are one of the people who have worked their way through this mountain of conventionality? All the others fall by the wayside. I have huge hopes for your future." It was one more step in an elaborate and careful dance of not quite courtship. Otto's expressions of gratitude for Paula's letters, and of eagerness to see the exposition in her company, took on a warmth that answered hers and could not be accounted for by mere courtesy.

Though one of his early letters had dropped the first hint at a trip to Paris, Otto did hesitate to answer Paula's call, saying that he was deeply involved in his new work and expressing fear of influence and reservations about modern art in general. His wife's health was certainly an unstated consideration. He was older, too, and had already been to Paris; at Paula's age he had gone to see the exposition of 1889, and he was much further along than she was in his search for an artistic identity. In the end, though, he decided to come, and Paula's letter in response was ecstatic: "I'm so *enormously* happy that you are coming. *What a treat that will be.*"

With Otto came Overbeck and his wife and Paula's fellow student Marie Bock. All of them stayed at Paula's hotel, and Paula played the role of guide. It was the great exhibition of French painting in the Petit Palais that had made the biggest impression on Paula, and about which she had so much to say; Clara, who had had her own opportunities to see the show beforehand, wrote later of the pleasure of seeing it under the guidance of her friend, "whose joy over Daumier, Corot and all the others furthered my own joy and my understanding."[6] (From this passage, from the account of Paula's taking Clara to Vollard's to see Cézanne, and even from Nolde's sketch of the two, one senses that, in artistic matters at least, despite her father's worries about her friendship with Clara, Paula was more leader than follower.)

Later that summer Otto would write in his journal, "In Paris we silently belonged together."[7] But after only a few days, on June 14, 1900, a telegram arrived for him. Perhaps because it had been delivered to her address, Paula was the one to open it, and she had to give Otto the news: Helene Modersohn was dead.

The visitors hurried home. Vogeler had been right; Otto had not seen it coming. He must have felt remorse at having been swayed to leave his wife to die without him, and awareness of his growing connection to Paula must have set him into turmoil. Paula, too, must have had troubled, mixed emotions, knowing how the death caused Otto grief, yet

knowing too what the death meant for the two of them. Even her first letter to her parents about the death shows her deepened involvement:

> The poor man has gone home with the others. After so many years of caring for her with the most unselfish devotion, heaven was cruel enough to take her when he was away. Even now he doesn't seem able to comprehend it. . . . This is a very sad ending to my stay in Paris, and my next period in Worpswede will also be sad and difficult. I have gotten so much from being with Modersohn these days.

Though Paula's prediction must have been true for a time, the tone of life in Worpswede soon changed radically for the better, for in a matter of a few weeks, however improbable it may seem, the brief golden age of the Family had begun, its colors more vivid against this background of mourning.

Having lived in Paris on minimal funds, Paula was in poor health when she returned, and was given a reprieve by her father from returning to Bremen to find work. It was then that she first rented the room in the house of the Brünjes family that would be, for the rest of her life, the true home of her art. Separated from the busy highway by a tall hawthorn hedge, it offered above all privacy and freedom from intrusion while she worked. In her new home, on her doctor's orders, Paula took to her bed for a time. Otto Modersohn began to visit her, reading to her and helping her pass the time; at some point the mutual attraction was acknowledged. Before long they were sending each other love notes, leaving them under a flat stone in a pit on the heath. So soon after Helene Modersohn's death, they felt the most urgent obligation to keep their love a secret.

By Otto's later testimony, which rings true, Paula was eager to press on to formal engagement and marriage, while Otto held out for observing the relevant proprieties.[8] One practical reason for Paula's eagerness was the pressure from her father to become self-supporting; in Paris she had developed with Marie Bock some not very promising plans for earning money by weaving, and entered design competitions sponsored by commercial firms in search of some income of her own. Marriage to Otto Modersohn would mean financial independence from her family, and freedom from her father's endless strictures—though these freedoms would not come without strictures of their own.

Writing retrospectively of how it felt to be back in Worpswede after Helene Modersohn's death had ceased to cast its pall, Clara Westhoff put

it this way: "In the summer following the time in Paris, everything sounded once again in a many-voiced harmony: joy in all we had seen and experienced, in the land, in people—in each other—like a festive period of rest before the actual work of realization."[9] She goes on to remember the best-known story of their youthful exuberance, of which Paula also wrote in her journal. Strolling in Worpswede on Sunday in their white dresses, still feeling the thrill of having been to Paris and looking for an occasion to go dancing, the two young women went by the church; Clara had been working on designs for stone angels for its interior. This is Paula:

> So, off to the church. It's locked. Only the door to the tower is open. We climb up together, the first time for either of us, and now we're sitting together on one of the beams in the belfry. Suddenly we're inspired. We must ring the bells.

Clara:

> But . . . we went about it in the wrong way, holding tight to the pull-ropes of the heavy bells instead of letting go of them after each pull; it muffled the ringing. With each swing of the bell we were pulled up along with it; when I came down, I saw Paula in her white dress high above me.[10]

Paula:

> Just at that moment one of the tallest schoolmasters you can imagine appears at the top of the steep stairway, draws himself up to his full height, and starts to scold us; but when he catches sight of us two young girls in white dresses, he turns right around and goes down.
> We follow him—and—there's the churchyard, swarming with people. We'd been ringing the firebell! Everyone had thought there was a fire. Farther down in the village they had hooked up the hoses. We wanted to escape as soon as possible but were stopped by the village pastor. Pale and panting, he hissed the word "Sacrosanctum" several times at us. Later on we made a special visit to calm him down.

The word soon spread through the village that the two young women were the culprits. Herr Brünjes, Paula's landlord, said on her return that he had looked for her at the door again and again, terrified that she'd been locked up, to which his wife added that she had "kept telling

58

everybody all along that the big one, she could take it, but our little miss, she'd catch her death for sure in the clink."

It was that summer that those who had come to think of themselves as the Family began to gather every Sunday at the Barkenhoff, the women in white dresses, the men in suits, smoking clay pipes. Music was played, poetry was recited, the ever more distinguished guests that Vogeler had been attracting spoke or performed, and were entertained in turn. The Barkenhoff and its ever more splendid grounds had become the center of a new Worpswede that had risen from the ashes of the old.

This, then, amazingly enough, is the tone of the summer of 1900 within the circle that had gathered around Vogeler. There was spontaneous joy, the more vivid because the summer had begun with heartbreak. There was a strong erotic charge. Vogeler and Martha Schröder were lovers by now, but because they could not live openly together in Worpswede, Martha was living at Adiek, the estate four hours away where two of Vogeler's brothers had started a poultry farm; Vogeler got away to see her as often as he could. Otto and Paula were lovers in secret, delaying consummation of their love but surely anticipating it. Clara and Paula, inseparable, were perceived fondly as another kind of couple, bound by feelings they did not hesitate to call love. The Barkenhoff was at this time very much what Vogeler meant it to be, a gorgeous setting for the rituals of love as well as those of art. Clara and Paula could feel blessed to have found their way to such a place, which must have seemed hospitable to their artistic aspirations in a way that no other place could be.

And Rilke, a supremely potent catalyst for this already volatile mix, was on his way.

Five

Arriving at the Barkenhoff on August 27, 1900, Rilke was assigned an upstairs gable room adjoining the white-walled music room that was a focal point of the Family's gatherings. His presence unnerved the Vogelers' aging housekeeper, who worried that he would wear his Russian peasant clothing into the village. "Beyond this," Vogeler wrote in his memoirs, "she could not understand why he prayed. 'He's praying again, he prays all day,' she often said, listening in utter distraction from down below, as upstairs he declaimed his verses."[1]

On the first of September he made his first Worpswede journal entry. It was addressed to Lou, as all his journals, begun at her instruction, had been. In it he recalls having said to her, after reading her one of his poems, "Yes, everything that is truly seen *must* become a poem!" But then he considers the possibility that either it was not so, or else he had not, at times, truly seen—for someone with Rilke's commitments, a matter of grave significance. By way of memories of a number of occasions shared with Lou on their second trip, he comes to this discouraging conclusion: "I haven't used them, like so many things on this journey. I have failed to receive countless poems. . . . Everything that was coming found me closed. And now that I open the doors, the streets are long and empty." And so he abandoned almost immediately one of the goals he had brought to Worpswede: to process and put into words there the experiences of the trip. But the sense of having had a failure of seeing in Russia opened up the prospect of learning to see more truly through intimacy with the young and impressive visual artists of Worpswede, and

this became the conceptual center of the story he told himself about what he was doing there.

Rilke remained in correspondence with Russian acquaintances about several writing projects and an exhibition of Russian art planned for Berlin in October. He still counted Russian experiences as among his most profound: the story he told himself about Russia was that he had found his spiritual homeland there. But, as always, he did what he believed would serve his central work as poet, and he had found a way to see living in Worpswede in the company of the young artists of the Family as doing so. For the rest of this stay in Worpswede he returned to addressing Lou only once, after receiving word from her that Tolstoy, a shared possession, was gravely ill. With this exception he turned to recording for himself, with great immediacy, the daily experiences that absorbed him from the start. His journal entries from this sojourn are lengthy, expansive, often ecstatic; what he wrote between September 1 and October 4 fills a hundred pages of type in the printed edition.

Rilke met Clara Westhoff before he met Paula Becker. The first walk he took around Worpswede with Vogeler, at twilight, continued in the dark past Clara's cottage in nearby Westerwede, and they found her in the doorway. Standing outside, the three spoke of Russia, Rilke relating his visits with Tolstoy and other high points of his journeys. Clara, says Vogeler in his memoirs, spoke of how unsettling she found the mystical inclinations of the Slavic peoples, whose highly un-German traits she described vividly. She stopped in her tracks, he says, after fetching a lamp from inside and getting her first good look at Rilke, whom her description fit perfectly.[2] Rilke must have been pleased rather than offended, for he liked to think of himself as a Slav—as neither of his parents would have—and found in this assumed identity confirmation of his passionate feeling for all things Russian.

Rilke's earliest written impression of Clara, a few days later, speaks of "all her dark liveliness, which is strength, strength and indignation at the lack of occasions for strength."

The first recorded meeting of Rilke and Paula Becker took place on the first of the Sunday gatherings at the Barkenhoff that he attended, on September 2. He thought of himself, in fact, as its host, for Vogeler was away with Martha at Adiek. Paula's first impressions of Rilke were pointed by contrast to another guest in Worpswede, for the writer Carl Hauptmann—less renowned than his brother Gerhart, Germany's best-known playwright—was visiting his friend Otto Modersohn. Paula was more impressed with Hauptmann than Rilke was: "He is a great, strong,

struggling soul, someone very much to be reckoned with. A great seriousness and a great striving for truth is in him." In the next paragraph of her journal she turns to Rilke: "In contrast, Rainer Maria Rilke, a refined, lyrical talent, gentle and sensitive, with small, touching hands. He read his poems to us, tender and full of presentiment. He is sweet and pale."

Rilke wrote at length about the evening in his second Worpswede journal entry, dated September 4. He began by writing about Vogeler's elegant music room, whose decor was particularly flattering to Paula: "white, with white doors with vases painted on them, from which chains of roses cascaded gently to each side. Old prints, gallant little garden scenes, graceful portraits. J. J. Rousseau's tomb. Empire chairs, an armchair just perfect for the blonde sister." Early on, Rilke often referred to Paula and Clara as sisters, in honor of the intimacy of their relationship and its place in a group that called itself a family. And they were girls in the sense he had used so often in his work; he began immediately to weave elaborate fantasies around them. After the music on that first Sunday—songs by Strauss, Schubert, Robert Franz, sung by Paula's sister Milly—Rilke was asked to read. With one eye on the girls, the young poet just back from his travels intoned a ballad in medieval dress in the voice of a girl whose heart is carried off by a wandering singer:

> I was a child and dreamed and dreamed
> And had not yet reached May,
> And then a wandering singer passed
> Our dwelling on his way.
> I looked up in fear and said,
> "Oh mother, set me free."
> And with the first sound of his lute
> Something broke in me.
>
> I knew before his song began
> That it would mean my life.
> Oh no, strange man, don't sing, don't sing
> For it will mean my life.
>
> You sing my joy and sing my pain,
> You sing my song, and then
> You sing my fortune all too soon
> And I, although I bloom and bloom
> Can't have it back again.

He sang. And then his steps grew faint
For he was on his way.
He sang the pain I'd not yet known
And sang my joy till it was gone
And carried me off and carried me off
And where, no one can say.[3]

Rilke's favorite sort of frisson is added by the hint that it might be death that has carried her off. He was acutely conscious of audience response: "The Girls loved the song. Dr. Hauptmann didn't understand it; he suggested leaving off the last line, 'and where, no one can say.'" How much more of a poet's response, he complained, the poem had got from Nicolai Tolstoy, a distant relative of Leo Tolstoy whom he'd met in Russia.

Rilke was by all accounts a spellbinding performer; his readings were an immediate sensation in the colony. Otto Modersohn later described their effect: "Rilke gave these evenings an air of especially solemn consecration. He often read from his works, with his wonderfully soft, vibrating voice. No one could escape the deep, gripping effect. It was as if one was entranced by the evocative power that radiated from him."[4] From the beginning, he began to cast over the Family a poet's spell, intoxicating both to his listeners and to himself.

Later that first Sunday night, when Rilke had shown his Russian pictures and icons, and gone on to tell a story, too long to retell here, told to him by the sculptor and collector of icons Prince Ivan Kramskoj, Hauptmann dismissed it firmly as contrived, and reflecting a view of the artist as scorned outsider that Hauptmann rejected. It was the exception rather than the rule, he insisted, in a world that is good and in which souls are noble. To Rilke this was sheer philistinism. It was bad enough that his tale had been challenged so bluntly in front of the girls, but later Hauptmann had read a drinking song from his large notebook bound in pigskin—its pages so large, Rilke wrote in irritation, that the wind from their turning could snuff out the stars. Rilke did not drink and loathed the sort of gathering whose tone is set by drinking. In fact, his entry goes on to contrast the party he has just described—of which, despite the clash with Hauptmann, he approved for its intimate seriousness—with the events of the next day, when the artists had joined in the peasants' harvest festival, with its beer and smoke, its carnival atmosphere. The girls, in particular, had disappointed him by dancing. Even Vogeler had taken part, and so diminished himself in Rilke's eyes. The journal contains a memorable sketch of Vogeler in his Biedermeier costume—high

collar with fine cameo, velvet vest—as a painted portrait, "an infinitely distant ancestral portrait," but in this setting, like a portrait out of its frame, on sale in a junk shop.

On the rainy Friday evening of September 7, 1900, Rilke visited Paula for the first time in her studio at the Brünjes's, which he dubbed "the lily-studio" for the heraldic lilies on a tapestry there. He spoke of his impressions of the Worpswede landscape, which struck him as heavy, full of sadness. He remarked how the vibrant colors of autumn—the purple of the heather, the red of a single dahlia, "burning with ripeness"—persisted even when the sky went gray and offered little light. In his journal, training his eye in the presence of an artist, he rendered these observations painstakingly into their particulars. Paula responded with confidences: "Yes, I laugh much less often since I've been here." But in Paris she had been homesick for Worpswede. Spring, surely, had a gayer mood? More like *moving,* Paula answered. Its greens indescribably bright.

A few days later, his mind full of Worpswede color and this fascinating new girl, he turned an elegant love lyric:

Those red roses never were so red
As on that evening when the rain was there.
I went on thinking of your lovely hair . . .
Those red roses never were so red.

The bushes never darkened to such green
As on that night, in all its raininess.
I went on thinking of your lovely dress . . .
The bushes never darkened to such green.

The stems of birches never stood so white
As on that evening with its rainy weather.
I saw your hands, so beautiful and slender . . .
The stems of birches never stood so white.

The water gave me back a darkened land
On that evening with its rainy skies.
I saw myself reflected in your eyes . . .
The water gave me back a darkened land.[5]

There it is, as later he would use it in the Requiem: his favorite metaphor in those days for the inner reality he was coming, as he grew into the

64

man and artist he would be, to give priority over external reality—the mirrored reflection, insubstantial yet present. There would be other occasions to see himself reflected in Paula Becker's brown eyes, but he would not always be so pleased by what he found there.

The second Sunday's gathering, on September 9, with Vogeler again absent and Hauptmann still on the scene, was much like the first. This time it was Clara that Rilke singled out for beauty and harmony with the setting:

> She wore a dress of white batiste without bodice, in Empire style. With lightly supported bust and long smooth folds. Around the beautiful dark face hovered the delicate black hanging curls that, in keeping with her costume, she lets hang down at both cheeks.— The whole house flattered her, everything became more full of style, seemed to fit itself to her, and as she reclined in my great leather armchair, upstairs during the music, she reigned over us, a great lady.

Milly Becker sang an Italian folk song, something from Handel, and the songs of the strange girl Mignon from Goethe's *Wilhelm Meister.* Rilke then read his mutely ominous verse play *The White Princess,*[6] seeing it as fitting tribute to Clara in her white dress. In it the white princess, though she has been married for many years to a man she does not love, has managed to save herself—her white is the white of virginity, and the play had been written under the influence of Rilke's fantasy-belief that Lou Andreas-Salomé had been a virgin when they'd met—until at last her true love may come to her. Now he will be coming on this very day, by boat, as long as she signals to him from the balcony of her villa by the sea that the coast is clear. But a messenger describes the great plague that has been ravaging the countryside, and the aggressive black-clad Brothers of the Misericordia who come to carry off the dead, and who seem to be somehow agents of the plague itself. In the play's final moment, as the sound of oarlocks first rises and then fades, the white princess is horrified to see a group of the black brothers on the beach, approaching the villa, and by the time she can regain her composure, her chance to give the signal has passed and she can only stand there as the one moment recedes that would have given her life meaning.

Rilke wanted the reading to be savored in silence, but Hauptmann spoiled the mood by beginning promptly to theorize, forcing him into a conversation he didn't care about. The girls, he consoled himself by saying, had known better than to talk. Then the discovery of wine in

Vogeler's cellar threatened to turn the evening into a disaster for him. Hauptmann pressed him for a drinking song. The girls danced again— Clara, whom he had crowned the evening's white princess, with Hauptmann—and later the group made up a poem for the absent Vogeler. "Fun, fun, fun," Rilke wrote, "the ghastly end of German sociability." Though Milly Becker had sat with him for a time and asked him about Leopardi, mostly he sulked in a corner, feeling utterly alone.

Finally, though, the girls redeemed the evening. He opened the door to his room and raised the window; they came to feel the night air on "their cheeks still hot from laughter."

> I find them all so moving here in their way of seeing. Half knowing, that is, painters; half unconscious, that is, Girls. First the mood, the whole tone of this misty night seizes them, with its almost full moon over the three poplars; this mood of muted, beaten silver makes them defenseless and forces them into their Girl-existence, dark and full of longing. . . . Then the artist in them gains the upper hand, gazing and gazing, and when its gazing has grown deep enough, they are again at the boundaries of their being and its wonder, and they glide gently over into their Girl-lives again.

The next day he wrote a gallant poem for them:

> They are poets, girls, who learn from you
> To *say* those things which you, in your loneliness, *are;*
> From you they learn to live, you distant ones,
> As evenings grow accustomed to forever
> In the presence of a distant star.
>
> No girl may give herself up to a poet,
> Though for a wife his eyes may mutely plead,
> For he can only think of you as maidens:
> The feelings in your delicate maidens' wrists
> Would be broken by brocade.[7]

The poem may have been intended to reassure the two girls that, as gallant as his demeanor might be, he was pressing no suit. Two other poems written the same day go so far as to regret the transition to manhood— in the presence of these girls, he dreamed of being a boy again. In the first, the change from a boy's soft face to "the man-mask, bearded, hard and red" is seen as "a kind of death"; to be a man is to be "no longer young, no longer wonderful / and yet alone."[8]

That Thursday, September 13, Rilke spent two hours in earnest conversation with Otto Modersohn, by whom at this point he was considerably impressed. He admired the collections of Otto the naturalist, particularly his stuffed birds, including one of every species found in the vicinity of Worpswede. These—their colors, above all—were before Otto at those times when sky and cloud were not, and they prepared him for his long sketching excursions over the moor. But the pictures that come from such sketches required something else, something inexpressible, and it was Otto's way of pursuing this indefinable essence that struck Rilke most of all:

This is preserved on small sheets, which Modersohn dreams at home under the lamp with chalk and red pencil. These little pages ... give the observer infinitely much. For they are created out of the overflowings of this temperate personality, and in contrast to the starkly realistic studies, dark and visionary.

That he perceived Otto as having a temperate personality testifies to both Otto's self-mastery (for his journals were often anything but temperate) and the tempering effect of his joy at having found Paula.

Feeling inspired, "in gratitude and good spirits," he went straight from Otto's studio to Paula's. She had just put down, he noted with satisfaction, his book *Advent*. At times they spoke; at times they were silent together. He shared with her his conviction that one could know, as an artist, when one was on the right path, living one's own true life, when each new beauty one perceived fit precisely there where one's childhood had been broken off, overwhelmed by the adult world. It was an idea he'd spun, as we have seen, from *Niels Lyhne,* and when he shared it with Paula she understood perfectly, and agreed.

And in this confession we were one, understood each other both about the past and about what was to come ... had suddenly heard each other,—and after many words that were no more than mere sound, came the great eloquent silence: the stones spoke.

He wrote a poem called "Encounter" about how two people may share such moments:

Then comes the silence we've long waited for,
comes as night might come, all great with stars;
two people grow, as if in a single garden,
and where this garden is, time disappears.[9]

The journal entry continues this way:

Perhaps that is what all togetherness is: to grow in one's encounters. Down a long road, whose end neither one could foresee, we came to this moment of eternity. Astonished and trembling we looked at each other like two who, unsuspecting, have already reached that portal behind which God is.

He hurried away over the heather, and had he been alone, perhaps he might have stepped through that portal. But he had to go back to the Barkenhoff, and there were people there, and everything faded. Near the end of this long entry, thinking of how returning to the Barkenhoff had destroyed the mood, he wrote, "Friends don't protect us against loneliness, they only limit our solitude."

Saturday evening he was back in Paula's studio. She made tea. They spoke "of Tolstoy, of death, of Georges Rodenbach and [Gerhart] Hauptmann's *Friedensfest,* of life, and of beauty in all experience, of being able to die and wanting to die, of eternity, of why we feel related to the Eternal." Her bodily presence, this time, is more prominent in what he wrote: "Her hair was of Florentine gold. Her voice had folds in it like silk. I had never seen her so soft and slender in her white Girlishness." Another white princess? But then a shadow passed through the room, he wrote, and though they both looked up at the window, no one had passed by outside. He left the blonde Girl, her warm cheeks and still eyes, and went out into the blonde evening. How much he was learning, Rilke wrote after that night, from the gaze of these two girls—especially the blonde painter, with "such brown, *seeing* eyes."

How much mystery there is in these slender forms, when they stand before the evening, or when, every contour alert, they recline in velvet armchairs. Because they are supremely receptive, I can be supremely giving. . . . Slowly I place word after word on the delicate silver scales of their souls, and I go to great lengths to make each word a jewel. And they can feel that I somehow adorn them, bestow on them an ornament full of brightness and goodness.

It is not difficult to imagine the effect on the girls of Rilke's strange but compelling adornments.

The shadow that passed over Paula and Rainer Maria may have been Otto Modersohn's, though Rilke would not have known it; it may have been his way of registering some signal conscious or unconscious from Paula that, on a level different from that on which they had been sharing

dreams and confidences, she was already taken. For in Otto's journal a catalog of meetings with Paula, as laconic as Rilke's was effusive, was being kept that culminated in this entry: "Wed. 12 Sept. Afternoon boat trip—Paula Becker—Rilke. 5–2 PM engaged."[10] Just three days earlier, when he'd come to her straight from Otto, and the stones had spoken, the couple had, after an excursion on the river Hamme at which Rilke too had been present, agreed to marry. But the secret of this newly affirmed connection was zealously guarded, for it came much too soon after the death of Helene Modersohn. Rilke had no idea how often, late at night, Otto Modersohn visited the studio with the lilies.

It is clear from Rilke's accounts of these encounters with Paula that when they were alone together something came over them that originated in Rilke's exalted response to Paula's youth, her beauty and the knowledge that, beyond these, she was an artist as well. For her he could wear the medieval dress of the singer who celebrates the beauty of a fair maiden—and then engage her, as worldly and well-traveled outsider, in sophisticated and modern artistic and literary talk. And Paula's responses to Rilke were genuine and intense. She could scarcely have met anyone like him; an inspired conversationalist and brilliant flatterer, he touched chords in her that no one else could touch. She responded to his confidences with confidences of her own. It was a private, rarefied, perhaps slightly feverish world that they entered together, almost that of a fantasy created by two children, which cannot be shared with any third. Perhaps the fact that it was so clearly a fantasy, an inner rather than an outer experience, dampened any sense that it might be inconsistent with Paula's new role as Otto Modersohn's betrothed.

There is one vital thing that did not happen in these encounters, though it happened when Rilke visited Clara Westhoff in *her* studio: Rilke paid no attention to Paula's work. Because her work meant everything to her, Paula can scarcely have failed to notice. In the loneliness of her determination to make something of her art, she was hungry for recognition; on the infrequent occasions when it came to her, she rejoiced. Yet there may be some truth in one of the explanations Rilke gave later: she had never shown it to him.

Here is the beginning of one of the letters Paula left for Otto, under their stone, at some time during the week of their engagement—a week in which Rilke had been showering her with attention:

I was thinking of the two of us, and then I slept on it, and now I am clearer about everything. We are not on the right path, dear.

You see, we must first look very, very deeply into each other before we give each other the final things, or before we even awaken the demand for them. It is not good, dear. First we must pick the thousand other flowers in our garden of love before we pick, at a beautiful moment, the wonderful deep red rose.

But she also left him a picture puzzle, a small drawing at first indecipherable, but coming clear after one read the solution, written upside-down below the drawing: "You and I and our heaven—full of violins."[11] Then one sees that the odd black shapes filling the high Worpswede sky are indeed violins, and that two tiny black figures in the center are a man and a woman walking together.

The entire mood of the Family was colored by the fact that at its core there were two couples, now, who could not yet publicly be together. Into this already erotically charged atmosphere had come Rilke, with his poet's air, his exoticism and gallantry, his intense, theatrical performances, which affected everyone. Paula could not have failed to sense his exalted state during those visits in her studio, or the nature of his responses to her person. As she wrote in secret to Otto, just days after hearing *The White Princess,* that it was not yet time to consummate their love, surely the play, with the glamor it cast over virginity saved, must have resonated within her, as surely as she found Rilke strange, stimulating, intriguing.

The idealism bathing all the doings of the Family left no room for the acknowledgment of jealousy. Possibly Paula acknowledged to herself no conflict between her encounters with Rilke and her new commitment to Otto, and by her innocence left Otto no room for objection. Had not Rilke's poem said that the poet pressed no claims on the girls whose praises he sang, for making them wives would destroy what his poems celebrated?

At the next Sunday gathering, September 16, Rilke read again from his works. Afterwards, the evening went on and on; it was, for Rilke, a high point of togetherness with his newfound circle of friends. They all went out to the inn, and he felt enveloped by happiness and kindness—even spoiled, like a child, by the gratitude of the others. On the way back to the Barkenhoff he told Paula how much he had underestimated Worpswede at first, in imagining that he could come here and write about his memories of Russia. Here he had no memories, for he could not close his eyes to what was in front of him. Back in the white music room he read one more of his stories, and something from Hofmannsthal. Then they all went to Paula's studio for coffee, and someone remembered

that the Brünjes's goat needed milking. The girls went off with a pail, and soon the others could hear a great stirring and whispering. When they returned, Paula held out a cup of the milk, and it was black. And all of them drank the black milk of the night-milked goat. This, at least, is the account in Rilke's journal.

It was three in the morning before Rilke, Clara, Vogeler, and his brother Franz arrived back at the Barkenhoff; even then, only Vogeler turned in, while Rilke and Franz Vogeler escorted Clara back to her cottage. They remained outside awhile, in Clara's grape arbor, talking. Finally, Franz fell asleep, and Rilke and Clara decided to leave him and go into her studio, for Rilke was eager to see her work. But the door was locked, and those with the key could not possibly be awakened, and so Clara produced a heavy sculptor's hammer with which to break the lock. Somehow Clara's hand fell under the very hammer blow that finally opened the door, and they rushed back to the living room for water, a washbasin, handkerchiefs. Pulse on pulse, Clara's blood flowed out into the water as they waited for the pain to subside, and their conversation ran nervously on.

Finally they went to the studio, feeling by then much closer for what they had faced together. There Rilke saw the beginnings of a piece that remained a favorite of his among Clara's work, a boy sitting on the ground, one knee drawn up beneath his chin, arms encircling both legs. He was deeply impressed. Clara told him all about Klinger, and then Paris and Rodin. Rilke shared with Clara one of his ideas about Rodin:

his works do not look out from inside, do not look outwards in a personal way from some point or other, as if for the sake of a conversation, but always remain works of art, that is, nothing truly present, but what is in every moment possible. . . . A human being can never feel brotherly toward a work of art, and what is created descends steeply to a lower level as soon as it takes on any relation to one of those who observe it.

Works of art, he elaborated, are like images reflected in a well: beyond a certain point we cannot approach them without blocking from view, with ourselves, the very thing that we came to see.

It was the first step in the process by which he, who had only admired Rodin's work from afar, began to interpose himself between Rodin and Clara, who had studied with him in person—in other words, to appropriate Rodin the way, with Lou, he had seemed to appropriate Russia, if only to offer it back to her as a gift. And finally, we will meet this vital

idea again in the Requiem; it defined the terms by which he praised Paula's art, the product of that gaze so free of desire that it was holy.

On Saturday September 22, Rilke traveled with Heinrich and Franz Vogeler, Otto, Clara, Paula and Milly Becker, and Marie Bock to Hamburg for the premiere of Carl Hauptmann's new play. This excursion in the bosom of the Family made such an impression on him that, taking up his pen after it was over, he was unsure whether he could do it justice. Where was the thread, he asked himself near the beginning of his entry, that would lead him into "these dark-yet-colorful tapestries of experience and memory?" He met the challenge by stitching into his lengthy account a leitmotiv: the rose.

The first leg of the journey—to Bremen, where they would catch the train to Hamburg—was taken in a large farm wagon trimmed in red velvet and filled not only with travelers but with flowers they were bringing for the playwright. Rilke sat facing forward, opposite Paula, and savored her brown eyes, in which, he fancied, he could see both the land disappearing behind them and her responses to it. Her eyes unfolded to him, he wrote, like blossoming roses, soft and warm, full of warm shadows and tender lights. Paula could scarcely have failed to be aware of his blissful contemplation, and it must have complicated the ride for her, for Otto, too, was in the wagon, no doubt already irritated by Rilke's attentions to his fiancée and her sufferance of them.

Clara Westhoff was not in the wagon. Ever the prodigious cyclist, she pedaled from Worpswede to her family's summer home in Oberneuland, outside Bremen, and from there went on to meet the travelers in the city. In fact, she overtook the wagon on the way, and stopped to exchange a few breathless words with those inside. She had made Hauptmann a large wreath of heather, which she had given Rilke to hold; now she flattered him brilliantly by saying that he was the one who really deserved it, for his reading the day before from one of *his* plays. A sign of the awakening in Clara of feelings for Rilke? For his part, Rilke loved holding the wreath, and so having both girls to contemplate at once: he felt that he could still feel around it "the simple reverent strength of her sculptor's hands" as he went on savoring Paula Becker's eyes.

On the Sunday morning after the premiere, still in Hamburg, Rilke brought the girls a large quantity of red roses: when they awoke Sunday morning, they found them in their shoes. Each member of the party carried a rose around that day as they toured the town and the harbor— that was how, he fancied, they could recognize each other on the streets. Some days ago, members of the Family had drunk a potion, the goat's

black milk; on this day they all bore an emblem. And some of them knew a secret.

Remembering how Paula's eyes had seemed to open like roses, Rilke invented in his journal a new caress: "to lay a rose gently on the closed eye, until its coolness can scarcely be felt, and only the gentleness of the petals still rests over the picture, like sleep before sunrise." Moved by his own invention, he went on to a morbidly romantic fictional fragment in which a young man, standing watch over the bier of his bride—he still found the thought of beautiful dead girls delicious—places over her eyes two hard, frostbitten rosebuds from the garden outside. After a time he is stunned to detect a movement in one of the rosebuds, and then in the other, and by the end of the fragment he has two red roses in full bloom: "As if in two chalices, trembling under their weight, he carried her life, the overflow of her life, which even he had never before received."

On Monday afternoon the travelers visited a Hamburg banker's private art collection. Rilke paid the greatest attention to two Corots, describing them in detail and deciding at the end that he was finally learning how to look at pictures. In the past he'd been able to see them only in terms of narrative or lyrical content; now he was capable of appreciating, for itself, the execution of even small and thematically unimportant areas. Two things were certain, he wrote: he must learn a lot from these artist-friends, and then later he must go on to Paris and Rodin. At the end of the passage he returns to his new friends:

And how they love me here. How good was our sense of togetherness in Hamburg. How they perceived me as someone who could help and advise. How necessary I was to them. And how capable I grew, under the protection of their confidence in me, of being the most joyous and alive among them. All kinds of powers are arising in me. All of life is gathered up in my voice. I say everything so richly, as if my words were embroidered with dark gems.

For the young man still close to the memories of the sheltered and isolate child, to feel togetherness and be able to accept welcome not from a single person but from a group—one, moreover, that thought of itself as a family—was a revelation and an accomplishment. Feeling thus empowered, he wrote a poem that he called "Prayer":

Again the rush of my deep life grows louder,
like a river that has grown much wider.
All things know me and allow me nearer;

all images are seen with greater power.
To the nameless I feel ever closer:
I feel my senses, as on birds' wings, rise
out of the oak and into windy skies;
into the shards of day inside the ponds
my feeling sinks, as if it stood on fishes.[12]

Closing his journal account of the excursion, Rilke wrote that, like Mackensen, Modersohn, and am Ende eleven years ago, he had decided to stay in Worpswede through the winter. Before long he had rented and moved into a small house of his own.

Rilke's final entry about Hamburg was written on September 27. On the same day Otto Modersohn began in his own journal an expansive series of entries. He repeated his old habit of listing one after another all those on his mind in Worpswede, only this time those named were the members of the Family, and he went on not to curse but to bless them:

> Heinrich Vogeler is the most stimulating person here. Dr. Hauptmann definitely initiated me and showed me the way. . . . Everything was favorable. Rilke is eminently so, and the whole circle (HV, CW, PB, M[illy] B[ecker]). And so for Worpswede a new time has begun, a time full of spirit and rich in hope.[13]

In a way not so very different from Rilke's, Otto too, who had not long ago endured a cruel loss and had been thinking of leaving Worpswede, was finding new reasons to stay, feeling that his life had taken a definitive and richly deserved turn for the better. A euphoric feeling of community had come over the Family and moved all of them in their various ways. With Vogeler rushing off to Adiek to see Martha, Otto and Paula meeting secretly and leaving love notes under their stone, Rilke enchanted with, and enchanting to, Paula and Clara both, the erotic charge in the atmosphere was intense, and as artists the five members of the Family living in Worpswede were all intensely productive as well.

On the day after their return from Hamburg, Rilke dropped in on Paula again. First they spoke about Clara, then about Jacobsen and Richard Beer-Hofmann. Jacobsen, Rilke told her, had had "no learning, no love, no experience and no wisdom—only a childhood." From this "uncannily colorful childhood, in which he found everything his soul needed to clothe itself in fantasy," he had spun all his works. Then their conversation was interrupted for a time when Ottilie Reyländer

dropped in, preparing to leave Worpswede impulsively for Paris. Twice in the course of his visit, Rilke fixed Paula Becker in his blue eyes and paid her gallant compliments, the first over her fond way of speaking about Clara: "I am your admiring observer, your apprentice, when you speak so, and I become your teacher, now, as I tell you that you are good and holy. Do you understand me?" Remarking later on her behavior toward Reyländer, he said, "You are kind. . . . I say it to you a second time. When I have said it to you three times, it will be irrevocable." Paula answered that she was not equally kind toward everyone, and Rilke trumped his first compliment: "That is exactly what kindness is: being good to people one chooses. . . . One who is kind without selectivity is good, but one who is kind toward a few, *does* good." He paused here, then went on: "Are you still choosing?" His reconstruction of the conversation makes clear that it was a highly pointed question. Was he asking whether she was still choosing among suitors, and whether he had a chance? He recorded no answer, only this: "Then came evening, and parting." But a heightening of his gallantry toward Paula is unmistakable. He still did not know that she had already chosen.

Rilke's journal entry of October 3, 1900, describes the silence of the girls, on the previous Sunday evening, after his reading of his "Sketch for a Day of Judgment": "How beautiful the Girls became, as they sat there, among the many lights, in the shadow of my words, like reflections that fall from the sky onto dark water." He went on to write about the Family: someone had pointed out that, for unstated reasons, they would not be together on the next two Sundays. Striking, indeed almost astonishing for Rilke, is the fact that the account is written from the point of view of the collective *we,* as if all had effortlessly shared the same feelings: "We stood around each other, utterly saddened. Until it occurred to us, that the Sundays and our togetherness must be something very beautiful, if the thought of having to do without them can sadden us so. And we all felt beauty and gratitude toward one another."

Two days earlier, Rilke recalled in the same entry, he and Vogeler had visited Clara in her studio. It was raining, and as so often happened in those days, a profound mood came over the three of them: "We spoke of the danger to our circle that arose each time we widened it. Yes, I said, simply because any togetherness is based on limitation, and requires a certain one-sidedness of harmony which is broken whenever any new element is introduced, from whatever direction." To Rilke the thought of being thus *contained* gave rise to an unexpected moment of resistance: "Suddenly the one-sidedness of the circle which seems to be self-sufficient appears as

poverty, as mere chance, as *one* possibility of togetherness among very many others." But then he found his way back to his newfound devotion to togetherness, and spoke of the difficulty of firmly but inconspicuously removing from the circle anyone who did not belong there. "Let us protect," he wrote, "our holy place."

On the first three days of October Rilke wrote three clearly related poems in medieval dress that may be seen, when taken together, as expressing his mythic redaction of his aristocratic past. The third of these, called in *The Book of Pictures* "The Singer Sings Before a Child of Princes,"[14] was written explicitly for Paula Becker; in later editions, after her death, it would be inscribed to her memory. Eager to read it to her, he called on her the following day.

The poem imagines that the young daughter of princes (thus he conferred nobility on Paula as well) is daunted by the weight of her family history, and that it is the task of the singer to turn this burden into a blessing:

> For you, pale child, shall every evening
> the singer dark among your bright things stand
> and on the bridge of his dark voice shall bring,
> with his harp, so full of his quick hands,
> tales that down the halls of your blood ring.
> [. . .]
> From these you have your pearls and all your turquoise,
> these ladies standing in the rows of portraits
> as if they stood alone in evening meadows;
> from these you have your pearls and all your turquoise,
> finger-rings with darkening inscriptions,
> silks exuding weary fragrances.
> [. . .]
> They have, as if you never were to come here,
> set their mouths to drink at all the goblets,
> pursued in every joy a selfish pleasure,
> left no sorrow less than fully mourned,
> so that now you stand
> and feel ashamed.

Its high point is a long bravura passage, far more richly rhymed than any translation could be, of the sort of family history he liked to imagine for himself, and now bestowed on Paula, as if to make her worthy of him:

So it was, these women seemed of ivory,
bathed in the crimson glow of many roses,
so the monarchs' tired faces darkened,
so pale mouths of princes turned to granite,
unmoved by the orphaned and the weeping,
so youths began to sound as violins would,
and died for the sake of women's weighty hairdos;
so virgins entered the Madonna's service,
to whom the world was formless and bewildering.
So rose the sounds of lutes and mandolins, when
some unknown hand gripped them much more greatly,—
daggers came to rest in flesh-warmed silk,—
fates were built of joy and of believing,
partings were sighed out in evening gardens,
over a hundred helmets of black iron
great pitched battles rose and fell like warships.
So cities slowly grew and then subsided,
each a single wave in one great ocean,
so thrust itself toward many a glorious purpose
the eagle-power of the iron spear-head,
so children dressed for games out in the garden
and so occurred things trivial and weighty
only that you might be given a thousand
great images to bring to daily living,
by which you might more powerfully grow.

So much of the past is planted in you
to grow out of you as a garden would.

Finally the world of the Barkenhoff is evoked, and the poem ends on a
high note of gallantry:

You, pale child, you make the singer rich
with your great fate that lets itself be sung;
so the bright celebration in the garden
mirrors itself in the astonished pond.
In the dark poet silently each thing
repeats itself: a star, a house, a wood.
And many things that he would celebrate
surround, in him, your bright, compelling form.

In the journal Rilke recorded, quoting himself, the gloss of the poem that he gave Paula that night:

"There comes a time when every past loses its heaviness, where blood becomes like splendor, splendor like ebony to our feelings. And the darker and more colorful our pasts have been, the richer the images in which our daily lives resolve themselves. This is so in the individual instance, and in the broad developments of history. All horror becomes glory for the grandchildren. All grandchildren wear past destinies like jewels. Dead eyes full of lament have become precious stones; a gesture of parting is repeated in some small movement of their clothing as barely seen

This entry, the last Rilke wrote in Worpswede, breaks off in mid-sentence, for here the story takes a turn worthy of a novel: Rilke, who just days earlier had rented a house in which to pass the Worpswede winter, left on the mail coach, bound for Berlin, early in the morning of October 5, without good-byes. Nothing in this final entry hints at the thought of leaving, and it ends so abruptly because at this point a page has been torn out of the journal—we do not know when or by whom.

We know that Rilke sought Paula out the night before he left, and finding her not at home, left one of the small sketchbooks in which he copied his poems, along with a note:

I have a request: would you keep for me, for the time that I am away, this little sketchbook, in which there are many of my favorite verses? Here, among my other papers, it can give no one pleasure. With you it will be an instrument over which your hands will sometimes wander in the evening hours. For you must use this little book, whenever you are alone and quiet, whenever you are as you were in those hours for which I am so grateful to you.

He promised to read to her in person, when they saw each other again, any of the poems in the sketchbook that she might request.

Among students of Worpswede there is a widely accepted and very convincing interpretation, originating with Heinrich Petzet, of Rilke's sudden departure and its attendant attentions to Paula: that he had finally learned somehow of her engagement to Otto, found the news devastating, and retired in confusion to lick his wounds.[15] Niels Lyhne, too, had received such a blow, when the girl Fennimore, whom he loved, had abruptly announced her engagement to his closest friend, Erik Refstrup.

It is clear enough, as one looks back over Rilke's Worpswede journals, that he had responded differently and more intensely to Paula than to Clara. He had seen Clara's work and been genuinely impressed: he saw her, at the time, as a fellow artist, of whose charms as a girl he was also aware, having commented on them more than once in his journal. He had paid little attention to Paula's painting—to which she had characteristically done nothing to draw his attention—because he could not take his eyes from her hair like Florentine gold, from the brown eyes in which he loved to see himself reflected. It was for Paula that he had written poems, and for Paula that he had constructed a fantasy world that she had willingly entered. It is the bursting of that bubble that he would have found shattering.

After the torn-out page, the journal resumes in midpoem. This is how the poem, "Earnest Hour," begins:

Whoever weeps now, anywhere in the world,
 weeps for no reason, in the world,
 is weeping for me.

Whoever laughs now, anywhere in the night,
 laughs for no reason, in the night,
 is laughing at me.[16]

Three more poems follow; all sustain the reading that Rilke had received some powerful blow, for they speak of loneliness, fear, an inability to speak.

It may not be necessary to assume that he had begun to entertain serious conventional hopes with regard to Paula, though it is possible ("Are you still choosing?") that he had. It may be that he would have wanted the magic of that summer to continue, and Paula above all to remain a girl so that he might remain the eloquent singer of her praises. Had he known that she had been in love, even before his arrival, with someone undeniably already a man, and within two weeks of this arrival had become engaged, none of their intense private interactions would have been possible; knowing that the days of Paula Becker's girlhood were so strictly numbered would have spoiled things. That despite their intimacy, his gallantry, their silent moments when the stones had spoken, she had kept this secret from him—it would have seemed to mock him. And it would have created, between Rilke and Otto Modersohn, the sense of strain that, when we see them begin to interact again a short time later, is unmistakably, and for the first time, present.

For Paula, it seems, their meetings had always had something of make-believe: she had played Rilke's fantasy game of minstrel and fair maiden, which he had enacted once again in his newest poem. It appears unlikely that she had ever seen him as a suitor. Her art meant everything to her, and Rilke, interested only in the idea of it, had paid no attention to her actual work. She loved Otto Modersohn; she admired his painting; he had a house and a steady income that would free her from worry over money; he would surely understand the needs of a fellow painter.

Later Rilke would claim that he had left because he needed the resources of a city like Berlin in order to pursue his studies of things Russian. Helmut Naumann insists that he left simply because he had put off as long as he dared returning to Berlin to see to the hoped-for exhibition of Russian artists there, of whose collapse he learned only after his arrival.[17] But neither explains as Petzet's suggestion does the abruptness of Rilke's departure after having rented a house in Worpswede just days earlier, and all the signs in the correspondence that followed that Rilke felt abashed and apologetic toward Paula and Otto.

Whether or not it was the shock of Paula's engagement that broke the grip of his Worpswede dreams, of that sense of community that he both longed for and dreaded, he retreated in disarray to the last place in which he had felt safe, for Berlin meant Lou and the world that she had opened to him: Russia. It was, for Rilke, a decisive, defining decision. He would always be alone; he could never be part of a family. Even when he married Clara Westhoff, fathered a child, and returned to the home of the Family, he would be alone, for to him even marriage and parenthood meant not human sharing but a respect for mutual solitude. It must be so, for otherwise he could not bear it.

\mathcal{S}ix

There are few traces of what Rilke did in Berlin in the first weeks after his sudden departure. Apparently he first stayed at the home of Lou and her husband, though they were away traveling until mid-November. J. F. Hendry says that Rilke had left Worpswede so agitated that he spent some of the time confined to bed.[1] In any case, by October 20 he had found an apartment in Schmargendorf. His announced reason for his departure—that he meant to take up again his Russian studies—was not a pure fabrication, for he did busy himself with things Russian. The first surviving record of his contacts with the circle around Lou is a letter of October 24 to Frieda von Bülow, recalling the days he and Lou had spent as her guest, preparing for their second trip to Russia. He had renounced poetry in those days in favor of the Russian work, he told her—hoping to make gentle amends for having renounced her company as well—and now he had renounced Worpswede for the same reason. But he went on to give another: "There is, in addition, the fact that Worpswede has too powerful an effect: its colors and its people are so powerfully great as to reign, rich and mighty, over every other mood." The embrace of the village and the Family had been too peremptory: he was running from commitment.

When Lou returned to Berlin in mid-November, she and Rilke spent a good deal of time together in the old ways; they went walking in the forest again, and he presented her with a poem he wrote in Russian. But nothing was the same, for they were no longer lovers. All the while, Lou was working on several pieces of more or less autobiographical fiction

with characters recognizable as versions of herself and Rainer; one of them is set on a boat trip down the Volga like the one they had made on their last trip. It was her way of finishing off the affair. Rilke's visits finally became a burden to her; she was not always kind. But by the time that she finally sent him away, he had gone a long way toward restoring his relations with those in Worpswede, ensuring that, if he chose to return, he would be welcomed and find a tenable place.

For his sudden departure had torn the fabric of the Family. It is good to remember that when he had spoken so reverently of the Family as "our community," one that had to be protected from outsiders, his journal had registered a moment of protest at the very idea. Like many young people, he had rebelled against being imprisoned too early in a single identity, held in place by the expectations of a fixed group of friends—even if his rebellion had yielded for a time to the rewards he had found in belonging.

With Rilke's departure, the first shape that the Family had taken after coming together so quickly and in an atmosphere of such exaltation had broken at its weakest point. In the remainder of the fall and winter of 1900–1901 it remade itself in what must have seemed a more lasting shape, confirmed by three weddings in the spring of 1901. In the process, first Paula and then Clara went to Berlin. It is impossible to follow in a single narrative all the interactions within and outside the Family at this time of transition. They will have to be treated in a series of overlapping movements recounting Rilke's attempts to restore his shattered relation to Paula Becker and Otto Modersohn, his subsequent rapprochement with Clara Westhoff, the preparations of Otto and Paula for their own approaching marriage, and the ultimate break with Lou.

That Rilke had decamped so abruptly must have been spoken of a good deal in Worpswede, and in the letters he exchanged with Paula and Otto there are clear signs of acknowledgment that he had left in disarray, and even that learning of their engagement had played a role in his departure. The earliest document we have, Paula's letter to Rilke of October 15, contains a warm expression of gratitude for his having left her his notebook:

> You have brought me beautiful, contemplative hours through your sketchbook during, and in spite of, your absence. It is the only thing that I wanted to read during this period. We had wonderful moonlit evenings. And I sat in my little room with the golden lamplight and outside the blue moonlit night was breathing. And

when I had enough of looking and thinking, then I would reach for your little book—

Though they had not displaced Otto Modersohn in her affections, Rilke's youthful, extravagant writings and recklessly courtly behavior had had a deep impact on the equally youthful, equally passionate Paula. Paula ended by speaking for the Family: "Come back to us again soon. It is good to be here. We all look forward to your return and to being with you."

Rilke's answer broke the news that he would not be returning soon. In a characteristic way, his explanation to Paula differs from the one he gave in a letter to Clara the same day, and both differ from the one he gave Frieda von Bülow; he found for each correspondent a highly personal metaphor. Russia, he explained to Paula, had come to mean to him what her Worpswede landscape meant to her. Though she was surrounded and sustained by this, her true home, his own lot was different:

> My true surroundings are *not* around me. At a distance, over long roads, have I seen the cities in which I live, and the gardens which whisper of me are many rivers away. Churches which stand on the Volga, and are repeated in its rushing currents with a softer white, a more subdued gold in the cupolas, ring to me morning and evening from their great upright bell-towers, and songs that blind men and children sing circle around me like the mad, and touch my cheeks and my hair. Such is my landscape, dear friend. . . . As yet I may have no little house, may not take up residence. My lot is to wander and wait.

In its eloquent excess it is classic young Rilke. Plucked from context, it would make a convincing comic monologue for a posturing fraud. Within six months, in fact, he would be married and settled near Worpswede. Yet over the whole of his life, by sheer will, he made it true—not the Russian home but the not settling, the wandering and waiting—and made art that justified it in all its extremity. This is the enduring astonishment in his life story.

With this letter, fixing in place a fictive world in which they could still be alone together, Rilke sent Paula two books by Jacobsen: the novel *Marie Grubbe* and the one volume of poems. They were gifts, not to be returned; on the title page of the first he changed "ex libris Rene Rilke" to "ex libris Paula Becker." On the title page of the second he copied a short poem he had written for Jacobsen, "lonely poet, / pale poet of the moon," in

whose portrait one senses that he has placed a good bit of himself.[2] Paula later bound these books in silk, something Rilke knew she liked to do, and had even referred to in "The Singer Sings before a Child of Princes."

Rilke closed his letter with an allusion to a passage he knew Paula would recognize from *Niels Lyhne*. He wrote, "And when you think of me, judge me as a friend, that is, on the basis of the hours in which I was poorest and most humble. I am not rich. Not yet. Your Rainer Maria Rilke." This is Jacobsen's original, in which Niels, though he will later betray his friend Erik Refstrup by becoming his wife Fennimore's lover, takes up Erik's cause in the face of Fennimore's disillusion: "Don't think of who is right or how great the wrong is, and don't treat him according to his deserts—how would even the best of us fare if we got our deserts! No, think of him as he was in the hour when you loved him most; believe me, he is worthy of it."[3]

On October 22, before receiving an answer to this letter, Rilke sent Paula a poem called "Sunday Evening," an evocation of the Barkenhoff gatherings and of how, on his lonely Sunday evenings in Berlin, it was enough to know that the Family was gathered at that very moment. And the next day he wrote, as he knew he must, to Otto Modersohn. At the beginning he compared his memories of Worpswede to precious cloths contained in trunks that he could not open because the heavy containers of his present disorganized days still lay on top of them. "I still don't know," he says, "what is woven into these cloths, which futures in which landscapes would have to come true so that pictures might be there for this multiplicity of threads and folds." It takes little effort to hear in this an expression of uncertainty about just how all the members of the Family might fit into the pattern of a single future, and perhaps a tacit acknowledgment that he had conceived some future that could not be.

The chief burden of the letter is extravagant praise for Otto's art, particularly the little dream-sketches he did at home by lamplight, in red and black, in the evening. Though it is not cynical, for Otto's "compositions" had indeed impressed him, the letter reflects Rilke's gift for flattery. Otto, though ambivalent at best about Rilke, felt undervalued as an artist in Worpswede, and so was hungry for such praise.

Paula's next letter crossed in the mail one of Rilke's from October 25, in which, after details about the furnishings of his new apartment, he pronounced it ready for visitors: Paula, Clara, Vogeler. Even more than her first, this letter of Paula's is kind and reassuring, as if she were aware that, having left in some pain, he needed evidence of her continued fondness for him and his continued welcome in the Family:

Clara Westhoff and I, we were speaking recently and saying that you are an idea of ours that has become real, a wish fulfilled. . . . Each of us turns to you in gratitude and should so much like to make you happy again. It is so lovely making you happy because one does it without noticing it, and without intending to. You are with us on our lovely Sundays, and we with you. It will stay that way.

There follows a request that Rilke call on her aunt Herma and cousin Maidli Parizot. In league with her mother, Paula was trying her hand at matchmaking—another way of resolving the erotic tensions that still threatened the Family. The letter Mrs. Becker wrote Paula on learning of Rilke's engagement to Clara a few months later says, "And you and I had selected the lovely Rainer for our lovely Maidli."[4]

Finally, Paula's letter edges closer to acknowledging openly her relation to Otto, speaking of him in affectionate terms:

It is the beginning of a wonderfully rich creative period for Modersohn. I always feel as if I should be shielding him with my hands. Doing something like that makes me feel good. On that afternoon you saw into the hidden waters of the man's soul, but it is deep and beautiful and whoever can see it is blessed.

The pace of the correspondence was quickening. On October 28 Rilke wrote a second "Sunday-poem," long and extravagant, which he sent to Paula though it honored both sisters this way:

I am with you. Am thankful to you both,
you who are like the sisters of my soul;
for my soul, also, wears a maiden's dress,
and her hair too is silken to the touch.
I am seldom given to see her cool hands,
for she lives far away, behind great walls;
lives as if in a tower and hardly knows
that one day I will come to set her free.[5]

It is tempting to see in this passage Rilke's acknowledgement of having been, for his mother, the sister who had not lived—and having worn, as a child, her maiden's dress. Calling both girls the sisters of his soul honored their relation to each other as well as to him.

On November 1, returning his sketchbook as promised and thanking him for this poem, Paula sent Rilke a garland of chestnuts from the tree outside her window. He thanked her on November 5. Sometimes, he

wrote, he ran the garland through his fingers like a rosary. These November days, he went on, were always Catholic days, and though he no longer went to graveyards on All Souls' Day, he had been visiting the grave of Heinrich von Kleist, who had shot first an incurably ill woman he had befriended, and then himself, on a late November day on the shores of the Wannsee near Berlin. He closed this letter by abruptly turning away from the subject: "But I notice that this is no letter for you, and actually not for me either." In a postscript he promised to copy "The Singer Sings" for her, now that she no longer had his notebook; it did not truly exist, he wrote, unless she, in whose presence it had come to be, possessed it.

On November 11 Otto Modersohn reacted vehemently in his journal to the letters Rilke had been writing Paula. It was their aestheticism that he objected to: "I see it as I have so many times before, all this pretentious, arty nonsense, this to-do, this nibbling here and there and nowhere penetrating to the depths, nowhere true seriousness, power, endurance."[6] This is the clearest outward sign of a troubling of the relations between Rilke and Paula's intended that would never quite go away, despite occasional efforts by each to overcome it. Though, as the letter makes clear, they had very different tastes and values, at the center of it lay, unmistakably, a clash of interests over Paula that was still driving Rilke when he wrote the Requiem.

On the very next day Paula finally wrote Rilke the letter in which she came out and told him about Otto. Palpably strained by the conflicting demands and appeals of the two men, she relieved some of the tension in expressions of irritation with Rilke, seizing on the way he had closed his last letter:

> And you say your letter wasn't a letter for me, and really wasn't a letter from you? I hope it was for me and to me, and that it was also from you. . . .
> My soul is not celebrating any Sunday today either. It doesn't even know what it's celebrating or not celebrating today. My soul is under a veil today. A fog covers it and makes it motionless. And still I'm writing to you. You will permit me my everyday soul's day, won't you?[7]

A bit further on, in response to reading Georges Rodenbach's *The Veil* at Rilke's suggestion, she reacted against the play's, and Rilke's, eroticism of death: "It's against this love cult in death which clings so to material things, it's against this that something in me screams out and was even screaming at the time you told me the plot of this play."

Finally, as if everything she had written so far had been meant to postpone it, Paula came to the point:

> And all of this, all of it is only incidentals and little trivia and things with which one kills time. The one thing for me, the whole thing, the great thing, the thing that stands firm for me is my love for Otto Modersohn and his love for me. And that's something wonderful and it blesses me and pours over me and sings and makes music around me and within me. And I take a deep, deep breath and walk along as if in a dream. You know about that, don't you? It happened long ago; even before Hamburg. I never spoke to you about it. I thought you knew. You always know, and that is what is so beautiful. And today I had to tell you that in words, to baptize it and place it piously in your hands so that you could be its godfather.

It is a gracious passage, and if it contains an untruth—"I thought you knew"—it is a kind and mannerly one, the kind of lie that mends the social fabric.

A day later, November 13, Otto wrote in his diary, "Paula came to me yesterday at twilight, it was wonderful. She loves me more than I have sometimes thought. I had said bad things to her on Monday in my unhappy mood. It drove her to me."[8] His suspicion of Rilke, who'd played a vital role in the summer he remembered so fondly, had been excessive, he wrote in the same entry; he resolved to try to salvage the relation by sending, as a peace offering, three of the little sketches Rilke had praised so.[9] It seems clear that in the stormy days preceding they had finally had it out about Rilke, with Otto insisting that he be told the lay of the land, and Paula at last, reluctantly enough, complying.

Rilke spun the metaphor in Paula's letter—"to baptize it and place it piously in your hands"—into another long poem meant as a peace-offering of his own. It was sent to Paula by return mail, and the speed of this response suggests that the Worpswede stories he told himself were regaining their primacy over the stories about Russia and Lou. Later he called it "Blessing for a Bride":[10]

> How strange it is: to be young, and to bless.
> And yet, how great my thirst to have it so:
> to meet you at the very edge of words
> and with my hands, which make their way through books
> so far away,
> to take my rest at evening in your hands.

That is the hour when our hands can speak:
the sounds of the day's work still resound in them,
they tremble gently and they truly feel
each thought that the mouth has only spoken;
and if piano keys were placed beneath them
the air would rise, laden with song, in the night,
and if they lived beside a small child's cradle
the child within would waken with a smile—
with great wide eyes, as if it knew and kept
the secret of what gives each spring its power.

And now, as these hands take their place in yours,
listen to the blood that softly speaks,
imagine, please, a good and fitting face
for these hands of mine that your hands hold.
A wise face worthy of its life, a still,
silent face to grasp the softest whisper,
a deep face that beneath its windy beard
stays peaceful, as if sheltered by the crowns
of oaks through which a storm speaks, a still house
in which you would not be afraid to live.

Imagine, please, a good and fitting face. This passage has been read by Petzet
as a plea for Paula to paint his portrait.[11] The portrait she did paint, six
years later, is the central image of his groundbreaking book about the two.
This is the blessing with which the poem ends:

I bless you, then, and with the kind of blessing
that one may see at evening, in the spring:
after days that whisper, freeze, or rain
a stillness comes, as simple as a song.
[. . .]
No word then is soft enough to say it,
no dream deep enough to live it out,
and old tales are no more than empty chests
since now all persons wear the very clothes
that rested once, so fragrant, in their darkness . . .

The ending recalls the image with which he had opened his earlier let-
ter to Otto, when the chests had been full and inaccessible through the
clutter of his new Berlin life. It is supposed to be a happy ending: each

person has found the proper clothes, and the old stories (of what could not be) can be forgotten with the empty chests. The short note he sent with the poem ends with "heartfelt greetings to Otto Modersohn."

When, a week later, the three sketches Otto had sent Rilke arrived, he wrote an effusive letter of gratitude. As he opened the package, he wrote, "I felt as if I should hastily pack together everything in my rooms and send it to you, as if nothing else could belong to me in the moment in which I accept these riches, which outweigh all others." He wrote Paula a short letter immediately after: "I recognized each [sketch] again, and found immediately just the right nuance of love with which each one could be grasped."

These letters were received by Paula and Otto, together, with a good deal more irony than Paula, in the privacy of her studio and her thoughts, brought to the letters she went on writing to her "Dear Friend." Formally, though, and in public, Rilke and Otto Modersohn had done the right thing by making peace, and so the tear in the fabric of the Family could be pronounced mended. When, before long, an edict from Paula's parents brought her to Berlin, she and Rilke could resume the contacts each valued so, with fewer illusions and with the Family's collective sanction.

At first, Rilke's correspondence with Clara Westhoff was less copious and less intense than that with Paula and Otto, but it increased perceptibly as the other waned. Rilke's letter of October 18 begins with a detailed recounting to her of her own experience: the story she had told him, just a few days before his departure, of sculpting her aging grandmother before being allowed to go to Paris, to which her thoughts had already gone rushing ahead. In Rilke's gloss, the discipline of being called back to something familial and near at hand was positive, and her acceptance of it a sign of her humility. The letter became an explanation and justification, in terms personal to Clara, of his sudden departure for Berlin. Worpswede had filled him with dreams like the Paris dreams filling her head then: "My eyes, too, had already been captured by the splendor [of Worpswede] and bound to great, deep beauties." But he had been called back, he said, to "the still face of that life which awaits me, and which I must create with humble, serving hands"—as Clara had been called back to her grandmother's face. "You worked for a month," he told her, "I may have years worth of work to do, before I may give myself up to something which is most deeply congenial, but still unexpected and full of astonishments." He had only begun to feel the sort of

humility she had felt at *her* task after he had renounced Worpswede and decided to remain in Berlin, where he had everything he needed to pursue his Russian studies and a hoped-for third trip to Russia.

Rilke's letter of October 23 is strikingly and atypically domestic. It reconstructs a fantasy Rilke had spun just before leaving, of cooking dinner for Clara in the little house he had rented with every intention of spending the winter there. It is too deliciously excessive not to be quoted at length:

> In the little cottage there would be light, a soft, shaded lamp, and I would stand at my stove and prepare a dinner for you: a lovely vegetable or grain dish,—and heavy honey would gleam on a glass plate, and cold butter, pure as ivory, would quietly stand out against a colorful Russian tablecloth. Bread would have to be there, strong, coarse whole-grain bread and zwieback, and on a long, narrow dish, rather pale Westphalian ham, streaked with bands of fat like an evening sky with long, wispy clouds. Tea would be ready to drink, gold-yellow in glasses with silver holders, exhaling a soft aroma, the aroma that harmonised with the rose in Hamburg, and would also harmonise with white carnations or fresh pineapple. . . . Large lemons cut in disks would sink like suns into the golden twilight of the tea. . . . And there would be roses around us, tall ones bowing from their stems and reclining ones gently raising their heads, and the kind that wander from hand to hand like girls in a dance. So I dreamed. Premature dreams; the cottage is empty and cold, and my apartment here too is empty and cold.[12]

The melodramatic closing evokes once again the speech of a stage actor portraying a shameless poseur, but Rilke abandoned himself to such fancies with utter sincerity.

In early November Clara sent Rilke grapes from the vines at her Westerwede cottage—striking a domestic note in return—and he produced a poem that recalled one late evening in Westerwede, their conversation in Clara's grape arbor, the hammer blow that had bloodied her hand: "It was then that this sweetness rose into the grapes."[13] Ever praiseful of Clara's work, he urged her to have it photographed for him, joking about how, on receiving one gift, he had asked her for another. He had seen a lot of beautiful art lately: Cottet, Rodin, and—his first mention of a painter Paula had earlier taken Clara to see in Paris, and about whom he would later write Clara a series of vital letters—"a remarkable Frenchman, Cézanne."

In her answer Clara asked him to write a poem for her birthday, a request that, he answered, he could probably not satisfy. But he wrote her instead a lovely, praise-filled letter, one in which, as he had done before, he recounted to her a story she had told him—letting her know how precious it was to him and what a gift she had for storytelling. This time it was one she had told him in the wagon on the way back to Oberneuland after the Family's trip to Hamburg—about the first time she had spent a winter there in the rural setting and not in Bremen—that he gave back to her, embellished, and he ended with a kind of blessing that she could hardly have helped being moved by:

Dear Clara Westhoff, when something autumnal or wintry enters your life, or a feeling of fear, as may happen before spring: be comforted: it will be as it was then in Oberneuland. You will only receive new beauties, the beauties of pain and of greatness, and you will be richer when you enter the summer days that are already tuning up their hymns behind each darkened sky. May you be blessed! Amen.

This retelling of his correspondent's own stories is something that Rilke was particularly inclined to do for Clara, and it is tempting to speculate about the relation between his way of appropriating parts of her inner life, embellishing, transforming, and then returning them to her as gifts from him, and what all their friends agreed was the strange and disturbing change that came over Clara after their marriage. Was this his way of enchanting her, of casting his spell? The practice had become so apparent that in the letter he spoke of it himself:

I am not ashamed that again, as before, it is *your* images, your words almost, with which I attempt to express myself, as if I wanted to make you a gift of your own possessions. But so it is, Clara Westhoff, we receive many of our greatest treasures for the first time when they come to us borne on the voice of another; and if this winter had become what I had dreamed of its becoming [when he rented a house in Worpswede for the winter], then this would have been my daily duty: to load my speech with your possessions and send you my sentences like heavy, swaying caravans, to fill all the spaces in your soul with the beauties and treasures of its hidden mines and treasure-chambers.

To fill all the spaces of your soul. If one breaks, for a moment, the spell of Rilke's eloquence, it is a strikingly aggressive proposition, antithetical in

spirit to the maxim by which he would soon attempt to structure their marriage: "that each should stand guard over the solitude of the other." A soul so penetrated and filled can hardly be spoken of as having solitude, and Rilke would have been the last one to allow himself to be penetrated so.

Rilke's postscript names all the birthday gifts he was sending: *In My Honor,* copies of *Wild Chicory* (the journal he had published in Prague), and—in a gesture of reckless trust—his manuscript copy of *The Lay of the Love and Death of Cornet Christoph Rilke,* which had not yet been published. Read them, he said, on some lovely evening, in your white dress. Soon he would send her his newest thoughts on Rodin, and someday the two of them together must write an essay on him.

On November 20—the day before Clara's birthday, and the anniversary to come of Paula's death—Rilke received another letter from Clara, in which she described weaving, from the ivy on the walls of her Westerwede cottage, a wreath for the funeral of her childhood friend Gretel Kottmayer, who had died young, somewhere in the south. Another dead girl. He wrote in his journal of how impressed he was, once again, by Clara's stories:

> Clara W. writes today of a black ivy wreath, and again it's a whole poem [*Dichtung*], the story she tells. The way she speaks of this heavy black wreath, how she gathered it without thought from the gable of her house, out of the grey November air, and how now, in the room, it becomes so terribly grave, a thing in itself, suddenly there is one thing more, and a thing that seems to grow ever heavier, while drinking up all the grief that is in the air in the room, and in the early twilight.

Rilke soon began to weave a macabre fantasy:

> The black wreath will perhaps break through the lid of the coffin and its long vines will creep up the white death-dress and grow through the folded hands and through the soft hair that has never been loved, and which, full of stopped blood, has also turned black and flat, and which in the darkness of a dead girl can hardly be distinguished from the heart-shaped leaves of the ivy. . . . And the ivy will travel through the empty passages of the blood with its long vines, leaf on leaf, like nuns who lead each other on a rope, on a pilgrimage to the stopped heart, whose doors are still just ajar.

"I would like to write a requiem with this image," Rilke wrote, and immediately did so. In the end it would appear, entitled simply "Requiem," in *The Book of Pictures*.[14] He had written her a birthday poem, and a long, impressive one, after all. Once, in Worpswede, he had written poems chiefly for the blonde sister; now, increasingly, he wrote them for the dark one.

The poem is in better taste than the journal entry. Clara is the speaker; here too, in a poem, he imagined her experience for her. This requiem contains an early statement of the idea, mined from Jacobsen, of the individual death:

And so the Lord placed before you a sister,
and then a brother,
who would show you how to die,
show you death,
your death.
[. . .]
For your death
lives were conceived;
hands to bind flowers into wreaths,
eyes to find roses red
and human beings mighty
were made and then destroyed
and deepened, twice, your death
before it was turned toward you
from out of the darkened stage.

Deepened, three lines from the end of the passage, is an inadequate translation of a pun in the German *gedichtet,* which means "composed" in the sense that poems are composed (for *Dichter* means "poet") as well as "thickened," for *dicht* means "thick."[15]

The poem ends with yet another blessing for Clara. In the last lines she speaks:

Was something hovering about me?
Did night-wind come in?
I never trembled.
I am strong and alone.—
What have I done on this day?
In the evening I gathered ivy and wound it
and bent it until it wholly obeyed.

Its radiance remains, its black radiance.
And my own strength
goes round in the wreath.

In the wagon on the way to Carl Hauptmann's Hamburg premiere, Rilke had held the wreath Clara had made for the playwright and felt "the simple reverent strength of her sculptor's hands" as he looked into Paula's eyes. That note in his journal became part of this requiem, just as Clara's letter had.

And this requiem became part of the requiem he wrote years later for Paula. The form of address is similar, as is the stance of *instructing* the dead. The wreath Clara has made will enable Gretel to achieve an acceptance of death: the same goal as in the later Requiem. Of course Rilke would put this requiem to use, for he put everything to use: as if Gretel's death had occurred, her requiem been written that they might compose and thicken Paula's.

Beyond this poem, it is unmistakable as one reads these letters that as Rilke made his peace with Paula and Otto and their union, some of the fierce absorption which he perforce began to withdraw from his dreams of Paula began to be redirected toward Clara. When, on November 26, he received the photographs of her work that she had had taken at his request, they made a deep impression. He wrote this in his journal:

The sitting boy with his knees drawn up astonishes again this time by the simplicity and greatness of its bearing. You can imagine it on a gigantic scale. It is Clara Westhoff through and through, as is everything soft and precious that she says: it could be sung by chorales, and received by broad landscapes.

Rilke wrote again on December 9, warning as he had in the previous letter that he might not write for a while, this time adding the hope that she would go on writing to him in any case. His letter seems chiefly designed to console Clara after a disappointment: she had been expecting her old teacher Max Klinger in Worpswede, and hoped to show him her new work, but in the end he had not come. Rilke tried to convince her that the value of such an expected visit lay in the anticipation, and in the responses it called up in the one who waited. Valuing, as always, inner over outer experience, he did his best to convince her that Klinger's actual coming would have been redundant.

On December 13 Rilke registered in his journal an acute emotional crisis, to which nothing he had written of in any of his journals from

Italy on compares. The journal entry says nothing about events that may have triggered this crisis, but brings to bear on it all the eloquence we have seen him bring to many of his ecstatic Worpswede emotions. It is worth quoting at length, if only as one of a small number of passages in which Rilke wrote with all his powers in this emotional key:

Such days, I fear, don't belong to death, just as they don't belong to life. They belong to . . . oh, In-between-land; if an in-between-spirit, an in-between-God rules over us, then they belong to him, this secret sinister one. . . . Who knows how many of those trapped in the in-between existence live in asylums and are destroyed? It is frightfully easy to be destroyed. It is itself destruction, this grow-ing-indifferent, this balancing of the other pan of the scale, full of uncertainties and desolations, with one's own heaviness that lies there in all its indolence. . . . One becomes completely timid. Timid like a dog with a bad conscience. Flat, without feelings, nothing but fear, fear of what has happened and what has not, fear of what is, fear that it may change, though one can scarcely endure it. Out of mistrust, one flatters. Crawls before each chance event of the day, receives it like a guest one has been waiting for for weeks, celebrates it, is disillusioned by its grimace, tries to conceal one's disillusion, tries to wipe it out of oneself, to deny it to one-self, to deceive oneself though one is already deceived, sinks ever deeper into confusion and madness, dreams, awakens, wishes for an inheritance, the title of prince, glory, poverty and great power all at once, values everything now like a child by its golden glitter, now like a whore by its pleasure, by night,—accepts everything that happens, is screamed at by all the day's pettiness and ugliness as by drunken watchmen, goes about with a rabble of thoughts, drinks, gets drunk on sump-water, wallows among stones, walks filthy in the company of precious memories, drips filth on hal-lowed paths, takes in one's clammy, sweaty, swollen hands what out of reverence one has never before touched, makes everything common, general, typical.

"Apparently Lou had been mistreating him," writes Binion, after quot-ing from Rilke's outcry.[16] Hendry attributes the crisis to Paula, and her having finally told him directly about herself and Otto a month earlier.[17] He had run from the collapse of his dreams of Worpswede, and turning back to Lou he had found little solace. Neither Paula nor Lou could, in the conventional sense, be his now, and if these two were both to be con-

signed to the past, he could not face the future, or perhaps yet perceive that it lay in the direction of Clara. He was "in between" Berlin and Worpswede, though surely nothing we have said exhausts the significance of "In-between-land"—which was also the title of one of Lou's works in progress. There was no longer any reason to remain in Berlin; without a continuing connection to Lou he would be incapable of realizing his more concrete Russian plans, and such an incapacity sounds very much like the incapacities he bemoaned in this long, grim passage.

By the testimony of his journal, Rilke resolved the crisis that very same night, by writing a prayer:

> Night, silent night, into which are woven
> things all white, red, parti-colored things,
> scattered colors that you raise up toward
> the great One Dark One Silence, raise me too
> into some connection with the greatness
> that you woo and would win over.[18]

The poem goes on to sketch a life plan suggestive of the life he would soon try to make with Clara in the rural isolation of Westerwede:

> the nights wide, never idle, full of gesture,
> the mornings all sunshine,
> every day spent close to the earth
> and in connection with its shapes, its stone.
> A simple trade that simply filled my hands
> and someone who would shelter me
> that I might stay unnoticed and alone
> and solitary—stay hers and my own.
> And simple food: vegetables, jam and bread,
> and simple sleep, dream-gentle, almost death,
> and weariness, and in the red of sunset
> every night, a prayer.

Someone who might shelter me / that I might stay unnoticed and alone: someone to stand guard over his solitude. A woman, in particular. It was a dream Rilke would harbor for the rest of his life; before long he would conclude that he had found such a woman in Clara Westhoff. The day's final journal notation reads, "After many utterly heavy and indeterminate days, I experienced today an hour of sunshine in the forest."

Another soon followed. At Lou's, on the first of December, Rilke had met Gerhart Hauptmann and been invited, with Lou, to attend the dress

rehearsal of Hauptmann's new play, *Michael Kramer.* The play moved him deeply, pained him and in the end, he felt, healed him. At the end of a journal entry almost nine pages long—the last in this volume of his journal—he wrote this:

> I was stirred up, plowed to my innermost being, I was like a newly plowed field, and as the great motions of the sower passed over me, I could feel the painful falling of the seed on my heart, which had been laid bare. It was a day of receiving for me, painful and joyous, the first of many future days that could not come without this awful and beautiful first day.

He felt ready now, perhaps, to face what lay in front of him, particularly a decisive encounter with Clara.

As Paula and Otto prepared, singly and together, for marriage, they shared their secret with progressively more of those around them. By October 28 Paula's parents knew; in a letter to her father she wrote, "Now please don't start worrying about any celebrations," and asked that he provide her with only a modest dowry so that money could be saved for her younger twin siblings, Herma and Henry. To all, Paula introduced Otto in glowing terms, but through their glow one perceives significant statements about how she saw herself and her fiancé. To her aunt Marie Hill she wrote this after a twilight rendezvous with Otto:

> He is like a man and like a child, has a pointed red beard and gentle sweet hands, and is seventeen centimeters taller than I. He has a great intensity of feeling. . . . Art and love, those are the two little tunes that he plays on his fiddle. He has a serious, almost melancholy nature combined with a great capacity for cheerfulness and a love of sunshine. . . . I am such a complicated person, always so trembling and intense, that such calm hands will do me a world of good.

Like a man and like a child—this perception of Otto runs through Paula's letters about him from this time. Before Paula had ever gone to Worpswede, her father and a group of other citizens interested in art had met in the Bremen Rathskeller with the Worpswede painters: a meeting that must have engendered a good deal of mutual suspicion. Closing the account he wrote in a letter to Paula, he depicted Otto as having "the soul of a child who winces and dives under the table at every little joke, no matter how innocent."[19] Vogeler's high opinion of Otto included the perception that he was an innocent victim needing protection from the

likes of Mackensen and am Ende. Paula, as we have seen, wrote Rilke, as she prepared to tell him directly the news of the engagement, of her desire to hold her hands over Otto, to shield him. In letters from this time Paula represents herself as not nearly so innocent, nor so simple. This passage appears in a letter to her mother from November 3:

> I believe that I'll become quite a good wife. I have even been con-
> cerned, lately, that I might completely lose my old obstinate head as
> time goes by; and because it's already a quarter of a century old, it
> has antique value. So, the philosopher in me says I really mustn't let
> it completely get away from me. But the man is so touchingly good,
> like a child, that whenever he hurts someone, he does it with such
> divine naiveté that one must kneel before him in humility. . . . We
> who are aware of things, we really have it twice as hard. We are not
> permitted to hurt anyone, just because we are aware.

Paula had long since accepted the fact that to others she would often appear obstinate and self-willed. She knew that these qualities were guarantors of her determination to make art, and that she would still need them after the wedding.

Otto saw differences, too. On November 26 he wrote this in his journal:

> How often when I am with her I feel as if I were growing wings,
> as if I were made lighter; everything becomes alive in me, becomes
> so light and joyous. That is worth so much to me! There is no ques-
> tion that I am inclined to be ponderous and brooding; how often
> I am like that when I am alone. For this, Paula is a true balm. She
> brightens, refreshes, enlivens, rejuvenates.

On December 20 he wrote that in addition to her "genuine artistic sen-sibility," she had "a happy disposition, cheerfulness, freshness, liveliness, a sunny nature."

Paula saw herself as knowing, mercurial, willful; Otto saw himself as moody and deep. Each thought of the other as simpler and happier; each saw the other as a source of ease and release.

In December Paula and Otto were often apart, especially during the holiday season, when Paula returned to Bremen and Otto, to Münster. On Christmas day her letter to him turned to thoughts of motherhood:

> This little piece of Christianity warms me and I accept it for the
> fairy tale it is. And then, you know, it is such a celebration for

women in particular, because these tidings of motherhood go on and on, living in every woman. All that is so holy. It's a mystery which for me is so deep and impenetrable, and tender and all-embracing, I bow down to it whenever I encounter it; I kneel before it in humility. That, and death, that is my religion, because I cannot comprehend them.

This is a vital passage for understanding both Paula's work, in which depictions of motherhood abound, and her life, in which determination to be a mother was a defining and fateful constant.

Paula wrote this on December 27:

I have the wonderful feeling that this period of separation is puri-fying our love and making it more spiritual. The thought of it fills me with a feeling of great goodness toward the universe. My King Redbeard. I am the maiden who loves you and who gives herself to you, whose modesty lies in pieces before you, melted away as in a dream. That is my humility, dear, the fact that I give myself to you as I am, and place myself in your hands and shout, here I am.

One of Otto's Christmas gifts for Paula was the recently published *Letters of Prince Bismarck to His Bride and Wife,* for Paula shared the widespread reverence for Bismarck. One of Paula's gifts to him was a photograph of herself, Otto, and Clara Westhoff, accompanied by a little poem: "Thee and I, and I and thee, and Clara Westhoff makes us three."[20] At this time, clearly, she had no intention of letting marriage loosen the bonds of her friendship with Clara.

But Paula's lettter of December 28 reveals that all was not well with Clara: "Things are not going any better for Clara Westhoff. She staggers along with her own crown of thorns, hoping for a quick end to this year 1900." It seems likely that the new intensity of her exchanges with Rilke had begun to raise questions—in the ambience of family and holidays and blissful couples soon to be wed—that needed prompt answers.

To Paula, at least, eager thoughts of impending marriage did not dimin-ish but heightened her joyous identification with the larger "Family"; in the midst of these days, on December 30, she wrote about the group and its quiet, shared life in Worpswede in a letter to her Aunt Marie:

Out in Worpswede our little community leads a quiet life: Vogeler and his little bride, Otto Modersohn and I, and Clara Westhoff. We call ourselves "the family." Every Sunday we're together, enjoying

each other's company and sharing a great deal. It would be wonderful to live my whole life this way.

Even in Paula's enumeration of the members of the family one feels that an incomplete construct awaits completion through the pairing of Clara Westhoff and—someone. Who more likely than Rilke? To the extent that the notion of the Family had captured the imaginations of all concerned, including—despite his resistances—Rilke, this sense of an emerging gestalt becomes a reason in itself for the marriage. Even if Rilke's responses to Paula had not, before his sudden departure, taken the form of hopes for marriage, the knowledge that in the spring *two* marriages would now be taking place—that even in an enchanted place, girls do not remain girls—made it likely that his thoughts, too, would turn in that direction.

Paula's parents now placed what seemed to Paula a nearly intolerable obstacle between her and her fiancé: they arranged for her to attend a cooking school in Berlin, while living there with her aunt Herma and cousin Maidli. When the dreaded day came, both Otto and Clara Westhoff accompanied Paula as she returned to Bremen for the train departure for Berlin. In the manner of the Family, they made it as festive an occasion as they could: the three of them skated from Worpswede into the city on the iced-over canals. Paula, the best and most zestful skater, was always, by Clara's account, in the lead. But the glum letter she wrote Otto from the train station says, "Each of us is going to have to try to remain brave now and work hard during the two months we must be apart. For you, my King, it will be beautiful, beautiful pictures—for me: soups, dumplings and stews." She brought along the photograph of herself, Otto, and Clara to help keep up her spirits.

This is the opening of Paula's first letter to Otto after her arrival, written on January 13:

> Well, now I'm in Berlin and feel very tamed and very confined and would like to blow up these walls so that I could see a little bit of the sky. . . . I don't fit into a city like this, and particularly not into this elegant district. I fall right out of the frame. It was quite a different thing being in Paris, in the Latin Quarter. . . . My poor little soul is marching right into a cage.

Worst of all was not being able to paint for two months.

With Paula away and her engagement to Otto still not general knowledge in Worpswede, the Family devised a scheme for concealing

the correspondence between the two. Paula's letters to Otto were mailed in envelopes addressed by Rilke, and bearing his name; Otto's to Paula in envelopes addressed by Clara or (after Clara, too, went to Berlin) by Vogeler.

Leaving for Berlin, Paula had written Rilke, too, a note from the station: "We have again spent wonderful days together, we the 'family.'" She told him that she planned to call on him, and asked him to keep the promise he had made on leaving his sketchbook with her—to read any poem she might request—by reading "The Singer Sings before a Child of Princes." When she did call, he read her not the poem but something from his latest enthusiasm: the final act of *Michael Kramer*. She wrote in her journal later that evening, "I entered a quiet, industrious life full of beauty and tenderness. He was not as happy as in Worpswede. He lived in creativity and in the fullness of his art. Now he is catching his breath for the new things to come."

At the same time, Rilke was writing her a long letter, as extravagant as some of his Worpswede journal entries. Returning to his apartment after seeing her home, he had touched nothing, so as not to disturb the delicate aura of her having been there. He had spoken aloud the poem she had requested, "The Singer Sings," and then cooled his voice (grown hot in the reciting) with the remainder of a piece of fruit they had shared, "which your hands had so beautifully opened." He proposed that they see a Daumier exhibition at Cassirer's on Thursday—perhaps her cousin Maidli could come along?—and asked her to keep next Sunday, and many more of her Sundays, open for him.

Paula answered the next day, asking him to read "The Singer Sings" to *her* next time. She accepted the Daumier invitation and expressed pleasure in their having renewed their connection: "Your great work and the number of your Russian volumes lay so heavily upon me. I thought that the books would turn into a barrier that I could not hop over. (I now have quite a respect for barriers.)" Her rueful parenthesis acknowledges that her intense interactions with Rilke had once threatened to overstep the bounds of her status as Otto's fiancée.

Though this was so, their interactions remained intense; it appears that, once together, they could not help it. They spent nearly every Sunday of Paula's Berlin stay together, and exchanged letters whose characteristic salutation was "Dear Friend." Whether or not either could have said so, *Niels Lyhne* was still present: in the time after Fennimore's marriage to Erik Refstrup when Niels's relation to her remains innocent, and immediately after Niels had made the gesture of loyalty to his

old friend that Rilke had alluded to in a letter a few months earlier ("think of him as he was in the hour when you loved him most"), Fennimore asks Niels for a pledge of friendship:

> He was silent.
> She said nothing either, but lay very still with a melancholy smile on her lips, pale as a flower.
> Then she half rose and stretched out her hand to Niels. "Will you be my friend?" she asked.
> "I am your friend, Fennimore," and he took her hand.
> "Will you, Niels?"
> "Always," he replied, lifting the hand to his lips reverently.[21]

Something of this tender and pregnant idealism remained in the air when they were together. If to Paula such encounters had always had an element of fantasy, now it seemed that they could share it freely with no fear of misunderstanding.

Paula had admired a photograph of Gerhart Hauptmann at Rilke's apartment; ever the inspired giver of gifts, he presented it to her. In part to thank him, in part to return the gesture he had made the night of his sudden departure, Paula sent him on January 23 her journal, asking him to read only the more recent entries. Her new respect for barriers notwithstanding, Paula, always inclined to keep her deepest thoughts to herself, nonetheless granted Rilke access to vital areas of her inner life, perhaps those to which Otto would not have known how to respond. He devoured the journal immediately and sent her the next day a long letter in which, playing to her as he could not stop himself from doing, he spun out an elaborate conceit:

> in the reading of your journal entries I took many things out of the vessels of your words, which I cannot give back. So it is with strands of pearls, when they break. The pearls had not been counted, and even when one thinks that one has found them all again,—there remain in the most hidden corners pearls that rolled away, silent and—if you will—ill-gotten treasures in the room in which the strand broke. I am at the same time the room and the perpetrator. The seeker of all the pearls that were scattered through my impatient reaching for the lovely necklace, the finder and unintentional keeper of those that have not been found. What shall I do? Confess and ask for mercy. Am I doing so? I promise, now, that I shall return whatever part of your garland of jewels may reappear where I live,

set in the hour in which the discovering light first brought to the rolled-away pearl a smile. Set in the joy of the finding.

Rilke also acknowledges with regret that he has seen almost none of Paula's work. The journal had revealed to him the intensity of her commitment to her art, leading him both to apologize and to make strained excuses for his failure to perceive it earlier:

> There is something I now must regret: in Worpswede I was always with you in the evening, and I doubtless saw here and there, while we were conversing, a sketch (a canal with a bridge and sky is still very clear in my memory) until words came from you, words which I wanted to see at once, so that I denied my eyes the view of your walls, and followed your words. . . . Thus it happened that I never saw much by you, for you yourself never showed me anything.

He had not asked because such sharing must come of inner necessity, not simply of asking and being asked, and he had thought he would be in Worpswede long enough to wait for it to happen.

Rilke closes this long letter with one of his eloquent blessings, a response to a journal entry in which, under the spell of the journals of Marie Bashkirtseff, Paula had written, "Such an observer of her own life. And me? I have squandered my first twenty years. Or is it possible that they form the quiet foundation on which my next twenty years are to be built?" This is Rilke's reply:

> You have not lost your "first twenty years," my dear and earnest friend. You have lost nothing that you could ever miss. You did not let yourself be confused by the eyes in the veils of the Schlachtensee [a reference to a fantasy she had spun one day in the journal]. . . . You went home and created. Much later you will know how much. And someone will perceive this in your life, someone who will receive and magnify it, and raise it into new and broader harmonies with his ripe, rich, understanding hands.

Paula wrote candidly to Otto about her times with Rilke and expressed satisfaction that Otto was seeing a lot of Clara Westhoff in Worpswede. The members of the Family seemed, at least, to have attained a warm, open, high-minded interaction, untainted by desire, jealousy, and dissembling.

When Clara came to Berlin at the end of January, she and Paula went to the museums together, saw *Michael Kramer,* and heard a performance of

Beethoven's *Eroica* symphony. "We have gotten so *much* from each other," Paula wrote to Otto on January 31. Of course they called together on Rilke; he read them his poem "The Annunciation," based on a painting of Vogeler's, and Paula wrote to Otto, "and that [the conception of a child] will happen to the two of us also, dear, and I fold my hands silently." It is one of many small signs that Paula looked forward to motherhood; in Berlin she also bought a coral bracelet intended for a future daughter.

With half of the family now in Berlin, the times that the three spent together took on an air of festiveness. Together they produced a letter-poem and sent it to Vogeler, in Rilke's hand but signed by all three, as an invitation to come to Berlin for Paula's twenty-fifth birthday, on February 8. Paula had begged Otto, too, to come, and to bring Vogeler and Martha Schröder along: to assemble, in short, the entire Family. In the end the plan fell through, and Paula spent her birthday with the Parizots on an excursion to the countryside. Otto sent her a painting, and she thanked him effusively; Vogeler wrote a birthday letter describing Martha's wedding dress. Rilke's gift was a volume on the painter Oldach, along with candy and a bouquet of lilacs. "I am a lucky little human being," she wrote to him in her note of thanks, "and wonderful gentle hands are rolling one ripe red apple after another to me."

And I receive each one of them as a new wonder from heaven, and I sigh with happiness. I give thanks to those hands for having taken you by the hand, too, and leading you to me here on my green meadow. And I throw you one of my red apples, and you lay such sweet flowers into my lap, even a sweet bouquet of lilacs today. *Spring is coming*—and then you came yourself, not just to my green meadow, but all the way up to my tower, which is so hard to do and so very exhausting. I reach out both of my hands to you with thanks and look into your kind eyes, and as the one who receives, I ask you to remain so for me.

She was certainly recalling the hands in Rilke's "Blessing for a Bride," sent in mid-November. One senses that in her answer Paula has let herself go, trusting in the new protection of her official status as fiancée to make it permissible. To some degree, she may be attempting to match the extravagance of Rilke's writing—one senses at times, in Otto Modersohn's letters to Rilke, similar but less successful attempts. When, a year later, both Rilke and Clara would forget Paula's birthday altogether, one need only remember the intensity of this exchange to understand why it stung Paula so.

On a very different note, Paula's father wrote her a somber, interminable birthday letter, a lecture on the duties of a bride, whose tone makes it clear that he thought of Paula as unduly headstrong:

Your duty now will be to merge with your future husband, to dedicate yourself completely to his ways and his wishes, to have his welfare constantly in sight and not let yourself be guided by selfish thoughts. For the most part it will certainly be easy for you, because you surely love Otto and seem to agree with him in most matters. But there will also be times when it will be difficult for you to subordinate yourself to him, and to bend to his will. Only then will you really be put to the test.

Paula had been musing, in her journal and apparently in letters she sent home, about what the couple's future homes would be like, and one dream involved buying an old farmhouse in Worpswede and furnishing it with old things of the kind she liked. Her father advised against it: old houses weren't as healthy as modern ones; Otto's daughter Elsbeth had grown accustomed to Otto's current house; Otto, too, had been content there, "and then you came along and inoculated him with the notion of copying Vogeler."

The letter Paula wrote Otto on the morning of her birthday captures a great deal of her style and her way with him:

It's a blessing to think about you in your simplicity. No, dear, you are not complicated. I know that. I knew it before and I shall know it tomorrow. And I thank you for being that. I don't know whether I'm complicated or not. If I am, then I probably have to be that way. In which case I wouldn't call being complicated a flaw. (If I were with you right now, I would have said that last little sentence very quickly and then stuck out my big fat tongue at you.)

In her letter of March 6, in which Paula informs Otto that she plans to return early to Worpswede, quite against her parents' wishes, Paula makes one of her few extant statements about societal expectations of women. The context is an awareness that no burden comparable to this forced confinement in Berlin had been placed on Otto:

Funny, from the very beginning of marriage it's we women who are put to the test. All you men are permitted to stay simply the way you are. Well, I don't really take that amiss because I do like you all so very much. It's only that in general the masculine nature

is bigger than the feminine, more connected, and more as if it had been made from one mold; that is probably why it is the way it is. By that I don't mean to refer to the two of us in particular, for I consider myself made from the same mold too. But I'm speaking in general about male and female. See, my cockscomb is growing again—that's a happy sign or omen for my Worpswede days.

In those first two weeks in February, while Clara and Paula were frequently together, and also frequently made a threesome with Rilke, Rilke and Clara, too, spent increasingly urgent times together; by February 11 they were lovers and most seriously considering marriage.[22] Paula seems not to have seen this development coming, at least not until it had nearly arrived, and there are small but intriguing indications that she had trouble accepting it. A short letter that she wrote to Rilke on February 16, after being together with the two just prior to Clara's departure, is the first even to hint at recognition. It begins with an admission of sadness:

> When I stood with the two of you in the room yesterday I was far, far away from you both. And I was overtaken by a great sadness which was still with me today, dampening my high spirits. But during my nap it left me, and I began to feel that it was just a small sadness. I'm happy for myself and for life; and I wanted to tell you this and that I am happy for you, too, and reach out to you. Your little tree has shot up and grown. And whoever sees it rejoices in it.

She closes the letter this way: "Here are greetings from one who sees it and is made happy."

Could Paula have sensed, after having made it so clear that she had no intention of letting *her* marriage disrupt her relation to Clara ("and Clara Westhoff makes us three"), that now Clara's wedding threatened to do the same? And that by the same unforeseen stroke of fate she might lose Rilke as well? Just a year later she would be convinced, in her pain and anger, that both these losses had come to pass.

Rilke's answer, the next day, was this: "Life is serious, but full of goodness. I am happy too. So much lies before me. You will soon hear all of what it is!"

Clara had left Berlin to return to her Westerwede cottage at just this time, and then asked Rilke to meet her there—where they planned, if the marriage went forward, to set up their first household—for a definitive decision: to marry or not. Paula's mother, in the letter she wrote to

Paula on February 24, when she got the news, added a juicy detail or two: "You know, of course, that she left Berlin completely undecided about things and then after they parted she felt she couldn't endure being without him, and so she wrote a letter to him from Hamburg," a stopover on her way home, by train, to Bremen.[23] Frau Becker had heard the news from Paula's sister Milly, who had dropped in to see Clara. Milly found only Frau Westhoff at home, but then the doorbell rang, and there stood the two new lovers, "still completely oblivious and blissfully surprised by their own fate."

Otto wrote to Paula, "And Friday afternoon—guess who turned up? You've probably got a good idea already: Clara W. with her little Rilke under her arm." There was a good deal of amusement in Worpswede about the incongruities of the new couple: the verbally reticent but strapping and physically exuberant six-foot Clara, the smaller, more delicate, mild-mannered but verbally extravagant Rilke.

Paula first mentions the couple in a letter to Otto, on February 28: "Yes, yes, the new couple. By the way I didn't say anything about it in my last letter because I didn't know anything about it myself." This last may be a fib—her pregnant exchanges with Rilke seem to hint at some degree of recognition. Her final comment is a knowing reference to the fence-mending role played by Rilke's letters to Otto: "Rilke will probably not be writing you another letter now for quite a long time."

He would not be writing letters to Lou Andreas-Salomé for a considerable time either, for in order to cut him loose she wrote him on February 26 a long letter under the heading "Final Appeal." She proposed, too, that they burn each other's letters, and Rilke complied; Lou kept at least some of his.

Rilke had gone on calling on Lou through January 1901, unable to heed her clear signals that she wanted him to go away. In her journal she wrote on January 10, "In the struggles with my work these days I have certainly sometimes been horrid. Afterwards it always hurts me terribly. I'd like to have seas full of love, to extinguish that feeling. I'm a monster. (I was bad to Rainer too, but that never bothers me.)"[24] On January 20: "So that R. would go away, *completely* away, I would be capable of brutality. (*He must go*)."[25]

The "Final Appeal" makes clear that he had gone to her for advice about marrying Clara, and she, invoking her maternal role, had advised against it and hoped that by being blunt and coercive the letter might put a stop to it:

Let me therefore, as a mother, speak out loud of the duty which I incurred several years ago as the result of a long conversation with Zemek [Dr. Friedrich Pineles]. If you wander off, free, into the indefinite [future], then you are answerable only to yourself; if you marry, on the other hand, then you must be told why I steered you tirelessly toward one definite path toward health: it was Zemek's fear of a fate like that, for example, of Garschin [a Russian poet who had killed himself]. What you and I called the "Other" in you—this one who was depressed one minute, excited the next, once all too full of fear, then all too easily carried away—he was a familiar and sinister companion, one capable of driving what is spiritually sickly all the way to disease of the marrow of the spine, or to insanity. *But this need not happen!*[26]

She had seen him healthy, at times, but then he had fallen back—on their second Russian trip, and in mid-December in Berlin—into the hands of the "Other":

Do you understand my fear and my vehemence when you slipped away again, and I saw again the old signs of illness? The old combination of crippling of the will with wild, manic eruptions of will that tore through your organic equilibrium . . . again the wavering uncertainty simultaneous with loud accents and strong words and assertions, full of drive toward madness, without drive toward reality.

The way Lou brings the letter to a close is masterful: on Rilke, who through sheer conviction, self-confidence, and eloquence would spend a lifetime imposing on others the myths by which he lived, Lou imposed her own personal myth, justifying on her terms, as he would so often justify on his, leaving someone behind. She had needed to grow, to grow in fact toward her own youth: for the first time, in Russia, she had felt truly young and totally herself.

Therefore your form—in Wolfratshausen still right in front of me, precious and meaningful—was more and more lost, like a single small part of a great whole landscape—a wide Volga landscape, and the small hut in it was not yours. I obeyed without knowing it the great plan of life, which held out for me, smiling, a gift beyond all understanding and expectation.

Now Rilke must do the same thing: "Go the same way toward your dark god!" She could do no more to save him from his "Other," but this dark god of his could heal him.

At the last minute she scribbled on the back of an old milk bill of Rilke's, and put into the envelope before sealing it, this promise of some future reprieve: "If ever, much later, you are in poor spirits, then there is a home for you, here with us, for your worst hour."

In response to the "Final Appeal," Rilke wrote this poem, which surprises chiefly by its clumsiness. He must have been utterly shattered, to write so badly:

I stand in the darkness, as if blind,
for their way to you my eyes no longer find.
In their mad progression my days are no more
to me than a curtain, behind which you are.
I stare at it, to see if it will rise,
the curtain behind which my life lies,
my life's reward, my life's commandment, yet
my death.
[. . .]
You were the tenderest thing I met,
the hardest thing with which I fought,
the height from which all blessing fell—
the abyss that devoured me, as well.[27]

To Gerhart Hauptmann, the same day, Lou wrote this:

I can send you no regards from Mr. Rilke, as he is gone. Nor will he return to Schmargendorf: he had been here incessantly for far too long already, and to let that continue proved undesirable. . . . He is a nervous, even nervously encumbered and endangered, homunculus that easily snaps between your fingers if you don't take good care.[28]

Rilke would resist invoking Lou's impulsive last-minute promise—that in spite of everything she would welcome him at his "worst hour"—for two years and four months. In the end, though, her independence, her resistance to being merely assigned some necessary role in the stories he told himself about his life, seems to have been what gave her the unique authority he would later grant her to advise and teach him. Even near death, he would ask those caring for him to consult Lou, for she would know, if anyone could, what was wrong with him.

Seven

For the Family, the spring of 1901 was the spring of the weddings. On March 3, Heinrich Vogeler and Martha Schröder were married in the old Romanesque church at Heeslingen bei Zeven, not far from Adiek. The wedding of Clara and Rainer Maria took place next, on April 28, at the home of the Westhoffs in Bremen. Rilke had spent the period from March 5 to March 12 with his mother in Arco, in the South Tyrol, where they met every year at this time, and told her about his wedding plans. He had also taken the formal step of leaving the Catholic Church so that the ceremony could be performed by the Westhoff family's Protestant pastor, but he did not tell his mother, who would have been distressed. In one of his letters to Clara he appears to renounce the cloak of the wanderer that he had donned to justify to Paula his departure for Berlin: "I, the homeless one, shall have a home."[1] In late March, after staying for a time in the Westerwede cottage, he had fallen ill with scarlet fever; he was nursed back to health at the Westhoff home, but his illness delayed the wedding. Soon after the ceremony, with Clara already two months pregnant, the couple left for the White Stag Sanatorium, near Dresden, where they spent the month of May on a cure that passed for a honeymoon.

Paula and Otto had hoped to be married in the Zion Church atop the Weyerberg in Worpswede, where Paula and Clara had impulsively rung the bells, but the declining health of Paula's father, who would die that November, made it impossible, and so the wedding took place on May 25 at the Beckers' home, with the bedridden Woldemar Becker

looking on from an adjoining room. Paula was twenty-five, Otto, thirty-six. The couple then left on a proper wedding trip that took them to Dresden, Berlin, Schreiberhau (where they stayed for a week with Carl Hauptmann and his wife, and went to meet his brother Gerhart), Prague, Munich, and the artists' colony at Dachau.

After their month at the White Stag the Rilkes moved into the Westerwede cottage. Much work had been done to make it livable for three; Vogeler had played a vital role in the renovation and the design of furnishings, though Rilke himself had tried his hand, too: one of many small indications that in this period Rilke admired and emulated Vogeler, his way of living, the breadth of his accomplishments. Rilke worked in an attic room; over his desk hung a wedding gift from Otto: a painting called *Moonlit Night with Couple in the Garden.*

Rilke's most eloquent description of his ideal conception of the Westerwede cottage is in a letter of November 12, 1901, to Franziska von Reventlow, an acquaintance from his Munich days. It is reminiscent of the poem he had written at the end of his attack of terror in mid-December of the previous year:

A house like this in the middle of the moor, without neighbors (except for a few unknown farmsteads) lying on no street and dis-covered by no one, is a good refuge, a place into which one can blend with a kind of inconspicuous mimicry, and designed, both forwards and backwards, in future and in memory, for a life full of peace and equilibrium.[2]

The isolation of Westerwede, then, as opposed to the community to be found in Worpswede itself, was at least in part a choice: marriage, for Rilke, meant refuge and protection.

At the end of July 1901 Rilke made a presumptuous yet touching gesture of devotion to his new wife. He wrote to the painter Oskar Zwintscher, whose work he admired, sending him a copy of *Stories of God* and a photograph of Clara. He and his wife were poor, he said, and could not pay for a portrait of Clara, but they invited Zwintscher to spend some time at their home in Westerwede in the hope that the desire to paint such a portrait would come over him there. Rilke acknowledged the boldness of the request, and explained it this way:

I am descended from a family of the oldest Carinthian nobility, once well-to-do and possessed of much property, and even though with the loss of our properties none of the portraits of our foremothers

has come down to me,—I feel nevertheless that one must show one's wife to a great and thoughtful painter, in her first beauty, before the second beauty of her motherhood, so that the children and descendants may have an inheritance, and unmistakable evidence of that beauty and goodness.[3]

We have already seen these imagined rows of ancestral portraits in the poem he had written for Paula just before leaving Worpswede; now it was Clara who was to take her place there.

Zwintscher did come, though not until after the birth of Ruth Rilke, and he stayed not in Westerwede but in the Vogelers' guest house at the Barkenhoff. He painted not only Clara but Rilke himself—who disliked his portrait, as he did nearly every portrait of him—and Vogeler.

At first both Rainer Maria and Clara were productive in Westerwede. From the eighteenth to the twenty-fifth of September, in one of his fits of prodigious productivity, Rilke wrote the second part of *The Book of Hours*—thirty-four poems in just over a week. He saw a volume of novellas, *The Last Ones,* and the first part of *The Book of Pictures,* an assortment of early poems written between 1898 and 1901, through the press with Axel Juncker. Perhaps in imitation of Vogeler, he took personal charge of the appearance of both books, writing Juncker letter after letter on details of type, paper, and so on. For *The Book of Pictures* he secured from Vogeler a title-page vignette of a fountain—but he also insisted, with dire effect, that the poems be printed entirely in capital letters.

In Westerwede Clara finished several portrait busts, including those of Heinrich Vogeler, Martha Vogeler, and Rilke himself, as well as groups called *Siblings* and *Mother with Child.* At least in part through Rilke's efforts, one of them appeared in an exhibition of the Vienna Secession, in February 1902. Vogeler's mother bought a copy of the portrait bust of Vogeler. In the summer of 1902, making the most of models that she needn't pay, she sculpted both her younger brother, Helmuth, and her daughter, Ruth.

This is how Rilke announced to his mother the birth on December 12 of their daughter:

Toward one we had our precious little daughter. She is an unusually large and robust child (weighs 4½ kilo), has firm flesh, a strong head with high, serious forehead and dark blonde or even darker hair above it, and beautifully shaped hands. And everything else that belongs, in the best form. We are very happy.[4]

"Our daughter," he wrote to her a few days later, "shall be called by the beautiful biblical name Ruth, Ruth Rilke, without addition of any other names."[5] He did not mention that *Ruth* was also the title of one of Lou's novels.

There was, by all accounts, a short time after Ruth's birth in which Rilke was happier than at any other time in his life; even near death, he recalled it in this way. For this time he was an extremely proud and perhaps even a moderately helpful father. To Carl Hauptmann and his wife, Paula wrote, "With his duties as a father Rilke has suddenly become a strong man and looks ferociously courageous." But Rilke's happiness—a state on which, in any case, he placed little value—did not last long.

Clara and Rainer Maria were determined to share their financial burden equally. Clara, whose family had greater means than Rilke's and was a frequent source of support, tried to arrange to take on sculpture students. She applied for various stipends but had little success, in some cases because there was no precedent for awarding them to women. Rilke had begun even before the wedding to try to raise what money he could; to his bookseller and future publisher, Axel Juncker, he had written that he needed fifty marks "for a necessary trip to Bremen," the purpose of which he did not specify.[6] He was at work translating a history of Russian painting by Alexander Benois, whom he had met in Moscow; it was never finished. He filled the mails with letters seeking books to review, editorial positions with journals or newspapers, whatever bits of literary piecework he thought he might scare up by writing to his already extensive network of acquaintances. The list of such odd jobs he did carry out is impressive in length, but it brought in little money. He left no stone unturned; on one day in January 1902 he wrote fourteen letters, or so he claimed in one of them.

Not only was new income hard to come by, but Rilke learned in early January, with his daughter less than a month old, that the stipend left for his studies in his Uncle Jaroslav's will would be terminated that summer by its executors, his cousins, who took his marriage to mean that he was no longer a student. Rilke's father had offered to find him a job in a bank in Prague; to him it was out of the question. To Pauli, director of the Bremen Kunsthalle, he explained his rejection of the prospect:

From the spiritual point of view alone, that is a sort of resignation, a frost, in which everything would have to die. . . . If it were a question of a painter, [my father] would understand that such a position would mean the ruin of his art,—*my* activity I could still

pursue satisfactorily (so he thinks) in a few evening hours. And moreover, I especially, who haven't too much strength at my disposal, must live out of a collected and unified state and avoid every hindrance and division.[7]

"I would rather starve with my family than take this step," he wrote later in the letter, "which would be like death without the grandeur of death."

The letter was an appeal for Pauli's help, and he did what he could. The Kunsthalle would soon be opening a new wing, and Rilke was already engaged in directing a production of Maurice Maeterlinck's *Sister Beatrix* (for which Vogeler was designing the set), along with an additional scene of his own composing, a dialogue between "the stranger" (read, the bourgeois) and "the artist," for its dedication.[8] The performance took place February 15, 1902, and was by Rilke's account a great success. Rilke had asked about a job in the newly expanded museum, and suggested that Clara could take over the museum school; neither of these proposals bore fruit, but Pauli did buy Clara's bust of Vogeler for the Kunsthalle and direct potential students to her in Westerwede. He secured for Rilke not only some journalistic work in Bremen newspapers but, more importantly, a commission to write a monograph on the Worpswede painters. When art historian Richard Muther, on whom Rilke had paid a call in Breslau in the time between his two Russian trips, had come to Worpswede in November to research an article on its artists, Rilke had led him around to their studios, earning a note of gratitude in the article and ingratiating himself to the painters in ways that would help him secure their cooperation for the monograph.

On December 20, 1901, Rilke's play *Daily Life* premiered in Berlin. He had written it in Schmargendorf, and the contacts he had made through Lou with the Berlin theater world had helped in arranging the production; a further production in Hamburg had already been scheduled. Nothing could help the play in pleasing its audience, though. In an uncharacteristic gesture, evidence of his brief but intense devotion to fatherhood, he stayed in Westerwede to be with Clara and the newly born Ruth (and perhaps to avoid coming face to face with Lou at the premiere). He was spared seeing his play nearly laughed off the stage. One reviewer wrote, "the people speak as Pre-Raphaelite angels carrying lilies would speak. . . . The audience was nearly writhing with laughter."[9] The flop resulted in the cancelation of the Hamburg production; this meant another financial hope was dashed, but artistically Rilke kept his poise by incorporating the rejection into his personal myth under the heading of

the persecution of the artist by philistines. To Carl Mönckeberg he put it this way:

> [This laughter] is not new to me, and arises everywhere, where a crowd of people meets an isolate one, who begins to speak. It is directed, it seems to me, not only against the drama,—it is something like the answer of the times to my art. And only the fact that my verses are not widely known prevents them too from standing up to their necks in laughter.[10]

There is sad irony in the failure of Rilke's desperate attempts to earn a living from his writing at the time when he still hoped to keep the Westerwede household together: only a few years later, they might well have succeeded, for in them he was perfecting the methods of securing bed and board that would place him for long periods, never wealthy but usually secure, in the hands of a series of wealthy, mostly aristocratic, overwhelmingly female patrons, even as he gently pressed on them his need for privacy and time alone to work. As a young man, in the small pond of literary Prague, he had learned the value of personally inscribed copies of his books, praise of the work of other writers and artists, extravagant bread-and-butter letters to anyone who had shown the least interest. He was, about his work, as scrupulous as any poet has ever been, yet he found a place in it for innumerable occasional poems in presentation copies of his books and in the guest books of his hosts and hostesses. He developed an astonishing knack for making the recipients of the enormous numbers of letters he wrote feel addressed with the greatest intimacy, especially when they were women whom he could praise and instruct with his courtly eloquence. It is difficult to keep a present-day account of Rilke's procedures from sounding cynical, but he gave himself to them with complete and unself-conscious abandon, as he did to every impulse that, he believed, served his work. The time when Rilke still hoped to save his and Clara's life together in Westerwede was simply too soon: he had not yet made enough of a name for himself to make him a prized catch for an editor or a hostess, and few besides Rilke himself could see at this time the poet he would soon become.

There was good domestic help in the prospering Modersohn household, and Paula, like Otto, had eight hours of most weekdays to spend painting, out of doors or in her studio at the Brünjes's. Her younger sister, Herma, a frequent visitor, described her day:

They got up at seven, and a few domestic things were taken care of by nine o'clock. Then she would disappear on her little path through the meadows behind the clay pit and head for her atelier, avoiding the road and its inevitable encounters with people. The noon meal was at one o'clock. After a ten-minute nap she would appear at afternoon coffee, fresh and ready for her work, and at three o'clock her painting began again and went on until seven.[11]

By and large, she had little trouble asserting her claims to the time and support required by a serious painter, and Otto, madly in love with the woman and increasingly impressed by the artist, had little difficulty in accepting these claims.

Sometimes Paula and Otto worked side by side on the same motif, producing works that are difficult to tell apart; both did, for example, quick studies of the trunks of birches. Among their other common subjects were Elsbeth Modersohn in the garden, with the silvered glass ball they had set on a post there; naked children swimming in the canals; children celebrating the summer solstice with paper lanterns carried on poles; the Schützenfest, an autumn celebration that featured shooting matches. "Even after supper," Paula wrote on June 27, 1902, to her mother, "the two of us dash over to the poorhouse and do oil studies of the cow, the goat, and the old woman with her walking-stick, and of the children there." Though in a few instances a painting first attributed to one of the two has had to be reassigned to the other, typically Otto's work can be distinguished by longer, more landscapelike perspectives, a higher level of detail, an anecdotal or lyrical quality; Paula's, by the thicker application of paint, flattening and filling of the picture plane, and increasingly severe simplification of forms.

In the first years of the marriage each thought the other a good partner in artistic terms. In April 1902, comparing Otto's production favorably to Vogeler's, Paula wrote, "Art that is abundant and always giving birth thinks only of what is to come. That is the grand and hopeful quality that I see in Otto's work." Paula had known Otto's work since 1895, and from the start found it striking and appealing. Her high opinion of it held in the first years of the marriage, but it cannot be said to have grown, for it was already great. It is hardly surprising that the intimate daily contact afforded by marriage finally began to reveal what she saw as weaknesses. Like Rilke, Paula was inclined to value most highly what served her own work, making it predictable that her opinion of Otto's work would suffer as her own drew her in different directions. She had an instinctive independence of

judgment, as in this journal entry of June 3, 1902, which reveals both how closely they worked together and how readily Paula distinguished her own goals from Otto's. The subject is the response of each to techniques they were learning from a book on the Italian painter Giovanni Segantini:

> Otto is very excited by Segantini's technique of placing next to one another bits of color like a mosaic and thus producing a concrete, brilliant effect. He is enthusiastic about color in motion. And I am, too. I dream of movement in color, of gentle shimmering, vibration, of one subject setting another in motion. But the means which I should like to use are very different ones. There is something almost tactile for me in the thick application of paint. And I should like to produce it by glazing techniques, maybe over a thick underpainting. A different kind of glazing than Otto has in mind. He really knows only the single-glaze process. . . . I think that one can glaze ten times, one layer over the other, if only one knows how to do it correctly.

Rilke, who had reviewed the Segantini volume for a Bremen newspaper, had called their attention to it; though their relation to him was by then severely strained, he remained an ever-flowing source of stimulation.

Otto, for his part, had been struck by Paula Becker first in strictly human terms; we have already seen his journal notes on her manner and presence, which he had found captivating. He had seen far less of her work than she of his—though, unlike Rilke, he had shown interest—and the new intimacy with it afforded by marriage was a revelation. His earliest responses to perceiving what a highly gifted painter he had married were joyous and generous, even though he had some of the biases of the time to contend with. On March 11, 1902, he recorded this judgment:

> I have really been astonished by Paula's progress this winter. If she continues to develop like this, I am certain she will produce something very fine with her art. First of all, her style is very personal; nothing conventional and nothing traditional, unlike almost all women painters, in form, color, material, treatment—that for me is the best evidence of her truly artistic calling.

In the same entry, he remarks with equanimity on Paula's sharp judgment of his own work: "Her judgment is extraordinarily fine. So far she has always proved to be right. From the beginning she did not like my three pictures in Bremen, nor last winter my painting of the elfin dance; and now that is exactly my opinion, too." Perhaps under Vogeler's influence,

Otto sometimes introduced elements of fantasy and *Märchen* into his work. Paula discouraged the practice, and her judgment remains convincing to a modern sensibility.

Upon returning from their wedding trip, Paula and Otto had resumed saving their Sundays for the Barkenhoff and the Family, assuming that Clara and Rainer Maria would do the same. Even earlier, answering a letter of Clara's from the White Stag, Paula had written of the eagerness of the rest of the Family to have the group reassembled:

> *Dear* Clara Westhoff, I'm almost beginning to get used to not seeing you and being able to talk about all these things with you. But not yet completely, and I feel how much remains unspoken within me because you are not here. . . . Yesterday, Sunday, I read some of [Clara's letter] to the others on the Vogelers' terrace and we were thinking very much of the two of you, as indeed we often think *very* much about you and about the fact that our Sundays no longer have their full sound without you two.

But before long it began to appear that the Rilkes had withdrawn from their group of friends. To the Vogelers and the Modersohns, it was clear who was responsible: Rilke, with his obsession with solitude and his extreme view of the precedence of art over life. It did not take long for Paula to begin missing Clara; soon she was writing notes inviting Clara to call and journal entries, like this one of October 22, 1901, confiding how much she missed her friend: "Clara Westhoff has a husband now. I no longer seem to belong to her life. I really long to have her still be a part of my life, for it was beautiful with her."

The same entry had begun this way:

> For some time there have been three [other] young wives living in Worpswede [Martin Schröder, another painter, had also married]. And around Christmastime their babies will be arriving. I'm not ready for that yet. I must wait a little while longer to be certain that I will bear glorious fruit.

Paula did not wish to bear a child at the very beginning of her marriage, but neither did she wish to wait very long. The testimony of those who knew her is unanimous in asserting that she did want to be a mother, and shared for better or worse the belief that for a woman this was a form of fulfillment that nothing else, including art, could make up for. She had already become stepmother to Otto's daughter, Elsbeth, not quite three at the time of the marriage, in whom she took delight and

whom she won over without difficulty. After her death, Otto would say that he had never thought Paula suited for motherhood and had not expected her to bear children, but there was, by then, a measure of self-interest in this assertion.

The withdrawal of the Rilkes from the Family in those months after the marriages must be carefully described. It was chiefly the women who were isolated from one another, in part by motherhood (and step-motherhood); the men, going about their work and their business, all saw each other more frequently. Rilke was in constant contact with Vogeler over the monograph he planned to write about the Worpswede painters, the production of *Sister Beatrix* in Bremen, and other matters; his widening web of connections enabled him to be useful to Vogeler, always in need of design commissions to support the continuing elaboration of the world he was creating at the Barkenhoff. Rilke was even in correspondence with Otto about the monograph and other things. In this case, each overcame reservations about the other, in part because each had uses for the other: Rilke needed Otto for the monograph, and Otto knew that the monograph might well enhance his reputation—as indeed it did. The Vogelers and the Modersohns did see more of each other as couples than either did of the Rilkes. Paula was less burdened than the other women: her new role as stepmother did not drain her energy and limit her activity the way pregnancy, childbirth, and the nurture of an infant limited Clara's and Martha Vogeler's.

In Paula and Otto the sense that Rilke had withdrawn both himself and Clara from the Family soon merged with the growing astonishment and concern of many in Worpswede at how their beloved Clara Westhoff seemed to be changing under Rilke's influence. The consensus was that Rilke had forced on Clara a life of self-conscious, pretentious, ritualistic devotion to art that removed them from daily life and simple pleasures— a stance that suited Rilke, everyone agreed, but was alien to Clara, whose sufferance of it astonished them. Carl Hauptmann responded with incredulity to reports in Otto's letters of how Clara had changed. In previous letters he had taken pleasure in inventing fond epithets for Clara: she had been "the joyously storming Clara Westhoff," and then "the wonderfully life-exuding, conquering Frau Rilke."[12] At the end of March 1902 he responded to Otto's description of the new state of affairs: "Now tell me: what is this with Rilke? He's not really around at all anymore, and the high-flying Clara Westhoff has grown silent, no longer goes roaring along like a storm-wind—she's silent and a zephyr? No, that can't be. Or at least it can't stay that way."[13]

Hauptmann had just read Rilke's novella collection *The Last Ones,* and it had made a bad impression on him that resonated with Otto's reports: he had found it precious and pretentious. But he was sure that Clara was the stronger of the two, and that in the end her influence on Rilke would overcome his on her:

> I believe that when for the first time Clara Westhoff has her say—the time won't be long in coming—then he will give thought as well to the blooming of actual springs and the sparkling of the stars born out of dust. Then he will no longer permit himself to whisper and mystify.[14]

Retrospectively, at least, Vogeler saw Rilke's relation to Clara in the same way. In his unfinished memoirs, some forty years later, he wrote of Rilke's effect on Clara:

> There came a great, strong love between the two, there came the ceremonious building-up of a madonna-like being by Rainer Maria from a nature to whom this constant ritual solemnity in which he clothed her natural being was at bottom antithetical. But the loving woman fell under the control of the remarkable power of this poet, whose character seemed soft and yielding, but was in its end results as direct and forceful as the blade of a rapier.[15]

This passage went on to characterize later developments:

> There came the great pitiless struggle of two human beings who lived together in this farmhouse and crippled each other in their artistic capabilities. There came separation. Her suffering was infinitely heavy, to the point of a quiet resignation that remained characteristic of her life.

Rilke's effect on Clara at this time may be described this way: he imposed on her, perhaps not knowingly but with supreme self-confidence, the mythology by which he lived his life, though it was a mythology that left her no room to be herself. The central tenet of this mythology, central as well to the Requiem, was that, for the artist, art was more important than anything else, its demands taking precedence over those made by everything that, taken together, we call life.

At the time, Vogeler wrote, Paula hated Rilke for the effect he had had on Clara. Even if we question the extremity of this characterization, there was in Paula a rising anger that would necessarily come to a head before long. It must at the same time be said that Paula's vision of

Clara—and that of others in the Family—was also a myth of a kind, one particularly precious to her, and so what she resented in Rilke was the complete success with which he imposed his myth on Clara at the expense of hers. One of the ironies of the way in which the relations among the three played themselves out is that Rilke, on his first Worpswede visit, had done so much to reinforce the bond between Paula and Clara, praising each to the other and calling them first sisters and then the sisters of his soul.

Though neither Rilke nor Paula held conventional religious beliefs, both set great store by Christmas and its rituals. It was Christmas—not the single day but the season, at the outset of which Ruth had arrived like a gift—that Rilke chose to remember most fondly in later years about Westerwede. His gift to friends that season was the newly published collection of novellas, *The Last Ones.* In the copy he presented to Clara he wrote this poem:

We have built a house for this my book,
and you have given me true and faithful counsel.
So let us now, with deep and silent deeds,
build the house to which we entrust ourselves.
We'd have the greatest things to be our lot
and ask not, therefore, happiness for alms,
ask not to be spared all suffering,—
and thus our house shall grow as if on granite,
and shall, when our eyes turn to distant goals,
stand about our child with all its stillness.[16]

When our eyes turn to distant goals—he foresaw already the time when Ruth would lose the spot she held so briefly at the center of their shared life. Yet he would go on insisting for years that the house they had so briefly shared still existed, at least in the way that, to him, really mattered: inside them.

Maintaining civility and still hoping for the best, the Modersohns called on the Rilkes and their new daughter shortly before Christmas. This is Hans Wohltmann's version of Otto's account:

The girl announced us, but we were made to wait outside, and we had already grown somewhat impatient. At last we were permitted to enter. There in the room we found Madame Clara sitting ceremoniously on the chair, her little child in her arms—like Mary with the Christ child—and next to her stood Rainer Maria like

old Joseph, leaning on a long staff, and both gazed, silent and exalted, upon their child.[17]

Vogeler, in a series of paintings, had cast Martha Schröder as the Virgin (Rilke had written a poem about his version of the Annunciation), and depicted the Magi in a setting that looked an awful lot like Worpswede—Rilke's version may have been an allusion to Vogeler's. But it cannot be assumed that Paula and Otto would have found the joke funny; they were already sufficiently estranged to be sensitive to any sign that the Rilkes, under Rainer Maria's influence, were taking themselves too seriously.[18]

In early February the underlying tensions between Rilke and the rest of the Family burst to the surface, and it is no surprise that the one who finally gave voice to them was Paula. Again, the structure of the Family broke down at its most problematical point: the emotional interaction between Rilke and Paula, whose valence had changed (as that of strong emotions, balked, will do) from positive to negative, while losing none of its intensity. The occasion was Paula's twenty-sixth birthday, February 8, which Clara forgot—to Paula, an unthinkable and wounding oversight. To make things worse, Rilke himself had written Otto a business letter about his planned monograph on the day itself, writing the date without noticing its significance and sending Paula regards but not birthday greetings.

Clara caught her mistake the next day, and began an apologetic letter recalling their two previous celebrations of the day, in Berlin a year ago and two years ago in Paris. That she was interrupted and had to finish her letter of apology yet another day later made it worse, as did the terms in which she tried to explain and justify her absence from Paula's life: "I am (in this case unfortunately)—so very housebound that it is impossible for me simply to get on my bicycle and pedal away as I used to do."[19] Her need for isolation she explained this way:

I now have everything around me that I used to look for elsewhere, have a house that has to be built—and so I build and build—and the whole world still stands there around me. And it will not let me go. All my building blocks have to remain in the house if the house is to become solid and cannot be carried off hither and thither.

Rilke added a short note with excuses, birthday wishes, and greetings for Otto, as well as a copy of his latest book.

On receipt of Clara's letter, Paula exploded, writing on the same day a furious and eloquent reply: "Isn't love thousandfold? Isn't it like the sun that shines on everything? Must love give *everything* to *one* person and take from the others? Is love permitted to take? Isn't it much too precious, too great, too all-embracing?" "Rilke's voice speaks too strongly and too ardently from your words," she went on to say, and it was true: the passage about the house and the building blocks is pure Rilke.

In the middle of the letter, Paula turned to addressing Rilke directly, in her anger misspelling his name in an evocative way, as "pure" Maria Rilke: "Dear Reiner Maria Rilke, I am setting the hounds on you. I admit it. I believe it is necessary to hound you. And I have every intention of hounding you with my thousand tongues of love, you and that colorful seal of yours with which you stamp more than simply the elegant letters you write." One of Rilke's small vanities was the use of exquisite stationery and various colors of sealing wax. Once, no doubt, it had been one of Rilke's exotic charms, as now it became one more irritating reminder of his alien nature.

Turning back to Clara, Paula wrote, "I believe that I have a faithful heart, a simple German heart. And I also believe that no power in the world gives you permission to trample it." *A simple German heart*—it was something that Paula and Otto could be tempted to think that Rilke would never possess. Near the end of the letter, Paula evokes the once-shared dream of the Family:

> I bless you two people. Cannot life be lived the way the six of us once thought it would? Whenever you are with us, are your souls not also united with us in this greater community? Can we not show the world that six people can love one another? It would be a wretched world, indeed, in which that couldn't happen!

Paula's worst apprehensions were confirmed when the answer, when it came, was in Rilke's hand, not Clara's. He addressed one of the erstwhile sisters of his soul not as "Dear Friend" but as "Dear Frau Modersohn," and he offered not a single word of apology. Paula was wrong. He explained the nature of her error—as later he would do in the Requiem—and what she must do to correct it:

> If your love for Clara Westhoff now wishes to do something, then this is the task and the work of your love: to make up for what it has failed to do. For your love has failed to see where this human being has gone; it has failed to accompany her in her broadest

development; it has failed to spread itself out over the new horizons that encompass this human being. And it has not stopped looking for her where she was at one particular point in her growth. It stubbornly seeks to hold fast to one particular point of beauty that she has gone beyond, instead of waiting patiently and faithfully for the new and beautiful things that the future holds for both of you.[20]

Rilke's one concession to Paula's concerns is his brief explanation and justification of the couple's new distance from their old friends: "We had to burn all the wood on our own hearth just to warm up our house and make it habitable." But soon he returns to his confident didactic tone:

You must constantly experience disappointment if you expect to discover the old relationship unchanged. But why not rejoice in the expectation of the new relationship that shall begin when Clara Westhoff's new solitude will one day open the gates to receive you? I, too, am standing quietly and full of deep trust *outside* the gates of her solitude, because I consider this to be the highest task of the union of two people: that each one should keep watch over the solitude of the other.

This letter is among Rilke's best known, and widely cited for its succinct statement of his view of marriage, which is often seen as attractively idealistic and modern: nonpossessive, respectful of each partner's individuality, clear-sighted about the limits of human sharing. It creates this impression most convincingly when read as an excerpt, removed from context, for in context another, more vulgar human sense of Rilke's "standing guard" over Clara's solitude arises: he was keeping her away from her old friends and relentlessly persuading her that it must be so lest too much contact with them spoil her taste for the sort of solitude that he valued so highly.

But Rilke's ideas about marriage, which may have been influenced not only by the failed marriage of his parents but by Lou's eccentric arrangement, was no mere defensive improvisation in the face of Paula's accusations; we can find it formulated earlier and even more fully in Rilke's August 17, 1901, letter to Emanuel von Bodman, at which time his direct experience of marriage encompassed all of three months, the first of them spent with his new wife in a sanatorium:

A *togetherness* between two people is an impossibility, and where it seems, nevertheless, to exist, it is a narrowing, a reciprocal agreement

which robs either one party or both of his fullest freedom and development. But, once the realization is accepted that even between the *closest* human beings infinite distances continue to exist, a wonderful living side by side can grow up, if they succeed in loving the distance between them which makes it possible for each to see the other whole and against a wide sky![21]

The explosion of her feelings, Rilke's response and Clara's failure to assert herself and reclaim her old friendship left Paula depressed, and at times discouraged about marriage in general. Her journal shows that the feelings were particularly intense during Easter week 1902:

> My experience tells me that marriage does not make one happier. It takes away the illusion that has sustained a deep belief in the possibility of a kindred soul.
>
> In marriage one feels doubly misunderstood. For one's whole life up to one's marriage has been devoted to finding another understanding being. And is it perhaps not better without this illusion, better to be eye to eye with one great and lonely truth?

Niels Lyhne is here, on his deathbed, in his one act of genuine heroism, looking the truth in the eye and making no pleas to God: "It was the dreary truth that a soul is always alone. Every belief in the fusing of soul with soul was a lie. Not your mother who took you on her lap, nor your friend, nor the wife who slept on your heart."[22] And Rilke, too, is here: however much his account of marriage had angered her, one vital part of it ("a *togetherness* between two people is an impossibility") was pressing upon her now, its relation to him no doubt making it a bitter pill.

On March 11, Otto, already having resumed his old mode of denouncing, in the privacy of his journal, virtually everyone else in Worpswede, began to decry the lack of attention Paula and her work were receiving from the others, and soon found himself returning to Rilke's letter:

> She is understood by no one. In Bremen: her mother, aunts, brothers and sisters have a silent understanding: Paula will accomplish nothing. . . . Overbeck and Schröder don't know her. Mackensen and the Rilkes likewise? Their behavior proves it. No one asks about her work; Clara Westhoff has never visited her—she who claimed to be her friend. What arrogance there is in Rilke's words that P. is supposed to wait outside the gates, till his lofty wife and great artist opens them up; that P. has failed to follow her into

higher regions. The fact that *she* is somebody and is accomplishing something, no one thinks about that.

On May 2, Paula was still struggling with Rilke's proposition:

> Rilke once wrote that it is the duty of the husband and wife to keep watch over each other's solitude. But isn't a solitude that someone has to keep watch over merely a superficial solitude? Isn't true solitude completely open and unguarded? And yet no one can get close to it, although it often waits for someone to walk hand in hand with through the valleys and fields. But waiting is perhaps only weakness, and the fact that no one comes makes the lonely person stronger.

She went on with the rueful yet determined recognition that the difficulties of her life's work were only beginning:

> It seems to me terribly difficult to live one's life to its end in a good and great way. Up to now, still the beginning, that was easy. Now it is probably starting to get more difficult, there will be many inner struggles. Anyone can cast one's net—but the point is to make a good catch!

Most often, Paula's understanding of the *way* in which Rilke's and Clara's behavior removed them from the Family is presented in the Worpswede literature as simple fact. About the extent to which Rilke's way of seeing things had been stamped on Clara, disrupting the singularly close friendship between the two women, Paula's description is right on target. But of the physical isolation of the Rilkes from the rest of the Family there is more to be said than Paula understood. The first is that Paula likely underestimated the role played by their financial desperation, their struggles to escape it absorbing vast amounts of their time and energy. She may have underestimated, too, the roles of pregnancy, childbirth, and the care of an infant in sapping Clara's strength, modulating her emotional needs, reordering her priorities. The blowup between them occurred near the end of winter, when the distance between Westerwede and Worpswede, otherwise no more than a good walk, must often have been a more formidable obstacle. When Clara forgot Paula's birthday, Ruth Rilke was less than two months old, perhaps not yet sleeping through the night. Clara's memory lapse was that of a tired and preoccupied young woman, still mastering the skills of mothering—and one she nevertheless caught the next day. Between the

joyous early Christmas of Ruth's birth and the exchange of hurtful letters in early February, more than one misfortune had befallen the Rilkes: the premiere of *Daily Life* had flopped, dragging down with it the planned Hamburg production, and Rilke had learned in January that the stipend from his uncle would be cut off. It was in January, too, that Rilke had written fourteen letters in a day in his desperate search for work both remunerative and acceptable to him.

At the time of the blowup itself, Rilke was in Bremen, busy, in collaboration with Vogeler, with the staging of *Sister Beatrix,* the little scene he had composed for the dedication of the Kunsthalle, and related undertakings like a lecture on Maeterlinck. He was also busy laying the groundwork for the monograph among the painters; his note to Otto on the birthday itself had asked him to confirm his willingness to be included. The day Rilke delivered his Maeterlinck lecture, February 9, was the day Clara began, but was interrupted before she could finish, the apologetic note she finally sent the next day. Paula's angry reply to Clara's note reached him in Bremen, and he answered by return mail with a defense of his understanding of marriage, but it must be noted that in the midst of the perpetual crises preceding any amateur dramatic presentation, he must have done so hurriedly and distractedly. The letter he wrote Clara from Bremen on February 13, the day after he sent Paula the letter that offended her so, is full of details of last-minute changes in casting and other emergencies. Only a small passage indicates that something else was going on. Apparently Otto and Paula had seen, along with others, the previous day's dress rehearsal:

> I asked Heinrich Vogeler what the Modersohns, to whom I haven't spoken, had said about it. Otto Modersohn had been very moved by it. "And—Paula Becker?" I asked. "She said something that I could not quite understand, apparently on the negative side"—said Heinrich Vogeler. So I can imagine.[23]

On February 24, 1902, still not far removed from the turmoil we have been describing, Paula walked to the Worpswede churchyard to lay a wreath at the grave of Otto's first wife, Helene. Her thoughts turned to what her own grave would be like, and she set them down that evening in her journal:

> It must not have a mound. Let it be a rectangular bed with white carnations planted around it. And around that there will be a modest little gravel path also bordered by carnations, and then will come

a wooden trellis, quiet and humble. . . . Perhaps at the head of my grave there should be two little juniper trees, and in the center a black wooden tablet with just my name, no dates, no other words.

But history's final word on this passage of Paula's has been an ironic one, for in the end her grave would be very different and out of keeping with the spirit of these musings.[24]

At this time Paula was well satisfied with what her new life as married woman had done for her art, which had gone on developing rapidly. Her artistic differences with Otto Modersohn had not yet come to seem a threat to her own development. But she was disillusioned, already, by the effect of marriage on human relationships: she missed the old, shared life of the Family and her friendship with the old Clara she had known before intimacy with Rilke had begun to transform her. With her own new intimacy with Otto she was also disappointed, though no one around her knew the depths of her disappointment.

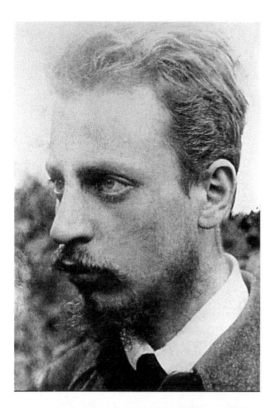

1
Rilke on a visit to
Adiek with Heinrich
Vogeler, September 18,
1900 (Rilke Archive)

———

2
Paula Becker and Clara
Westhoff in Paula's
studio, ca. 1900 (Paula
Modersohn-Becker
Stiftung, Bremen)

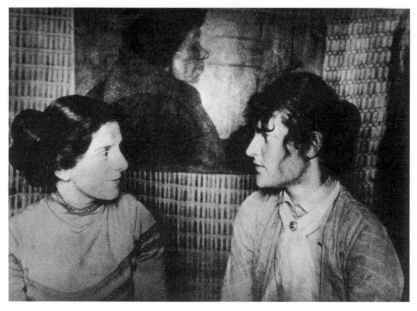

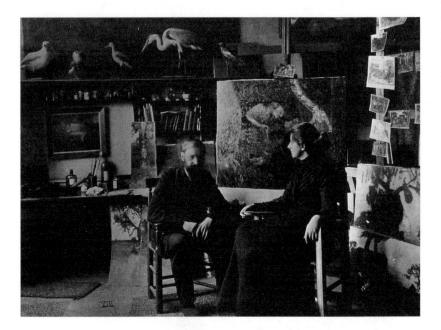

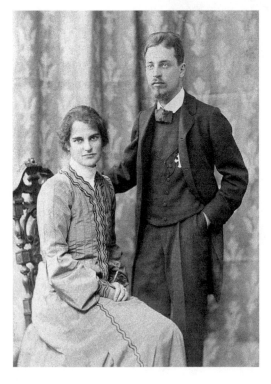

3
Paula Becker and Otto
Modersohn in Otto's
studio, 1900 (Paula
Modersohn-Becker
Stiftung, Bremen)

———

4
Rilke and Clara Rilke-
Westhoff in Rome,
December 1903
(Rilke Archive)

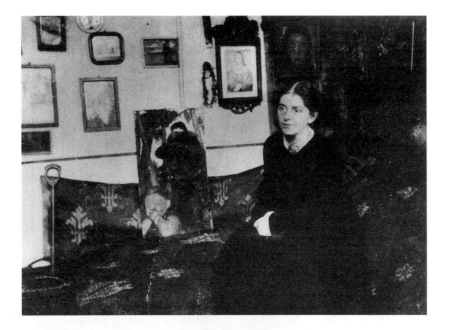

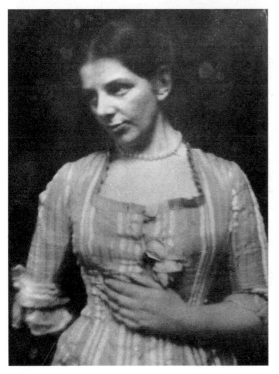

5
Paula Modersohn-
Becker in her studio,
1905, with heraldic
lilies visible in
background (Paula
Modersohn-Becker
Stiftung, Bremen)

6
Paula Modersohn-
Becker, 1905 (Paula
Modersohn-Becker
Stiftung, Bremen)

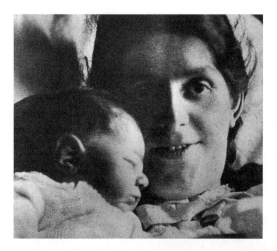

7
Paula Modersohn-
Becker with daughter
Mathilde, November
1907 (Paula
Modersohn-Becker
Stiftung, Bremen)

8
Heinrich Vogeler,
Summer Evening at the
Barkenhoff (The Concert),
1905 (Worpsweder
Museum; © 1998 Artists
Rights Society [ARS]
New York/VG Bild-
Kunst, Bonn; photo-
graph © Artothek
Peissenberg)

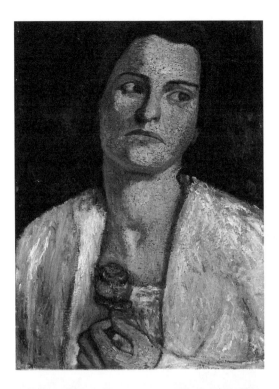

9
*Portrait of Clara Rilke-
Westhoff, 1905* (Ham-
burger Kunsthalle;
photograph © Elke
Walford, Hamburg)

10
*Self-Portrait with Red
Rose, 1905* (Private
collection, Hamburg;
photograph © Paula
Modersohn-Becker
Stiftung, Bremen)

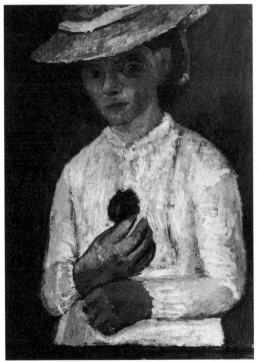

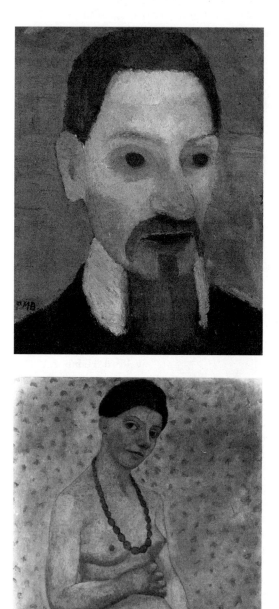

11
Portrait of Rainer Maria Rilke, 1906 (Private collection; courtesy of Dr. Gisela Götte, Clemens-Sels Museum, Neuss)

12
Self-Portrait on Her Sixth Anniversary, 1906 (Roselius Sammlung, Bremen)

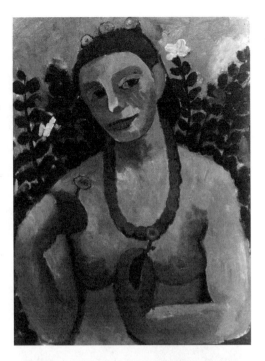

13
*Self-Portrait as Half-Nude
with Amber Necklace, 1906*
(Private collection)

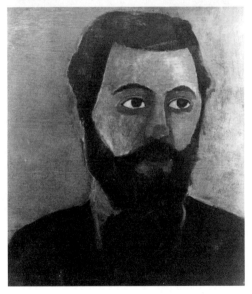

14
*Portrait of Werner Sombart,
1906* (Kunsthalle,
Bremen; photograph ©
Paula Modersohn-Becker
Stiftung, Bremen)

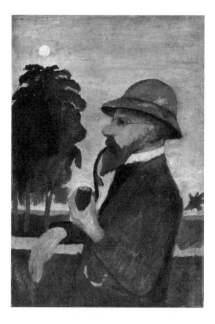

15
Otto Modersohn with Pipe, 1906–7
(Kunsthalle, Bremen; photograph
© Paula Modersohn-Becker
Stiftung, Bremen)

16
*Self-Portrait with Two Flowers in
Her Raised Hand, 1907* (Private
collection, Zurich; photograph
© Paula Modersohn-Becker
Stiftung, Bremen)

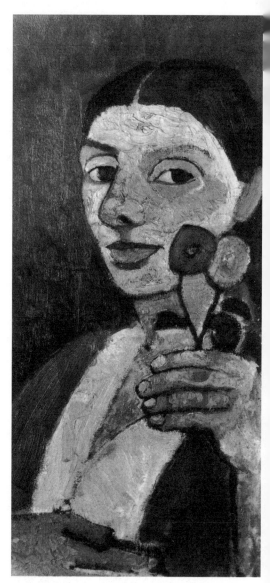

Eight

By January 1902, just weeks after Ruth Rilke's birth and in the
midst of his most frantic moneymaking efforts, Rilke's letters begin to
mention the possibility of breaking up the household in Westerwede.
The commission to write a monograph on the Worpswede painters was
the central stroke of good luck, among many strokes of bad, that kept the
family together in their cottage through the summer. But what drove
Rilke at this point, as he undertook a project about which he was
ambivalent at best, was not the hope of saving the one common home
that he, Clara, and Ruth would ever share, but that of opening the way
to a future that might lie for him—and perhaps for Clara, if not Ruth—
in Paris. If writing about art was to bring him his livelihood, then any
other city than the birthplace of the modern in art—and Rodin's city—
was out of the question. Even before his first abrupt departure from
Worpswede, in the fall of 1900, he had named Paris and Rodin, to him
virtually a single destination, as the next shrine on his pilgrimage.

But first he had to write the monograph. As soon as he knew, in
January 1902, that the commission was a real prospect, he began the
work of getting the painters' consent. In a letter to Carl Vinnen, whom
he hoped at first to include, he emphasized his intent to portray not a
school of painters but six individuals with only the place in common.[1]
It was the right thing to say to the painters in their mutual estrange-
ment, but Vinnen declined involvement, and others resisted. Otto
Modersohn, with his prickly conscience, took the most persuading and
was the last to sign on, and then only after Vogeler and Pauli intervened.

Faithful to his convictions, shaped first by *Niels Lyhne,* about the centrality of childhood to the artist, Rilke wrote to each painter asking for childhood stories, "a few memories out of the milieu in which you grew up, the traces of a few important early impressions."[2] It was the response of each painter to this inquiry that Rilke drew on and, with his enormous capacity for empathy, elaborated into myth. Even with such help, though, the writing of the monograph would not be easy; if he had not known that he would be leaving Worpswede before its publication, it might have been impossible.

Rilke began the writing itself on May 1, 1902. To Arthur Holitscher he wrote that day of his intent essentially to lock himself in his study until it was done, and added, "And because it is only half joy, and half forced labor, it is urgently necessary that I get it over with soon."[3] If he did so, he could still offer sincere praise at least to Modersohn and Vogeler; with the others he would perform a masterful dance of dissembling and skirt vital issues.

To set the tone he made his most inspired use of a favorite quote from *Niels Lyhne* (to which we have already seen him allude in a vital letter to Paula) in this brief passage he placed at the beginning of the book:

This book avoids making judgments. The five painters with which it concerns itself are in the process of becoming. What has guided me in the examination of each one is, in Jacobsen's words, this: "Don't think of who is right or how great the wrong is, and don't treat him according to his deserts—how would even the best if us fare if we got our deserts! No, think of him as he was in the hour when you loved him most; believe me, he is worthy of it."[4]

In truth, the book avoids making judgments in the attempt to avoid insincerity, for in his steep ascent toward immortality Rilke was leaving the Worpswede painters behind, and they were shrinking toward insignificance in his eyes. While he had a great gift for flattery that extended as far as letters and occasional poems, on the formal occasion of a book, even one he regarded as a burdensome obligation, he could not quite bring himself to lie.

As one reads the monograph today, knowing that he got it done, under great pressure, in a month in which he rarely left his room, even taking meals at his desk, it strikes one first as a masterful solution of a ticklish literary problem, full of flashes of insight, brilliant evasions, and changings of the subject, and occasionally—he could not help himself— a cut so fine that the painter (especially Mackensen) who suffered it

might well not be aware of how gravely he had been wounded. Whenever he needed to change the subject, Rilke relied on Jacobsen. He did believe in Jacobsen's contribution to the sense of the modern in art, but when one notes that in addition to the book's epigraph Jacobsen is invoked in all six sections (the introduction and the chapter on each painter), it becomes clear that Rilke uses him as a kind of conversation piece, something to turn to whenever his inspired monograph-mono-logue is flagging.

Rilke's introduction represents itself as a history of landscape paint-ing, which he defines as the story of man's engagement with nature, the not-human, the other. It is equally the story of the growth of the poet's mind, brilliantly disguised as art history. In this aside he contrasts, to the indifference toward nature of the typical human being in society, the engagement with her of children—of just the sort of child, in fact, that he himself had been:

Children see nature differently; lonely children especially, who grow up among adults, join her with a kind of like-mindedness and live in her as small animals do—given over completely to the events of the forest and the sky—and in an innocent apparent harmony with them. But for this reason there comes later to young boys and young girls that time, trembling with deep melancholy, when, precisely in the days of their physical ripening, unspeakably abandoned, they feel that the things and events of nature no longer concern themselves with them, and human beings still do not yet do so. Spring comes, although they are sad, roses bloom and the nights are full of nightin-gales, although they would like to die, and when at last they come again to a smile, the days of autumn have arrived.[5]

Most, finally, find their way forward to human society—and the ones who do not, who instead are determined to find their way back to that lost childhood connection to nature, are artists. That landscape painting addresses nature most directly allows Rilke to call it the most vital paint-ing of the day, and to make in passing the fascinating suggestion that to paint a portrait is to treat a face as a landscape—that the appeal of Rembrandt's portraits is that they treat faces as landscapes. (This is an assertion worth recalling when, in the Requiem, Rilke describes Paula as having portrayed her body as fruit in a still life.) The beauty of nature was its "sublime indifference," and so was, or ought to be, the essence of beauty in art: impenetrable, irreducibly mysterious. Near the end of his introduction he encapsulates his thought on art and artists: "The role of

the artist is to—love the mystery. That is what all art is: love, that has poured itself over mysteries—and that is what all works of art are, mysteries, surrounded, adorned, engulfed by love."[6]

Rilke praised Otto almost without reservation. He was a poet, the one to whom the distinctive Worpswede landscape revealed, through his conscientious study, the never-before-spoken language in which Otto could express, as the artist must, himself. He praised Otto's "compositions," the dark little drawings, more suggestive than representational, that he made at night by lamplight: the subjective and visionary complement to his studious sketching from nature. As he had earlier in his journal, he held out the prospect that a perfect fusion of the two would produce great work.

In response to Rilke's questions about influences, Otto had given him Julius Langbehn's *Rembrandt as Educator,* a work of sometimes ominously fanatical German—and specifically northern and Protestant German—nationalism that had influenced all the young Worpsweders, including Paula Becker. In praising Otto's color sense as his greatest gift, he invoked one of Langbehn's most memorable passages to express it: "For [Modersohn] too, a hen, a herring, an apple have more coloristic interest than a parrot, a goldfish, an orange."[7] He ends his treatment of Otto on this note:

> He does not want to paint the southern, which has its color always on its lips, and boasts of it. Things that are *internally* full of color, what in his own unsurpassable phrase he calls "the north's hidden reverence for color," these he considers it his mission to paint. . . . He is a still, profound human being, who has his own tales to tell, his own, German, northern world.[8]

To incorporate Vogeler, in whose work landscapes played only a minor role, into the monograph, Rilke elaborated on an ingenious conceit he had developed in an article on Vogeler written not long before: Vogeler's work was given its tone not by nature but by the encapsulated, artificial world of the Barkenhoff gardens.[9] The increasing density of line in Vogeler's decorative work is attributed to the increasing density of the branches of the birch trees that separated the Barkenhoff from the highway below.

In a brief pendant to his Vogeler chapter, rounding the book toward its close, Rilke invokes the spring storms going on about him as he writes, the still pauses between them, the hours passing. This is his final paragraph: "There is so much that has not yet been painted, perhaps everything. And the landscape lies there unexhausted, as on the first

132

day. Lies there, as if it were waiting for someone who is greater, mightier, lonelier. For someone whose time has not yet come."[10] To the Worpsweders it must have seemed that Rilke had been unable to bring himself to close with praise of their accomplishments. *He* was outgrowing them; landscape art must outgrow them, too. To the extent that the monograph is the disguised story of his own artistic growth, the artist he prophesied, next to whom the Worpsweders would be as nothing, was the artist that he himself would become.

On finishing his task, Rilke wrote again to Arthur Holitscher. He had one positive thing to say: "It was a work that offered the opportunity to say something about [artistic] creation, and that is what, in the writing, endeared it to me."[11] He acknowledged that the book was unlikely to please the public, and that the publishers had been taken aback by what he had produced, but could do nothing but force a smile and make the best of it. At his opening quote from Jacobsen they had shaken their heads so hard, he wrote, that it caused an almost visible disturbance in the play of light and shadow on their letter paper.

Rilke's least guarded acknowledgment of how limited was his commitment to the monograph came after its publication, in a letter of August 1, 1903, to Lou Andreas-Salomé, with whom he had by then resumed contact:

> In the material itself there was too much that was disagreeable, and too many limitations; the painters with which it had to deal are, as artists, one-sided, and as human beings small and inclined toward irrelevancies. To judge them seemed to me unworthy, and when I tried to love them, they ran through my fingers, leaving only the land and the greatness which proceeds from it.[12]

Rilke's monograph is the locus, too, of one of the basic conundrums of Worpswede studies: Why didn't he mention Paula, seen by modern sensibilities to be the greatest of the artists there? Often the omission is held against him, or cited as an instance of the inability of male critics to perceive the accomplishments of female artists. But Paula was twenty-six, an age at which recognition in a monograph would have been more surprising than its absence. Rilke had not yet *seen* very much of her work, a fact for which we have already seen him apologize. At the moment of writing the monograph, his relations to Paula were utterly strained. The monograph was commissioned work, undertaken in dire need, for money; Pauli's intercession, leading to the awarding of a commission he had once sought himself to a young poet with no formal

training in art history, had been an act of enlightened charity. In the public mind (hence the mind of Rilke's publisher, whose forbearance he had already taxed), the Worpswede painters were a fixed quantity: the ones who had scored the great triumph in Munich in 1895. There is no reason why it would have occurred to Rilke to include the students they had taken on since they had grown famous. They themselves, whose egos he had had to massage to smooth the way for the undertaking, might have taken it as an affront.

By writing the monograph Rilke had finished with Worpswede—and burned his bridges. As it had to be, his relation to the place was unsentimental. He had grown all he could—a great deal—there, but now Paris beckoned. So, too, did Rodin, to whom none of the artists in Worpswede could begin to compare. Personal connections would bring Rilke back to the village often enough in the next few years, but intellectually and artistically he had no further use for it, and from such a judgment there was in Rilke's case no appeal.

A brief visit the Rilkes had made in 1901 to Prince Emil von Schönaich-Carolath, a poet from whom he'd once solicited work for his old publication *Wild Chicory,* at his Haseldorf castle in Holstein, had led to an invitation to Rilke to spend the summer of 1902 there. He accepted, and on May 30, the day after sending the final draft of the monograph to his publisher, he set out for the castle, where he would stay until mid-July. He spent much of the time looking through the archives for material he could use in his work—some of it ended up in *The Notebooks of Malte Laurids Brigge*—while Clara and Ruth went to Amsterdam for a time for rest and recovery. It was the first of Rilke's many stays in great aristocratic residences, and the first of his and Clara's lengthy separations.

From Haseldorf on June 25, 1902, Rilke wrote a remarkable letter to Frau Julie Weinmann, whom he had met in Munich, asking her, after a lengthy account of his tribulations, to support him for a year while he worked in Paris. By way of introducing Clara, he returned to the theme of women, childbearing, and art, espousing for the benefit of this potential patroness a wholly different view from those he had expressed in the past and those he would later bring to bear on Paula's case:

> I am filled with the conviction that the woman-and-artist who has had a child, and cares for and loves it, is capable like the mature man of reaching every artistic height that the man—making the same assumption, i.e. that he is an artist—can reach. In a word, I consider the woman in whom deep artistic striving dwells, from

the moment of her maturity and fulfillment [in childbirth], equal to the male artist.[13]

Perhaps, having brought Clara to just this pass, he truly believed for a time that childbearing was an enabling experience for the woman artist, rather than the source of an insoluble conflict; we must not forget to ask ourselves what the artist who had borne his own child must have thought of the very different thoughts that he expressed in Paula's case. In cultivating a patroness, though, which he saw as one of the valid demands of his calling, his job was to please, and it seems more likely that he simply struck the posture that he hoped would show him in the best light.

Rilke's service to the art historian Muther had been rewarded with a commission for a short book on Rodin in a series Muther edited. From Haseldorf, Rilke wrote on June 28, in stiff French that he had augmented at the Berlitz School in Bremen, his first letter to Rodin. He invoked the name of Clara, Rodin's former student, and even urged Rodin to send her some small response to the pictures of recent work that she had sent him a few months earlier: "a single word from you, your advice, dear master, which is so important and will decide her future, and without which she gropes her way forward like a blind person."[14]

Rodin responded with encouragement, and from Westerwede on August 1 Rilke enlisted him far more directly in the campaign he now undertook to convince Clara that for her, too, Paris was the proper destination:

> She is thinking of settling in Paris, in the fall, for several years. But she dares not take this step (through which she would be required to make many sacrifices) without asking in advance whether you are in agreement with it! The words that you wrote me about her work, these words of serious and justified encouragement, give her hope that in Paris, through intensive work, she might come so far as to be worthy of becoming your student, and she yearns for this with all her powers.[15]

This is the first occasion on which we see Rilke attributing solely to Clara decisions that would take her out of Ruth's presence; she would be left with Clara's parents in Oberneuland. From the first, though, despite her own intense commitment to her work, Clara made such decisions with a heavy heart, and under heavy pressure from her husband.

In the same letter Rilke acknowledged to Rodin that he was coming to him not only in order to write the book, but as a poet seeking a

master. He spoke of his discovery of Jacobsen, his old hope of seeking him out, his desolation upon learning that he was dead. By the third letter, written September 11 after his first meetings with Rodin—lacking confidence in his spoken French, he wrote letters even though he saw his new master daily—he had composed for Rodin's benefit a poem in French. He was determined to show him that he was a fellow artist, and an estimable one.

By this time, with Rodin in his sixties, Rodin's country home at Meudon was the destination of many a seeker's pilgrimage. But Rilke would in the end be among the few who mattered most to Rodin. This is Ruth Butler's account:

> Among all the people who showed up in Meudon, however, two Germans counted the most. Helene von Hindenburg [known to readers of Rilke's correspondence by her married name, Helene von Nostitz] was Rodin's perfect soulmate, while Rainer Maria Rilke became his greatest disciple and, in a sense, a son—a successful son. These two encounters were rich and fulfilling for Rodin. They took place because of the energy and attention of two curious and imaginative young foreigners. *They* chose him. This is not surprising. What is surprising is that he was waiting to be chosen.[16]

In Rilke's case it was in many ways an ideal match; Butler details their common traits:

> Neither could stabilize a domestic life (Rilke's infant daughter, Ruth, was already farmed out to relatives, just as [Rodin's son] Auguste Beuret had been). Both were enormously active socially, but felt ill at ease with people most of the time. Though not conventionally religious, both were haunted by religious ideas and felt a link between religious exaltation, artistic creativity, and sensuality. They were both very dependent on women. And their common love of travel and new experience was part of an incessant search for some never-to-be-achieved possibility of "home."[17]

Rodin would never formally recognize the son borne him by Rose Beuret, and beyond sending money occasionally and encouraging his artistic attempts, took no responsibilty for his upbringing. His duty was to his work; this was a part of the master's wisdom that Rilke received with particular eagerness.

Rilke left for Paris at the end of August. His second departure from Worpswede, though less abrupt than his first, was also accomplished

without any leave-taking. Clara, after leaving Ruth with her parents, remained in Westerwede through the end of September to do the heartbreaking work of breaking up the household. The Rilkes kept only their most prized possessions, some of which went to Clara's parents' home in Oberneuland, most to the Barkenhoff. The rest was sold at auction. Though Clara's attempts to secure public stipends to support her work in Paris failed, a small private stipend did come through to make it possible to join her husband there.

On August 31 Rilke wrote Clara a letter from Paris designed to discourage her from bringing Ruth along:

I would not like knowing that Ruth was in Paris: the air is thick, and when one has been outside for half an hour one's nostrils are black. . . . And also it's very expensive. I live so cheaply, and yet have to economize so severely. Food, however modest, costs so much. For noon and evening meals, with coffee, one could easily spend ten francs a day, even on the most modest fare.[18]

Though the earliest published versions obscure the fact by omitting the italicized passage below, Rilke's most famous citation of the cardinal rule he ascribed to Rodin was made in direct connection to the question of where Ruth belonged: "*Then I spoke of you, of Ruth, how sad it was that you must leave her,*—he was silent a while and then said, he said it with a wonderful seriousness: Oui, il faut travailler, rien que travailler. Et il faut avoir patience."[19] This letter, widely cited as central to Rilke's thought, goes on as follows, driving home Rodin's lesson, whether its connection to the couple's current situation was really Rodin's, or Rilke had merely made it seem so:

Tolstoy's unedifying household, the discomfort in Rodin's rooms, it all points to the same thing: that one must choose, either this or that. Either happiness or art. One must find happiness in one's art . . . and so, approximately, said Rodin as well. . . . The great men all let their lives become overgrown like an old path and brought everything into their art. Their life is atrophied like an organ that they no longer need.

Richard Pettit points out how specifically this new perception of Rilke's was directed against Vogeler's hope of fusing, in Worpswede, one's artistic work with a life of grace and love.[20] This hope was one to which Paula, as well, had a deep commitment; Rilke, who had embraced it for a time in Westerwede, now left it behind for good. His new conception

would be the culminating point of his admonition to Paula in the Requiem: "For somewhere an old enmity exists / between our life and that great work we do."

Rilke wrote this to a new correspondent, Swedish feminist writer Ellen Key, from Paris on September 6:

> Naturally [Clara] wanted to bring our dear Ruth along; the thought of a separation never occurred to her. But gradually, after quiet reflection, one impossibility after another presented itself. We had, already, many small worries and fears, and now came this great worry as well. My wife will have to live in Paris on very little money. . . . She will be able to rent only a small studio, and what would that be like for the child?[21]

Not only quiet reflection but a good deal of persuasion had determined the outcome—and the letter indicates that Clara still hoped to send for Ruth sometime later. Reading it we recall how Rilke had spoken for Clara in the letter that so enraged Paula; for as long as they went on living with or near each other from time to time, Rilke would represent the decision at other times to choose separation—from her husband, or Ruth, or both—as Clara's own, made by the merciless criterion he had developed through Rodin. It is clear every so often from the lengths that Rilke is forced to go, in his letters to Clara, to justify such decisions, that she raised sustained and strenuous objections.

Rilke's letter to Vogeler from Paris on September 17, thanking him and Martha for their help, speaks of the move to Paris as a desperate response to failure: "You know what has befallen us. You see how everything that we tried has failed."[22] A tone of justification is evident—Vogeler, surely, would have wanted Rilke to stay in Worpswede, as he himself intended to do—and is amplified when Rilke, knowing that Clara is now shouldering the far heavier burden, begs their two friends to help her:

> Please, please, both of you, counsel Clara Westhoff, and help her with your existence and your loyalty in the days when she begins to live, without our dear Ruth, in the shattered house. . . . Distance takes away none of the burden of these days,—I hear everything, suffer everything, and hope for almost nothing.

Rilke's state of mind in his first days in Paris was split. Having met Rodin and found him as awe inspiring as he had expected to, he was full of high hopes by then for his future under Rodin's star. His expressions

of regret at leaving Westerwede were not wholly false, but were reserved for those in Worpswede to whom the departure needed to be justified. These included Paula and Otto as well as the Vogelers; on September 15 Otto had recorded in his journal an encounter with Clara on the street in those dismal days:

> How gloomy—like a bad book—was the effect of her story on me and on Paula. . . . He's in Paris, with Rodin; she'll be going in two weeks, if she has the money. They've taken the child to her parents. The future totally uncertain. . . . How appalling: first marry and have a child, and then think about how to earn a living.[23]

Otto could scarcely have helped recalling the years in which he had deferred his first marriage until he had assured himself of an adequate income: years he knew might otherwise have been the happiest in that doomed union.

On September 29 Rilke wrote to Clara, still reassuring her just a few days before she was to leave for Paris, "Westerwede was fulfilled, Westerwede had its time, its great happiness, its great fear. . . . We have lived a great overture, the overture to a life. We will never forget it."[24]

There was more to Rilke's letters to Clara than repeated insistence on the rightness of the course he had chosen for them. The earliest convey first impressions of the city, many of them negative—he seemed to see hospitals everywhere—or give Clara quick tours of the city's art museums. But once he met Rodin in person, the letters became lengthy paeans to the new master's greatness in which, with his astonishing economy of means, Rilke redefined his relation to Clara, invoking Rodin's authority, and at the same time tried out on her his ideas about Rodin for the monograph he was preparing to write. Though Rilke was already a prolific correspondent, it may have been in these letters to Clara from their first separation that letters became, for him, *the* vital means of formulating notions that would later appear in published work—as the journal, originally addressed to Lou, had been in Italy, in Worpswede, and for a time in Berlin. Clara's own intense engagement with sculpture and with Rodin made hers an ideal ear for what he was learning to say about his new master. But an inescapable implication of an arrangement that placed Clara in the role of receiver of letters about art is that it required separation. And if Rilke's work seemed to him to require it, then separation there would be.

If regret at leaving Westerwede was played up in letters to certain correspondents, the anxiety, verging at times on terror, that the streets of

Paris produced in Rilke was played down in letters to Clara, who need-ed reassurance, and expressed chiefly in the letters he would write to Lou Andreas-Salomé after resuming contact with her—and fleeing the city—the following summer. Even later, they would be given their most vivid expression in *The Notebooks of Malte Laurids Brigge.*

That when Clara finally arived in Paris at the beginning of October the two took separate quarters under the same roof rather than, as later they often would when living in the same city, separate lodgings altogether, may have been the largest concession Rilke was capable of making to feelings in Clara for which, in the letter to Vogeler, he had professed such empathy. Clara, too, now set about, more grimly than eagerly, living her new life under the motto *toujours travailler.* She had her own studio at another address, and through Rilke regular critique of her work by Rodin was arranged. Every day of the week but Saturday, on which at times she brought new work to Rodin (who received many others as well—it was the day on which his studio was open to visitors) and Sunday, which the couple spent together, reading Jacobsen, visiting art museums or the Bibliothèque Nationale, Clara spent in her studio, sketching, modeling in clay, and after a time executing commissions for portraits of Polish painter Maria Czaikowska and of the daughter of Norwegian poet Bjørnstjerne Bjørnson. Much of her work from the time reflects Rodin's influence in that it consists of fragments rather than complete figures: a girl's thumb, a male torso.

Renewed access to Rodin was the chief reward for Clara of the move to Paris, and despite her sorrows it was a genuine reward. In her lecture on Rodin she spoke in later years of what it was like to leave Paris prop-er and go to Rodin in Meudon:

> I can still call up the feeling of being set free, of being surrounded by everything that did one good. The beautiful figures and frag-ments stood next to one in the grass or against the sky, the lawn invited one as if to children's games, and in the middle of a little depression an antique torso stood in the sun.[25]

The account Rilke gave Ellen Key in January 1903 of the beneficial effects on Clara of her regime of constant work is undoubtedly sincere, though at the same time dictated by his need to have it so:

> for several months now she's had a studio, in which she spends every evening until twilight, always at her work, which slowly grows, and from which is returned to her, as peace, everything

that she puts into it as fearfulness and as burden. . . . The nearness of Rodin, which does not confuse her, gives to her effort and becoming and growth a certain security and peace—and it proves to be good for her to be in Paris.[26]

He goes on to characterize the letters Clara received from her parents about little Ruth as the holidays punctuating Clara's many uniform workdays, but it is unlikely that Clara was able, as he was, to subsist on a diet of such letters. Still, she accepted this life and, when necessary, defended it—in a birthday letter to Paula, for example, just before Paula, too, set out again for Paris.

In mid-November Rilke began to write his Rodin monograph, and by mid-December, despite the recurrent bouts of influenza that lasted through the winter, he had finished. The monograph would appear—dedicated to "a young sculptress" not identified as Clara—at the end of the following March, by which time he had already fled to Italy in the hopes of regaining his health.

Rilke's little book on Rodin was an enormous step upward from the Worpswede monograph. Unlike the Worpsweders, Rodin was a truly monumental figure, about whom Rilke had, simply, no reservations; near the end of the book he would write *Er kann nicht mehr irren,* "he can no longer make mistakes."[27] Here was a new master, one from whom he could go on learning to *see* as he no longer could in Worpswede. Rodin would take his place alongside Jacobsen, and had the further advantage of being alive and accessible. Rilke's submission to Rodin's example, as he understood it, was complete. It was, like his earlier conceptions, a kind of myth, but Rodin's presence offered a solidity and substance so enormous that it would not, like that of the Worpsweders, run through his hands when he tried to love it. It became a permanent part of Rilke's sense of himself and his own art, expressed memorably in the book's final paragraph:

One day the source of this great artist's greatness will be recognized: that he was a worker who desired nothing else but to enter, with all his powers, into the hard and lowly existence of his tools. Therein lay a kind of renunciation of Life, but it was precisely through such patience that he won Life, for to his tools came: the world.[28]

As in his history of landscape painting, Rilke was writing here not only about his ostensible subject; he was writing, too, about the growth of the artist's—his own—mind. This time, though, it was a history of the

growth yet to come. He was determined to make it so and, to an astonishing degree, he did.

It is important to recognize, though, that he had given his total commitment to a mode of working that was utterly unsuited to him. He remained for his whole career an artist whose greatest work appeared in sudden fits of prodigious production, separated by long, agonizing droughts. He would despair for some six years over his inability to finish *The Notebooks of Malte Laurids Brigge,* for ten over the *Duino Elegies.* Though at times he exaggerated the severity of these droughts, it remains true that, when seen as practical advice rather than great guiding myth, the conception of the artist as humble daily worker was one by which he was never able to measure up.

Rilke's conception of a Rodin who had attained utter mastery and went on producing at his highest level even in his later years is far from universally held. In his sixties, Rodin had completed nearly all of the monumental works for which he is remembered, and increasingly spent his time on lucrative portraits of the wealthy or famous, and on the ever-multiplying duties of a public figure. But to Rilke he remained what he had to be: the impeccable master. The pupil was ready, and so the teacher must appear, even if the pupil must, in part, create him.

Nine

When Paula and Otto met Clara on the street in Worpswede in those sad days when she was, with no help from her husband, disposing of the couple's possessions, both must have felt that they were fortunate to have a very different marriage with much better prospects. The most consistent note at the beginning of their marriage was joyful common pursuit of the art they shared. But below the surface, Paula was not free of conflict. She had already lost some of her illusions about the degree of closeness marriage made possible: she missed her lost intimacy with Clara, and her new and flawed intimacy with Otto did not compensate. Like many a bride, she had been lonelier and less fulfilled than she had hoped. On April 2, 1902, she looked back fondly on own her days in Paris:

> I believe that what makes me happy is the anticipation that my wishes will be fulfilled. Once I have what I want in hand, it has already lost its excitement for me. . . . It's like being a child who wishes to be big and grown up. By the time it has grown up, the fact of adulthood has long since lost its excitement. That is why my stay in Paris was such a happy one. I had such strong hopes.

Paula still felt some quickening within her at the thought of Paris, and in February 1903, after a visit with Otto's parents in Münster to celebrate her birthday and his mother's, she would leave again, alone, for the city she would come to call "my city." In the intervening months the hope for her art that only Paris could offer had risen to the surface and been negotiated, not without difficulty, with her husband.

Otto had rejoiced, after his heartrending first marriage, at finding Paula; his reserve of goodwill toward her was deep. She and the shared life of the Family had renewed his love for Worpswede; it was there that, for him, hope now resided. He had been to Paris in *his* youth; the few days he had spent there later, having allowed himself to be drawn there in mute collaboration with Paula, had been tarnished by guilt at his own rising joy in her presence, and then shattered by a telegram. Though Paula would want to share Paris with him again, it is hardly surprising that he resisted. The reasons he gave, though different from these, were real: he believed in keeping his distance from the cosmopolitan center; he was absorbed in the directions in which his art was already developing and prepared to believe again and again that he was on the verge of a definitive breakthrough; sensibly, for an artist, he was always trying new materials and techniques he did not want to be torn away from.

At first, as we have seen, Paula had been awed and overjoyed at the chance to work alongside Otto, whose work she had admired from the start. But the artistic intimacy they did achieve gave her the confidence to turn the restless critical sense she applied to her own work on Otto's as well, and what is remarkable, at first, is how willing he was to accept her criticism. He saw the merits of her work as well and was, by far, the earliest to do so. He felt that they could go on evolving together, as in this journal entry of June 15, 1902:

> Last evening P. really surprised me by a sketch from the poorhouse with old Three-Legs, goat, chickens—simply wonderful in its color, very remarkable in its composition, and with its surface worked over with the end of her brush, made all swirly. . . . She has wit, spirit, fantasy; she has a splendid sense of color and form. When she has progressed to an intimate treatment [of subject matter], then she will be a superb painter. I am full of hope. At the same time that I am able to give her something of this intimacy, she gives me something of her greatness, her freedom, her lapidary quality. I always overdo things and so I can easily become small and fussy and I hate that; I want greatness.

The last sentence is typical: Otto often drew, ungrudgingly at first, not only inspiration from Paula's work, but critical insights from comparisons of his work to hers. We have met before Otto's practice of ticking off his fellow Worpsweders one by one, dismissing the work of each in turn; now he placed Paula, too, above all of them: "She has something completely rare—she is more artistic inside than F.M. or H.V. or F.O.,

not to speak of C.V. and HaE. None of them knows her, none of them values her—that will change."

Less than two weeks later, though, in a funk, he registered bitter protest, significantly linking Paula with the Rilkes, of whom in his worst moments he had come to disapprove utterly:

> Egotism, lack of consideration is the modern sickness. Nietzsche, the father. . . . That's the way Rilke and his wife are. Related to that is superficiality, which characterizes HV and his wife. . . . Unfortunately, Paula too is very much infected by these modern notions. She is also quite accomplished in the realm of egotism. Whoever is not deep enough or fine enough in her estimation is pushed aside gruffly and ruthlessly. . . . I, too, have already and frequently been the object of this gruff egotism.

He brought conventional notions about women as artists into what became a tirade:

> I wonder whether all gifted women are like that? In art, Paula is certainly gifted; I am astonished at her progress. But if only this were joined by more humane virtues. It must be the most difficult thing for a woman to be highly developed spiritually and to be intelligent, and still be completely feminine. These modern women cannot really love; or they grab hold of love only from the animalistic side of their nature, and the psyche has no part in it. . . . They think that egotism, independence, conceit are the best things there are; and no happy marriage can come from that.

It must be remembered, though, that this *is* a tirade, and that Otto's journals were a safety valve. They suggest a privately resentful and irascible man, often the captive of his emotions, who by venting them in his journals was able to present to others the serene and mild-mannered persona perceived by Vogeler, Rilke, and often Paula herself. When Otto is not forced into the much too narrow role of the villain in Paula's life story, this may be seen as an act of self-transcendence, a kind of—at least intermittent—ethical triumph. Even in the journal itself, the tirades are intermingled with touching expressions of loyalty to Paula, and unresentful acknowledgment that her work is at least on a par with his own. At times, at least, he is good-natured about his own awareness that she may well outstrip him.

The fragmentary sources we have reveal the outlines of what seems to have been a typical progression of events in the couple's shared artistic

life in the early days of July 1902—little more than a week, that is, after the tirade we have just quoted. We know that in this time—an entry in Paula's journal from the day before the tirade details it—the two spent day after day painting side by side the same motifs. Alone in her studio at the Brünjes's on Sunday morning, July 6, Paula sat down to write her mother of how, though at times her creative impulse lay dormant, at other times, "suddenly those feelings are wide awake in me again, and storm and surge so that the vessel seems about to explode, as if there were nothing else inside." She goes on to express confidence that in the end she was going to amount to something as an artist, and regret that her father had not lived to see it. These feelings were called up by her satisfaction with one of her most straightforwardly appealing and lyrical early paintings: Elsbeth Modersohn in the Brünjes's apple orchard, with chickens and a single tall, red-blossomed foxglove, the whole held gorgeously together by its blues and reds, including the unexpected blue of the foxglove's stem and leaves. She wrote with quiet pride to her mother: "It's not earthshaking, of course. But in painting it, my power to shape and form and express things has grown. I have a clear feeling that many other good things are going to come after this piece of work, and that is something I didn't know last winter." In her happiness, Paula saw Otto at his best: "My dear Otto stands next to me, shakes his head, and says that I'm one devil of a girl, and then we hug each other and we speak about the other's work, and then we talk about our own again."

The next day, in his journal, Otto struck just the note that Paula had described:

My Paula is such a fine wench. An artist through and through. Her sense of color—no one else here has anything like it; I can't keep up with her now. I am simply bowled over by it. . . . It is tremendously good for me. "This little wench should paint better than you? The devil, you say!"

The next day he recorded one of his periodic revelations, crediting it to Paula and referring back to a recent period of anger stirred up by one of Paula's new paintings—probably the very fit of anger that had unleashed his tirade little more than a week earlier: "After my recent upset over Paula's painting with the glass globes, I have finally, finally completely awakened from my seven years' sleep. . . . I owe that to Paula, this bedevilled wench." The next day's entry records the nature of this revelation: "In short, this is what painting is: seeing, feeling, doing. . . . Ever since my feelings have changed (since Paula's pictures) I have

sensed everywhere harmony, resonance, nothing separate—everything bound together. Air, light, the great unifiers."

Seeing, feeling, doing. For Paula, it was a lesson to be learned in Paris, from the French. Leaping ahead, we see that on the third day of her second visit, February 14, 1903, she wrote Otto a letter that drove home the same lesson, aiming it directly at his own work:

> I have noticed in general that one of the main things one can learn here in Paris is *impromptu* work. . . . We Germans always obediently paint our pictures from top to bottom, and are much too ponderous to do the little oil sketches and improvisations which so often say more than a finished picture. . . . You ought to perfect such a technique. That sort of thing is perfect for your talents.

Documents from the interim, like this journal entry of Otto's from January 15, 1903, reveal that Paula had gone on pressing Otto forward—or in the direction that to her was forward—and had not hesitated to point out his own pattern of repeated periods of exaltation followed by disillusion:

> She doesn't believe me when I say that I have now really had very important insights; she says it is only a phase, a transition, like all the times before when I used to make similar claims. I really can't blame her for feeling this way; I certainly have wavered very much and have often declared that now I have the answer. And yet, this time it is something completely different.

It would not be the last time that Otto would go through one of these cycles.

In early November Otto left to visit his parents in Münster. Paula's letters to him speak hopefully of the love they shared as still awaiting fulfillment. They are careful, too, to put an acceptable face on her satisfaction at this chance to be alone: "When I consider that the high point of the ultimate peak is yet to come! Look, dear, there's no reason to be sad or jealous of my thoughts when I tell you that I love my solitude. I love it in part because I can be quiet and undisturbed while I think good thoughts about you."

At the times when Paula was utterly consumed by her work, it appears, she saved less of herself for Otto than he was satisfied with—and for Elsbeth as well. Because it was a guarantor of her future progress, we can only be glad that she possessed so much of this capacity to focus on the work. Compared to Rilke's enormous capacity for putting other

claims aside, Paula's seems small indeed. More may have been expected of a wife and (step)mother than of a husband and father, but Otto, though he recorded (mostly mild) protests, must be credited with a good deal more acceptance of Paula's need to work than the typical husband in his position and in his day, even when acceptance required a furious private battle with himself in the pages of his journal. Paula's need to go to Paris, when she first expressed it, must have seemed to heighten the intensity of her demands enormously, but he overcame whatever resistance he felt, and she was able to leave, the first time, not too heavily burdened with emotional debt. A good deal of what debt there was was paid by Paula's widowed mother, who went out to Worpswede to care for her son-in-law and granddaughter in Paula's absence. A letter to family members remaining in Bremen shows that Frau Becker thought highly of Otto and found it virtually saintly of him to have agreed to Paula's going to Paris alone.[1]

In the late winter and early spring of 1903, then, Clara, Rilke, and Paula were all in Paris. In a letter to Paula from early February, timed to arrive on Paula's birthday and just before her departure, Clara had written of her life this way:

> I am at work now—not the great work that does great and bold things, but a small, tiresome daily work that goes slowly but step-by-step, and that requires all one's daily courage, thought and energy. And therefore I must collect them all and have them all around me and [be] at work every moment.—Il faut toujours travailler—This toujours, that's what it is that I'm learning, but it requires all my thoughts, even more, almost, than my hands.[2]

The tone is reminiscent of the letter Clara had written Paula after missing her birthday just a year earlier, to justify how little the two had been seeing each other. It may have been intended to prepare Paula for the fact that in Paris it would be no different, and to prevent her from expecting anything like the weekend outings they had shared in their first Paris stay.

Nevertheless, Paula began immediately to spend time with the Rilkes—and to send home mostly negative reports about them to Otto. Since the very fact that she was in Paris placed her in implicit agreement with them about the value of the cosmopolitan center, her work was cut out for her: she had to keep reassuring Otto that she remained skeptical of the values they had come to live by and that, unlike them, she valued Worpswede as highly as Paris. This, from February 12, her third day in the city, is the first mention she makes of them:

The Rilkes were just here, returning my visit. I was there last night. They are very friendly to me. But Paris is plaguing both of them with strange anxieties. . . . The same unhappy feeling of doom still hangs over these two people. And their joylessness can be contagious.

The next day Paula went with the Rilkes to an exhibition of Japanese woodblock prints, long a vital influence on the work of artists in Paris. Reporting on it to Otto, she expressed her wish that he, too, could see it—a theme in her letters to Otto from Paris that had already surfaced on her first visit. Then she returned to the subject of Clara and Rainer Maria: "Ever since Rodin said to the Rilkes, 'Travailler, toujours travailler,' they have been taking it literally; they never want to go out to the country on Sundays and seem to be getting no more fun out of their lives at all." She went on to speak of Clara:

Recently I visited her in her atelier where she was working on a little girl's thumb with great sensitivity. Only, as far as I'm concerned, she is becoming a little too wound up and speaks only about herself and her own work. Considering all of this, we shall see how she plans to avoid becoming a little Rodin herself.

But while Paula's letters stress the negative, the positive keeps coming through: the exhibition of Japanese prints impressed her, as did some of Clara's new work; she would eagerly accept the access to Rodin that Rilke afforded her, and begin to recite in her letters some of the lessons Rilke had drawn from Rodin's example. In spite of the pain she still felt from recent wounds, Paula the artist remained receptive to Rilke as a source of ideas and inspiration. He went on playing this role, sending her books and recommendations for reading that she followed eagerly and often passed on to her husband.

In her next letter, February 18, Paula addressed Otto as didactically as Rilke had sometimes addressed her. The letter was written in advance for Otto's birthday—her not being there to celebrate it with him was a sore spot—and it begins as a warm love letter: "And even though I have now run out into the meadow for a bit, I shall return soon and sit down quietly with you. You are my dear companion, and I think of you with deepest love and kiss your loving hands and your brow." But the next paragraph takes a sudden turn:

You know, I'm thinking a great deal here about your pictures. They must get much, much more striking. There must be a breath and a feeling of anticipation and something remarkable in them, as there

is in nature as it appears when our eyes are unclouded and clear and can see things in their rare essence. One of your expressions is: "I have a feeling that there are spirits in the air." When you paint a picture now, the most important thing for you is to express that feeling in all its strength.

On February 22, Otto's birthday, Rilke brought Paula a copy of the Worpswede monograph, finally published after some delay. Her first brief response, in a continuation the next day of the letter quoted above, is skepticism: "Only one thing is obvious to me: if you painters are not yet clear about things, then this book is not going to clarify things for you either. Otherwise it seems to me that many good and kind things are coupled with much that, artistically speaking, is quite awry." Through her sister Herma, Paula heard that Otto was eager to hear more of her responses to it, and she complied, putting her finger on some of Rilke's ambivalence and mixed motives:

this is not the right way or manner to write about art. Let your way of speaking be a simple "Yea, yea" or "Nay, nay." He knows nothing about that. These precautions, this anxiety of his about spoiling things with anybody who could possibly be useful later in life! . . . There is a lot of talk and beautiful sentences, but the nut is hollow at its core. Un-German.

This letter goes on to one of Paula's most jaundiced assessments of Rilke:

In my estimation Rilke is gradually diminishing to a rather tiny flame that wants to brighten its light through association with the radiance of the great spirits of Europe: Tolstoy, Muther, the Worpsweders, Rodin, [the Spanish painter Ignacio] Zuloaga, his newest friend whom he will probably visit; Ellen Key, his intimate friend etc. All of that is impressive at first. But the more one looks into life and into the rushing waters of art, the more shallow his life seems to me.

Though Paula was writing from the parts of herself that had most in common with Otto—perhaps even overstating what they shared in order to reassure him—his journal reveals that he found Rilke's praise irresistible: "I feel that I have been understood, by yet another since Muther. Now the facts will be set straight, that back then in '95 I played the main role. . . . Rilke points emphatically to my significance, especially for the

future."[3] To Rilke himself, Otto wrote, "I can truly say that I have never felt so lovingly understood as in your words. Your words truly touch me like sounds from my world, as I think it and dream it, and glow with the desire to have it arise before me."[4]

Rilke wrote Paula a letter of introduction to Rodin, of which she made eager use, though it referred to her as "femme d'un peintre allemand tres distingué" and did not mention that she, too, was a painter.[5] This slight is often mentioned in the Worpswede literature, and at times great weight is laid on it. Certainly it is the sort of slight to which female painters are eternally subjected, but Paula herself might well not have cared to be introduced to Rodin at this point as a painter. A few years later she would delay admitting this, even as they discussed art at length, to the far more approachable, merely mortal German sculptor and Rodin disciple Bernhard Hoetger. Rilke was very likely calculating, if anything, the effect of his words on Rodin, the sun around whom he was joyously revolving. Perhaps he even intended a show of deference to Otto. Paula, writing home on March 2, could not resist quoting the phrase, and her tone reveals at best a raised eyebrow and the desire to amuse and flatter her husband: "Armed with a little calling card from Rilke, who referred to me as 'femme d'un peintre tres distingué,' I went to Rodin's studio last Saturday afternoon." She saw little of Rodin himself, who scarcely glanced at Rilke's card, but as she left she asked his permission, which he readily gave, to visit in Meudon the next day. There, he showed her his sketches—pencil drawings colored with watercolor, often highly erotic in nature—and the tone of her letter begins to reflect awe and admiration comparable to Rilke's own:

> It is a passion and a genius which dominate in these drawings, and a total lack of concern for convention. . . . *You simply must see them.* Their colors are a remarkable inspiration, especially for a painter. He showed them to me himself and was so charming and friendly to me. Yes, whatever it is that makes art extraordinary is what he has. In addition there is his piercing conviction that all beauty is in nature.

In flawed French she repeats the lesson Rilke drew from Rodin: "'La travaille, c'est mon bonheur,' he says."

Rilke had been in contact with Otto, too, in the time before Paula came to Paris. To his letter to the Vogelers begging them to help Clara through the breakup of the household, he had added at the end, "Greet—if you see him—Otto Modersohn. No, Paris is *nothing* for

him!"[6] On New Year's Eve 1902 Rilke wrote a long letter to Otto directly, expressing the same belief:

Dear Otto Modersohn, stick to your countryside! Paris (we tell ourselves daily) is a heavy, heavy, fearful city. . . . It always seems to me, when I think of you, that you have everything there, and that if you come again to Paris, it will be for only a short time. For he who has a homeland must treasure and care for it, and go away from it only seldom.[7]

Otto, who answered with eager agreement about Paris, still played, in the story Rilke told himself, the role of the artist who, unlike him, had a home and stayed there: the counterpole, that is, to himself. Unmistakably, by his own lights, Rilke assigned himself the greater, Otto the lesser artist's role.

By tracking Paula's interactions with Otto and the Rilkes, we have risked missing the true center of her presence in Paris: her own intense and highly pointed artistic search. In these two months she arrived at some of her most distinctive formulations of what she was after. Because her letters to Otto always show at least small signs of her effort to please and reassure him, her journal is the best source. Of the showing of Japanese prints, she wrote on February 15, "I was seized by the great strangeness of these things. It makes our own art seem all the more conventional to me." The contact gave her that familiar sensation of turning one's eyes from the most compelling works of art and seeing the world itself (and for Paula this means the world of people) more clearly and intensely:

When I took my eyes from these pictures and began looking at the people around me, I suddenly saw that human beings are more remarkable, much more striking and surprising than they have ever been painted. A sudden realization like that comes only at moments. . . . But it's from moments like these that art must arise.

On February 20 she recorded one of her most widely cited formulas:

I must learn how to express the gentle vibration of things, their roughened textures, their intricacies. . . . The strange quality of expectation that hovers over muted things (skin, Otto's forehead, fabrics, flowers); I must try to get hold of the great and simple beauty of all that. In general, I must strive for the utmost simplicity united with the most intimate power of observation. That's where greatness lies.

This passage, written five days later, explains Paula's understanding of her most extreme attempts to reduce her portraits to their essentials:

> A great simplicity of form is something marvelous. As far back as I can remember, I have tried to put the simplicity of nature into the heads that I was painting or drawing. Now I have a real sense of being able to learn from the heads of ancient sculpture. What a grand and simple insight went into their creation! Brow, eyes, mouth, nose, cheeks, chin, that is all. It sounds so simple and yet it's so very, very much. How simply the planes of such an antique mouth are realized.

She could hardly wait to get back to Worpswede with this new insight and try it out on her models from the poorhouse.

Paula returned home in the middle of March, slightly earlier than she had planned; to Otto she wrote, "It suddenly took hold of me, and I have to come back to all of you and to Worpswede." Her comments about Clara and Rainer Maria had taken a further turn toward the negative: "They can express the craziest opinions now and I just sit there quietly and think my own thoughts, think of you and your good health and of how untainted and sane you are; and I secretly kiss my wedding ring." Rilke had been in bed with influenza off and on through the Paris winter; Paula had brought tulips to his bedside, but her judgment was, "suddenly I can't stand him anymore."

Otto's initial response to Paula's return was joy, but the gifts she brought, as he perceived them, were split:

> My dear Paula is back from Paris and has brought me the most wonderful things: on the one hand, a deepening of our love, which is wondrous; I live as if in a dream, true rapture flows through me. And then, as to art: she did not like the pictures that I somewhat hastily did in Raffaelli crayons. She points with the strongest and most insistent emphasis to nature. For her my pictures contain all sorts of things, but they lack one thing: study, nature. Oh, I have told myself that a hundred times and yet I always make the same mistake. I am always tempted by my prolific fantasy and then I fall prey to its charms, and nature retreats, becomes standardized, and turns into a cliché.

Otto's willingness to take such lessons from Paula remains impressive, and the more one reads of his journal, the more one is aware that it requires a transcending of his inclinations to be competitive, self-justifying,

obsessed with his own pursuit of greatness. In the months following her return, the negative notes about Paula in Otto's journal remain, and perhaps become more insistent. But usually they are followed, in the course of Otto's endless struggle with himself, by passages that show a touching loyalty and understanding. He was both men: the one who resisted Paula's example and the one who submitted; the one whom she angered and the one who loved her madly.

Ten

Just a day or so after Paula returned to Worpswede, Rilke, feeling that he could no longer endure the Paris winter and the terrors of the city's streets, left for Italy. Clara, busy with a commission, stayed behind. Finding first Genoa and then Santa Margherita full of German tourists, Rilke went on to Viareggio, which he knew from his earlier trip to Italy. Renting a cabana on the beach and adopting a routine of sunbathing in his small rented space, beach walking, and early morning nude swimming on the shoreline's more isolated stretches, he began to recover, and to work. The entire third section of *The Book of Hours,* "The Book of Poverty and Death," was written in a week's time, some of it jotted down in a volume of Jacobsen's novellas that he carried around with him. The poems are perceptibly stamped by the negative side of his experiences with Paris.

Not long after he returned to Rodin's city, arriving on May 1, 1903, Rilke was sick again with influenza and ever more susceptible to his fears. On July 1, feeling that they had nowhere else to turn, Clara and Rainer Maria left for Worpswede, where Vogeler, with whom he had kept up a warm correspondence, had offered them rooms. They stayed there, except for a week spent visiting Ruth in Oberneuland, until with the birth early in August of the Vogelers' second daughter they felt obliged to yield their space to the enlarged family and move in with Clara's parents. There was little sense of a reunion of the Family in Worpswede, for Paula and Otto were away traveling most of the time.

Just before leaving Paris, convinced in his misery that the "most difficult hour" in which Lou had promised to receive him again was near at hand, Rilke moved cautiously to reestablish contact. When she responded with a friendly note, he wrote a long letter about the fears that plagued him:

> Far back in my childhood, in the great fevers of its illnesses, great indescribable fears arose, fears of something too great, too hard, too near—deep, indescribable fears I still remember; and these same fears were suddenly there again, but they no longer required night and fever as pretexts, they came over me in the middle of the day, when I felt healthy and spirited, and took my heart and held it over the abyss.[1]

Though he had asked permission to visit her, Lou proposed that they first get to know each other again through letters. His attempts to arrange direct meetings would be thwarted, by circumstance or by Lou's evasions, for two more years.

All during the summer of 1903, then, from Worpswede and Oberneuland—and later, fall 1903 to early summer 1904, from Rome—Rilke poured out his soul to Lou in long letters, the earliest among them pure desperate lamentation over his recurrent fears, inadequacies, divided loyalties. Some, like a harrowing description of a man who suffered from Saint Vitus's dance, were destined for incorporation in *The Notebooks of Malte Laurids Brigge,* a book, begun in Rome, to which Lou would help Rilke find his way by insisting on the artistic value of the letters he wrote her about the Paris streets and their effects on him. All are vital to an understanding of Rilke's perception of himself and his difficulties at a time when his rapid artistic ascent and his awareness of his ability to meet neither the demands of the principle *toujours travailler* nor the personal obligations of friendship, marriage, and fatherhood combined to produce a terrifying, remorse-filled vertigo from which all the stories he had been telling himself had no power to protect him.

Rilke's writing of these helpless and desperate letters to Lou largely coincides with his writing to an aspiring poet named Franz Xaver Kappus, who had written him an awestruck fan letter about his old book *In My Honor,* the series of majestic and consoling letters that were made, after his death, into one of his best-loved "books," *Letters to a Young Poet.* Only once, near the end of the correspondence, after finding his way to a protective and isolated environment in Sweden, does he acknowledge to Kappus, in a supremely understated way, his own woes:

Don't think that the person who is trying to comfort you now lives untroubled among the simple and quiet words that sometimes give you pleasure. His life has much trouble and sadness, and remains far behind yours. If it were otherwise, he would never have been able to find these words.[2]

His ability to inspire and console Kappus in an almost magisterial tone at the same time as he declared his own abject, fear-filled wretchedness over and over to Lou is one more astonishing fact in this paradoxical time in which he grew as an artist in huge leaps while fighting desperately to maintain his own composure and eagerly embracing the comfort Lou was able to give him.

The letters to Kappus contain some of Rilke's most eloquent statements of his views on marriage, the sacrosanct nature of the artist's calling, the value to the artist of childhood—themes we have encountered all along that engage his relation to Clara and to Paula. In an early letter he names the two artists that have been vital to him, Jacobsen and Rodin, and the two books he would have Kappus read above all others: the Bible and *Niels Lyhne*.

On July 16 he counseled patience to Kappus in regard to all the unanswered questions—including those on love and sex—that fill the hearts of the young:

You are so young, so much before all beginning, and I would like to beg you, dear Sir, as well as I can, to have patience with everything unresolved in your heart and to try to love *the questions themselves* as if they were locked rooms or books written in a very foreign language. Don't search for the answers, which could not be given to you now, because you would not be able to live them. And the point is, to live everything. *Live* the questions now. Perhaps then, someday far in the future, you will gradually, without even noticing it, live your way into the answer.[3]

At the same time, the letters to Lou are full of desperate questions and pleas for answers. This passage was written from Oberneuland nine days later:

What shall one do who understands so little of life, who must simply let it occur to him, and learns that his own desires are always smaller than another great Will, in whose current he is sometimes caught like something floating downstream? What shall one do, Lou, for whom the books he would like to read open to him in no

157

other way than as heavy gates, which the next wind slams shut again against the castle? What shall one do, for whom people are just as heavy as books, just so superfluous and alien, because he cannot take from them what he needs, because he cannot choose, because he takes both what is important and what is incidental, and loads himself down with all of it? What shall he do, Lou? Shall he become utterly lonely and accustom himself to living with things, because they are more like him and place no burden on him?[4]

Lou's answers have something of the tone of his answers to Kappus. She insisted in the face of his protestations of helplessness that he *had* taken meaningful action simply by writing his long letters: "For they are all there now, not only in you but in me too, and outside of us both, as living things that speak for themselves—no differently than any song [poem] that has ever come to you."[5] It is here most directly that Lou opened for him the way to *Malte*.

In the past, seeing the man in Paris struggling with St. Vitus's Dance, you would—speaking metaphorically of the spirit—from this encounter have taken on something from him, and begun to see things through St. Vitus's Dance yourself: *today you describe it.* But as you do so, the suffering of his circumstance opens itself within you, seizes you with the clarity of insight,—and what separates you in fact from him becomes the power to suffer intensely along with him without all the mitigating self-deceptions of the sufferer.[6]

The artist in him, she told him, composed out of the fears of humanity. It was his calling. Moreover, she told him, "You were never so near to health as now!"

The letters to Lou reveal how he had come to see Worpswede and the Family in retrospect—how completely he had withdrawn his allegiance from both. Of the Worpswede landscape, whose presence had sustained him through the writing of the monograph, he now wrote this: "Back then I knew how to see it as great, and that helped me; (today, on this return visit, I found it small, German and full of settlements.)"[7] *German* was never, in Rilke's vocabulary, a term of praise.

Within days of leaving the Barkenhoff, he delivered a devastating account of Vogeler's life there:

it is becoming smaller and smaller around Heinrich Vogeler, his house draws itself together around him and fills itself with the everyday, with complacency, with convention, with indulgence, so

that nothing unexpected can happen any longer. The little woman who was so delicate and fairy-tale gentle becomes, with every birth, broader and sturdier, like a peasant, and soon she will be like her mother, who in damp, dark rooms gave birth to pale, stolid children year in and year out.[8]

With the clear implication that the same fate would have awaited him had he stayed in Westerwede, he goes on to deplore the effect of this life on Vogeler's art.

In the highly uncomfortable days that Rilke and Clara spent with Clara's parents, who could not understand why he did not simply get a job, Rilke's failures were brought home to him again and again. Clara's father was at this time in a depressed and angry mental state, and so his misgivings about his son-in-law were expressed in a heightened form.[9] Rilke, moreover, did not entirely deny their justice. From Oberneuland, during the couple's first, briefer visit there in July, he bemoaned to Lou his own limitations:

no one can depend on me: my little child must stay with strangers, my young wife, who has her own work, is dependent on others who concern themselves with her development, and I myself can't be helpful anywhere and can earn nothing. And although those closest to me, whom it truly concerns, do not reproach me, the reproach is nevertheless there, and the house I am in at the present is full of it.[10]

Later he tried helplessly to make Lou see what lay at the root of his incapacities:

O Lou, in a poem with which I am satisfied there is much more reality than in any human relation or inclination that I feel; where I create, I am true, and I would like to find the strength to base my life on this truth alone, on the infinite simplicity and joy which is sometimes given to me.[11]

Rilke sent Lou his Worpswede and Rodin monographs. From the Rodin book, of which Lou proclaimed that it was that one of his books that she loved the best, she invented for him, as no one else could have done, a story that made sense of all his suffering. She had said earlier in their relationship that he often came to her as a mother; here we see her as a mother telling stories to still the fears of a child. The greatness of Rodin's example, she said, to which he had submitted so utterly that

his union with the master in the book resembled a marriage, had aroused in him impulses which his calling as word artist did not allow him to transform into *objects* of art, as it would have done if he, too, had been a sculptor. Denied the physical being of art objects, these impulses had been turned against his own physical presence, his body, emerging as symptoms. But she assured him that a day would come in which his art would have grown equal to this task of transformation. This certainty confirmed not only Rilke's calling as an artist but his deep relation to Lou herself: "I for my part am now certain of what you are: and this is the most personal thing of all for me in your book, that I now believe us united in the heavy secrets of living and dying, one in the eternal things that bind human beings together. From now on you can rely on me."[12] This last must have been a comfort to Rilke, and from this time forward she did a great deal to live up to her promise. Her diagnosis itself Rilke accepted eagerly, writing, "You are so wonderfully right, Lou, I suffered from this too-great example."[13]

He begged her, too, to validate his desire to unify his life around the pursuit of his art:

I divide myself again and again and go flowing off in different directions,—though I would be so happy to move in *one* [river]bed and grow large. For isn't it true, Lou, that this is the way it ought to be; we ought to be one stream and not enter canals and bring water to the fields? Isn't it true, we should hold ourselves together and go rushing on?[14]

But Lou resisted Rilke's attempts to divide life radically from art with Rodin's example as justification, and she won from him this concession:

I too don't want to tear art and life apart from each other; I know that sometime and somewhere they have the same meaning. But I am one unskilled at life, and for this reason it is often a stopping point for me, a point of hesitation that causes me to lose a great deal, perhaps in the way in a dream one is sometimes unable to fin- ish dressing, and over two fractious shoe-buttons one neglects something important that will never come again.[15]

Both Vogeler, in his memoirs, and Clara's early biographer, Ilse Alpers, characterize Clara's response to Rilke's ideas about life and art—to which she could not stand up as Lou could—as a kind of suffering, fatal- istic resignation.[16] In May of the following year, when she was again in

Worpswede after the couple's stay in Italy, in a letter to her father, she justified Rilke's failures in terms that evoke resignation rather than, say, pride in her husband's higher calling:

> You asked in your latest letter whether my husband could not care for me. Rainer is not capable of this, but he has on the other hand always stepped in to help with out-of-the-ordinary expenditures, especially during our travels. He will continue to try to do this, but he is not capable of doing more.[17]

It was a fact she had faced by then, though it cannot have pleased her.

The Rilkes were still trying to share their expenses equally. Though the Worpswede monograph had paid well, the Rodin book had not, and Rilke was not able to pay his share. Clara's income, besides her few Paris commissions, came from a small stipend she had been granted for two years by an anonymous patron in Bremen, and a monthly sum given grudgingly by her father. Before they left Paris, Rilke had persuaded Rodin to visit Clara's studio and then write a letter in support of further attempts to win a stipend from the Bremen senate, but despite the master's endorsement, the grants were awarded to others.

Nevertheless, the couple was able to depart, as they had planned even before arriving in Worpswede, at the end of August for Rome; one justification was Rodin's advice that Clara get to know classic sculpture. Clara had never cared for the south; she went out of a sense of obligation to her work and to her husband, and without her heavy sculptor's tools, she worked mostly, as Rodin had recommended, at drawing. Shortly after their arrival, Rilke, who had been surviving on Clara's meager income, was able to secure one modest source for himself: fifty marks per month to serve as a reader for the press of Axel Juncker. They lived until November in separate quarters; after this Rilke, too, rented one of the many cottages available to artists in the Villa Strohl-Fern, where Clara had been staying from the start.

Rilke had continued to correspond with Ellen Key, who was now lecturing about his work in various Scandinavian cities. Clara, too, wrote letters to Key, and they often endorse, if only out of a forlorn solidarity in the face of an outsider, the assumptions that kept the two living separately for the sake of their work:

> And now? Now work is there again, and slowly begins to be the single thing, the great, important thing—and so we are two beginnings, learning how to work. What can one say to such beginnings.

One can only wish them peace and quiet and loneliness, to go fur-
ther, to grow beyond these beginnings, to work.[18]

"Westerwede was real," Rilke had written Clara not so long ago, hop-
ing to reassure her, but to Lou, from Rome on November 13, he added
a telling reservation:

Earlier I believed that it would be better once I had a house, a wife
and child—actual, undeniable things; I believed that I would
become more visible, palpable, actual. But, you see, Westerwede
was, was real: because I built the house myself and made everything
that was in it. But it was a reality *outside of* me, I was not inside it
and did not grow in it. And that now, when the house and its love-
ly still rooms no longer exist, I know that a person exists who
belongs with me, and somewhere a small child to whom nothing
is nearer than that house and I—no doubt it gives me a certain
security and the experience of many deep, simple things—but it
does not help me to reach that feeling of reality, that sense of
equality for which I long so: to be real among real things.[19]

The couple remained in Rome until early June 1904, and Rilke went
on writing long, lament-filled letters to Lou and exalted, magnanimous
ones to Kappus. He could not find his way toward new work, and
bemoaned his lack of practical skills. Often he had headaches. The rains
of winter oppressed him; at Christmas he missed northern Christmases,
and Ruth; the Italian spring, when it came, seemed garish and super-
ficial; even the earliest signs of the heat of the Italian summer overcame
him. In April his mother came to Rome for a visit; between the dread
of her arrival, the test of the visit itself, and the recuperation afterwards,
precious weeks of work were lost.

Once Ellen Key, as she had done in Paris, offered to make it possible
for Ruth to come to Rome, but in the name of peace and quiet for work
Rilke strenuously rejected the offer. His letters to her had been, in a
lower key, the same sort of laments he had written to Lou, and to one
of them Clara added a postscript that came out and asked her forth-
rightly for what Rilke had only hinted at: that she find some way to
invite him to stay with her for a time in Copenhagen, for Rilke still had
dreams of learning Danish in order to read Jacobsen in the original, and
even of writing a book about him.[20] Instead, Key came up with several
offers of hospitality from others in Sweden, and Rilke accepted one of
these, for a stay on the estate Børgeby-Gard as the guest of the painter

Ernst Norlind and Hanna Larsson. Clara accepted the prospect of separation, and made plans to return to Bremen or Oberneuland, where she might have a better chance of winning commissions and finding paying pupils. The move would also, of course, bring her back to Ruth.

Despite his constant lamentations, Rilke did begin *The Notebooks of Malte Laurids Brigge* in Rome, and though his lyric productivity was not so great as it could sometimes be, at the beginning of 1904 he wrote, under the influence of classical art, three of the great poems of his early years: "Orpheus. Eurydice. Hermes," "Graves of Hetaerae," and "The Birth of Venus."

"Orpheus. Eurydice. Hermes" is the single most important precursor of the Requiem. It is set in the dark caverns, "the wondrous mine of souls," through which Orpheus, Eurydice, and the messenger god, Hermes, make their way toward the upper world after Orpheus has succeeded in winning the release of his beloved.[21] Orpheus, tense and desperately conflicted as they approach the end of their journey, is seen in a remarkably unflattering light:

> First, the slender man in his blue cloak,
> looking ahead, all silence and impatience.
> His steps devoured the path in enormous bites
> without any chewing, and his hands hung down
> heavy and closed amid the falling folds,
> as if they knew nothing of the delicate lyre
> which had grown right into his left hand
> like roses into a branch of an olive tree.

That he neglects his instrument is the ultimate emblem of Rilke's disapproval. His desire to possess his beloved meets the same rejection as Otto Modersohn's in the Requiem:

> She was, by now, no longer the blonde woman
> resounding sometimes in the poet's songs,
> no longer the fragrant isle in his wide bed,
> no longer the possession of this man.

But in this poem, a far cry from the *Sonnets to Orpheus,* Orpheus is largely a foil for Eurydice, the poem's center. What is unique in its portrayal is her complete acceptance of her death:

> She was within herself, like one who'd conceived,
> and thought not once of the man who walked ahead,

nor of the path that led her back to life.
She was within herself. Her having died
filled her like sheer fullness.
As a fruit is filled with sweetness, darkness,
so was she all full of her great death,
still so new that she had not yet grasped it.

Here was a dead girl content to be dead, and to have found, in death, a "new virginity": "and her very sex had closed / as a new flower closes up toward evening." Eurydice has gone so far into her death that

as the god abruptly
stopped her and with pain in his outcry
spoke the sentence: he has turned around—
she did not understand, and said softly: *Who?*

In the Requiem Paula's restless return is a failure to live up to the ideal he has created here in Eurydice. It is a familiar story: whatever his passionately held views on what is proper for artists, women, the dead, Paula Modersohn-Becker could be counted on not to fit them.

Eleven

The rhythm of any account of Paula's and Otto's life together from this point on is necessarily that of Paula's two further departures for Paris and returns to Worpswede. After returning at the end of March 1903 to the village, she remained there for some two years before leaving for Paris in February 1905. This time she stayed through April, then remained in Worpswede for nearly a year before leaving in late February 1906 for her fourth and final stay, from which she did not, as she left, intend to return.

For a long time after her return from her second Paris stay, Paula believed that she was on the right path. In April 1903 she wrote in her journal, "I'm getting close to the people here again, sensing their great biblical simplicity." Simplicity had become a guiding principle of her search. In the same entry she wrote one of her most distinctive formulations: "Something urgent burns in me: in simplicity to become great." And with her work on track, she was happy. In a letter of April 20 to her Aunt Marie, she expressed utter contentment with Worpswede:

My life glides along day by day, and it gives me the feeling that it is guiding me somewhere. This hopeful, soaring feeling is probably what makes my days so blissful. It is strange; what people usually call "experiences" play such a small role in my life. . . . What lies between these so-called experiences, the daily course of events, that's what makes me happy.

In early July Paula, Otto, and Elsbeth Modersohn began nearly a monthlong vacation on the island of Amrum—the one that removed

them from Worpswede at the time that the Rilkes were staying at the Barkenhoff. Near the end of the trip Paula wrote a long letter to her mother, illustrated with droll sketches; the note struck by both letter and sketches is unalloyed joy in the shared life of the small family. In Bremen in mid-August she wrote home to Otto that she could scarcely bear to be away from "our Worpswede paradise."

Yet in the fall, unremarkably, there were notes of discord. This entry from Otto's journal on September 26 reminds us that he, too, had sometimes found marriage disappointing:

> Remarkable—how vexing almost all marriages gradually become.
> . . . Paula has more intellectual interests and a more spirited mind
> than anyone else. She paints, reads plays, etc. The household is
> also in very good hands—it is only her feeling for family and
> her relationship to the house that are too meager. I hope that it
> improves. . . . I only wish that our lives were a bit more together
> and with one another, then I could call it ideal.

The same entry goes on to reject the results of Paula's attempts to incorporate into her work with Worpswede models her Paris insights about the simplicity of antique portraits. He had seen some of Paula's work alongside the work of Ottilie Reyländer, which he judged "superficial, conventional, an external story tossed off," whereas Paula seemed to him to have gone to the opposite extreme:[1]

> She hates to be conventional and is now falling prey to the error
> of preferring to make everything angular, ugly, bizarre, wooden.
> Her colors are wonderful—but the form? The expression! Hands
> like spoons, noses like cobs, mouths like wounds, faces like cretins.
> She overloads things. Two heads, four hands crammed into the
> smallest space, never any fewer than that; and children at that! It is
> difficult to give her advice, as usual.

Writing to her mother in early November, wishing she could visit her in Bremen, Paula shows *her* frustration:

> I don't know how I can steal away from my little house without
> making glum orphans of the three other occupants [including a
> new maid Paula was breaking in]. These days Otto seems to need
> my face to look at several times a day. Elsbeth makes too much
> noise for him and consequently he is not very sympathetic to her
> presence. And so I must be the oil that calms the waves.

Documents from Paula's hand in 1904 are sparse; mostly at home, she wrote few letters, and few passages from her journal survive. In April, when Otto left for Münster for his father's birthday, she moved briefly back into her studio at the Brünjes's, sleeping and taking her meals there, reliving her earlier and more carefree Worpswede days. She told Otto of her little indulgence in a letter that is carefully reassuring about both her dedication to him and her active concern for Elsbeth, who was coming down with a cold and under the maid's care. "Do you know what makes my freedom so beautiful?" she wrote. "It's because you are there in the background. If I were free but didn't have you, then it would all be worth nothing to me." To her sister Milly, the same day, she wrote a less guarded account:

> I have moved into the Brünjes's where I am playing Paula Becker. I have just now boiled up tea water on my little oilstove and am letting the soft spring night flow through all my windows and through all my pores into me. . . . I'm feeling so marvelous; half of me is still Paula Becker, and the other half is acting as if it were. No matter what, there was and there still is, a great portion of my happiness under this thatched roof. I have probably never in my whole life loved a house so much as this one.

It was the house of her art—not the house in which she lived with Otto Modersohn and his daughter, in which, likely more by Paula's wish than by Otto's, none of her work hung on the walls.[2]

By late 1904 Paula no longer found such brief private escapes from domesticity, and the trips she and Otto had taken together that summer, satisfying. Paris was calling. Her younger sister Herma had gone there as an au pair after completing her studies, and a letter to Herma on Christmas Eve 1904 speaks of Paula's hope of arriving early in February:

> Otto, to be sure, has not given me a definite yes about this; but he certainly is noticing that I have such great longings for my city that one cannot possibly put up a barrier against them. And also, this is the way my marriage is now; in many little things I give in, and it's not very hard for me to do that; but in a few big things I could almost not give in even if I really wanted to.

She hadn't been getting anywhere with her work, she said, and this turn is surely related to the turn in her mood; she looked to Paris for inspiration. To Carl Hauptmann and his wife she wrote early in 1905, "I want to be right in the midst of life for a few months so I can see and hear

everything. I'm still too young to have to sit here forever. That will be very beautiful for me; Paris is my city. Beautiful and bubbling and fermenting and one can dive right down into it."

To her Aunt Marie she explained her need this way ten days later: "I think it must be that our life here is made up of purely inner experiences, and so one frequently has a powerful desire to be surrounded by external, active life from which one can always escape if one has a mind to." This letter reverses the stance she had taken in a previous letter to her aunt, at a time when the daily Worpswede routine, so short on "external, active life," was still enough for her. In another letter to Herma less than a week before her departure, Paula describes Otto's resistance once she is finally sure that she has overcome it: "Red is very apprehensive this time about our separation; his thinking about it is worse than he will actually feel when it happens. And the reunion afterward will be all the more beautiful."

Earnest and dutiful, Paula signed up for drawing classes at the Académie Julian, but the chief value of the visit, an intoxicating one in artistic terms, lay elsewhere. She was in Paris at a vital time in the development of postimpressionist painting, and its influences are everywhere in her late work. She had already gotten to know Cézanne; now she saw the Fayet collection of Gauguin and, at the Salon des Indépendants, a Seurat retrospective, forty-five van Goghs, and eight Matisses. She got to know the Gauguin disciples who called themselves the Nabis, and it is possible that her choice of Julian this time was influenced by the knowledge that it was there, in the late 1880s, that they had come together. One letter speaks of her plans to visit Edouard Vuillard and Maurice Denis in their studios—the visit to to Denis, at least, in his studio at St. Germain-en-Laye, did take place—and mentions Pierre Bonnard, then in Berlin and not available for a visit. She was living in a setting and a manner desperately necessary to her, and blossoming fulsomely in response. Gauguin was, for a time after this visit, her chief interest; after her return she wrote Herma asking for copies of materials on Gauguin that she could not lay her hands on in Worpswede or Bremen. His influence and that of his Nabi admirers may be summed up in the well-known dictum that Maurice Denis claimed to have deduced from his work, and expressed in an article in the journal *Art et critique* in 1890: "Remember that before it is a war-horse, a naked woman, or a trumpery anecdote, a painting is essentially a flat surface covered with colors assembled in a certain order."[3] This notion went far beyond the impressionists in setting easel painting free of the constraints of realism,

particularly in its use of color; it looked ahead to the Fauves. Taken only slightly further than the Nabis themselves took it, it pointed toward pure abstraction. In Paula's work it led to a bolder palette and ratified her continued search for simplicity of form. Still lifes took on a prominence for her that they retained till the end of her life. The most decorative and lyrical of her self-portraits, the *Self-Portrait against Green Background with Iris,* done after this visit, shows these influences in a formulation distinctly her own.

Paula's early letters home from this stay are full of pleas that Otto join her—a recurring theme. She hoped that if he could share her love for Paris, the tensions she felt might be resolved rather than merely coped with. (And here it is worth remembering Rilke's injunctions to Otto to stay away from Paris at all costs—to the extent that he was able to influence Otto, his thinking clashed here with Paula's own, and with her personal interest in reconciling her own needs and those of her husband.)

Otto finally did make plans to come, but the visit proved to be almost as ill-starred as the last trip to Paris he had undertaken at her behest, before the death of Helene Modersohn. This time, three weeks after Paula arrived, and not long before Otto was to come, his mother died after a short illness. Paula dutifully offered to come home if he wanted her to, but made it clear that she wanted very much not only to stay, but to have him come there anyway. Her mother, who had again been tending to Otto and Elsbeth in her absence, wrote to Paula that Otto himself wanted her to stay—though on some level he clearly hoped she would come home. In any case, he did not want to come to Paris to visit her so soon after his mother's death; emotions he had felt after that earlier visit must have linked themselves with those he felt now, casting a pall over Paula's Paris excitements that was as undeserved as it was inevitable.

In the end Paula got both of her wishes—she stayed, and finally Otto came—but he was unable to grant them without a lingering ill feeling. He set far greater store than Paula by outward forms of propriety, which would have dictated that Paula go to her husband's side and her mother-in-law's bier. Paula tried to engage these feelings in her letters, but in spite of herself she let her own rising excitement at being in Paris in the spring, and her hope of sharing the time with him, come through in ways that, in the midst of a lengthy and difficult stay with his bereaved father, only pained Otto further. Worst of all, in an uncharacteristic lapse into crude thoughtlessness, she described to her grieving husband how she and Herma had been keeping company with two Bulgarian men, a

169

sculptor and a painter, that they had met during Mardi Gras. Perhaps she hoped to draw him to Paris through jealousy.

Predictably, Otto's visit, when it came, was a disaster. Milly Becker, Heinrich and Martha Vogeler, and one of Vogeler's sisters came along, dooming the possibility of a private sharing with Otto of all she loved about Paris. In a letter written after her return that chiefly recalls their earlier good times together, Paula described it to Herma:

> As soon as I had Otto over the border the iron band that had clamped around his sad and grieving heart broke in two. He was very jealous of Paris, French art, French nonchalance, the boulevard Miche, the Bulgarians, etc. He imagined that I only preferred to stay in Paris and thought nothing at all of Worpswede.

Continuing, she reveals that she is not yet free of irritation at what she saw as a failure of Otto's: "Well, you know him. He had completely submerged himself in such thoughts, and wouldn't say a word, and really ruined the last week for me." Otto's bereavement was not of his choosing; most marital arrangements would grant the needs of the bereaved spouse precedence for a time over the needs of the partner, however ill timed death's intrusion into their lives. But Paula was helplessly possessed by all that Paris was offering her, and could not have chosen wholeheartedly to return any more than Otto could wholeheartedly urge her to stay, or arrive in Paris with an eagerness to match her own.

Paula's need to continue her stay and her work despite her mother-in-law's death echoes a story Rilke treasured about Cézanne, which Paula may well have heard: that, being caught up in work, he had been unwilling to stop long enough to attend his own mother's funeral. This became, along with his reading of Rodin's example, a vital part of Rilke's case that, for the genuine artist, art must claim a decisive priority over life. To Otto Modersohn such choices could only be instances of the egotism of the modern artist, and in Paula's case of the dire influence on his wife of Rainer Maria and Clara. In any case, Paula faced a choice between irreconcilable demands and the way that these were resolved was satisfactory to neither.

Clara and Rainer Maria were not in Paris during Paula's 1905 visit. Clara had returned to Oberneuland to be with Ruth when Rilke went off to Sweden in June 1904. In August she took up the invitation to join him there, and in September the couple traveled together to Copenhagen,

where they made fruitless attempts to find work for Clara in that city's porcelain industry. Soon after, Clara returned to Oberneuland, where Rainer Maria finally joined her and Ruth, in December, reuniting the little family for Christmas. Both remained there through February 1905, and then in March and April husband and wife sojourned together at the White Stag, the sanatorium near Dresden where they had spent the first month of their marriage. It was a great financial indulgence, but it paid off when they met there the ailing Countess Luise von Schwerin, who invited them for a visit to her castle Friedelhausen that summer, where Clara would make a portrait bust of her. With this to look forward to, one bright light in a dark time, Clara moved from the the White Stag into a studio in Worpswede while Rilke went off on a series of travels that included his first face-to-face meeting with Lou since her "Final Appeal." Having for two years poured out his heart out to Lou in letters, Rilke was permitted to see her again, in Göttingen. When, however, he began to hint that he might settle there, she saw him about to fall again into his old dependence on her, and discouraged him.

Rilke went on to Berlin, from which he wrote Clara a series of letters about the artwork so abundant in the city's museums and galleries. After Berlin he made stops in several other places where he hoped he might settle for a time, but none was satisfactory. He finally arrived at Friedelhausen, meeting Clara there. He met, as well, Karl von der Heydt, collector and would-be playwright, who would become a vital patron. When, on September 15, 1905, Rilke mentioned in a letter to Rodin that he would be in Paris for a few days, Rodin invited him to stay at Meudon.

Clara had been in desperate financial straits; in Bremen, in Oberneuland, and in Worpswede she tried to establish herself as a teacher with enough students to support her, but nowhere was she successful. On June 14, Paula wrote to Carl Hauptmann asking him to lend her four hundred marks "for someone else" whom she did not identify, and requesting further that he not mention the matter to Otto, as "it would upset him." It is tempting to speculate, with the editors of her journals and letters, that the intended recipient was Clara, but there is no proof.

When Clara arrived at Friedelhausen late in that summer of 1905, the Countess Schwerin was too ill to sit for her portrait, and instead Clara made what may be her best portrait bust of Rilke. Also the smallest, it is easily recognized by the downward cast of the head. A photograph has survived that shows Clara at work on this portrait on the terrace at Friedelhausen, and it shows her at her best: alert and intent, she molds

the clay in strong hands as her husband, head buried in a large book, pursues his quest for material in the castle's archive. But just two weeks into this stay Clara's father died suddenly in an accident, and she returned home. Besides the personal loss, Clara now faced the loss of the small family stipend that kept her afloat. Having raised her hopes at least briefly, she now saw her fortunes sink to a new low, just as her husband's, with Rodin's invitation, rose heavenward.

When Rilke arrived at Meudon in mid-September 1905, says Ruth Butler, "Rodin welcomed him as though he were a prodigal son."[4] Before long, to his astonishment and joy, he was invited to live indefinitely at Meudon, where in exchange for helping Rodin with his correspondence he could live free of financial worry, bask in the master's presence, absorb his peerless wisdom, and pursue his own work. This invitation makes it clear that, as much as Rodin had come to mean to Rilke, Rilke had come to mean a great deal to Rodin as well. Rilke's monograph had by then been translated into French; Rodin must have been moved by Rilke's eloquent praise.

Their contact went far beyond Rilke's secretarial duties. The two men, sometimes accompanied by Rodin's companion Rose Beuret, toured the Left Bank, Versailles, Chartres; they celebrated Rodin's sixty-fifth birthday, in November; Rilke's thirty-first, in December. With time Rilke's joy at this new opportunity would come to be tempered by the encroachment of the work he did for Rodin on the time and energy he needed for his own work, but at first it was extraordinarily rewarding.

Rilke did the best thing that he could possibly have done for Clara under these circumstances: he saw to it that she was invited to spend a month in Meudon as well, working under the eye of Rodin. After this interlude Clara returned to Worpswede, where she and Paula came into the closest contact they had enjoyed in years. Clara, surely, was still full of Rodin, and grateful for the opportunity to work in his presence. But she must have seen by then that any hopes she still retained for a married life even remotely conventional, or for becoming self-supporting as an artist in the near future, were vain. Rilke constantly sought commissions to send her way, and sent small sums from his own sporadic earnings, but such acts must be seen against the background of his having renounced responsibility for Ruth's upbringing and for reliable and regular support of either his wife or his daughter.

Clara left one evocative bit of evidence of her state of mind in 1905: a self-portrait in oil, done in February, clearly portraying a troubled, subdued, perhaps resigned young woman.[5] Her features, so sharp in life, are

markedly muted, shadowed in grey-violet, and the light in her eyes, which face but do not engage the eyes of the viewer, is dim. Her mouth is closed, but her jaw is not "set" in the way that is conventionally read as expressing determination. Turned inward, away from others and from an uncertain future, she endures. Clara had done no painting since turning to sculpture some seven years earlier, and aftewards she did not return to it until very much later in her life. It appears that the intensity of her feelings, in a time characterized mostly by discouragement, perhaps bewilderment, accounts for the work's existence as well as its somber tones.

After Clara's return from Meudon in late November, Paula painted her, as little Ruth sat on the floor playing; the resulting portrait of Clara in a white dress, holding a red rose, is moving testimony of her renewed affection for her friend, presenting a far more positive and hopeful view of Clara than does Clara's self-portrait. In his memoirs, Vogeler describes the portrait as "a painful leavetaking" from her friend and "a look back at what has been lost."[6] In the painting, he says, "Clara turns away with a heavy heart." Vogeler's memoirs often show not only lapses in memory but the influence of his own pained nostalgia and of the mythic versions of Paula's life and work that arose in the intervening decades, on which his nostalgia seems to have fed. While the impression made by Clara's averted eyes is one of vulnerability—pensive, shadowed, somber—an even more forceful impression given by the firm lines of head and neck is of an underlying strength. Clara herself wrote from Worpswede to Paula in Paris, "Every time I look at your portrait of me it seems, to me, to be something very grand. And real greatness must grow from this beginning—it is already a true path—an upward path."[7] On the first level she must have been speaking of the promise of the painting for Paula's work, but her words describe equally well the implied statement (or hope?) of the painting for Clara as well.

Paula painted herself with white dress and red rose at roughly the same time, and comparison reveals that in the self-portrait a good deal less strength and more uncertainty are portrayed.

At some time in the warmer months of 1905, Paula acceded to a request Otto had made in a letter during her Paris stay that she pose for him outdoors in the nude. Though they repaired to an isolated spot on the Weyerberg, surrounded by trees, they were observed. Word spread through the village, scandalizing many; according to Vogeler, Mackensen and am Ende demanded that he break off contact with the offenders, and am Ende finally challenged him to a duel over this blot on the

honor of the colony.[8] The contretemps may well have heightened Paula's sense of the limitations imposed by living in such a village. Within a year, she would be painting herself in the nude in Paris—another undertaking inconceivable in Worpswede.

One more painting finished in Worpswede in 1905 speaks of the relations at this time of those who had once called themselves the Family: Vogeler's enormous *Summer Evening at the Barkenhoff* or *The Concert*. It had taken several years to complete, though much of the work had been done in the summer of 1904. Though executed at the peak of Vogeler's popularity, it is his own "painful leavetaking," his own "look back at what has been lost." The scene is the Barkenhoff terrace, with its familiar white walls, curving stair, pair of large Empire urns; like the terrace itself, the painting is symmetrical, viewed almost precisely from the center and slightly below, as if the viewer were approaching through Vogeler's elaborate gardens. At the center and closest to the viewer, in white shawl and green flowered dress that nearly blends into the vegetation, Martha Vogeler stands just inside the gate, between the two urns. One stair below, just outside the gate, lies the Vogelers' Russian wolfhound. The dog looks toward the viewer, while Martha's eyes are averted both from the viewer and from the trio which is playing: Franz Vogeler violin, Heinrich Vogeler, mostly obscured, what is apparently a cello, and to the rear, a young man identified as Martin Schröder, flute.

On the left side of the terrace, behind Martha, four listeners are arrayed in a triangular figure. On the left, in the foreground, instantly recognizable in profile, her reddish-brown hair gathered in three rolls at the nape of her neck, Paula sits, her eyes closed or nearly so, lost in thought or contemplation of the music. Behind her and largely obscured, so that her presence does not modify the triangle, sits a woman identified as Agnes Wulff, daughter of a local physician. On the right, facing but not looking at the viewer, Clara sits in shadow, her dark hair and clothing nearly blending with the background vegetation. Her eyes are in shadow; like Paula she is turned inward, far away from the scene. The trunk of the other potted tree divides Clara from the rest of the figure. Between Paula and Clara but further back, at the apex of the triangle, Otto Modersohn stands. His eyes are the only human eyes that engage the viewer's; he is alert, watchful, fully present while the others have been transported elsewhere. He stands, literally, between Clara and Paula.

With its enormity, its cast of living characters (even the dog is identifiable, a gift from *Insel* editor Heymel), its representation of Martha as a living woman rather than a figure of myth or a contemporary ideal, the

painting is an something of an anomaly in Vogeler's work. He struggled to complete it (though this was not uncharacteristic); later he tried to get it back from its purchaser, Ludwig Roselius, in order to destroy it.[9] If it was indeed begun as early as 1902, it may have been conceived as a celebration of the Family, which the intervening years turned into an elegy. The profound isolation of each of the principals may have been conceived initially as representing only their being "lost in thought" as a result of the music, further subdued by the mood of a summer evening. Vogeler's limitations as a realistic painter may contribute to the static, dioramalike feel. Still, the painting can take on the dreamlike, underwater intensity of a Magritte or a Paul Delvaux, though none of its contradictions has quite risen to the surface. The human presences— even Martha, given pride of place—are so subdued that the Barkenhoff itself, more animated by far, engulfs them. That Martha, held out for display like the central gem in an ornate setting, does not shine outward but instead draws us in to a subjectivity we can perceive but then not engage, may be a truth about her place in the Barkenhoff world of Vogeler's dreams that he captured in the painting before he could recognize it himself—for within a few years of the painting's completion these dreams would be dashed. Likewise the little allegory of Paula, Otto, and Clara, though this appears more likely to have been conscious.

The group portrayed in the painting is, in essence, the Family before the spring of the weddings—and before Rilke's arrival changed everything. He had made himself part of it and then—so it might have seemed to Vogeler and the others—destroyed it by withdrawing himself and Clara, and by rejecting the notion of community at its heart. It is even possible that Rilke's presence *is* encoded enigmatically in the painting. While the dog it portrays was an actual member of the Vogeler household, it is also true that, as Vogeler knew, the coat of arms of the noble Carinthian family from which Rilke claimed descent featured *Windhünde,* typically translated as "greyhounds," but the common German name for the Vogelers' dog as well. Rilke sometimes sealed his letters with this coat of arms, and at some point Martha Vogeler reproduced it for him in tapestry. Perhaps the strange pall that hangs over the scene emanates from this lean, aristocratic, nonhuman Russian figure.

In November 1905 Paula described her renewed friendship with Clara in a letter to her mother: "I'm happy that I can get together frequently with Clara Rilke this way. In spite of everything she is still, of all my friends, the one I care about the most." She added a brief, ironic

175

comment about Rilke: "As Rodin's secretary, Rilke is gradually meeting the intelligentsia of Europe." In her most jaundiced moods she saw Rilke as a shameless opportunist. Yet she longed at the same time for more contact with "the world" than she would ever have in Worpswede—more of Rilke's opportunities. Later in the same letter she confesses to her mother, "I'm secretly planning another little trip to Paris, and have already saved up fifty marks." As would be expected, Paula took Clara into her confidence about the state of her perpetual attempts to reconcile Worpswede and Paris, her marriage, and her work—and the news was not good. Much later, in a memorial volume devoted to Paula, Clara described one visit to Paula at the Brünjes's during the winter that followed:

> the two of us were sitting by her stove in her little studio. Paula was throwing one piece of peat after the other through the little squeaky door and into the fire; and one tear after the other rolled down her cheeks as she tried to explain to me how very important it was for her to get back into "the world," back to Paris. "That's what I mean when I think: 'the world.'"[10]

This scene makes it easy to see why at some time during the latter part of 1905 Paula began planning to leave both Worpswede and Otto Modersohn, for she had despaired, finally, of his coming to share in what Paris meant to her. Clara soon knew, and encouraged her; as a result, Rilke, too, soon found out.

Paula's letters from this time portray Otto as imperturbably content with what Worpswede had to offer, but his journals reveal the same inner conflicts as always. On November 5 he was persuaded of the justice of Paula's dissatisfaction with Worpswede:

> Had a thorough and deep conversation with Paula. . . . Our life has become too monotonous, philistine. Paula suffers very much from that. At first I didn't accept that—but was not justified. Paula is right. The things that made our marriage so fine during the first period, an exciting active life, full of content, experience—we have fallen very far away from that. A great mistake, Worpswede: one gets stuck in the swamp, one turns sour too easily here.

On December 11, though, he was in a funk, rejecting the work Paula had done under the influence of her Paris visit as "a huge squandering of her powers":

She paints life-size nudes, which she can't do, no more than she can paint life-size heads. . . . A great gift for color—but unpainterly and harsh, particularly in her completed figures. She admires primitive pictures, which is very bad for her—she should be looking at artistic paintings. She wants to unite color and form—out of the question the way she does it.

This entry spills over into the kind of speculations about women artists that were typical of Otto's worst moments:

Women will not easily achieve something proper. Frau Rilke, e.g., for her there is only one thing and its name is Rodin; she blindly does everything the way he does it—drawings, etc. That is very false and superficial—what are her own qualities, does she have any? Fraulein Reyländer also wavers back and forth, arrogant like all talented women. . . . Paula is also like that. She won't budge either, and closes herself off to sensible insight or advice—she will shatter and destroy her powers, I'm afraid—if she doesn't soon change her ways.

By December 20 he had again changed his tune:

I am more than happy, for I know now, finally, that we are on an upward path. . . . Summer was enormously profitable for me with all my painting and then the studies I did—and at Paula's side with her masterful still lifes and sketches, the boldest and best use of color that has ever been made here in Worpswede.

Before Christmas Rilke returned to the area to be with Clara and Ruth, and he visited Paula in her studio as he had often done years ago. This time he finally got to know some of her work, and it impressed him greatly. In what was probably a conscious attempt to further her career, he wrote to his new patron, the influential collector von der Heydt:

The most remarkable thing was to see Modersohn's wife in the midst of a very important stage in the development of her art; I found her painting relentlessly, as though driven; the things and objects of Worpswede and yet which nobody else had seen or could paint in that way. And they were, in their own very individual way, strangely close to van Gogh and the direction which his painting took.[11]

Belatedly but permanently, this discovery of the depth of Paula's gift and the boldness of her progress transformed Rilke's perception of her. Now

that he saw her as an estimable artist by his own extremely high standards, he came to feel a virtually categorical allegiance that expressed itself in terms of his own personal myth: it meant that, like him and (necessarily) like Clara, she simply must come to Paris. In their personal contacts, Clara had been urging this course for some time: "Paris in autumn," she had written Paula from Meudon in October. "That is something that you must experience. Follow my example and surprise us with a firm decision."[12] Now Rilke, too, became an active conspirator in the cause of bringing Paula there, against the opposition of Otto and of that part of Paula herself that hesitated to take the step: the cause, in other words, of freeing her from Worpswede and from Otto. One small concrete step that the Rilkes took was to buy one of her paintings, *Infant with Its Mother's Hand,* from 1903, an act as vital to her morale as it was to her purse.

After Christmas, and well into January 1906, Paula and Otto traveled first to the home of Carl Hauptmann and his wife at Schreiberhau, where they met, among others, the economist and sociologist Werner Sombart, of whom Paula painted, either then or later, one of her most striking late portraits. It was clear that Sombart had made a strong impression on her. They went on then to Dresden and Berlin, both of which offered large painting collections that they visited eagerly. Like a three-day trip they had made to Westphalia along with Vogeler in early November, on which they had visited the vital collection of modern work at the Folkwang Museum, in Hagen, this trip was meant to give Paula the contact with stimulating people and important new works of art that she missed so utterly in Worpswede. It was the right medicine, but too little and too late. Paula knew, as she enjoyed it, that she would be leaving. She was biding her time and gathering strength, and a great hope for her future as an artist was possessing her. Otto, though he saw the problems and did his best to address them, did not believe that Paula might go so far as to leave him.

February 1906 was for Paula a time of agonized waiting. She had chosen to act, but felt that she had to endure this knowledge in silence past certain milestones: her thirtieth birthday, February 8, which long ago she had set as a kind of deadline for realization of her artistic hopes; Otto's birthday, February 22; the departure of her mother and her brother Kurt on a long-planned trip to Italy, which would make it impossible for them to intervene immediately in the coming crisis.

Clara called at Paula's studio on her birthday. They spoke of ways in which Paula might finance her stay, but more importantly, Paula took

her friend into her confidence on a matter that she and Otto had—naturally—kept secret, one whose secrecy I have chosen, as long as it remained hidden from even the couple's closest friends, to honor, though the Modersohn-Becker marriage can hardly be understood without it. A stunned Clara passed the news on immediately to her husband in Paris:

> [Paula] says, that for these five years she has lived unmarried; actually, that the man at whose side she lives was incapable, because of nerves, of completing the sexual act. That she herself had felt and experienced nothing but a great disillusion; that for a time he has been less nervous—but that for her naturally any rapprochement would be pointless, without meaning—in other words, impossible.[13]

In the "thorough and deep conversation" shared by Paula and Otto on November 5, Marina Bohlmann-Modersohn reveals, Paula had made it clear that she found the ongoing absence of sexual consummation intolerable.[14] While Otto, too, attributed the problem chiefly to his nerves, he would also say later that he had feared impregnating Paula, whom he thought better suited for art than for motherhood, and whom he feared losing in childbirth. Otto's journal entry shows that he had thought the problem solved and now hoped that she might conceive, though Clara's letter makes it clear that Paula was far less sanguine.

Clara's letter goes on to reveal the depth of Paula's desire to bear a child:

> She herself believes in her ability to bear children—and would still like to achieve this goal—even on her own, without a man. It's very strange—she means to do all that—and wants to represent [Otto's impotence] above all as the occasion and cause of the separation, because he doesn't understand the other reasons.

We know the other reasons very well—the limitations of Worpswede, the ambivalence of the older, more settled Otto toward his wife's determined modernism. Looking back in light of this newly revealed reason over the story told so far, we can see more fully the isolation felt at times by both partners, Paula's unmet needs and the periodic irascibility and jealousy of Otto Modersohn, who must have feared infidelity during her stays in Paris. We understand that a potential healing force was lacking that might have closed the rifts between them. Paula's writing in a letter to her sister "half of me is still Paula Becker" takes on a new, rueful subtext. An irresistible biographical reading attaches itself to Paula's 1905 self-portrait in white dress with red rose, as she appears subdued and

uncertain in the presence of conventional symbols of virginity and of sexual love.

It is hard to resist speculating about the effects on Otto of the burden of guilt left by his having fallen in love with Paula before his first wife's death, and been away from her bedside at her death because he had, in essence, followed Paula to Paris. His fear of losing Paula in childbirth was powerful and, alas, prescient. Those inclined to blame Paula for leaving Otto would surely have been more understanding had they known of this state of affairs. But we can no more perceive this new revelation as the *real* reason for Paula's leaving than we can ignore it—especially if we resist the temptation to see this marriage through late twentieth-century eyes. It is possible that, if Paula had thought that staying with Otto served her art, she would have stayed, tried hard to see in Otto's decreasing nervousness a hopeful sign, and made the best of the life she had.

By February 17, when Paula wrote Rilke thanking him for kind words about the painting he and Clara had bought and for various other small services he had provided to ease her way, she had quietly moved to her studio at the Brünjes's the few belongings she meant to take with her to Paris. "The ground is burning a little beneath my feet," she wrote. "But I'll stay here until the end of this month so as not to upset my family. . . . Later, when we are apart, will be the best time to come to an understanding with them. Or not." Echoing, consciously or not, her favorite Gerhart Hauptmann play, *The Sunken Bell,* she closed the letter this way:

> And now, I don't even know how I should sign my name. I'm not Modersohn and I'm not Paula Becker anymore either.
> I am
> I
> and I hope to become I more and more. That is surely the goal of all our struggles.

Paula forgot, under the pressure of events, to mail this letter the day that she wrote it, and later added a postcript moving up the day of her departure. She also asked Rilke whether she might be able to see him before his own imminent departure—he was leaving to read and lecture on Rodin in a series of German cities. In his answer, Rilke expressed thanks "that you take me with you into your new life, which I am happy to see and take part in as your friend."[15] He promised either to meet her train or, if that proved impossible, to call later at the room she had arranged for at 29, rue Cassette, the same address as she had had on her two previous stays.

To Rilke, Paula's decision to act was an acknowledgment that he had been right all along: that the claims of Worpswede and Otto negated the claims of her art; that she belonged in Paris—and that Otto did not. While we understand Rilke's need to have it so for Paula in order to buttress his own case for having made similar choices, it would be naive to separate completely his satisfaction at Paula's being freed from Otto from the pain and confusion he had once felt on learning of their engagement. Recalling this, too, adds to our perception of the stance he would take in the Requiem toward their reconciliation.

That Paula had not dared let her sister Herma, still in Paris, know what was coming—in fact, had let the subject drop lest out of family loyalties Herma betray her—is suggested by a letter that Herma wrote to her mother on the day of Otto's birthday itself: "Today is brother-in-law Otto's birthday. The good fellow will be happy to have his wife with him this time and not hopping around Paris the way she did last year. That wounded him deeply. Paula seems to have given it up for now."

But in the night that followed Otto's birthday, while he slept, Paula slipped away. One would like to be able to reconstruct the scene—how did she leave? Who, if anyone, helped her get away—Clara? What sort of note, if any, did she leave? But the purpose of her departure is clear: to call an end to a marriage that had not met her needs; to pursue her work beyond limits that this marriage and the Worpswede setting had seemed to impose on it. Rilke, too, we must not fail to notice, had once slipped away from Worpswede without goodbyes. Later, he had left again, this time for Paris, after his own much briefer attempt at marriage and a settled life. Paula was never more in agreement with him on fundamental matters than when she too set out to put Worpswede behind her.

Arriving in Paris on the evening of February 24, she wrote in her journal, "Now I have left Otto Modersohn and am standing between my old life and my new life. I wonder what the new one will be like. And I wonder what will become of me in my new life? Now whatever must be, will be."

Twelve

Paula did not stay long at rue Cassette; she soon left for a new studio at 14, avenue de Maine that was cheaper and a better place to work. The Bulgarian sculptor she had met on her previous stay made her some crude furniture out of pine boards. In addition to attending drawing classes at Julian and anatomy and art history lectures at the École des Beaux Arts, Paula threw herself into painting in her new studio. Her sketchbooks show that she found time to roam the Paris streets capturing images of "her city."

The first letter that Paula wrote to Otto from Paris is no different from a letter she might have written after any of her earlier, sanctioned arrivals; it does not acknowledge any crisis in the marriage. Sister Herma, it says, was surprised at her sudden appearance, and appeared troubled by something; Paula claims not to know what it might be. While Herma Becker would spend a good deal of time with Paula in the coming weeks, her letters to other family members show that she believed as they did that Paula was in the wrong, and exhibiting again the egotism with which she had been charged at times ever since adolescence. Despite her disapproval, though, Herma Becker not only sat as model for her sister but visited her often and accompanied her on outings. Over the Easter holiday, Herma and Paula undertook together, at Otto's suggestion as well as his expense, a trip through Brittany, that fertile spot for painters, particularly Gauguin. It is usually assumed to have been Herma who, when Paula began her nude self-portraits, helped her by photographing her in the poses in which she painted herself. When

Herma left Paris on the first of July, Paula would miss her greatly and feel even more alone.

In his answer to Paula's first letter, Otto made no effort to hide his feelings:

> I ran in vain to meet each mail delivery; finally I stopped because I could not hide my agitation from Kellner [the postman]. . . . I've had not one night of sleep—I can't paint a single stroke—can't read a word—you can imagine how I live. I can only write, write to you. . . . Paula, all the boxes and chests, all the drawers are empty—what a discovery! That I was so blind![1]

He pleaded for her return, promising to make all the changes she asked for, but Paula's letter of March 2 shows the firmness we have seen her exhibit as far back as the letters she wrote to her Aunt Marie as a teenager:

> For the moment let us not even talk about this; please let it rest for a time. The answer, which will come by itself, will be the right one. I thank you for all your love. The fact that I am not giving in is neither cruelty nor hardness. It is difficult for me, too. I am acting the way I am because I know for certain that after another half year, if I don't finally put myself to the test now, I would be tormenting you again.

If I don't finally put myself to the test—these words create the most productive context for understanding Paula's flight to Paris. The vital question is this: did she pass—in her own mind, for it was self-imposed—this test? It was a test to be passed or failed in her art, which meant everything to her—not, finally, in her decisions about marriage or living arrangements.

Paula's letter of March 9 makes it clear that her attempts to close the subject of a reconciliation had no prospects of success:

> Your many long letters lie before me. They make me sad. Over and over again there is the same cry in them, and I simply cannot give you the answer you would like to have. Dear Otto, please let some time pass peacefully and let us both just wait and see how I feel later. Only, dear, you must try to grasp the thought that our paths will separate.

While insisting throughout on the possibility of a final parting, Paula just as consistently deferred the final decision, asking Otto simply to wait until she had done what she needed to do.

Otto's letter of March 22 takes his accomodating stance to greater heights than his earlier letters:

> You seek experiences—good, go out and look for them, and if a love affair calls to you, pursue it; I remain true to you, and wait for you, because as ever you are the world to me.
>
> You seek freedom. Take every kind of freedom, ripen, travel, live apart from me for a time, do everything that your nature requires.[2]

Paula's letter of April 9, while it may show a small shift in tone in response to some skillfully applied emotional pressure, affirms her determination to finish what she has started:

> I have just finished reading your letter. It moved me deeply. I was also moved by the words from my own letters that you quoted. *How* I loved you. Dear Red, if you can do it, please hold your hands over me for just a little while longer, without condemning me. I *cannot* come to you *now*. I *cannot* do it. And I do not want to meet you in any other place, either. And I do not want any child from you at all, not *now*.

Determinedly seizing on the positive, Otto wrote in his journal, "The first ray of hope from Paula!"[3]

Otto had written a candid leter to his friend Carl Hauptmann acknowledging his own failures in the marriage, even the absence of consummation, and attributing Paula's discontent to her childlessness; Clara, he added, had reinforced her most negative thinking. Hauptmann's answer of April 15 urged him to be firm: "Be proud and hard! What you are is what you are. The brave man bears his wound in silence and laughs outwardly. If you are cold, your wife will become warm." Hauptmann wrote bluntly to Paula as well: "It was not difficult to recognize in you that vague and transient longing without object that prepares human beings for adventures at all costs."[4] In her answer, Paula matched his bluntness:

> I put myself *totally* in Otto Modersohn's hands and it has taken me five years to free myself from them again. I lived at his side for five years, and he never made me his wife; that was torture. And if he is suffering now, I have truly had my share earlier.[5]

She goes on to emphasize fundamental differences in values: "My feeling toward him at the moment is such that I would not be capable of having a child with him, and I would not at all like knowing that my child

would grow up around him. He is a philistine and repressed in every single way." Hauptmann was unmoved, seeing the only hope in Paula's coming to her senses: "May the wellspring of healthy, clear feelings flow again for that lonely, creative life," he wrote back, "which you, either from ignorance or weakness, call philistine." He went on to a dire warning: "You speak of love! It has a thousand masks. The one you call love, who knows if nothing more than a straw doll is hiding behind it? . . . By the end of the play Lear, too, knows where love was, but he looks for it there in vain. You must also be careful!"[6]

Marina Bohlmann-Modersohn deduces from Hauptmann's letters to Paula that he knew somehow of an involvement with another man.[7] She proposes that it was Hauptmann's acquaintance Werner Sombart, whom Paula had met on her visit to Hauptmann with Otto the previous winter, and whom, this scenario proposes, she painted not then but later, at her studio in Paris.

From the beginning, Paula found it necessary, though painful, to ask Otto for favors while continuing to refuse his entreaties. She needed first some drawings from her studio to submit to the École des Beaux Arts, then some citizenship documents. But soon, more painfully, she needed to ask for money: first for single sums, and then for one hundred twenty marks on the fifteenth of each month so that she would not have to go on asking. In each case, Otto sent it. Paula was doing what she could—had sublet her studio at the Brünjes's for twenty marks a month—but it was clear from early on that lack of money was the weak point in her plans, leaving one tie that she could not hope to cut.

Art, we must not forget, was in any case the point of Paula's being there, and the spring of 1906 was a joyously productive time for her, reaching its greatest heights in May, a month so full of revelations that it challenges the writer to convey in linear narrative all of its nearly simultaneous components. The greatest external spur to these accomplishments was a vital experience of recognition. Early in April Paula had sought out German sculptor Bernhard Hoetger, who was in Paris studying with Rodin, and by whose work she had been impressed in Germany and then in the Salon des Indépendants. Though Paula and Hoetger spoke intensely about art, she did not at first tell him that she, too, was a painter; her familiar secretiveness is evident. Likely she presented herself to Hoetger at first in the way Rilke had once presented her to Rodin: as the wife of a distinguished painter whose name would have been well known to him. Hoetger's retrospective account, perhaps not untainted by self-interest, describes how, at a further meeting, on

May 4, Paula finally made herself known, and he told her just what she desperately need to hear:

> she let a little sentence slip out: "Well, yes, I would certainly have done that differently." What, you paint? And then a modest "Yes." I got up, and for the first time I went into her studio, full of curiosity. There I experienced, quietly but full of emotion, a miracle. She hung on every word from my lips. The only thing I could say to her was: "All of them are great works. Remain true to yourself and give up further instruction."[8]

Herma Becker happened to drop in during Hoetger's visit, and described it in a letter to Otto in which, for a time, she became so caught up in the drama of Paula's "discovery" that she forgot whose side she was on:

> Höxter [sic] looked at her things and was very impressed by them. "Magnificent, very fine," etc., he kept repeating things like that, very softly. . . . I just happened to drift in at the time and watched and listened and rejoiced at seeing Paula's big eyes, so eager and humble, drinking in this revelation. Yes, now she is firm as a rock and has faith in herself and is working. New work simply pours from her hand. . . . She won't even rest on Sunday. It's nothing but paint, paint, paint—something will come of this! . . . Amazing how one's star sometimes leads us down winding paths! We must abandon ourselves to it and not ask where they lead.

Paula wrote to Hoetger the next day in terms that make palpable the depth of her need:

> That you believe in me is the most beautiful belief in the world, because I believe in you. What good is other people's belief in me if I don't believe in them? You have given me the most wonderful gift. You have given me myself. Now I have courage. . . . Now I have begun to believe that I shall become somebody. And when I think about that, I weep tears of joy.

Three days later, Paula sent Otto a postcard: "I'm getting there. I'm working tremendously. I believe I am getting there." To her sister Milly, mixing joy and bitter necessity, she wrote, "I am becoming somebody—I'm living the most intensely happy period of my life. Pray for me. Send me sixty francs for models' fees. Thank you. Never lose faith in me."

Paula's mother, in Rome with her brother Kurt, had not been told that Paula's latest departure for Paris was different from the others; only on her return in early May did she learn the truth. Like the rest of the family, she had seen nothing in Paula's art to justify the extremity of her pursuit of it, and so she saw Paula's behavior as a symptom of emotional distress. She perceived Otto as he wished to be perceived: as kind, long-suffering, generous to a fault, an innocent victim of his wife's obsessions. On May 8 she wrote her daughter a long, remarkable letter, informed by both loving concern and highly pointed emotional pressure to call her back to the bosom of her family—including Otto.

> You poor child. In your solitude you must have piled up every disappointment, every wound, until you had built a pyre, and one day it just went up in flames! . . . Oh, Paula, why didn't you come to one of us, to me, to Kurt, to Milly—and let yourself be loved and cared for a while until you were better?

The letter paints pictures of Otto, perhaps more revealing than intended, whose purpose is clearly to work on Paula's conscience:

> He has dragged your oil studies into his atelier and has surrounded himself with your still lifes. . . . He got your oils from the Brünjes and is painting the most remarkable things with them, pictures of stuffed birds and old jugs, and he's putting your still lifes next to them to compare whether he can duplicate the effect of your colors.

Finally, Paula's mother also reminded her of all the promises Otto had offered in exchange for her return:

> His great and mighty love for you is very moving. It fills his whole being. He often says to himself, "Oh, when I have her back again, the things I will do!" . . . "She will have everything. No more desolate winters. She shall have joy; she shall have Paris—everything, everything, if only I can have her back again!"

Arriving within days of Hoetger's first look at Paula's work, the letter had little chance of achieving its intended effect; Paula's answer made it clear that *she* was not suffering, but reveling in her newfound freedom: "I am beginning a new life now. Don't interfere with me; just let me be. It is so wonderfully beautiful. I lived the past week in such a state of excitement. I believe I have accomplished something good."

Paula had no intention of turning back, for she knew that she was passing her test.

187

The speaking tour for which Rilke had left just after Paula's arrival was interrupted on March 14, 1906, by the death of his father. Lou, at least, believed that, knowing the end was near, he had avoided arriving in time to see Josef Rilke alive.[9] But now he and Clara rushed to Prague, whereas his mother chose not to interrupt her yearly stay in Arco for the funeral. It was a genuine loss, for Rilke thought of his father with a fondness he had never been able to feel for his mother, and it formed an early link in a chain of deaths striking those close to Rilke that would culminate in Paula's and create a preoccupation with death that, by his own testimony, would dominate his life for years after.

Rilke returned to Paris on March 30, and the next day he spent three hours—breakfast and a walk—with Paula, writing to Clara afterwards on her condition: "She is brave and young and, it seems to me, on a good, upward path, alone as she is and without any help."[10] He lent her a hundred marks, and in the time that followed he did what he could to give her access to the world around Rodin. At the unveiling of *The Thinker* in front of the Panthéon in Paris, Rilke's party included Paula, the sculptor Maillol (who had been among the original Nabis, and whose work Paula admired), and Mrs. George Bernard Shaw. Shaw was having his portrait done by Rodin—a process Rilke had been watching in sheer fascination.

In those days just after Hoetger's visit, Paula must have conveyed to Rilke her rising joy in her new life and work, for he wrote her, probably on May 10, what is clearly a response to the news: "Dear Friend, Life, the truly good life, has taken you by the hand; you have every right to be happy, to your very depths. By the way, I wish you to know that your Rainer Maria Rilke is happy about you and with you."[11]

But on May 10 as well, Rodin abruptly expelled Rilke from paradise, leaving him thunderstruck. The reason given was that he had overstepped his bounds as secretary by adding a personal postscript in his own name to one letter regarding Rodin's business, and by writing a letter of his own to another correspondent whom he had met through Rodin. Writing to Clara the next day, Rilke adopted a tone of wounded loyalty, even suggesting that the master, in his wisdom, had seen his growing frustration with the burden of his secretarial duties and fired him for his own good. He assured Clara that he was "cheerful and full of anticipation."[12] To Rodin, he wrote a long letter firmly explaining his side of the matter, reminding Rodin that his invitation to Meudon had been made from friend to friend rather than from employer to prospective employee. Now he'd been sacked like a thieving servant, and was

"profoundly wounded."[13] Further on he compared his state to that of the disciples after the crucifixion. He chastised Rodin for not thinking of the effects on Clara of his own disgrace, and expressed his faith that the "immanent justice" in life would one day undo the wrong that Rodin had done him.

Rodin biographer Ruth Butler approaches the sacking from Rodin's point of view. As she sees it, a weary, ill, and overworked Rodin fired Rilke in a fit of jealous pique over Rilke's interest in Shaw. Rodin had been laboring mightily to finish Shaw's portrait, and at the same time preparing for the unveiling of the bronze *Thinker* in front of the Panthéon. His work had never ceased to be controversial; when a patinated plaster *Thinker* had been installed in the spot two years earlier, a deranged worker had hacked it to pieces with an axe. The unveiling of the bronze in this place of honor would be a public triumph of the kind that Rodin, for all his successes, craved deeply; as a result, he was nervous as the day approached, and frustrated at having to work at the Shaw commission at the same time. Even after the inauguration, Shaw, says Butler, although he thought Rodin one of the great geniuses of the age, had been unable to resist turning the sitting into a contest of wills. She cites Shaw's expressed determination to see to it that Rodin portrayed him as an intellectual, not "a savage, nor a pugilist, nor a gladiator."[14]

Shaw's last sitting, Butler points out, took place on May 8; Rilke's sacking just two days later. She continues this way:

> The week of the "geniuses"—three generations, three languages, three different art forms—along with the inauguration of *The Thinker* must have raised the level of tension beyond what Rodin could bear. He needed a great deal of support, and apparently he resented his protegé's losing his heart to a new hero.[15]

Not knowing where to turn, Rilke moved to a room at a familiar address: 29, rue Cassette, where Paula had lived on two previous sojourns and at the outset of this one. Once he had recovered from the initial shock, he would take up the work of his own that his duties in Meudon had kept him from: revision of *The Lay of the Love and Death of Cornet Christoph Rilke* and preparation for publication of the complete *Book of Pictures,* for which he was writing new poems, especially the series "Voices." These tasks Rilke accomplished, largely, in May and early June. In late June and all of July a flood of new work would appear, much of it deeply indebted to Rodin; it would find its way into the second, expanded edition of *New Poems.*

Within a few days of his expulsion, Rilke had agreed to sit for his portrait with Paula: a highly practical gesture of support. This meant that they would be seeing each other almost daily at a time when both were floating free of the lives they had been living: Paula at a height of euphoric fulfillment, immune to the claims of husband and family; Rilke, far from his wife and daughter, at first stunned and disoriented, but before long aware that he, too, was entering a vitally productive period. Though we cannot know everything about their interactions at this time, it was the most profound and artistically significant encounter in their troubled friendship, without which Rilke's Requiem would be inconceivable.

Paula wrote little to Otto in those joyous weeks at the beginning of May. This is the beginning of the long letter that she finally wrote him on May 15:

> These last two weeks have gone very well for me. Night and day I've been most intensely thinking about my painting, and I have been more or less satisfied with everything I've done. I am slackening a little now, not working as much, and no longer so satisfied. But all in all, I still have a loftier and happier perspective on my art than I did in Worpswede. But it does demand a very, very great deal from me—working and sleeping in the same room as my paintings is a delight. Even in the moonlight the atelier is very bright. When I wake up in the middle of the night, I jump out of bed and look at my work.

Telling Otto about Hoetger's response to her work, she felt the need to assure him that Hoetger was married and devoted to his wife, "no reason for jealousy." Knowing that it would not please him, she did not mention the prospect of painting Rilke.

Paula's letter crossed one of Otto's in which he made a confession and an attempt at self-justification.

> In the first years, because I loved you too much, I did not want to see you become a mother, I couldn't bear the thought that your life would be in danger; I wanted you, your self, your spirit. (I couldn't help thinking that Rembrandt had lost his Saskia to childbirth.)[16]

Partly because they had expressed interest in buying several paintings, Paula was in touch with both Heinrich and Martha Vogeler. This letter of May 21 is addressed to Martha:

Yes, we shall remain "family," in spite of everything, even if I'm not with you. I am not sick at all, despite what Otto Modersohn thinks. I am in very good shape and ecstatic about my work. I know that I'm doing the right thing, even though I naturally have sad feelings about Otto Modersohn and Elsbeth and my own family.

All the previous week, she added, she had not left her studio until late in the evening. This suggests that she had accepted Hoetger's advice that she take no further instruction.

On May 26, Paula wrote in her journal, "When I read Otto's letters they are like a voice from the earth. And I seem to myself like one who has died and now dwells in the Elysian Fields and hears this cry from the earth."

With so little money for models' fees—and feeling the pull of Cézanne—Paula painted a series of intensely realized still lifes of flowers, fruit, small domestic objects. In the Requiem, Rilke proceeds through praise of these to the most remarkable paintings from this time, the nude self-portraits, in which she dared a stripping away of the social self virtually unprecedented among female artists:

> For that is what you understood: ripe fruit.
> You laid it down in bowls in front of you
> and measured out, in colors, the weight of each.
> [. . .]
> At last you saw yourself as fruit, you took
> yourself out of your clothes and brought yourself
> before the mirror, then let yourself go in,
> all but your gaze, so great it stayed outside
> and said not: I am that; no, said: this is.

We have seen from the beginning Rilke's fondness for using the world seen in reflections—in mirrors, in bodies of water, in Paula Becker's eyes—now as metaphor for an inner world of essences not surfaces, now for the immaculate other world of art. Paula's body, says Rilke, entered that world where it was, in essence, a fruit, but her artist's gaze, those brown, *seeing* eyes he had remarked on so soon after meeting her, had remained outside. The procedure as he represents it was, for Rilke, exemplary, an essential component of the story he told himself about what art was.

There is clearly one of the nude self-portraits that answers Rilke's characterization—"at last you saw yourself as fruit"—more fully than any of the others. It is one of two versions, the brighter, of what has

come to be called *Self-Portrait as Half-Nude with Amber Necklace.*[17] It is a still life of flowers as well as fruit. In each hand Paula holds a pink flower; there are three pink flowers of the same not quite specifiable kind in her hair, and white flowers on the stylized bushes behind her. As in the other nude self-portraits, she wears a necklace of large amber beads. It is chiefly in the broad modeling of cheeks, neck, hands and arms, especially breasts with various darker tones, all containing an element of red or pink, that the sense of flesh as fruit is summoned and the painting comes to resemble most markedly some of the still lifes of fruit that Paula was painting at the same time. The bright pure red of the lower lip, answered more mutedly in cheeks and nipples, gives the whole a touch of the luscious that is unquestionably erotic but, unlike Manet's Olympia or even a Matisse odalisque, in a pure, impersonal, asocial way that must stem in part from the fact that the painter's eye and hand, as well as the subject, are female. The bodily eyes, in the mirror world, are all inwardness: though animate, their brown faintly inflected with the red of the lips, they are not looking outward. Like the body, like fruit, they simply and radiantly *are.* As it is by fruit, fertility—fruitfulness—as impersonal life force is embodied and radiated by the image here. Rilke, with his stunningly acute, utterly subjective eye, has got it exactly right. This painting says precisely: This is. Fruit.

We have the grainy mirror photograph from which Paula worked in creating this painting.[18] The pose makes it unmistakable, and this small similarity points up a world of difference. In the photo we see Paula herself, in her studio, in the exalted, weightless freedom of her spring in Paris, looking herself and us in the eye, living, judging, and boldly recording her life, posing, composing, and preserving at once. Knowledge of what lay ahead of her clouds our response to seeing her this way; before meeting her fate she was both eager and vulnerable. We know all too well what will happen to the woman in the photograph. It is a heartrending document.

Seeing the photograph, we see that the transformation in the painting is absolute. (Paula, says the Requiem, has "transformed / so much more than any other woman.") Desire for a child is, we know, present in the woman in the photograph. But this desire is not present in the woman in the painting; no desire is, at all. It need not be there because in the painting nothing is missing. Fruitfulness is everywhere immanent. For Rilke, as we have seen, this was exemplary. He follows his praise of the holiness of Paula's impersonal gaze with an attempt to fix the moment of that painting as the one in which she was her best self, the

one by which he would have chosen to remember her: the moment, to use the phrase of Niels Lyhne's that both knew so well, when he had loved her best: "So it is I'd keep you, as you placed / yourself inside the mirror, deep inside, / beyond all things."

But ever unable to be only the woman Rilke wanted her to be, Paula has come back to him in the Requiem very differently. It is equally possible to identify the painting that lent Rilke his image of the misguided and terrifying Paula who haunted him. It was done on her sixth wedding anniversary, May 25, in the middle of Rilke's portrait sittings, and so he would have seen it. We can date it so precisely because she gave it this inscription: "I painted this at thirty years of age on my sixth anniversary, 1906." The age of thirty was her self-imposed deadline for "becoming someone" in her art; the anniversary invokes the conflicting demands of her marriage. Paula initialed the inscription "P.B." As the signature of the letter Paula wrote Rilke just before leaving Worpswede ("I'm not Modersohn and I'm not Paula Becker anymore either") makes clear, Paula was alert to the interpretations that could be placed upon all the forms of her name that, following the conventions of the day, were used as a matter of course after her marriage: she was Paula Modersohn, Paula Modersohn-Becker, occasionally Paula Becker-Modersohn. Only her maiden name was conspicuously incorrect, and its use was an unambiguous assertion that she now stood outside that marriage. In letters of the period, Paula signed many versions of her name. Most of the letters to Otto and others, when they use any last name or initial at all, are signed Paula Modersohn or Paula M. One letter to Martha Vogeler is signed Paula Modersohn, but contains a postscript initialled "P.B." A note to Rilke from July 31 is signed, "Your Paula— — —?"

In the painting, Paula is draped only at the hips. The amber necklace we have seen before is the only adornment, and her abdomen, framed by her hands in a mutely expressive gesture, is so prominent that she is widely taken to have depicted herself as pregnant. That the woman in the painting is Paula is unambiguous; her features are more specifically and pointedly reproduced than in many of her other self-portraits, although not without a whisper of the good-natured irony about her appearance that is common to virtually all of them. That her hands frame her abdomen clearly introduces the issue of pregnancy, but it is less clear that a literal state of pregnancy, rather than a wish for it or dream of it, is depicted. If this is the body of a pregnant woman, then her pregnancy is not very far advanced. In none of the nude self-portraits does Paula represent herself as slender, for not since her youth

had she been so. The one full-length nude self-portrait that culminates the series depicts a full-bodied woman whose abdomen would have appeared equally prominent without need for pregnancy as an explanation. For decades the anniversary painting was not typically read as *depicting* pregnancy; this interpretation was made popular in 1961 by Carl Georg Heise.[19] It may even be that, if the picture is interpreted attentively enough, it is rather the absence of pregnancy that Paula's hands announce.

But what is most striking about this painting, when compared to Paula's other self-portraits nude or clothed, or to most self-portraits we know by other artists, is the unceremonious immediacy with which it conveys the presence of Paula Modersohn-Becker herself. It is not an icon; the pose is not ceremonial; she holds none of the mutely symbolic objects—lemon, orange, camellia branch—that appear so evocatively in the other self-portraits from this time. The inscription is personal: the speaker is *I,* and the time references are of strictly personal significance. Up close, the eyes in the portrait are blank brown dots, but from a slightly greater distance, especially from the figure's right, the direction in which she looks though her body is turned slightly to her left, they engage the observer's eyes with a compelling human look. Naked from the hips up as she engages the observer in this way, she blushes fulsomely: an immediate human response to nakedness in the presence of another. The nose is Paula's long, upturned nose, also captured in Clara Westhoff's busts of Paula, and often the vehicle by which irony enters Paula's self-portraits. The mouth, closed, conveys a determined composure, barely hinting perhaps at a smile. The breasts are depicted in a way that evokes neither erotic interest nor symbolic interpretation; they are simply a woman's breasts. The abdomen, clearly, is the single impersonal element, visible sign of woman's role in a suprapersonal process. This aspect of the painting is best captured by Christa Murken-Altrogge: in the painting, she says, Paula represents herself as "a vessel which desires equally to bear the fruit that is a child, as well as the fruit that is art."[20] Whether or not we would wish to force the woman artist to see a dilemma in these two desires, they presented a highly personal dilemma to Paula—one that she tried persistently, first on one tack and then on another, to resolve. For the rest of her life, the outcome of her struggle would be at stake in her every action, every choice. But what we see here is an uncannily living and *present* person asserting herself across nearly a century, in the words of Brigitte Uhde-Stahl, as "woman, artist, human being."[21]

Like the nude photograph already mentioned, with which it has much in common, the anniversary self-portrait is antithetical to the *Self-Portrait as Half-Nude with Amber Necklace*. It takes place, however ironically, not in the ideal mirror world of art but in the world of anniversaries, family relationships, roles, and careers, where a woman's nakedness is an occasion for a blush. The body in it is not a fruit, not so *essential* as to be impersonal; it is one woman's body, and the painting as a whole says precisely "I am that"—*that* being, as we have said, woman, artist, human being. This is the painting's distinction and its essential difference from the other self-portraits, unclothed and clothed, that Paula painted after her flight to Paris. It is a fascinating anomaly.

Here is Rilke's account of it in the Requiem:

Why disavow that, what would you have me believe:
that in the amber beads around your neck
some heaviness remained that has no place
in the mirror of a painting wholly at rest?
Why show me, by your bearing, some bad omen;
why display the contours of your body
as if they were the lines in the palm of a hand,
which I can see now only as your fate?

It is the gesture in the last four lines that makes the identification unquestionable. Framing her womb with her hands, Paula had identified herself as woman, fertile if not necessarily pregnant, and in Rilke's mind foretelling her unfortunate fate. It is in this painting and no other that the untransformed weight of human desire—the desire for a child, which to Rilke was in Paula's case sheer error—is not only unmistakably present, but central.

For Rilke this pose, however we interpret it, would have linked itself to the shocking news that Clara had passed on to him after her birthday visit to Paula three months earlier: that the marriage had gone five years unconsummated, and that Paula had thought of bearing a child on her own in Paris. It may well have been news that Rilke had no wish at all to know. Rilke found this painting appalling, antithetical to the one he had just praised as exemplary. He felt personally addressed by it ("Why show me . . . ?"), and it haunted him.

The amber beads, as they appear in this painting, are Rilke's emblem not of Paula's fully transformed, weightless, and thus exemplary image of self as fruit, but of the failure that has led her astray. And through the amber beads *Niels Lyhne* enters the painting, immeasurably heightening

Rilke's sense that it spoke to *him*. In one of the novel's most richly evoked and fateful scenes, the young woman Fennimore, whom Niels loves but who has chosen his close friend Erik Refstrup, is alone in the house she shares with her husband, now a failed painter and a drunkard. It is Fennimore whom Niels has earlier admonished to remember Erik at the moment when she loved him best. In this scene he is off on yet another drunken escapade, and Niels, now Fennimore's lover, may or may not skate across the fjord to be with her:

> Fennimore was walking up and down the room almost as if she were balancing on a red stripe in the carpet. . . .
> She was humming to herself and holding with both hands a string of large pale yellow amber beads that hung from her neck. Whenever she wavered on the red stripe, she would stop humming, but still grasped the necklace. Perhaps she was making an omen for herself: if she could walk a certain number of times up and down without getting off the red stripe and without letting go with her hands, Niels would come.[22]

Who would have seen, in the mute iconography of the amber beads, an encoded reference to the doomed relation of Niels and Fennimore? No one more than Rilke, whose intimacy with this book was unequaled. For years he had seen himself as Niels in the mirror of Jacobsen's work, and Paula, it would have seemed to him, now saw herself as Fennimore.

The scene in which Fennimore fingers her beads and prays for Niels to come is drawn out deliciously, as is the the series of scenes in which Niels and Fennimore become ever more intimate "friends" before being swept away by the forces that will make them lovers. Here is another passage, only slightly further on, that makes clear the depths of Fennimore's passion:

> She went over to the window again and stood gazing out, till the darkness seemed to be filled before her eyes with tiny white sparks and rainbow-colored rings. But they were only a vague glimmer. She wished they would be transformed into fireworks out there, rockets shooting up in long, long curves and then turning to tiny snakes that bored their way into the sky and died in a flicker; or into a great, huge, pale ball that hung tremulous in the sky and slowly sank down in a rain of myriad-colored stars. Look! Look! Soft and rounded like a curtsy, like a golden rain that curtsied.—Farewell! Farewell! There went the last one:—Oh, if he would only come!

Both Fennimore and the reader anticipate a tryst, but instead of love it is death that arrives: when someone taps at the window, it is not Niels but a messenger bearing the news that Erik Refstrup has been killed in a drunken carriage ride. When Niels does arrive soon after, Fennimore curses him for having led her to betray her husband, and in the morning she disappears from his life and from the novel.

If, in a possibility that, once perceived, is difficult to dislodge from the mind, the old, mildly guilty pleasures of Paula's and Rilke's breathless exchanges under the heading "Dear Friend" had been lived out, consciously or not, under the sign of the time in *Niels Lyhne* when Niels and Fennimore's pact of friendship had licensed them to spend increasingly intimate hours together, savoring the slow but inexorable approach of sexual passion, then this figure itself would have created a pull toward consummation of the relationship. If Rilke and Paula were Niels and Fennimore, they must become lovers.

Whether they ever did so is an often asked, never answered question. Typically, Rilke biographer Wolfgang Leppmann, noting that after the end of the portrait sessions Rilke seems to have avoided Paula, edges up to it this way:

Was it really only work that caused him to behave so stand-offishly toward this woman who was in need of companionship, or was he suffering from the wound just dealt him by Rodin? Was he afraid of entering into a relationship with his wife's best friend . . . that, under the circumstances, might well have become intimate?[23]

Setting out, in the complete absence of direct evidence, to try to answer it, one encounters first a striking number of reasons why it might have been so. To Leppmann's considerations we add the knowledge, shared by Rilke, that Paula had spent five years in a sexless marriage she now considered over, and Bohlmann-Modersohn's assertion that she had an affair with Sombart. For his part, Rilke's sense of his obligations to Clara Westhoff as his wife was becoming ever less conventional; at just this time, he first began to feel free to write to other women what were unmistakably love letters, writing them first, in that early summer of 1906, to the woman he called "Madonna," the Princess Madeleine de Broglie. At just the time of the portrait sittings, too, Rilke wrote two *Tagelieder,* aubades, whose premise is that the male speaker awakes in the morning with a woman with whom he may not be seen in the light of day. The final line of "Oriental Aubade" is "for our souls live upon betrayal."[24]

Petzet passes on Clara's verbal account of the way in which the sittings were interrupted:

> Later, Clara Rilke still remembered clearly Rilke's stories about his portrait sittings, and finally about that second day of June, on which there came a sudden knock on the door of the studio. . . . The painter went to the curtain that served as a "windbreak," looked outside—and gave a start. Then she pulled the curtain closed again, turned quickly back to the room, and whispered to Rilke: "It's Modersohn."[25]

The unmistakable impression is given—perhaps originally by Rilke, perhaps by Clara in the retelling, perhaps only by Petzet—that the shock and disarray were like those that would have come from the couple's being surprised by Paula's husband in the act of making not art but love.

After a time, however, one's doubts reassert themselves. My own intuition is that Paula would have been more likely, in those dreamlike, transcendent weeks in May when social realities seemed scarcely able to touch her, to show Rilke some human need than Rilke to be able to face it. In the anniversary self-portrait, as framed in the Requiem— inside him—she had done precisely this. That Paula's eyes met Rilke's in life once with some such piercingly vulnerable look seems far from inconceivable; if so, it would probably have terrified him. For Rilke, too, it might well be less important that such consummation take place in the outer world, in Paula's studio or his apartment, rather than in the mirror of *Niels Lyhne* or of Paula's painting. This, then, is the best answer this book can offer to questions about the nature of the encounter between the two that spring in Paris: in the inner world, mirrored by Paula's painting and belatedly by the Requiem, it was extraordinarily, for Rilke even harrowingly, intimate. In the outer world governed by the literal senses of words, it was probably not.

It is far more important in any case to examine what unquestionably did happen in Paula's studio on a series of mornings between May 13 and June 2, 1906: Paula painted Rilke's portrait. It was the truest consummation of their encounter.

It is among the smallest works in her oeuvre: ten inches wide and less than thirteen inches tall. The small size is achieved not by a reduction in scale but by severe cropping: the head she painted is roughly life-size, but the top of it nearly reaches the frame, and the tip of the elongated and sparsely painted goatee nearly reaches it at the bottom. In this constricted space, which suggests both a diminution of Rilke and a need for firm

control of the process, Paula painted all she knew of him: weakness and strength, smallness and greatness, what she admired in him and what she did not.

The mouth, large and open, is the portrait's most striking feature. Along with his singular blue eyes—brownish, perhaps unfinished, in the portrait—Rilke's mouth is the aspect of his appearance most widely mentioned by those who have remembered him in print, typically being described as large and sensual to an incongruous degree, even to the extent of being likened to an open wound. One of the most memorable characterizations is by Rudolf Kassner:

> Rilke's face ends at the mouth, flows down into the mouth, as into the mouth of a river. After, or below, such a mouth there can be no chin worth mentioning. This great mouth, which was there in order that the words might gather into something great, greater, universal, had something sick, something dead about it. How well this fits his teaching that everyone should die his own death, give birth to his own death.[26]

As Günter Busch observes, the portrait is reminiscent of Paula's depictions of small children; Busch finds in it just the characteristics of Paula's late work that troubled Otto: "Hands like spoons, noses like cobs, mouths like wounds, faces like cretins."[27] That the mouth, in particular, conveys precisely the helpless, elemental appetitiveness Paula captured in the mouths of infants is the most strikingly apt characterization of the portrait I have seen. In relation to his work, Rilke was quite as helplessly absorbed in his needs as the infant in its most basic drives, and this characteristic, though it often gave rise to both self-reproach and the reproach of others, was an essential, enabling condition of his genius. The portrait strips him bare of his delicate, imperfect, always imperiled social exterior, revealing, in one light, the "nervous, even nervously encumbered and endangered, homunculus" that Lou Andreas-Salomé had seen (and described to Gerhart Hauptmann) at the moment of cutting herself free of him. And in an only slightly different light we see in it the fanatical Svengali he had seemed at his worst to some of those in Worpswede (including Paula)— the one who had seemed to hold Clara Westhoff in thrall in the early months of their marriage. We recall the confidence of Carl Hauptmann, who had not seen into Rilke's interior, that Clara, apparently so much more energetic and forceful, would soon burst out of her thralldom, and how wrong this confidence proved to be. The portrait reveals precisely what it was in Rilke that Hauptmann had failed to see.

And, undeniably, it shows Rilke the great poet. The case that this is so is made best in *Portrait of the Poet,* Heinrich Petzet's groundbreaking book on the relation of Rilke and Paula. To Petzet it is Paula's distinction in the portrait to have shown Rilke the poet he was to become, the poet of the *Duino Elegies* and *Sonnets to Orpheus,* long before he himself could imagine this future poet-self. Of the effect of a first look at the portrait he is utterly accurate:

the impression made by this picture, even or perhaps especially when one knows nothing of the man it depicts, is shocking [*erschreckend*]; not that it is ugly or repellent, and thus an unpleasant experience, but everyone who approaches the picture and engages it seriously finds it strangely shocking, and asks instinctively, that's supposed to be Rilke?[28]

Petzet is eloquent on the portrait's penetrating quality:

no gesture of explanation or mediation mitigates what is almost pitiless in this portrait. In it only this lonely visage is exposed, as if the skin were removed: a visage whose gazes extend into the inconceivable, perceiving neither the inner nor the outer world. Like that anemone in the Orpheus-sonnet that can no longer close itself because the light is too great, these eyes appear to ask:
But oh, in which of all our many lives
are we at last all open, all receiving?[29]

Petzet, too, finds that what is most uncanny about the portrait resides in its portrayal of Rilke's mouth:

It is the mouth of an ancient mask, from which stream the "sighs and laughter" of an entire world, and through which a god speaks, "as if his singing came from outside himself . . ." It is the mouth from which a single great cry of woe strikes the ear:
And if I cried out, who would hear me from out of the ranks of
angels . . .
It is the poet of the Duino Elegies and the Sonnets to Orpheus, which the portrait reveals to us as present—half a human lifetime before he finished these poems at Muzot. Thus his friend Paula saw him far in advance, and painted him before she died.[30]

Petzet's ultimate assertion is that the portrait thus becomes a depiction of "the poet" in the most absolute sense, as archetype. He would credit

Paula with having summoned Rilke to a mature greatness that he himself could not yet imagine. This makes her utterly vital to Rilke's development. "Fundamentally," Petzet writes as he makes this point at its most ambitious, "Rilke was always, though he never spoke of it, on the way toward her."[31]

Paula's flight to Paris was her boldest and most successful attempt to attain the pitch of abandon with regard to her own artistic impulses that came so naturally to Rilke in regard to his. We remarked early on that what members of the Becker family, and later Otto, were inclined to see in Paula as egotism was in fact the guarantor of her determination to make art, and that she had more of it than any of those around her except Rilke, in whom it rose to a level several orders of magnitude higher. The near ecstatic joy Paula felt early in her stay was the joy of surrender to these needs, after years of an increasingly uneasy compromise between them and the requirements of marriage and family. Thus the portrait, done very near the peak of this surrender, takes on a more positive than negative coloration: in a period of joyous freedom, Paula recognized and portrayed in Rilke a fellow artist on a level that, she knew, none of the other artists around her—Otto? Clara? Vogeler?—had attained. At the same time, she saw a wounded and fragmentary human being, the one that Rilke had revealed in his desperate letters to Lou in the years just preceding, whose terrors always threatened to overwhelm him and who dreaded the most elementary human obligations.

After the sittings were interrupted by Otto's arrival, Rilke declined to resume them. It is unclear, as a result, whether the portrait was ever wholly finished. If not, little more than the stiff, thinly painted, indistinct depiction of Rilke's beard—would she have given the eyes their famous blue?— would have required more work. It is possible that when Rilke ended the sittings she set the painting aside and, as full as she was of ideas, simply found no occasion to return to it. But even the strange depiction of the beard is well within the range of the lengths to which Paula sometimes went to achieve an effect she was seeking—extremes by which even those most familiar with her work can at times be shocked. Everything else in the portrait appears complete, and Paula could have brought the beard to a higher finish, if she had cared to, without further sittings. Another strikingly modern portrait of a literary figure, Picasso's depiction of Gertrude Stein, lay incomplete that summer after Picasso abruptly painted out the head in frustration and left for Spain. On his return, he completed it without new sittings.

Comparison of these two contemporaneous portraits is instructive, and honors Paula: at this highly charged moment in the development of a postimpressionist painting shocked by the Fauves and trembling on the verge of the cubist explosion, Paula's portrait is every bit as modern and "advanced" as Picasso's, and Paula had reached this state of development by a far lonelier road.

Rilke was extraordinarily sensitive to both photographic and artistic depictions of his person; in almost every case, including that of the portrait painted by Zwintscher in Westerwede in the summer of 1901, he rejected them and suppressed them when he could. There are several signs beyond his unwillingness to continue the sittings that this one struck him hard. The first is the same sort of silence on the subject that he later kept about Paula's death: he simply did not mention the portrait anywhere. Even in 1916, when Loulou Albert-Lasard completed her portrait of him, he referred to it as the first to be done since Zwintscher's, ignoring this one's existence.[32]

The painting shows Rilke with the goatee he had worn for years, and just weeks later he had it shaved, leaving only a mustache, as if he wanted to see in the mirror another face than the one the painting had revealed. And he wrote at just this time "Self-Portrait, 1906," widely taken to be a response to the portrait. As Petzet observes, the poem does not affirm the portrait but negates it. Rilke was making magic of his own to break the spell of Paula's, reclaiming from her the face she had appropriated—using his own procedure against him—for her own story.

In the build of the brows, an old, long-noble race's
steadfast standing. In the look of the eyes
childhood's uncertainty and blue, and in places
humility—not that of an underling, and yet
that of one who serves, and of a woman.
Mouth the essential mouth, large and precise,
pleading no case, pronouncing only justice.
The forehead clear, free of any taint,
in the shadow of the downward gaze content.

All this, in its relation, just now divined,
not yet, whether in suffering or success,
gathered to a penetrating force;
and yet it is as if, in scattered things,
true and earnest work were distantly planned.[33]

In the first week of June 1906, as we have seen, Otto Modersohn traveled to Paris in an unsuccessful attempt to work things out with Paula. The scene of his arrival during one of Rilke's portrait sittings suggests that she had not expected him. Herma Becker was present for some of their meetings, and her letter of June 8 to her mother pronouncing them a failure is our one direct source of information. "Otto," Herma says, "was touchingly decent, tried everything, promised anything." The letter makes it clear where most of the family stood: "What [brother] Kurt says I, too, feel very strongly: how unfair it is for so many people to have to suffer on account of one, that such power should be given to *one* person." Some of Herma's comments amount to a discussion of strategy for bringing Paula to her senses:

> The longer this stretches out . . . the harder it will be, because it will become almost a point of honor to her to accomplish what she is about. And for her to have to come back to all the people who will suddenly stare at her severely in judgment and whose sermons she has heard before is a very difficult thing indeed. I wonder if it was right of Otto to tell her all of it so openly, so that suddenly she saw her home as if it were a joyless vacuum.

This letter reminds us of the weight on Paula of societal expectations toward women: many would condemn her sternly as a wife for abandoning her husband, as a stepmother for leaving a small stepchild. Paula knew this; just two days later, she wrote to Carl Hauptmann, "I hope in the course of time you may get a somewhat better opinion of my womanhood." This letter makes it clear that right after Otto's visit Paula was standing firm: "But I do not *want* to return to Worpswede and to Otto Modersohn. That is my reason."

When Otto arrived, Rilke made himself scarce. When he heard through Clara that Otto had gone home, he wrote Paula this letter, explaining why he could not resume the sittings:

> a confession of faithlessness. In these fourteen days I've found my way into all sorts of work, which needs me urgently, so that I cannot sit now. Often I go early in the morning to the Bibliothèque Nationale, for precisely the time that I tried to give you. Is that very bad?[34]

It was true; Rilke had entered one of his periods of extraordinary productivity, writing in just a short time many of the poems that would go

into the second part of the *New Poems*. Still, the bad conscience with which he wrote this letter is apparent; in the end he would feel obliged to apologize. Paula sought his renewed company and support, and he avoided her.

As we have seen her do earlier in stressful times, Paula fell ill after Otto left as well. If we have seen Paula's early days in Paris as a leaping free of Worpswede and Otto, and her ecstatic and hugely productive May as their high point, we begin to perceive June and July as months in which the gravity of her previous life began to pull her back. Resisting, she wrote less often to Otto and to her mother. On July 1 Herma Becker left Paris, and Paula must have missed her greatly despite her support for Otto.

Paula's letter of July 30 to Heinrich Vogeler reminds us that her rejection of Worpswede was less than absolute: "Yes, I really should be spending the summer there in the country, painting the local people out-of-doors. But I hope to have many more summers in my future, when I can do just that." She even agreed to fix the time when Otto would come and they would experiment with reconciliation:

> Things are sad now for Otto Modersohn. I know it. I have written him that as soon as his pictures are finished for the Gurlitt exhibi-tion, he should come here and try painting out in the countryside somewhere. Then we shall see what we still have to give each other. No matter what, there will be a decision in the fall—

Paula pressed Rilke for continued contact. Along, no doubt, with the pull of his work and the increasing demands from Clara that they find a way to spend some time together, Rilke's sheer dread of being *needed* won the day; mostly he declined her invitations, and invited her only where others would be present, as on an outing to the chateau at Chantilly with Ellen Key and others.

In response to Clara's repeated entreaties, Rilke had asserted—it simply had to be so—that Clara's work as well as his own required sep-aration. The best he could do was to secure several invitations for both of them from his new patrons and patronesses, and to begin to plan an interlude at the seashore for the whole family—in his earlier plans, on the coast of Brittany, but finally on the Belgian coast. Clara was suffer-ing from the isolation of Worpswede just as Paula had done, and it is important to remember that in the spring of 1906 her dear friend had enjoyed both Paris and the company of Rainer Maria while she had been forced to remain unhappily behind.

Just as this family interlude was finally about to come to pass, a desperately needful Paula, hearing of the plans, simply invited herself along, in a short note forwarded to Rilke in Berlin as he made his way to Belgium. But Rilke's answer pointedly did not name the spot on the Belgian coast for which the family was about to leave, naming instead only places in Brittany that they had considered and rejected, and faulting the unnamed destination as crowded and expensive. It ended bluntly: "Therefore—no; I can't advise you to come here. . . ."[35]

This clash of needs and interests is reminiscent in important ways of the one that had brought Rilke and Paula to their heated exchange of letters in early 1902. At stake were the claims of the small and fragile Rilke family, and those of a needful friend whom both Clara and Rainer Maria had urged to take the course that had led her into such need. As before, it was Rainer Maria who answered for the family, and we have no way of knowing how Clara would have answered if given a voice. There was, perhaps, no satisfactory answer; the one Rilke gave left him with feelings of guilt still palpable in the Requiem. Could he and Clara, by accepting Paula's plea that they include her in their plans, have saved her, as he would have seen it, from the fateful error of returning to Otto Modersohn?

Paula never made it to the seashore that summer, but the Hoetgers did invite her to join them for a few days in Bures, outside Paris. It was a festive time; Hoetger wrote retrospectively of the whole party happily gathering flowers for still lifes. In this visit or soon after Paula began one of her three portraits of Hoetger's wife, Lee—probably the decorative and lyrical one with stylized flowers that shows the influence of the *douanier* Rousseau, whose work Paula had known since the Salon des Indépendants in 1905. Hoetger had one of Rousseau's pictures in his studio as well.

Paula's agreement to Otto's coming to Paris in the fall began to weigh on her as August waned. On September 3 she made a final attempt to leap clear of him, begging him not to come:

> Now I must ask you for your sake, please spare both of us this time of trial. Let me go, Otto. I do not want you as my husband. I do not want it. Accept this fact. Don't torture yourself any longer. Try to let go of the past—I ask you to arrange all other things according to your wishes and desires. If you still enjoy having my paintings, then pick out those you wish to keep. Please do not take any further steps to bring us back together. It would only prolong the torment.

Painfully, Paula needed to ask once more for money: five hundred marks. On the same day she wrote to her mother, "Mother, I have written Otto and told him that he should not come at all. I am now going to take steps to secure my livelihood for the immediate future. Forgive the troubles that I am causing all of you. I cannot do otherwise."

We do not know what steps Paula planned to take to secure her livelihood, nor how any such plan may have fallen through. But six days later, in any case, Paula's resolve broke. She wrote Otto a subdued and conciliatory letter:

> My harsh letter was written during a time when I was terribly upset. . . . Also my wish not to have a child by you was only for the moment, and stood on weak legs. . . . I am sorry now for having written it. If you have not completely given up on me, then come here soon so that we can try to find one another again.

It was Bernhard Hoetger, to whom Paula felt such gratitude and on whom she had come to depend so heavily, who persuaded her to change course. Thus, at least, the account Paula gave in a subsequent letter to Otto, and in this letter to her sister Milly of September 16: "Otto will be coming to Paris after all. Hoetger preached to me one whole evening about it. Right after that I wrote him to come." To Otto she wrote that she hoped that he and the Hoetgers would become friends, and to Milly she defended them: "You seem to mistrust the Hoetgers a little. They don't deserve it. They are better than many others and they treat me as a friend. Life has, of course, made me a little cautious, too, and so naturally I have yet to make a final judgment about them. But when does one know other people completely?"

Even before doing what he did to persuade Paula to return to Otto, Hoetger had begun to play a double role in relation to Paula that resembles Herma Becker's. Like Herma, he wrote to Otto—perhaps fearing to offend someone of Otto's stature in the German art world. Thus his far more guarded evaluation of Paula's work in this letter to Otto of August 10 is probably less than fully sincere:

> Whenever I praised your wife I was always careful to temper it with an additional remark, out of a natural and sincere urge; for, as you must know, we can consider the great talent of your wife only as a still untutored gift which will not come into blossom until serious conflicts of the soul permit her to recognize good discipline, and until calm consideration leads her to apply it to her work.[36]

While Paula's account of Hoetger's influence on her decision must surely be credited, there is no reason to think of it as exhaustive. That Paula's last desperate plea to be allowed to break free had to be accompanied by one last request for money makes the ultimate weakness in her position achingly clear. She could not yet support herself in Paris on her art—she had in fact been so utterly absorbed in her painting that she had scarcely tried—and she had no other means of support. Clearly enough, Paula's gender played its usual role of limiting others' expectations as well as her own options. Social class also limited these options: she had always lived by choice an essentially bourgeois life, and could not conceive for long (despite what she confided to Clara about the thought of raising a child alone in Paris) of living the bohemian life of Montmartre. She could not, on the one hand, like Mary Cassatt, live on family money and show with her fellow artists while keeping herself largely aloof from the less than respectable aspects of their personal lives; nor on the other could she, like the housemaid's daughter Suzanne Valadon, scrape by as model, mistress, and perhaps prostitute.

Above all, though, it was the experimental nature of her work that denied her recognition. There was as yet no large audience for the kind of pictures she was painting. That at the age of thirty she could not support herself on her art is not surprising—neither had the other pioneers of modern art been able to do so at that age. Paula now appears to have sold more paintings in her short lifetime than Vincent van Gogh in his longer one, and by doing almost nothing to make her work public she largely escaped the scorn that had been heaped on the young Cézanne. Finally, she bowed to what seemed the inevitable in her living arrangements—and went on painting.

Thirteen

In return for abandoning the dream of living independently, Paula had received the promise, at least, of virtually everything short of independence that she had asked of Otto, and for as long as she lived, the promise seems to have been kept. Her going to Paris alone had always been determined in part by Otto's lack of interest in going there with her, as she had repeatedly asked him to do. Now he came to Paris at the end of October, and the two of them stayed there until March, returning to Worpswede only briefly, for Christmas. In his wavering way, Otto had been converted: a letter he wrote to Fritz Overbeck, urging him, too, to come to Paris, and countering each of Overbeck's reservations—contentment with the village, absorption in his work, money problems, fear of powerful influences—sounds uncannily like one Paula might have written to Otto.[1] In yet another formulation of his artistic principles, this one written just before Paula's death, he speaks of the sins of Worpswede, the virtues of the French, and the merits of Paula's art as if each were an axiom on which he planned to base his own future work.[2]

Paula and Otto moved into larger quarters on the boulevard Montparnasse where once, they were told, Gauguin had lived, and where each had a separate studio. They shared Otto's first week in Paris with Heinrich and Martha Vogeler, visiting the Autumn Salon, where they saw work not only by Cézanne, Matisse, Bonnard, Derain, and Redon, but by Delaunay, Jawlensky, Kandinsky, and an enormous Gauguin retrospective.

Not surprisingly, though, the new arrangement caused disruptions; Paula could not at first maintain the productivity of her days alone in Paris, and she did not hide her frustration. In a brief letter of November 1 to her mother, she wrote, "At the moment I'm not really very happy. My moving, Otto's being here, and last week's partying with the Vogelers have taken me completely away from my work. But next Monday I plan to begin again." In retrospective testimony to Kunsthalle director Pauli, Otto said that she had again taken to spending whole days in her studio, emerging only for dinner; he had feared for her health, he wrote, and thought his fears borne out by her death.[3] Her answer when he had tried to persuade her to moderate her pace, he wrote, was that her life might well be a short one, and she had to put it to the best possible use.

Among the works that Paula completed before her return to Worpswede are two paintings of a mother nursing an infant; as she began to see her future again as that of a married woman, motherhood was central to the life she imagined. The darkly backlit *Kneeling Mother with Child,* her most intense depiction of this recurrent theme, suggests that the return of Otto Modersohn to her life inhibited neither her formal experimentation nor the ferocity of her engagement with her subjects. Three more obviously experimental works from this time are nude pictures of dark-skinned children (*Nude Child with Goldfish Bowl, Nude Child with Stork, Nude Girl with Vases of Flowers*) that clearly bear some relation to Gauguin's Tahitian pictures.[4]

On November 11 Paula's mother sent heartening news from home: four of her paintings had been included in a selection of Worpswede work to be shown first at the Kunsthalle in Bremen and then at the Gurlitt gallery in Berlin. Director Pauli, in a newspaper article, recalled the attack on Paula in the same paper almost seven years ago, and both defended and explained her work to what he knew would be a skeptical audience:

Whoever might choose to see Paula Modersohn's *Head of a Young Girl* as ugly, and then brutally decide to subject it to his scorn, can safely count on the smug approval of many of his readers. On the other hand, whoever would assert that this young woman artist possesses a most uncommon energy, an enormously developed sense of color, and a strong feeling for the decorative function of painting will have to be prepared for the opposition.[5]

Mother Becker confessed her own judgment of the picture Pauli had defended: "I really cannot stand that portrait."

To Milly, who had been the most supportive member of the Becker family, Paula wrote on November 18:

Otto and I shall be coming home again in the spring. That man is touching in his love. We are going to try to buy the Brünjes place in order to make our lives together freer and more open. . . . My thoughts run like this just now: if the dear Lord will allow me once again to create something beautiful, then I shall be happy and satisfied; if only I have a place where I can work in peace, I will be grateful for the portion of love I've received. If one can only remain healthy and not die too young.

The most intimate of the gaps between Paula and Otto was, at least to some degree, bridged during their stay together in Paris; on March 9 Paula wrote short notes to both her mother and Milly to say that she was pregnant.

After spending August 1906 at the seashore, Clara and Rainer Maria, their funds depleted, had spent two weeks as guests of the von der Heydts; Clara made a bust of their daughter. Then, in early September, they began a longer period as guests of the Baroness Gudrun von Uexküll, daughter of the now dead Countess Schwerin, at a familiar refuge, the castle Friedelhausen. This stay led to an invitation to both from the countess's sister, Alice Faehndrich, to spend the winter at her villa on Capri. Rilke accepted; reluctantly, Clara declined in favor of going to Berlin, where she would set up a studio and try once again to support herself on students and commissions. Rilke's letters to friends and patrons, like this one of September 28, 1906, to Elizabeth von der Heydt, represent the choice of Berlin over Capri as Clara's own: "Clara feels that she must, as far as external circumstances allow, make what is relatively the bravest choice, and therefore she is making diligent preparations to go from here to Berlin."[6] In a letter to Paula of October 19, 1906, shortly after she had arrived in Berlin, Clara wrote of the decision, claiming responsibility for it:

I myself now want to take upon myself [the challenge of] Berlin— in the first days of being here I was tremendously homesick for Paris. But now I feel more and more that it should and must be this way, and I believe with confidence that I stand on the verge of good and fruitful work, and of much that is useful for my life.[7]

There were many good reasons for an artist and a teacher in search of students to move to a cosmopolitan art center like Berlin. But one senses

that Clara had reached her conclusion under considerable pressure from her husband; that the old ventriloquism we have seen since the earliest Worpswede days was still at work.

In Berlin, Clara had spent time with Lou Andreas-Salomé, and the two had spoken about Rilke, the state of the marriage, and the decision to separate again. Lou had never fully accepted Rilke's version of the artist's necessary choice of art over life, both of which created genuine obligations; without giving up her personal loyalty to Rilke, she took Clara's side. Rilke's remarkable letter of December 17, 1906, to Clara from Capri makes it clear that Clara had found it difficult to defend, to someone as intimate with and unawed by Rilke as Lou, the latest turn their life had taken. Its desperate intensity clearly answers strong objections which Clara had raised in letters to her husband, invoking Lou's opinions as well as her own, even as she went on submitting to his judgment:

> If Lou only know how many such letters I write to myself, in my thoughts. Long letters with just such objections. They are all utterly familiar to me. I know their faces, into which I have looked for hours; I know how they come nearer and nearer and then directly, blindly up to me. I thank you for passing on these words [from Lou], which it must have been enough of a chore and an imposition on you simply to receive, to put into order and, where you felt it was best, to reject. You had to watch all of that rise up in front of you, with all the menace, hardness, momentary hopelessness that comes with it, and had to find the determination, the unswooning sobriety, to place yourself over it, vis à vis Lou, and to defend it, defend the very thing that has so often attacked you when you were defenseless.[8]

Here, as before, Rilke tells Clara what she has experienced. As before, too, he goes on to make it clear that his needs as artist must be his primary concern:

> By any premature concession to that which, as "duty," wants to overcome me and make use of me, I could probably shut out of my life a number of uncertainties, and that appearance of the constant desire to evade. But I feel that at the same time the great wondrous helps that appear in me in almost rhythmic succession would be shut out of an obvious order, guided by energy and the awareness of duty, in which they no longer belong.

He went on to define the role that Clara and Ruth played in his life, but not to address the question of what role he was to play in theirs: "Aren't you [pl.] first the one tree in the indescribably wide plain of my journeys, to which I find my way back again and again, toward which I sometimes direct my gaze in order to know where I am, and in which direction I must go on from there?" The nub of his argument is that in the inner world, which to him was primary, they *did* share a home:

> isn't there, nevertheless, a house around us, a genuine one, for which only the outward sign is lacking, so that others cannot see it? But don't we ourselves see it most clearly, this heart-house, in which from the beginning we have been together, precisely then, when one day we step outside it, only to walk in the garden?

The next passage reminds us that Rilke has been addressing Lou as well as Clara: "This orderliness, to which in small matters some police would need to force us (I understand very well and with utter seriousness what Lou meant by that), haven't angels held us to it with the deep, unrelenting conviction that is given to angels?" This reference to the police responds to one of Lou's firmest statements to Clara about Rilke's obligations: that if he himself could not recognize them, the police ought to teach him the lesson, as they would any other deadbeat father.[9]

The Rilkes remained together in Berlin until Rainer Maria left at the end of November for Capri. Clara's letter to Paula of October 19 reveals that she and Rainer Maria did not yet know that Paula and Otto had been reconciled more than a month earlier: "Is your life in Paris continuing to be the same as it was in the summer? In case you are planning to remain alone and are having a difficult time, we would perhaps have a possibility for you in mind."[10] We do not know what this possibility was. Paula did not answer until November 17, in a letter meant to arrive for Clara's birthday:

> I shall be returning to my former life but with a few differences. I, too, am different now, somewhat more independent, no longer so full of illusions. This past summer I realized that I am not the sort of woman to stand alone in life. Apart from the eternal worries about money, it is precisely the freedom I have had which was able to lure me away from myself. . . . The main thing now is peace and quiet for my work, and I have that most of all when I am at Otto Modersohn's side.

A postscript acknowledges the rift between Clara and Otto, which must have given rise to awkward encounters on the streets of Worpswede: "I

certainly hope that the misunderstanding between you and Otto Modersohn will turn into an understanding again."

After a few months in Berlin, not as fruitful as she had hoped, Clara was invited by the Baroness May Knoop to join her in Egypt; she spent January through March 1907 at Helouan, near Cairo, writing her husband long letters about what she saw. These Rilke praised fulsomely, though later he would cite them as evidence for the prosecution: she had imitated his style. In Egypt Clara completed both a portrait bust of her hostess and a group of gazelles; the latter, however, were destroyed in the process of casting soon after her return—one more disheartening turn of events.

On February 5, after Clara and Rilke had met in Naples on Clara's way to Egypt, Rilke, back on Capri, first wrote to Paula again. They had chosen there as a gift for Paula's birthday a collection of photographs of ancient wall paintings. "We selected these photographs for you," he wrote, "with particular concern for your art, of which we spoke a good deal in the few days that Clara spent here."[11]

Paula did not answer until March 10. Though she had just learned that she was pregnant, she did not mention this. Her prickly, self-justifying tone reflects the expectation that he would disapprove of the latest changes in her life:

I am a bad correspondent; in fact I am one of those people who move very slowly and make people wait for them, and who also wait themselves. Just don't expect anything from me. Otherwise I'll probably disappoint you, because it may still be a long time before I am somebody. And then, when I am, perhaps I won't be the somebody you thought I would be.

But she ended on a note both grave and intimate:

I shall return to Worpswede. I hope everything will be all right this way.

Please give my best to Clara. It is lovely that the trip [to Egypt] is so rewarding for her.

I think so often of her.

If only we can all get to heaven.

I wonder where you will be when next summer is in bloom.

I believe that I am satisfied with my life.

Rilke's remarkable answer of March 17 begins with an apology:

[Your letter] answers, a little, all the letters that I have not written you. It answers them with goodness and confidence, for which I must be particularly grateful. For now I may say to you, that ever since a short letter [the one in which Paula offered to join the Rilke family at the seashore] was forwarded to me in Berlin, I have felt guilty the whole time that I did not write to you that you should come. I was so absorbed in those days with seeing Clara and Ruth again, and Oostduinkerke [the coastal town his letter had declined to name] made no compelling impression. But later I felt myself becoming aware that I had done an injustice with my answer, and been inattentive in a moment in our friendship in which I ought not to have been so.[12]

The letter then gives its blessing to Paula's return to Otto, as once before, with no choice but to accept it, Rilke had blessed their original union:

But if, back then, something was neglected: I believe, nonetheless, that your life has the strength to restore and compensate, and to come into its own at all costs. And even if the outward circumstances have come to be otherwise than we once thought they might be, nevertheless only one thing is definitive: that you are bearing up bravely and have won the possibility of finding within existing arrangements all the freedom needed by that within you that must not be lost, to become all that it is capable of becoming.

For loneliness is actually an inner condition, and the best and most useful progress is to understand this and live by it.

For the rest, just leave me to my expectations, which are so great that they cannot be disappointed.

The Requiem, of course, flatly contradicts this assessment. It was a gift for Paula, a story by which the latest turning in her life could be understood in the most hopeful terms; though he probably did not believe it, it may have had more truth for Paula than he had ever believed it could have for him.

Preparing to return to Paris, he asked Paula whether he might be able to take over her studio there, including her furniture; the inquiry would set in motion one last misunderstanding, the least painful, between them.

By early April 1907 Paula and Otto were back in Worpswede. A letter from Paula's mother to her sister Herma after a visit paints an idyllic picture of their life there:

Again there was a happy hour at the breakfast table, after which Paula had to be alone a little, for in the morning she always feels a little faint and dizzy. Then Otto helps her out of her chair and because he can do nothing more to help, he sacrifices his greatest pleasure, his little pipe, because the tobacco makes her feel sick. . . . [Paula] was altogether charming, and exuded goodness and mischief. One never had the feeling that anything had been patched and put back together again here. Rather, you would have felt security and clarity everywhere.

While the source, one eager to see things at their best, must be considered, there is nothing inherently implausible in this version. Paula had always wanted a child, and inclined toward a middle-class life like the one in which she had grown up. There were aspects of Worpswede she loved—above all, her studio at the Brünjes's, which she and Otto now hoped to buy. In a letter that conveys real feeling and does not hesitate to express frustration, she wrote this to Rilke:

> I am sitting again at my little studio at the Brünjes' with the green walls, and light blue below. I walk the same path to get here as I did in the old days, and everything seems wondrous to me. This is the room I love more than any other in my whole life, all the more so because I did nothing during the last months in Paris.

She had left her furniture behind with her landlady, she wrote, so that he could take what he wanted and have her sell the rest.

Most importantly, Paula had every intention of holding Otto Modersohn to the promises he had made in order to win her back. She expected to return to Paris and to go on painting in the directions she had been pursuing there. She had never let Otto's recurrent misgivings about her new directions turn her back in the past, and there is no reason to think that she would have done so now. Otto had pleaded; his behavior after her return seems to have been enormously accommodating and grateful. To put it bluntly, Paula was the stronger of the two and usually had the upper hand. She had never perceived having a child as incompatible with pursuit of her art; Elsbeth Modersohn had been a toddler when Paula had married Otto, and her presence, though sometimes an irritant between them, had never seriously hampered her progress. There is no apparent reason to doubt that, with the help of the housemaid and her mother, the steady income Otto could earn from his work, and that single-mindedness about her painting that we have observed in

her all along, she would have continued to follow her own path as she had always done. Beyond this, there is no point in speculating.

Paula produced fourteen paintings after returning to Worpswede. At times pregnancy left her too uncomfortable to work, but when she could, she worked fiercely and intently. She found her way back to Worpswede subjects that still rewarded her attention, including two very different paintings of old peasant women from the poorhouse. One was her most radiantly ominous painting yet of old Three-Legs, seated in a field of poppies and holding a single foxglove, her dark face backlit by the afterglow of a sunset. In the second, an old woman in deep blue holds her arms crossed over her chest. In a brief excursion outside her usual subject areas she painted two biblical scenes: the good Samaritan and the adoration of the Christ child by the three kings. Perhaps these, with their simplicity and charm, were painted for the child soon to be born. She painted Otto sleeping, and in profile, smoking his pipe, on a moonlit night; in the latter portrait, enigmatic but evocative, we search for but do not find a clue to her current feeling for him. Her last painting, still on her easel at the time of her death, was an homage to van Gogh, a still life in dark tones of sunflowers, hollyhocks and mallows. As a last work it is almost too perfect, as her last words would prove to be, and so, like her occasional intuitions of an early death, it contributes to the nearly irresistible mythic redactions of Paula's life that both compel our attention and obscure our sight of her.

To these eyes there is no sign that Paula's inspiration or determination wavered (as inevitably her production did) during her pregnancy, and to represent her return to Otto as spelling doom to her artistic aspirations, as a few have wanted to do, seems to be to underestimate her in a way unsupported by her past achievements. She was no more completely satisfied with the work she had done on her own in Paris than we have seen her be with any of her earlier work; she wrote to Bernhard Hoetger in the summer, "The paintings I did in Paris are too cool, too solitary and empty. They are the reaction to a restless and superficial period in my life and seem to strain for a simple, grand effect." Her ability to make the choices that supported her work had been in the past the most important guarantor of her artistic progress, and it is possible to see both her leaving Otto Modersohn in February and her accepting him again in September as in turn representing the choice to go forward. She had passed the vital test to which she had put herself then. Perhaps the real test now was whether she had indeed, as a kind if unconvinced Rilke had told her, won an inner freedom that would

have enabled her to continue her progress in Worpswede now that she had returned.

Paula did not hesitate to face herself in the mirror after returning to Otto. In her final self-portrait, *Self-Portrait with Two Flowers in her Raised Hand,* one recognizes immediately in the flushed face, and the right hand rested atop what must be a greatly swollen abdomen, that it depicts Paula in the advanced state of pregnancy in which she painted it. Her eyes engage the reader's directly and serenely; what rises from prolonged contemplation of the face is an irresistible smile. The flush of pregnancy and the full red lips give her face the same aura of flesh as fruit that Rilke saw in the *Self-Portrait as Half Nude with Amber Necklace;* indeed, the face of that portrait rises in memory out of this one. This time, however, the fruitfulness immanent in the painting is not metaphorical but literal and wholly embodied: what Rilke saw as inner truth has been made flesh. Compared to the Paris *Self-Portrait on Her Sixth Anniversary,* with its ambiguous evocation of pregnancy as potential, this new self-portrait radiates fulfillment. Paula had, in a way that Rilke believed impossible, reconciled for the time her art and her life.

Rilke's next letter to Paula, from Paris on June 28, is an apology: he'd simply forgotten about her furniture until an exhibition of Cézanne watercolors had reminded him of her last letter's mention of "glorious things from his [Cézanne's] youth." And then he had forgotten the street number of her studio. Was that very bad? What should he do?[13] Paula's answer sounds almost as if it had been written to a child: "Yes, it is a little bad of you to have forgotten my furniture, for now I must ask you to go and see if any of it exists. You must go to the blvd. Montparnasse 49 to Mme Vitti and enquire what might still exist of my estate." Rilke's answer told her that Madame Vitti had left Paris and would not return until the end of September, at which point he would take up the matter again.

Paula's letter of October 17—just two weeks before the birth of her daughter—addresses Rilke earnestly as a fellow artist. He had published his lecture on Rodin as an essay; Paula had read it and been pleased.

I have just finished reading your essay on Rodin in *Kunst und Künstler* and enjoyed it very much. I believe your work is more mature, simpler. It seems to me that the youth with his fragile exuberance is vanishing now and the grown man is beginning to emerge with fewer words, but words which have more to say—I don't know whether this is your opinion too, or whether it will

remain my opinion only, or whether this is any opinion to your liking at all. In any case, it is not meant as an insult, as many of the things that I often said may have been, although they were not intended to be insults.

Paula responded in kind, then, just a month before her death, to Rilke's air-clearing apology with an acknowledgment of past resentments. Having passed her self-imposed test and come fully into her own as a painter, she felt free to be generous with Rilke and able to address him as an equal.

Coming to the matter of the furniture, Paula hides any irritation she may have felt behind a bemused tone that mocks Rilke's stylistic excesses. She knew that he was about to leave on a reading and lecture tour, and planned to visit Venice on the way home. "And before you enter the mother-of-pearl garland of Venice, do go once again to the dark corridors of Madame Vitti. May the thought that Gauguin once ascended the same staircase illuminate your way. Even if he only did it for three months."

In his answer, the last direct communication between them, Rilke wove out of the fact that, when the furniture was finally offered for sale, no one wanted to buy any of it at even the lowest of prices, a sad comedy whose dénouement was that at last it had to be given away.[14] He offered to compensate Paula (twenty francs?) for his original negligence. One last time, sending her the catalog of the Salon d'Automne and two articles on Cézanne by Emile Bernard, he shared with her some of the fruits of his artistic search.

Indirectly though, through Clara, Paula received a final vital communication from Rilke. Returning again and again to the Cézanne retrospective at the Salon d'Automne—his newest master had died the previous October—Rilke had been writing to Clara in Berlin a series of letters about the artist which late in her life Clara would publish as a book. In her last letter to Clara, Paula wrote less than two weeks before giving birth, "Please come soon and bring the letters. If it were not absolutely necessary for me to be here right now, nothing could keep me away from Paris." So near to Mathilde Modersohn's birth, Paula's head was full of Paris and French art.

Clara did come, and brought the letters. Petzet claims to have had Clara's assurance that at bottom the letters were written more to Paula than to Clara, and the suggestion is not implausible. In them, Rilke raised Cézanne—whom Paula had discovered long ago and shared with Clara—to the same status he had accorded first Jacobsen and then

Rodin: that of exemplary artists, his personal tutelary spirits. As he did in Rodin, he saw in Cézanne an example of the artist who was always working. And in Rilke's view the key to Cézanne's work was color:

no one before him ever demonstrated so clearly the extent to which painting is something that takes place among the colors, and how one has to leave them alone completely, so that they can settle the matter among themselves. Their intercourse: this is the whole of painting. Whoever meddles, arranges, injects his human deliberation, his wit, his advocacy, his intellectual agility in any way, is already disturbing and clouding their activity.[15]

The previous day's letter had praised the objectivity that was poverty, but poverty of a fruitful kind, which sacrificed all for the essential:

Surely one has to take one's impartiality to the point where one rejects the interpretive bias even of vague emotional memories, prejudices, and predilections transmitted as part of one's heritage, taking instead whatever strength, admiration, or desire emerges with them, and applying it, nameless and new, to one's own tasks. One has to be poor unto the tenth generation. One even has to be poor for those who preceded one, otherwise one only reaches back to the time of their rise, of their first brilliance. But one has to feel beyond them into the roots, and into the earth itself. One has to be able at every moment to place one's hand on the earth like the first human being.

This is the "true poverty" that, in the Requiem, Rilke would praise in Paula's gaze. Of a Cézanne self-portrait he wrote this on October 23:

How great this watching of his was and how unimpeachably accurate, is almost touchingly confirmed by the fact that, without even remotely interpreting his expression or presuming himself superior to it, he reproduced himself with so much humble objectivity, with the unquestioning, matter-of-fact interest of a dog who sees himself in a mirror and thinks: there's another dog.[16]

Another formulation we find in the Requiem Rilke attributes, in the letter of October 12, to the painter Mathilde Vollmoeller, who had accompanied him on one of his trips to the exhibition:

And Miss V. said very significantly: "It's as if they were placed on a scale: here the object, there the color; never more, never less than

is needed for perfect balance. It might be a lot or a little, that depends, but it's always the exact equivalent of the object."[17]

In the Requiem this would be stated more simply: "For that is what you understood: ripe fruit. / You laid it down in bowls in front of you / and measured out, in colors, the weight of each." Of those on the wrong track he wrote in the October 13 letter, "they'd paint: I love this here; instead of painting: here it is."[18] Says the Requiem: "and said not: I am that; no, said: this is."

Little more than a month before Paula's death, Rilke had formulated the terms by which he would praise the work of hers that he knew best—having been present at the creation—and approved of most, at least in part because she had done it on her own, in Paris, in implicit congruence with his most deeply held convictions. The relation of the letters to the Requiem confirms at least a metaphorical sense in which the letters were written for Paula. By portraying her under the sign of Cézanne, he was praising her in the strongest terms he knew.

Bringing the Cézanne letters—and Ruth—to Paula's bedside, Clara also saw Paula with her child: "In November I stood with my little daughter at the bed in which she lay with her little baby girl who was only a few days old—with the happiest and most peaceful smile on her face."[19] This smile, mentioned in other accounts and present in her final self-portrait, was also captured in a photograph; it was no sentimental fiction. Back in Worpswede, in what would prove to be the last months of her life, Paula *was* happy—she believed in the choice that she had made and was full of hope for her future.

Our best records of Paula's giving birth and of her brief time as a mother come from her mother's letters to her sisters Milly and Herma. Like Clara's account, they all stress the joy of the occasion. Satisfaction at having Paula back shines through repeatedly, but there is no hint that it caused Mathilde Becker to falsify the record. This recounting was written to Milly on November 5, three days after the birth:

> The birth was difficult. Late Friday night the midwife came into Otto's room and asked him to fetch the doctor; she was afraid that the child was dead, for there were no heartbeats to be heard. . . . Saturday morning the contractions stopped just as the child was about to be born. About two o'clock the doctor chloroformed Paula and drew out the child with forceps. Otto was pacing anxiously about outside looking for Kurt's arrival. [Paula's brother

Kurt was also a physician.] Suddenly Dr. Wulf appeared from the house, flushed and streaming with perspiration, and extended his hands to Otto saying, "Congratulations! A splendid little girl." "Is she alive?" asked Otto trembling. "And how! And she has a voice like a lion!"

The same letter goes on to describe Paula's few days as a mother:

> On Sunday Paula kept saying, "You ought to see her in the nude!" And Otto boasted as the proud father, "A very fine nude!" . . . She surely is a splendid baby girl, large and developed as if she were three weeks old. She has a head of brown hair, shiny little eyes, and gesticulates energetically with her arms. The bathing scene today was a splendor! Paula reclines on snow-white pillows beneath her beloved Gauguins and Rodins. . . . After the bath she is laid at Paula's breast and takes hold as cleverly as an old hand, and nurses and feeds until she falls asleep, a little brunette next to a big brunette.

This last was a scene that Paula had imagined over and over in her work, and had always intended to realize as well in her life.

About a week after the birth, Paula had pains in her legs for two days. Phlebitis was feared, but finally the pains were dismissed as "a kind of neuralgia." There was no sense in the joyous household that Paula's life could be in danger; the pains caused her to be kept in bed longer than she otherwise would have—Kurt Becker was now in charge—but the length of time she spent there was not unusual for the time. As late as November 18, Paula's mother describes in a letter to Herma Paula's "heavenly cheerfulness," and her plans to expand the garden, "for Paula has declared that in the future she wants to paint in the garden a good deal. (Thank God!)"

There are two extant descriptions of Paula's last moments, neither as direct as one would like. This one, long printed in editions of Paula's letters and journals, is taken from a "family letter" of uncertain origin:

> Kurt gives her one more thorough examination and says that she may get up. The nurse quickly helps her into her clothes, and then she walks about the living room with little effort, supported on each side by her husband and her brother. An armchair is moved into the middle of the room where she is happily enthroned, the men of the family to the right and left of her. The infant has just been nursed and is bursting with health. Paula says that all the candles in both chandeliers have to be lighted: "It's almost like

Christmas. . . . Oh, I'm so happy, so happy!" Suddenly her feet seem to become heavy, there are a few gasps for breath. She says softly, "A pity," . . . and dies.[20]

Much later, Clara wrote this description, based on Otto's account to her:

Paula was given permission to get out of bed and happily prepared herself for this occasion. She had a large mirror placed at the foot of her bed and combed her beautiful hair, braided it, and wound the braids into a crown around her head. She pinned roses which someone had sent her to her dressing gown and when her husband and brother were preparing to support her on either side, she gently walked ahead of them into the other room. There, candles had been lighted everywhere in the chandelier, on a garland of candleholders around the body of a carved baroque angel, and in many other places. She then asked for her child to be brought to her. When this was done she said, "Now it is almost as beautiful as Christmas." Then suddenly she had to elevate her foot—and when they came to help her she said only, "A pity."[21]

Rilke refers to Paula's preparations before rising from bed this way in the Requiem:

You sat up in the bed
and there before you stood a mirror, giving
everything back to you. All was *you* again,
in front of it; inside was only deception,
a woman's sweet deception who puts on
pretty things and combs her hair and changes.

He deplored, in light of her death, what she, in blissful unawareness, had rejoiced in: in her last moments, while no less a painter, she was wholly herself, fully embodied, wholly a woman in the outer world in which human beings engage one another. She had never been one to dwell only in the mirror of art, or the mirror of Rilke's passionate inner world.

Paula was buried in the Worpswede churchyard, next to Otto Modersohn's first wife, Helene. Clara, who had returned to Berlin after visiting Paula, did not learn of her death until more than a week later. Her account goes on to what she saw when she finally reached Worpswede:

As dawn gradually broke on the morning of the last day of November, I walked along the avenue of birches with a bouquet of autumn foliage in my hand—the same avenue which we had so often walked along together. I found the house empty—Otto Modersohn had gone away. Milly had taken the child with her, and Paula was no longer there.[22]

Recalling the death of Otto's first wife, his joy at finding Paula, his near-unhinged desperation when she left him, his joy at her return and his new daughter's birth, it is not difficult to imagine the depths of despair to which Paula's death drove Otto. How much could he be asked to endure? It is hardly surprising that, unable for a time to bear it, he went away.

Fourteen

Rilke left for his speaking tour on October 30, 1907—three days before Paula gave birth—and did not return until the end of November, when word reached him belatedly of her death. In Prague, Breslau, and Vienna he read from his own work; in Vienna he lectured on Rodin as well. The tour was a swirl of names and faces, a whirl of mostly superficial social occasions: his first exposure to the joys and tribulations of celebrity, for he was now a famous poet. Rilke's letters to Clara reveal that he had found the entire prospect daunting—especially the first destination, where he must face both his mother and the city of his birth. Neither of these terrors-in-advance disappointed him, but he found a series of consolations, the first in the form of four Cézannes in an exhibition of modern painting that also included van Gogh, Gauguin, and Emile Bernard. He planned to reward himself when it was over with a stay in Venice, which he had visited briefly in his youth and found inspiring.

Rilke was, as we said at the outset, in Prague on All Souls' Day 1907, when Mathilde Modersohn was born. Early in the day he visited the grave of his father, concealing the plan from his mother lest she insist on accompanying him. In the afternoon he went for tea with Sidonie Nádherný von Borutin and her two brothers at the family's Janowicz castle, followed by a walk about the grounds. Rilke had met Sidonie Nádherný and her mother, the widowed Baroness Amalie von Borutin, in his capacity as Rodin's secretary, on April 26, 1906, at Meudon. Two days earlier he had answered in French, over Rodin's signature, an

inquiry of the Baroness Nádherný about a visit to Rodin in Paris. They were invited instead to visit at Meudon, and Rilke escorted them around the estate. The Baroness's handsome young daughter wrote him a note of thanks, and on May 8 he wrote her, in his own name and in German, what is clearly a personal letter meant to initiate a correspondence. Though it was not one of those cited by Rodin in sacking Rilke just two days later, it might well have been, for it makes only perfunctory gestures of staying within his secretarial role.

Sacked, as we have seen, on May 10, 1906, Rilke took rooms where Paula had until recently lived, and began in a matter of days to sit for her portrait of him. In the interim—the time of the portrait sittings—Sidonie Nádherný answered Rilke's letter in a way that encouraged him, but it was not until June 3, the day *after* Otto Modersohn's arrival had brought the sittings to an end, that he answered, with a longer and bolder letter. More than coincidence may have been at work; turning away from an intense encounter with Paula, he began to cultivate "Sidie." By the time Rilke knew that his tour would bring him to Prague at the beginning of November 1907, he felt free to invite himself to tea.

Though Rilke spent just a few hours, from midafternoon until twilight, at Janowicz, one of his vital relationships with women was born there. He was utterly taken with Sidonie Nádherný, for both her beauty and her position; to Clara he wrote a day later, on the train from Prague to Breslau, that she looked like "a miniature that was made a day before the great Revolution, at the last moment."[1] This is pure praise; Rilke treasured anciens régimes. Over time he distilled their brief encounter into yet another personal myth, expressed most clearly in the opening passage of the letter with which this book began, written the day after he finished the Requiem: "However my life may go, this I will always be able to call up from inside me: how the park closed around me, the wanderer; and always, as often as I wish, I shall see within me the red of your cloak, which was so permanently bound up with the motion of your approach."[2] His old fantasy of being taken in and sheltered by a woman is visible here. He wrote to his new friend on November 4, 8 (twice), 14, 19, 24, and 29 from Prague, Vienna, and Venice, and continued after his return to Oberneuland. He told her that she had been the one listener to whom his reading in Vienna had truly been addressed; she sent roses to his hotel room there.

In Prague Rilke had received, to his great joy, a letter from Rodin, asking his opinion of the bookseller Hugo Heller, in whose shop in Vienna he would read his poems; Heller had proposed an exhibition

there of Rodin's drawings. Rilke answered eagerly, and when, on November 10, he received Rodin's second letter, he felt that the breach between him and the master was closed.

Rilke arrived in Venice on November 19, the day before Paula's death. He had arranged through Paris art dealer Pietro Romanelli to stay as a paying guest in the family home there, then occupied by Romanelli's two sisters. He promptly fell in love with Adelmina "Mimi" Romanelli, a young woman, by all accounts, of extraordinary beauty. There had been nothing that could be called a romantic encounter with Sidonie Nádherný, and there would not ever be, quite; but to Mimi, Rilke declared his love, and found it returned. We can only speculate about how much their encounter may have resembled a conventional affair, and to what extent the body, that most troubling plane of human existence to Rilke, may have been involved. Katherina Kippenberg later wrote that it had been platonic, and late in life Mimi Romanelli herself called it a spiritual love. In any case, Rilke began even before he left Venice to write Mimi love letters in French, all the while addressing her with the formal *vous*.

Into this encounter that, whatever form it took, did not lack ecstatic extravagance on Rilke's part, broke a telegram from Clara bearing the news of Paula's death, and he tore himself away from Mimi on November 30, some ten days earlier than planned, to return to Oberneuland. We know him well enough to imagine the intensity with which he would have responded to such simultaneous yet contradictory stimuli. He wrote Mimi on December 8 of their trip to the railway station for an abrupt and painful parting:

> I am not ashamed, Dear One, to have wept, one bygone Sunday, too early in the morning, in the cold gondola that turned and turned, passing through vaguely sketched quarters that seemed to me to belong to another Venice, located in limbo. And the voice of the gondolier calling out for right of way at the corner of some canal went unanswered like a cry in the face of death.[3]

This passage appears in the same letter:

> And even in my sadness, I am happy to feel that you exist, Lovely One; I am happy to have given myself without fear to your beauty, as a bird gives itself to space; happy, Dear One, to have walked as a true believer on the waters of our uncertainty, to that island which is your heart, where sadness blooms.

Rilke felt no need to conceal this new love from Clara when he returned; in fact, he placed a portrait of Mimi in his room in Oberneuland. To Mimi he wrote this in the letter of December 7:

My wife is in agreement with me in admiring you, and we spend hours before your beautiful portrait, although it gives but a limited reminder of your splendor. And the little one, how she loves you already. "Now if I go into your room," she said yesterday, "I must always look there" (that is, at your portrait); she calls you her dear Godmother; she knows that you are beautiful without my having told her how true it is.[4]

Having matured far beyond his earlier, simpler fantasies about girls, Rilke was creating, in the belief structure by which he lived, an elaborate, idiosyncratic shrine to women. This labor required ever more frequent and more intense encounters with them—not excluding praise of their beauty and declarations of his love for them—and he would no more deny himself such encounters than he would anything else that his work required of him: not for Clara's sake, nor for the sake of each woman in turn when her conventional expectations had to be gently corrected, and she had to be taught another of the lessons the Requiem would affirm, that to love is to let go. If it was largely in writing to Clara that he had perfected his use of letters not only to develop his thought but to interact with other people in a manner that he could endure, he had now begun to use them in a similar way on a series of female correspondents. Love was often the subject of these letters; with some of these women, letters became Rilke's chief means of loving.

Rilke's letter to Mimi of December 8, little more than a week after he learned of Paula's fate, begins with thoughts on death that can scarcely have been uninfluenced by it:

There is death in life, and it astonishes me that we pretend not to know it: death, whose pitiless presence we feel in every change that we survive, because we must learn to die slowly. We must learn to die: there you have it, all of life. To prepare, from far away, the masterpiece of a proud and masterful death, a death in which chance plays no part, a well made, joyous, enthusiastic death of the sort the saints knew how to create, a long-ripened death which itself effaces the disgrace of its name, which bestows on the anonymous universe the known and preserved laws of a life intensely accomplished.[5]

His convictions about the need to prepare one's own death surely came into sharper relief against the background of his sorrowful conviction that Paula had not done so.

Rilke wrote Sidonie Nádherný, too, on December 7, speaking in pregnant terms while mentioning neither Mimi nor Paula:

And in Venice this time there came such a remarkable convergence, such unexpected paths led into the innermost part of [my] enchanted world and emerged from it in the form of [my] own joy, of indescribable astonishment, and of such remarkably real suffering that those few quickly passing days came together in the unity of an entire existence, something inexpressibly whole, that would have wished to exist and endure, but that (being human) was bounded and cut off by birth and death, and appears to me, like an action painted by Michaelangelo, mightily and bewilderingly foreshortened when I look back on it.[6]

Here Rilke's letter to Sidie becomes a lament about present circumstances:

Look back at it from a wintry-woeful Other Side: from this land in which my wife is at home and knows how to take care of herself, and in which now my little daughter too is growing up, brave and understanding and earnest in her early aloneness,—but in which I myself remain forever a stranger, who takes upon himself this heavy air like a fate to which he is not equal.

Reading the letters Rilke went on writing Sidonie Nádherný between their encounter in Prague and the writing of the Requiem a year later, one senses that what he was doing, precisely, was making a disciple of his new friend. Not so much in matters of art, though they had met over Rodin, he initiated her into his cult of Jacobsen, and he did not tire of repeating his determination to learn to transform everything into art—but in matters of love. All of the women with whom Rilke entered into such largely epistolary relationships were artistic, and a few were professional artists of some standing, but none could be characterized as his equal. Most striking about the way such relationships developed is the way so many of them recapitulate, in their essence, his relationship with Clara Westhoff, both before and after their marriage. The kernel at the center of this resemblance is his dream of being taken in and sheltered by each woman in turn, while at the same time instructing her on the mysteries of love and art—and the poet's need for solitude.

One of those to whom Rilke later expressed much later his most pitiless retrospective account of Clara was Sidie:

There is in Clara very much of the girl, and therefore, again and again, a great deal of desire to have the life of a woman; and yet, when she submits, she is immediately more disciple than woman, more student and dependent, and this not in the strongest sense, but rather in that of giving up and imitation. Therefore I don't believe that she would have been able to stand at someone's side as a wife; in devotion to the life of another she becomes not strong but submissive, reflects instead of offering opposition,—even if, as she sometimes now believes, she ought to have had a completely different fate, a proper great marriage, many children: it would not have become any easier for her, any less ambiguous.[7]

We have seen in the course of this book the ways in which Rilke pressed Clara into the role that he now deplored. He had praised her letters to him from her 1907 trip to Egypt, even suggesting that they be turned into a book, but later they would become damning evidence that she had imitated his style. We recall that in her anger Paula Modersohn-Becker had made the same charge as early as 1902: "Rilke's voice speaks too strongly and too ardently from your words." What he charges Clara with being unable to provide is precisely what Paula did provide in their far more limited contact: resistance, opposition, a counterexample to Rilke's own instead of a reflection of it.

Rilke was developing his list of exemplary female lovers from earlier ages, familiar to readers of *The Notebooks of Malte Laurids Brigge* and the *Duino Elegies:* the medieval Heloise; the Portuguese poet Louise Labé; the Venetian poet Gaspara Stampa; the young Bettina von Arnim, whose love object had been the aging Goethe; Marianna Alcoforado, the "Portuguese nun," whose letters we now see as fictions created by the French writer Guilleragues, though Rilke never doubted that they were genuine. Chiefly these women were exemplary in Rilke's eyes because they loved men who did not return their love, and it was by transcending the need for requital that, in Rilke's gloss, their love became immortal. This is the version he caused to be written by his doomed alter ego, Malte Laurids Brigge:

Women who are loved live poorly and in danger. If only they could surpass themselves and become women in love. Around women in love there is sheer security. No one is suspicious of them

any more, and they aren't in a position to betray themselves. In them the mystery has become inviolate; they cry it out whole, like nightingales; it is no longer divided. They lament for one man; but the whole of nature joins in with their voice: it is the lament for an eternal being. They hurl themselves after the man they have lost, but even with their first steps they overtake him, and in front of them there is only God.[8]

He instructed Sidie that it need not matter much to Gaspara Stampa if the man she loved was unworthy, her love requited poorly or not at all; men, preoccupied with their masculinity, were not capable of it. Although we think of Rilke, with much justification, as having been of a different party than such men, it seems impossible not to remark that such women, whom it was so delicious to adore and to be loved by, were precisely those who would make no inconvenient demands on him, who would be content to be loved through the mail or, in times spent together, to be guardians of his solitude. Often he praised the writing in Sidie's letters, as he had Clara's before their engagement. Often we find him recounting to her, as he had once done to Clara, her own experiences, past or to come: what it was like for her to be home alone at Janowicz; what her forthcoming trip to Italy would be like.

The letters to Mimi Romanelli follow a similar course. They would study Gaspara Stampa together, and together create the book he had in mind about all the women who had loved in that exemplary way which expected nothing in return. (One recalls his telling Clara that one day they would collaborate on a book about Rodin, a prospect we can see at this distance to have been inconceivable.) One day he would come to Venice, he wrote Mimi in August 1908, and in solitude, in the shelter of her presence, he would work: "You will give me a room and you will stand guard over my tranquility and my labors. You will be the Angel at the Gate and the silence surrounding my heart. But first I have to finish, here, my next book."[9] It ought not to be surprising that Mimi Romanelli, who never married, in later years considered Rilke, along with one youthful suitor who had killed himself over his lack of prospects, to have been one of the two great loves in her life, ahead even of Gabriele D'Annunzio, who had once been enamored of her. She seems to have taken Rilke at his word that someday they would live together and she would stand guard over his solitude as he worked. In the one book so far devoted to her, the aging servant woman who had outlived her is said to have revealed a secret that Mimi thought she had

taken to her grave: that it was with Rilke, on one of his visits to Venice, that she had chosen the location for the villa on the Lido in Venice where she would spend most of her adult life, the Villa Isolana.[10] Clearly it was to have been the locus of their idyll.

It is striking how different are Rilke's letters to these two women Rilke had addressed as "friend" from the ones he had once written to Paula; how little he had been able to work on the mature Paula the spell of his eloquence, which captivated both Mimi and Sidie. Though she had learned from him, she had never been a disciple; once he had truly seen her work she was no longer friend but fellow artist, as these were not.

Looking far ahead we see that, like his personal encounters with Sidie, those few with Mimi over the years were largely disillusioning, and the letters in between soon begin to fill with explanations and excuses for having placed his need to work above answering one of her letters, or even above seizing one of their rare opportunities to meet. In these, too, the resemblance to Rilke's indoctrination of Clara remains. In May 1910 he was in Venice, but Mimi was not satisfied with their time together, and as he was leaving he wrote her in bitter reproach:

> I cannot leave Venice without telling you that, for the first time, I think of you with nothing but bitterness.
>
> Believe me, the influence and comfort which my heart might be able to transmit to yours do not depend on the time we pass together or the force with which we restrain each other; it is a fluid which must be allowed every freedom so that it may act.
>
> Never forget that I belong to solitude, that I must have need of no one, that my very strength itself is born of this detachment, and I assure you, Mimi, I *pray* to all those that love me to love my solitude; without this, I must hide myself from their eyes, their hands as a wild animal hides from the pursuit of its enemies.[11]

After his return from Venice in 1907, Rilke stayed at Oberneuland, in poor spirits and at times oppressed by a tenacious grippe, until the middle of February. On a trip with several intermediate destinations, he traveled to and from Capri again and so managed to avoid a month and a half of the Paris winter and early spring. He returned to Paris at the beginning of May, this time for a stay, not without interruptions, of several years, during which he would finally complete the long-deferred *Notebooks of Malte Laurids Brigge,* a process underway when the Requiem interrupted it. Clara, too, went to Paris again at the beginning of May,

and stayed, with one interruption, until June 1909. By the end of May Clara had found a large studio at the Hotel Biron, 77, rue de Varenne. Rilke moved into this studio in August, while she was away; later he took a room of his own there. He called Rodin's attention to the building, the former Convent of the Sacred Heart; Rodin soon installed himself there and finally bought the place, which today is the Musée Rodin.

In a letter from Paris written July 16, 1908, to the Countess Lili Kanitz-Menar, whose sister Frau Alice Faehndrich, with whom Rilke had translated Elizabeth Barrett Browning's "Sonnets from the Portuguese" on Capri, had just died, forging another link in his chain of deaths, Rilke wrote words about his relation to death that, without naming Paula, clearly apply to her and define the occasion for the Requiem:

> And now I stand in such a relation to death, that it terrifies me more in those I have neglected, those who have remained unclarified or portentous for me, than in those whom, when they lived, I have loved with certainty, even if they have only for a moment blazed up in the clarity of that nearness which is accessible to love.[12]

It is for just such reasons that Paula would come back to haunt him. The death of Frau Faehndrich led him again, just weeks before the writing of the Requiem, to write in this letter of September 23 to her niece these further ruminations on the relation of the living to the newly dead:

> But as for the influence of the death of someone near and dear on those left behind, it has seemed to me for a long time that it must be no other than that of a higher obligation; does not the depart-ed leave behind to those that survive him, if he stood in some degree of inner relation to them, those hundredfold beginnings he has made, as something that must be carried on? In recent years I have had so many deaths among those near to me to learn from, but no one has been taken from me without my having found the duties all around me multiplied thereby.[13]

Clara's one interlude away from Paris in 1908 took her, from mid-August to the end of September, to the estate of her friend Anna Jaenecke, where she would complete a number of portraits. Clara and Jaenecke were reading *The Discourses of Gautama Buddha* together; when Clara urged Rilke to read them, he declined, even after Jaenecke made him a gift of a handsome copy. In a letter that makes it clear that Clara and her friend had been hurt by his refusal, he explained it by his need to limit not, as Clara had apparently charged, his own outlook, but that

of Malte Laurids Brigge, whose notebooks he was desperately deter-mined to complete.[14] Whether or not this was the beginning of Clara's search for a spiritual direction independent of Rilke's thinking, the search was now clearly in progress; in the long run it would lead her to Christian Science.

During this stay Clara finally addressed Paula's death in her own art, completing a second, revised version of her 1899 bust of Paula. On September 4, Rilke wrote her from Paris a response to her account of it, the single breach I have seen of his silence about Paula between her death and the Requiem:

I forgot to tell you how well I understand your joy and new involvement with the lovely bust of Paula Becker; I too recently thought of it suddenly with utter intensity. I saw it as I discovered, on the second floor of the Louvre, a sandstone royal bust from the [Egyptian] XVIII Dynasty. It resembled [the early bust of Paula] so wonderfully in bearing, in coherence, in expression; I thought then how much greatness there must be in your early work, if such a timeless impression can call it up in one, as the mirror image of a thing, when one notices it, immediately calls up the thing itself, even if one does not see it.[15]

Such praise was, in 1908, the best of what Rilke still had to give his wife.

Rilke's correspondence in the weeks just before the writing of the Requiem shows that he was feeling beleaguered and defensive. Clara and her friend had resented his unwillingness to share in their reading of Buddha; to Ellen Key, who had been visiting Lou Andreas-Salomé, he wrote this in self-defense after she passed on to him some of Lou's familiar complaints:

You know that I understand the complete seriousness of Lou's crit-icism—; but to answer with equal seriousness, especially in relation to what is "difficult"—that would mean writing now that book that (I hope) will one day be completely there, in order to make an accounting; to justify a course of development, which must be jus-tified, unless I have been wrong my entire life about everything.[16]

This is the first time that we encounter in Rilke's own words a line of reasoning that we have attributed to him all along: certain choices in Rilke's life simply *must* be justified, at whatever cost, lest his life be shown to have been lived in error. It was the *Duino Elegies,* when at last he had completed them—and been blessed with the unanticipated

Sonnets to Orpheus as well—that, in Rilke's view, culminated and justi-
fied his life.

In a way that cannot have been pure coincidence, the writing of the
Requiem was bound up not only with the approach of All Souls' Day,
the anniversary of Mathilde Modersohn's birth and Rilke's encounter
with Sidonie Nádherný in Prague, but with his first encounters in per-
son with Mimi Romanelli, who came to spend the winter in Paris, since
he had left Venice in such turmoil. We have the note of October 30,
1908, in which Rilke invites Mimi to his room at the Hotel Biron the
following day—the very day that he began the Requiem—and we know
from further communications that she did come.[17] The potent mix of
love and mourning that had suffused the end of his stay in Venice had
been revived by Mimi's visit, and in turn called up Paula, the memory of
her death—and the poem.

After finishing the poem on All Souls' Day, Rilke immediately broke
his yearlong silence about Paula—in the letter to Sidonie Nádherný
with which this book began. As we have already seen, the letter express-
es his mythic redaction of Paula's death: she had been pulled back from
her heroic artistic progress by her family and her old life, and so suffered
a meaningless, common female death instead of a death fully her own. It
goes on to deplore what had been made of Paula's work since her death,
and the role of those in Worpswede—now the villains of Rilke's myth-
ic piece—in the process: "They are now quickly preparing a kind of
fame for it, this work; the same ones are doing this, who pulled her back
from her alone-ness and progress."[18] This is the accusation Rilke directs
at Otto Modersohn (by claiming not to) in the Requiem; in the letter it
is surely directed at Vogeler as well, who was actively involved, with
Otto, in promoting her work after her death.

To Hugo Heller, the Vienna bookseller, he wrote on June 12, 1909, a
brief exegesis of the Requiem, knowing that Heller's first wife, like
Paula, a painter, had died in childbirth:

> The destiny I attempted to relate and to lament in the "Requiem"
> (the inevitable fate of which you too recognized at painful proxim-
> ity) is perhaps the real conflict of the artist: the opposition and
> contradiction between objective and personal enjoyment of the
> world. That is all no less dangerously and conclusively demonstrated
> in a man who is an artist by necessity, but in a woman who has
> resolved upon the infinite transpositions of the artist's existence, the
> pain and danger of this choice increases to an unforgettable visibility.

Since she is physical far into her soul and is designed for bringing forth living offspring, something like a slow transformation of all her organs must take place in her so that she may reach a vital fruitfulness of soul.[19]

Rilke *is* careful in the next paragraph to insist, as he elaborates on the transformation that must take place, that he is speaking metaphorically and at times exaggerating for emphasis.

The birth processes which in a purely spiritual way the male artist enjoys, suffers and survives, may also broaden and be exalted into the most highly spiritual in the woman capable of artistic gestation, but in this they really undergo only a gradual intensification, still remaining, in unlimited ramifications, within the physical (so that, exaggerating, one might say that what is most spiritual in woman is somehow still body, body become sublime). Hence for her any relapse into a more primitive and narrow kind of suffering, enjoying, and bringing-forth is an overfilling of her organs with the blood that has been increased for another greater circulation.

But even when discounted as metaphorical, this version of what killed Paula sounds, in the human world in which letters are written rather than the mirror world of the poem, self-serving, fanatical, and repellent. Paula did not die as a result of attempting to bear a child after having painted beautiful, advanced, compelling pictures. She died of a lung embolism: a blood clot, likely originating in the varicose veins in her legs (which had pained her for a time after the birth), that had traveled to her heart and from there been pumped straight into the main artery leading to the lungs, cutting off the supply of oxygen to the blood and leading to almost immediate death. Though she lived, apparently healthy, eighteen days after giving birth, pregnancy and childbirth *were* implicated, for the hormonal changes of childbearing dispose women to such blood clots, against which precautions are still routinely taken.

Despite the appeal of many of Rilke's thoughts on the nature of women, for the woman artist to accept his notions on the relation of art and childbearing could only be utterly oppressive; fortunately, they can be dismissed out of hand. One cannot help wondering how Clara, the artist who had borne Rilke's own child, perceived them. Though it scarcely needs saying, there is no greater physical risk in childbirth to women artists than to other women. But for Rilke it was so—because it had to be. It was necessary for his own confidence, for the efficacy of the

stories he told himself in order to continue. This instance helps bring into focus the role of these stories: to mediate between life in the historical world in which, try as he might, he could not avoid living, and that other world of his art in which, given the choice, he would have dwelt exclusively.

On November 4, Rilke sent the manuscript of the Requiem to his publisher, Anton Kippenberg, along with the declaration that it would not, like other poems, be published first in a journal, and then included in his next collection; it must be, and remain, a small book by itself. But later the same day he began a second requiem, for the young Count Wolf von Kalckreuth. To Kippenberg he wrote that the new requiem belonged to the same "current of work" as the first.[20] "The two poems complete and strengthen each other," he continued. "Not for a long time has my work astonished me so as through this wave, that approached so peacefully and surpassed what I was doing at the time." Kalckreuth, son of a distinguished painter, had made promising beginnings as a poet and translator of French poetry; soon after enlisting on the army in October 1906, at the age of nineteen, he had shot himself. Rilke knew of him through Kippenberg, who had published his translations and was soon to publish his own poems.

The second requiem is a smaller and less intense work than the first. Some reasons are obvious: Rilke, directly engaged with Paula for years, had never met Kalckreuth; Kalckreuth had died a year earlier than Paula, and the death had not affected him greatly in the interim until Paula's shade appeared and forced on him an encounter with death so intense that the first requiem could not resolve it. Paula's shade is literally present for Rilke; Kalckreuth's is addressed but never appears in this way. The link between the two poems is that each responds to a death Rilke both deplored and saw as unnecessary, one that foreclosed on the possibility of the one true death that each might have died. Paula should not have moved back to Worpswede and conceived a child; Kalckreuth need not have shot himself. Each pronounces the dead in error, and takes its accusations to extraordinary lengths; each, in the end, forgives and blesses. Some of the lessons are the same, as is apparent from this ceremonious passage near the end of the poem:

This was yours, you artist: these three open
vessels. See what pours out of the first:
a space that opens out about your feeling;
from the second I release to you that way
of looking that desires nothing, that great
gaze that is the artist's; in the third,
which you yourself broke open all too soon,
when that first trembling sustenance from the heart's
white heat had scarcely entered—was a death
deepened by good work, that death all one's own
which needs us because we alone can live it,
to which we are never closer than right here.[21]

The poem's last lines, among Rilke's most widely remembered, pro-
nounce the end of the era of heroic deeds in the outer world: "Who
speaks of conquest? To endure is all."

ℱifteen

To the extent that Rilke's Requiem was meant to serve as an exorcism, it failed, for the shade of Paula Modersohn-Becker went on appearing to him, sometimes as a result of inner, sometimes of outer, promptings, for many years after. The Requiem itself, of course, as Rilke grew toward the worldwide fame of his later years, did a good deal to keep Paula's memory alive. For the rest of his life, Rilke spoke willingly of Paula to intimates and admirers, passionately expounding the Requiem's mythic version of her life and fate. The version that Katharina Kippenberg recorded begins from Rilke's sense that for a woman, for whom the demands of life included those of marriage and the bearing and rearing of children, the dilemma posed by that old enmity between life and work is particularly acute:

> Of Paula Modersohn-Becker, Rilke said that she had made the noble attempt to unify them, "and," he said, his eyes growing sad, "she is the only one of the dead who burdens me." He took her death as the ultimate answer to an ultimate question, and a dreadfully bitter one, because this woman who strove to be doubly productive was incomparably worthy of artistic productivity, but also wanted to be productive as a woman, and was chastised for this by death—when she was not prepared for death—by a wrathfully negating God.[1]

Loulou Albert-Lasard, herself a mother, painter of a portrait of Rilke, and one of his lovers, heard the story in Munich near the beginning of

the war.[2] Elisabeth von Schmidt-Pauli writes of Rilke's having told it to her on All Souls' Day 1919 as they lit candles for the dead at his apartment in Munich.[3]

In 1913 the first limited and heavily edited selection of Paula's letters and journals appeared in the Bremen publication *Die Güldenkammer.* Reading it in Paris in the spring, Rilke was moved to write Paula's brother Kurt an eloquent letter in praise of her, the very effort he put into the writing making palpable, conventional sentiment aside, the degree to which he had been moved by the reading:

> she was so generous and masterful in her joy that she never lost control of it, but rather, in an orderly way, taking in quite seriously and thoroughly the anticipation of joy and, calmly feeling, proceeding into joy itself; and it was precisely beyond this joy that the way was open for her into the eternal.[4]

He mentioned having once been given an early journal of Paula's to read, back when both had been in Berlin before their marriages, but said that even in the parts that he had not read before he felt "a boundless recognition."

> For in those moments of transport which made up her life, she spoke as if for eternity, placed herself with every line, whether written when aroused or fatigued, in doubt or in good spirits, into a relation with the whole. Where she believed, she was a star; and where she could not yet believe it was like the twilight of a dawning day, enveloping the earth. But there was in her being no disillusion, no regret, no trace of diminished expectation, nothing that could turn bad, spoiled, gloomy.
>
> Ah, how it all comes rushing down with the exuberance of a mountain spring, and how pure, pure, pure it comes forth at that spot where the first alien intimation of death fell over her.
>
> You know, d[ear] D[octor] B[ecker], how the fate of her death shook me; a few other circumstances may have played some significant part, but that she, so exceedingly lovable in her heart, left us so soon and so shatteringly—: it was perhaps the first reason why for many years death outweighed life for me, was greater, more just and of more pressing concern to me than all the fullness of this-worldly forces which otherwise so happily occupy us.

He urged Kurt Becker, and through him Paula's mother, to release a far wider selection. He added, however, a caveat: he did not want to see

all of it published, for Paula's writing on the likes of Cottet and Simon no longer had real value.

Three years later, Rilke's suggestion bore unanticipated fruit: in the fall of 1916 Paula's mother sent him a large packet of the letters and journals, asking him to edit them for book publication. He waited to read them until Clara's birthday, November 21, the day following the anniversary of Paula's death—and used the occasion to consult Clara as well. Finally answering Frau Becker on the day after Christmas, he represents the decision to decline the task as Clara's as well as his own—the sort of representation of which we have learned to be skeptical.

> even the first reading that evening made us realize that the editing (and publication) of these papers would be wrong, if for no other reason than that the picture of Paula Modersohn to which they contribute would inevitably be an indescribably inferior image to the one she ultimately attained in her final year and in the great beauty of her departure from us. Much of what was unique in her would, of course, be conveyed, but not she herself—only what was ready and waiting in her. But not her freedom, not her great productive heart, nothing of the rapid, sudden ascent which is revealed and remains preserved in the final stages of her art.[5]

Acknowledging that he had once encouraged the publication, he grasped at the one way out of this commitment that his letter to Kurt Becker had left him: "I did so in the anticipation that from her last years, from these years of ruthless independence and accomplishment, notebooks and letters would have been found." As always, he could judge only by what he believed to be the highest standards; since the publication of van Gogh's letters and journals, anything "less complete and less passionate" could not be justified.

Further on, the letter exhibits the same sort of need to have the last word in his debate with Paula that one sees in the Requiem. What was unsatisfactory about Paula, it says, was that, until she left Otto, she had tried to do justice both to life and to art:

> Up until February 1906, she somehow insistently clung to being "worthwhile and likeable." This phrase which she applied to herself could stand as a motto for the entire packet of letters and notebooks. Concerned, indeed, worried, about being charming and gracious, but at the same time fundamentally obligated to being so, indeed promoting these qualities in the face of the frequently coarse condi-

tions of her life, Paula caused a certain compromising nature to take hold of and activate her responses. In the ultimate and absolute sense, most of what she wrote is not truthful; rather it is adapted to a way of living in which agreeableness and graciousness were the decisive qualities.

Leaving Worpswede, Otto and the "coarse conditions" of her prior life behind, she had finally found the "true poverty" of sight he had praised in the Requiem:

It was then that a "validity" finally commanded her attention that no longer depended on her own scale of measurements; and so far as charm and grace were concerned, only a quite unguarded and involuntary remnant of them was now left to be transformed from emotional involvement into the shape of her art. And so there arose out of desperation and hope, out of unconditional self-liberation, that incomparable work of hers to which she surrendered concern about validity and grace, in order that they now might be truly metamorphosed.

We must not fail to give due weight to this assertion of Rilke's: it is the work of Paula's last year in Paris that matters. And while this time was a decisive and defining one for Paula, it was not the only such time. Though she painted wonderful pictures then that she could not have done in Worpswede, she also painted wonderful pictures before and after. Rilke is revising here; he had given far greater credence to Paula's work in Worpswede when writing to von der Heydt in 1905. But now it could not be so, for it was necessary that Paula have been wrong—lest a vital corner of his world view come loose from its foundation.

After Rilke declined to edit Paula's papers, they were offered to his publisher, Anton Kippenberg, who also declined. Rilke argued even more forcefully against publication of the letters and journals in letters to Kippenberg from the summer of 1917. He dismissed Kippenberg's own concerns about possible indiscretions contained in the documents: "If only the manuscript did contain things that, so to speak, resided on the far side of indiscretion, greater, riper, more mature judgments. But it never reaches that point."[6] Again, Rilke's chief reservation is that there was not enough surviving material from the time when Paula had seen the error of her ways, left Otto, and gone to Paris:

yet even taken together they still do not amount to so much as a prelude to this life. For where do they give us a glimmer of the fact

that this accommodating creature who so compliantly and cooper-
atively devoted herself to familial harmony would later, seized by
the passion of her task and renouncing all else, take upon herself a
life of loneliness and poverty?

It is astonishing to hear the Paula we have come to know in this book
described as "this accommodating creature"—no one else around her
saw her in this way. Only when Paula is compared to Rilke himself, with
his sheer dread of the least accommodation to human obligations, does
this characterization make sense.

In the end the papers were placed in the hands of Sophie Dorothea
Gallwitz. When, in 1917, for the tenth anniversary of Paula's death, the
Kestner Society sponsored a large retrospective show of her work in
Hannover, Gallwitz's edition of the letters and journals was published in
a limited edition for its members. The first edition for the trade was pub-
lished in 1919, the year in which Gustav Pauli of the Bremen Kunsthalle
issued the first monograph on her work. Gallwitz's intrusive editorial
hand complicated the tasks of later scholars by modifying the texts of
Paula's journals and letters to her parents, whose originals were lost in
the chaos at the end of World War II.

The career of Paula's journals and letters after this first publication
appears to justify Rilke's fears. This is Günter Busch's account:

The book became a veritable classic and best-seller in the
German-speaking world. It was loved and prized even by those
who had no understanding for her work as an artist and indeed by
some who actively disliked it. Thus it gradually happened that the
charming human personality which spoke so clearly and unequiv-
ocally from her writings was exaggerated and ultimately pushed to
center stage and out in front of her great creative talent.[7]

The popularity of this limited version of Paula's writings was such
that when Rilke encountered them again, in 1923, in his tower at Muzot
in Switzerland, it was because they had been given to his housekeeper as
a Christmas gift. He borrowed it for a time, and returned it to Frieda
Baumgartner with an inscription: "Read it with joy and devotion; it
concerns a life committed to what is purest, and bears witness to it in its
simple, truthful way."[8]

The interest of this encounter with Paula's memory lies in the fact
that it occurred late enough in Rilke's life to allow him to be more gen-
erous in his responses. His great, culminating lifework, the *Duino Elegies*
and *Sonnets to Orpheus,* lay behind him; he no longer felt such a need to

be in the right in regard to his differences with Paula. And he now saw the Requiem as having been a vital step in his own journey toward the elegies and sonnets. This perception is confirmed by his inscription in the volume of the sonnets that he presented to Clara in 1923: "Has not that which was earlier, in the Requiem, / still but a sound, and somehow passed away, / now become pure permanence, pure monument?"[9] In his Christmas letter to Clara, with whom by now he had little contact, he spoke of being more moved, reading them, than he had been by what he had seen earlier, and guessed that the edition had been expanded. "Only now can that fabulously pure linking of destiny and task be perceived; only now does one understand the measure of quiet exclusion and equally quiet assent vested in her, and admire, once again, the way she used it, almost undoubting, reverently, and joyfully."[10] Rilke went on to confess what he now saw more fully as his failures with respect to Paula, and in so doing to rekindle the lost intimacy between himself and Clara:

I had the feeling in reading that I should lay my two books [the elegies and sonnets] somewhere in a niche to her memory, so that she may now pardon me my "joylessness" and so much else. And with you too, dear Clara, she would be pleased and in accord and would remind you that, nearly twenty-five years ago, she noted down that whatever might befall you, it would always be for your best good!

These comments recall two passages Rilke had read in the journals and letters. From Paris, on February 12, 1903, soon after arriving there and seeing the Rilkes for the first time, she had written "their joylessness can be contagious."[11] (And Rilke would have had no illusions about the fact that Paula attributed this joylessness to him and his influence on Clara.) The second reference stems from Paula's and Clara's stay in Paris in 1900; she had written to her parents a candid description of Clara just after her enrollment in Rodin's short-lived school:

To my way of thinking, she often seems too big and cumbersome, inwardly and outwardly. But she has such a powerful nature, too, the kind that seizes on everything that approaches her and unwittingly twists and turns it until she can make use of it. People like that can never be unhappy. Whatever happens to her will always turn out to her advantage.[12]

We can only wish for Clara's sake that Paula had been right.

There are, to be sure, small signs that Paula's memory never fully lost its ability to trouble Rilke. In 1924, in answering one of a lengthy list of questions sent to him by the scholar Hermann Pongs ("What personal impression of the late pictures of Paula Modersohn?"), Rilke chose for some reason to deny her, writing, "Paula Modersohn I last saw in Paris in 1906 and knew little of her works of that time or her latest, with which even now I am not yet acquainted."[13] In the same answer to Pongs, Rilke denied ever having been formally employed by Rodin as secretary, and represented his departure from Meudon in May 1906 as his own decision. In the mythic version of his relation to Rodin it was simply unacceptable that he had been, as he had put it in his reproachful letter to Rodin at the time, "sacked like a thieving servant." What it was about his contact with Paula and her work that required this retrospective correction remains open to speculation.

It is satisfying to recognize, though, that Rilke did at last find a degree of peace with Paula Modersohn-Becker's memory, which finally no longer seemed to challenge by its example the validity of his own life. Never content merely to receive his admiration, his praise, his instruction, his admonitions, all of which many women had found irresistible, she had kept her own course independent of the enormous force of his personality. As a result, she had been able to derive great benefits from all that, in the tirelessness of his pursuit and the enormity of his accomplishment, he had to offer her. He had, in turn, benefitted greatly from her, precisely because his most superficial magic, by which he made his way through a world in which he never felt at home, did not bewitch her, and so she challenged him to use his most profound. Though in the Requiem, for purposes of his own, including the fixing of blame, he presented her life and work as abortive, tragically incomplete, we can see from here that it was not so. The evidence: more than six hundred paintings and studies, more than a thousand drawings—and the letters and journals by which so many still first come to know her. As we suspected from the first, what he had said about her in his letter to Sidonie Nádherný was not so: she did not ever fall back. If—like John Keats—she died an early death that we will never find wholly acceptable, she lived long enough and determinedly enough for her art to reach fruition. We have the evidence: ripe fruit.

More recently, others have sought to reach, for *their* own purposes, among them the fixing of blame, Rilke's flawed conclusion by other routes. Every scheme contriving to prepare for Paula Modersohn-Becker the role of victimized artist that might have been relies for its credibility

on a diminution of her actual achievements and a magnification of all she struggled against. It requires, too, that the embolism that killed her be seen, as Rilke saw it, not as a medical event but as a moral agent and the proclamation of a truth. Thus it is kin to the reasoning of those who rush to embrace the message from God that they believe they have deciphered in the HIV virus that has killed so many artists in our day. It relies on the desperate suppression of this truth: that her life, though cut short, was a triumph.

⌐*Notes*

Paula Modersohn-Becker, *The Letters and Journals,* edited by Günter Busch and Liselotte von Reinken, edited and translated by Arthur S. Wensinger and Carole Clew Hoey, is a virtual casebook on Modersohn-Becker's life, containing material not only from Modersohn-Becker herself but from nearly all of the principals in the story told here. All quotations without notes are taken from *The Letters and Journals,* except in chapters 5 and 6, where all Rilke quotations without notes can be found in Rainer Maria Rilke, *Briefe und Tagebücher aus der Frühzeit.* Notes are not given for quotations that can be readily located within the chronological sequence of either volume.

Except as noted, all translations of material not found in *The Letters and Journals,* and all translations of Rilke's verse, are by the author.

Chapter One

1. Rainer Maria Rilke, "Requiem für eine Freundin," in *Sämtliche Werke,* 1:645f. Rilke finished the poem, begun two days earlier, on November 2.

2. Rilke, *Briefe an Sidonie Nádherný von Borutin,* 89.

3. Lit. "between (the) life and (the) great work."

4. Katherina Kippenberg, *Rainer Maria Rilke: Ein Beitrag,* 230.

5. Stephen Mitchell's great series of translations is one of the fruits of the path of assent. Among those who have taken the path of resistance, one might name early biographer E. M. Butler *(Rainer Maria Rilke)* and critic Erich Heller *(The Disinherited Mind).*

Chapter Two

1. "Limitations in his makeup": see Peter Demetz, *René Rilkes Prager Jahre*, 11f.

2. Elisabeth von Schmidt-Pauli, *Rainer Maria Rilke: Ein Gedenkbuch*, 47.

3. *The Notebooks of Malte Laurids Brigge*, 99–100.

4. Demetz, *René Rilkes Prager Jahre*, 37.

5. Rilke, *Sämtliche Werke*, 1:21–22.

6. Jens Peter Jacobsen, *Niels Lyhne*, 18.

7. Ibid., 28.

8. Ibid., 58.

9. *The Notebooks of Malte Laurids Brigge*, 10.

10. *Letters of Rainer Maria Rilke 1910–1926*, 450n.

11. H. F. Peters, *My Sister, My Spouse*, 206.

12. Rudolf Binion (*Frau Lou*) scoffs; Peters suggests that Dr. Friedrich Pineles—"Zemek" as she called him—must have been her lover before Rilke, as he certainly was later.

13. Handwriting: Peters, *My Sister, My Spouse*, 209.

14. Binion, *Frau Lou*, 226n.

15. Rilke, *Sämtliche Werke*, 1:172f.

16. Heinrich Vogeler, *Werden*, 49.

17. Richard Pettit, *Rainer Maria Rilke in und nach Worpswede*, 11.

18. Rilke, *Sämtliche Werke*, 3:636. "Master": the German *Herr* also sustains the more pious reading "Lord," but Rilke is more likely to have had Vogeler in mind.

19. Rilke, *Tagebücher aus der Frühzeit*, 101–2. Ralph Freedman (*Life of a Poet*, 83), who glosses this passage differently, links it to the suggestion that Lou had been pregnant by Rilke. Binion (*Frau Lou*, 229) sees Rilke as merely parroting what he took to be Lou's thoughts on the subject.

20. Rilke, *Tagebücher aus der Frühzeit*, 115.

21. Peters, *My Sister, My Spouse*, 236.

Chapter Three

1. "My Sunken Bell mood!": Gerhart Hauptmann's play *The Sunken Bell* was one of Paula's chief enthusiasms of the time; she associated it with her intense responses to nature.

2. *Des Knaben Wunderhorn* (The Boy's Cornucopia): a collection of folk ballads that inspired the German romantic poets.

3. Jacobsen, *Niels Lyhne*, 87–88.

4. *Otto Modersohn Worpswede 1889–1907*, 41.

5. Hans-Christian Kirsch, *Worpswede Die Geschichte einer deutschen Künstlerkolonie*, 49–50.

6. *Otto Modersohn Worpswede 1889–1907*, 45.

7. Kirsch, *Worpswede*, 44.

8. Ibid., 96.

9. Transcription in Worpswede Archive.

10. Vogeler, *Werden*, 32f.

11. Ibid., 43.

12. *Otto Modersohn 1865–1943*, 302.

13. Eduard Hindelang, ed. *Die Bildhauerin Clara Rilke-Westhoff 1878–1954*, 11.

14. Rilke, *Tagebücher aus der Frühzeit*, 207f.

15. Hindelang, ed., *Die Bildhauerin Clara Rilke-Westhoff*, 11.

16. Vogeler, *Werden*, 57–58.

17. Inge Stephan, *Das Schicksal der begabten Frau im Schatten berühmter Männer*, 114.

18. Rolf Hetsch, ed., *Paula Modersohn-Becker Ein Buch der Freundschaft*, 42; translated in Modersohn-Becker, *The Letters and Journals*, 51–52.

19. Modersohn-Becker, *The Letters and Journals*, 464n.

20. Hetsch, ed., *Paula Modersohn-Becker*, 35f.; translated in Modersohn-Becker, *The Letters and Journals*, 467n.

21. Hetsch, ed., *Paula Modersohn-Becker*, 34f.; translated in Modersohn-Becker, *The Letters and Journals*, 52.

22. Modersohn-Becker, *The Letters and Journals*, 128.

23. Marina Sauer, *Die Bildhauerin Clara Rilke-Westhoff 1878–1954*, 27.

24. Modersohn-Becker, *The Letters and Journals*, 469n.

25. Pauli, *Erinnerungen aus sieben Jahrzehnten*, 155.

Chapter Four

1. Emil Nolde, *Mein Leben*, 78; translated in Modersohn-Becker, *The Letters and Journals*, 480n.

2. Modersohn-Becker, *The Letters and Journals*, 171. This observation and the possible relation to Cézanne by the editors of *Paula Modersohn-Becker in Briefen und Tagebüchern*.

3. Hetsch, ed., *Paula Modersohn-Becker*, 43; translated in Modersohn-Becker, *The Letters and Journals*, 173.

4. Hindelang, ed., *Die Bildhauerin Clara Rilke-Westhoff*, 141f.

5. Sauer, *Die Bildhauerin Clara Rilke-Westhoff*, 30.

6. Hetsch, ed., *Paula Modersohn-Becker*, 43.

7. *Otto Modersohn Worpswede 1889–1907*, 166.

8. Christa Murken-Altrogge, *Paula Modersohn-Becker*, 117.

9. Hetsch, ed., *Paula Modersohn-Becker*, 44.

10. Ibid., 45–46.

Chapter Five

1. Vogeler, *Werden*, 71.
2. Ibid., 72.
3. Rilke, *Sämtliche Werke*, 1:170–71.
4. Gert Buchheit, ed., *Rainer Maria Rilke: Stimmen der Freunde*, 48–49.
5. Rilke, *Sämtliche Werke*, 3:688.
6. Ibid., 1:201.
7. Ibid., 1:375. Second line, originally, "To say those things which you willingly [*willig*] are"; in the published version, *einsam* (lonely) replaces *willig*.
8. Rilke, *Tagebücher aus der Frühzeit*, 219.
9. Rilke, *Sämtliche Werke*, 3:695.
10. *Otto Modersohn Worpswede 1889–1907*, 166.
11. *Otto Modersohn 1865–1943*, 305.
12. Rilke, *Sämtliche Werke*, 1:402.
13. *Otto Modersohn Worpswede 1889–1907*, 167–68.
14. Rilke, *Sämtliche Werke*, 1:437f.
15. Heinrich Wigand Petzet, *Das Bildnis des Dichters*, 34f.
16. Rilke, *Sämtliche Werke*, 1:405. Because of the missing page, the four poems cannot be dated precisely; they were written at the time of, or in the two weeks after, Rilke's departure.
17. Helmut Naumann, *Rainer Maria Rilke und Worpswede*, 64. So widely accepted is the view that Rilke left Worpswede after learning about Paula and Otto that Naumann has written an entire book to refute it. He declines to see in Rilke's journals any sign that he was ever in love with Paula Becker—he claims that they show a relatively direct course of involvement with Clara Westhoff leading to marriage, while the encounters with Paula were instead a kind of apprenticeship in the art of seeing. He believes that the poems Rilke wrote when, months later, Paula finally told him about her and Otto, prove that he had not known earlier. He says that Rilke had simply put off as long as he dared going to Berlin to attend to the planned exhibition of Russian art there.

Chapter Six

1. J. F. Hendry, *The Sacred Threshhold*, 39.
2. Rilke, *Sämtliche Werke*, 3:566.
3. Jacobsen, *Niels Lyhne*, 193–94.
4. Modersohn-Becker, *The Letters and Journals*, 496n.
5. Rilke, *Sämtliche Werke*, 3:704.
6. Ernst-Gerhard Güse, "Otto Modersohn und Rainer Maria Rilke," in *Otto Modersohn Zeichnungen*, 40.
7. "My everyday soul's day"—in German, *Seelenalltag*, Paula's pun on *Allerseelentag*, All Souls' Day.

8. *Otto Modersohn Worpswede 1889–1907*, 168.

9. Güse, "Otto Modersohn und Rainer Maria Rilke," 40.

10. Rilke, *Sämtliche Werke*, 3:716.

11. Petzet, *Das Bildnis des Dichters*, 120.

12. Rilke, *Briefe und Tagebücher aus der Frühzeit*, 56–57; translated in *Letters of Rainer Maria Rilke 1910–1926*, 46f.

13. Rilke, *Sämtliche Werke*, 3:713.

14. Ibid., 1:469f.

15. In *ABC of Reading* Ezra Pound makes the same pun: *dichten = condensare*.

16. Binion, *Frau Lou*, 285.

17. Hendry, *The Sacred Threshhold*, 40.

18. The first half of this poem appears as "Prayer" in *The Book of Pictures* (Rilke, *Sämtliche Werke*, 1:401).

19. Modersohn-Becker, *The Letters and Journals*, 65–66.

20. Ibid., 492n. According to *The Letters and Journals*, it was a painting that this little poem accompanied. Marina Bohlmann-Modersohn (*Paula Modersohn-Becker Eine Biografie mit Briefen*, 151) says it was a photograph.

21. Jacobsen, *Niels Lyhne*, 194.

22. Donald Prater (*A Ringing Glass*, 76) cites Carl Sieber's unpublished account in the Rilke Archive, Gernsbach.

23. Modersohn-Becker, *The Letters and Journals*, 496n.

24. *Rainer Maria Rilke Lou Andreas-Salomé Briefwechsel*, 50.

25. Ibid., 51.

26. Ibid., 53.

27. Rilke, *Sämtliche Werke*, 3:637.

28. Binion, *Frau Lou*, 300.

Chapter Seven

1. Hans Wohltmann, *Rainer Maria Rilke in Worpswede*, 35–36.

2. Rilke, *Briefe und Tagebücher aus der Frühzeit*, 118.

3. Ibid., 104.

4. Pettit, *Rainer Maria Rilke in und nach Worpswede*, 98. Ruth Rilke's large size at birth is evidence that she was not premature, as some have suggested as alternative to the assertion that Clara was two months pregnant at the wedding.

5. Ibid., 98.

6. Rilke, *Briefe an Axel Juncker*, 17–18.

7. *Letters of Rainer Maria Rilke 1892–1910*, 62.

8. Rilke, *Sämtliche Werke*, 3:403.

9. Wolfgang Leppmann, *Rilke: A Life*, 142.

10. Rilke, *Briefe und Tagebücher aus der Frühzeit*, 161.

11. Hetsch, ed., *Paula Modersohn-Becker*, 16; translated in Modersohn-Becker, *The Letters and Journals*, 225.

12. Carl Hauptmann, *Briefe mit Modersohn*, 33, 36.

13. Ibid., 37.

14. Ibid., 38.

15. Vogeler, *Werden*, 139.

16. Rilke, *Sämtliche Werke*, 3:755.

17. Wohltmann, *Rainer Maria Rilke in Worpswede*, 39.

18. Ernst-Gerhard Güse has cited this passage as an embodiment of all that Paula, Otto, and others had come to hold against Rilke for the tone he had set for his life with Clara. Two words attributed here to Otto have negative senses that might reflect these grievances: *ceremoniously* (*feierlich*) and *exalted* (*selig*). Güse, "Otto Modersohn und Rainer Maria Rilke," 41.

19. Modersohn-Becker, *The Letters and Journals*, 268.

20. Ibid., 269.

21. *Letters of Rainer Maria Rilke 1892–1910*, 57.

22. Jacobsen, *Niels Lyhne*, 243.

23. Rilke, *Briefe und Tagebücher aus der Frühzeit*, 170.

24. The grave is marked by a melodramatic sculpture by Bernhard Hoetger of a child on the breast of its dying mother.

Chapter Eight

1. Rilke, *Briefe und Tagebücher aus der Frühzeit*, 157.

2. Transcription in Worpswede Archive.

3. Rilke, *Briefe und Tagebücher aus der Frühzeit*, 182.

4. Rilke, *Sämtliche Werke*, 5:8; quotation in Jacobsen, *Niels Lyhne*, 194.

5. Rilke, *Sämtliche Werke*, 5:13–14.

6. Ibid., 5:33.

7. Ibid., 5:87.

8. Ibid., 5:87–88.

9. Previous Vogeler article: text accompanying a Vogeler number of *Deutsche Kunst und Dekoration* (Apr. 1902). Rilke, *Sämtliche Werke*, 5:553.

10. Rilke, *Sämtliche Werke*, 5:134.

11. Pettit, *Rainer Maria Rilke in und nach Worpswede*, 129.

12. *Rainer Maria Rilke Lou Andreas-Salomé Briefwechsel*, 86.

13. Rilke, *Briefe und Tagebücher aus der Frühzeit*, 188–89.

14. Ibid., 199.

15. Rilke, *Briefe an Auguste Rodin*, 9.

16. Ruth Butler, *Rodin: The Shape of Genius*, 370.

17. Ibid., 375.

18. Hindelang, ed., *Die Bildhauerin Clara Rilke-Westhoff*, 100.

19. Ibid., 106.

20. Pettit, *Rainer Maria Rilke in und nach Worpswede*, 196f.

21. Sauer, *Die Bildhauerin Clara Rilke-Westhoff*, 41.

22. Transcription in Worpswede Archive.
23. Sauer, *Die Bildhauerin Clara Rilke-Westhoff*, 41.
24. Carl Sieber, "Rainer Maria Rilke in Worpswede," 70f.
25. Hindelang, ed., *Die Bildhauerin Clara Rilke-Westhoff*, 143.
26. January 19, 1903; Sauer, *Die Bildhauerin Clara Rilke-Westhoff*, 42.
27. Rilke, *Sämtliche Werke*, 5:200.
28. Ibid., 5:201.

Chapter Nine

1. *Otto Modersohn Zeichnungen*, 307.
2. Sauer, *Die Bildhauerin Clara Rilke-Westhoff*, 42.
3. *Otto Modersohn Zeichnungen*, 309.
4. "Rainer Maria Rilke–Otto Modersohn: Briefwechsel."
5. Rilke, *Briefe aus den Jahren 1902 bis 1906*, 61.
6. Pettit, *Rainer Maria Rilke in und nach Worpswede*, 186.
7. Rilke, *Briefe aus den Jahren 1902 bis 1906*, 57–58.

Chapter Ten

1. *Rainer Maria Rilke Lou Andreas-Salomé Briefwechsel*, 59.
2. Rilke, *Letters to a Young Poet*, 97.
3. Ibid., 33–34.
4. *Rainer Maria Rilke Lou Andreas-Salomé Briefwechsel*, 80.
5. Ibid., 76.
6. Ibid., 77.
7. Ibid., 87.
8. Ibid., 91.
9. Sauer, *Die Bildhauerin Clara Rilke Westhoff*, 43.
10. *Rainer Maria Rilke Lou Andreas-Salomé Briefwechsel*, 80.
11. Ibid., 97.
12. Ibid., 90.
13. Ibid., 93.
14. Ibid., 98–99.
15. Ibid., 108.
16. Vogeler, *Werden*, 139; Ilse Alpers, *Clara Rilke-Westhoff und Rainer Maria Rilke*, 17f.
17. Sauer, *Die Bildhauerin Clara Rilke-Westhoff*, 45.
18. Ibid.
19. *Rainer Maria Rilke Lou Andreas-Salomé Briefwechsel*, 126.
20. Sauer, *Die Bildhauerin Clara Rilke-Westhoff*, 46.
21. Rilke, *Sämtliche Werke*, 1:542.

Chapter Eleven

1. Letter of November 3, 1997, from Christian Modersohn of the Otto Modersohn Museum, who believes that omission of the comparison to Reyländer from this widely cited passage distorts its meaning. This is the full text of the Reyländer reference: "At Meyer's, works of Reyländer and Paula. Reyländer very uncongenial, superficial, conventional, an external story tossed off,—a dangerous manner, in which there is no development. Any ten people at the academy are like this. Paula the opposite."

2. Vogeler, *Werden*, 113.

3. Quoted in John Russell, *Vuillard*, 20–21.

4. Butler, *Rodin*, 376.

5. Reproduced in Sauer, *Die Bildhauerin Clara Rilke-Westhoff*, 225. For dating of the portrait, see ibid., 179 n. 252.

6. Vogeler, *Werden*, 116.

7. Modersohn-Becker, *The Letters and Journals*, 521n.

8. Vogeler, *Werden*, 84.

9. Petzet, *Das Bildnis des Dichters*, 74.

10. Modersohn-Becker, *The Letters and Journals*, 513n.

11. Ibid.

12. Ibid., 520n.

13. Renate Berger, *Malerinnen auf dem Weg ins 20. Jahrhundert*, 318–19 n. 501.

14. Marina Bohlmann-Modersohn, *Paula Modersohn-Becker: Eine Biografie mit Briefen*, 229.

15. Prater, *A Ringing Glass*, 129.

Chapter Twelve

1. Bohlmann-Modersohn, *Paula Modersohn-Becker*, 240–41.

2. Ibid., 245.

3. Ibid., 246.

4. Ibid., 247.

5. Quoted in Karin Brahms, "'diese Künstlerin, nein, dieser große Künstler,'" 61.

6. Modersohn-Becker, *The Letters and Journals*, 394.

7. Bohlmann-Modersohn, *Paula Modersohn-Becker*, 235.

8. Modersohn-Becker, *The Letters and Journals*, 526n.

9. Binion, *Frau Lou*, 322.

10. Rilke, *Briefe aus des Jahren 1902 bis 1906*, 304.

11. Modersohn-Becker, *The Letters and Journals*, 529n.

12. Rilke, *Briefe aus des Jahren 1904 bis 1907*, 133.

13. Ibid., 136.

14. Butler, *Rodin*, 390.

15. Ibid., 391.

16. Bohlmann-Modersohn, *Paula Modersohn-Becker*, 255.

17. This is the version once on display with the Roselius Collection in Bremen but now in private hands, rather than the much darker version at the Kunstmuseum Basel.

18. Günter Busch, *Paula Modersohn-Becker Malerin Zeichnerin*, 84.

19. Carl Georg Heise, *Paula Modersohn-Becker: Mutter und Kind*, 13. Liselotte von Reinken, editor with Günter Busch of the definitive version of the letters and journals, is one who questions this reading (von Reinken, *Paula Modersohn-Becker*, 120–21).

20. Murken-Altrogge, *Paula Modersohn-Becker*, 114.

21. The quoted phrase is the title of Brigitte Uhde-Stahl's book.

22. Jacobsen, *Niels Lyhne*, 206.

23. Leppmann, *Rilke: A Life*, 221.

24. Rilke, *Sämtliche Werke*, 1:486. The second aubade, ibid., 2:325–26.

25. Petzet, *Das Bildnis des Dichters*, 112.

26. Pettit (*Rainer Maria Rilke in und nach Worpswede*, 225) links this quote to the portrait, citing Rudolf Kassner, *Rilke*, 15.

27. Busch, *Paula Modersohn-Becker Malerin Zeichnerin*, 60; Modersohn-Becker, *The Letters and Journals*, 324. Ironically, one of Paula's most expressive paintings of an infant, which operates in just the way described above, is *Infant with Its Mother's Hand* (1903)—the painting Rilke and Clara bought from Paula in the winter of 1905–6 as they hatched with her the plans for her escape.

28. Petzet, *Das Bildnis des Dichters*, 116.

29. Ibid., 117.

30. Ibid., 118.

31. Ibid., 143.

32. *Briefwechsel mit Helene von Nostitz*, 96.

33. Rilke, *Sämtliche Werke*, 1:322.

34. Rilke, *Briefe aus den Jahren 1906 bis 1907*, 36.

35. Ibid., 62.

36. Modersohn-Becker, *The Letters and Journals*, 527n.

Chapter Thirteen

1. February 1907, 2; Worpswede Archive.

2. *Otto Modersohn 1865–1943*, 208.

3. Ibid., 339.

4. Karin Brahms bases almost solely on these three paintings her case that after returning to Otto Paula not only felt trapped and defeated but also had reached rather contemporary-sounding feminist conclusions about the reasons ("'diese Künstlerin, nein, dieser grosse Künstler,'" 58). She reads the small girls in the paintings as the artist's self-projections, and observes that while Gauguin's

works evoke an idealized natural paradise, Paula's are posed interior tableaux with certain bourgeois trappings: carpets, potted rubber trees, cut flowers in vases, goldfish in a bowl. Her conclusion: "For the first time in her life the artist was confronted by the inescapability of her situation in all its sharpness, knowing that this too was attributable to her gender; for the first time she was forced to reflect clearly on her position as a woman in society, and to realize that she had lived a dream, that her wish for the fulfillment of her art, her feminity, her freedom, her identity had been a utopian fiction."

5. Modersohn-Becker, *The Letters and Journals*, 412. In a letter to Otto, Paula's brother Kurt expressed the suspicion—certainly wrong—that Pauli had been put up to praising Paula in this way, and hadn't really meant it (Modersohn-Becker, *The Letters and Journals*, 532n).

6. Rilke, *Briefe aus den Jahren 1906 bis 1907*, 86–87.

7. Sauer, *Die Bildhauerin Clara Rilke-Westhoff*, 51.

8. Rilke, *Briefe aus den Jahren 1904 bis 1907*, 215f.

9. Binion, *Frau Lou*, 322.

10. Modersohn-Becker, *The Letters and Journals*, 532n.

11. Rilke, *Briefe aus den Jahren 1906 bis 1907*, 180.

12. Ibid., 224.

13. Rilke, *Briefe aus den Jahren 1904 bis 1907*, 341.

14. Ibid., 438–39.

15. Rilke, *Letters on Cézanne*, 75.

16. Ibid., 85.

17. Ibid., 47.

18. Ibid., 51.

19. Modersohn-Becker, *The Letters and Journals*, 426.

20. Ibid., 537n.

21. Ibid., 345–46.

22. Ibid., 537n.

Chapter Fourteen

1. Rilke, *Briefe aus den Jahren 1907–1914*, 14.

2. Rilke, *Briefe an Sidonie Nádherný von Borutin*, 88–89.

3. Rilke, *Briefe*, 215–16.

4. Rilke, *Lettres à une amie vénitienne*, 16.

5. Rilke, *Briefe*, 215.

6. Rilke, *Briefe an Sidonie Nádherný von Borutin*, 53.

7. Ibid., 200–201.

8. *The Notebooks of Malte Laurids Brigge*, 235–36.

9. Rilke, *Lettres à une amie vénitienne*, 63f.

10. Pietro Casellato, *La veneziana "misteriosa" di Rainer Maria Rilke*, 101.

11. Rilke, *Lettres à un amie vénitienne*, 65–66.

12. Rilke, *Briefe aus den Jahren 1907–1914*, 35.
13. Ibid., 57.
14. Ibid., 53 (Sept. 8, 1908).
15. Ibid., 46.
16. Ingeborg Schnack, *Rainer Maria Rilke: Chronik seines Lebens und Werkes*, 315–16.
17. Rilke, *Lettres à un amie vénitienne*, 39–40.
18. Rilke, *Briefe an Sidonie Nádherný von Borutin*, 90.
19. *Letters of Rainer Maria Rilke 1892–1910*, 345.
20. Schnack, *Rainer Maria Rilke*, 317–18.
21. Rilke, *Sämtliche Werke*, 1:657.

Chapter Fifteen

1. Katherina Kippenberg, *Rainer Maria Rilke: Ein Beitrag*, 230.
2. Lou Albert-Lasard, *Wege mit Rilke*, 48.
3. Schmidt-Pauli, *Rainer Maria Rilke*, 167–68.
4. Rilke, *Briefe aus den Jahren 1907–1914*, 285f.
5. Petzet, *Das Bildnis des Dichters*, 89f.; translated in Modersohn-Becker, *The Letters and Journals*, 538f.
6. Rilke, *Briefe an seinen Verleger*, 314–15; translated in Modersohn-Becker, *The Letters and Journals*, 540.
7. Modersohn-Becker, *The Letters and Journals*, 9.
8. Petzet, *Das Bildnis des Dichters*, 149.
9. Pettit, *Rainer Maria Rilke in und nach Worpswede*, 221.
10. Ibid., 220.
11. Modersohn-Becker, *The Letters and Journals*, 292.
12. Ibid., 179.
13. *Letters of Rainer Maria Rilke 1910–1926*, 356.

Bibliography

Paula Modersohn-Becker, Otto Modersohn, Worpswede

Modersohn-Becker, Paula. *The Letters and Journals.* Ed. Günter Busch and Liselotte von Reinken. Ed. and trans. Arthur S. Wensinger and Carole Clew Hoey. New York: Taplinger, 1983. A translation of *Paula Modersohn-Becker in Briefen und Tagebüchern,* with some new material.

Paula Modersohn-Becker in Briefen und Tagebüchern. Ed. Günter Busch and Liselotte von Reinken. Frankfurt am Main: S. Fischer, 1979.

Otto Modersohn 1865–1943. Worpswede/Fischerhude: Kunsthalle Friedrich Netzel, Otto-Modersohn-Nachlaß-Museum, 1977.

Otto Modersohn 1865–1943: Monografie einer Landschaft. Kunstverein Hannover, Landesmuseum Münster, Hoffmann und Campe, Otto-Modersohn-Nachlaß-Museum, 1978.

Otto Modersohn Worpswede 1889–1907. Fischerhude: Otto Modersohn Museum, 1989.

Otto Modersohn Zeichnungen. Ed. Ernst-Gerhard Güse. Munich: Bruckmann, 1988.

Worpswede Archive.

Worpswede 1889–1989: Hundert Jahre Künstlerkolonie. Worpswede: Worpsweder Verlag, 1989.

Rilke: Work, Letters, Journals

Briefe. 2 vols. Wiesbaden: Insel, 1950.
Briefe an Auguste Rodin. Leipzig: Insel, 1928.
Briefe an Axel Juncker. Frankfurt am Main: Insel, 1979.

Briefe an seinen Verleger. Enlarged ed. 2 vols. Wiesbaden: Insel, 1949.

Briefe an Sidonie Nádherný von Borutin. Frankfurt am Main: Insel, 1973.

Briefe aus den Jahren 1902 bis 1906. Leipzig: Insel, 1929.

Briefe aus den Jahren 1904 bis 1907. Leipzig: Insel, 1939.

Briefe aus den Jahren 1906 bis 1907. Leipzig: Insel, 1930.

Briefe aus den Jahren 1907–1914. Leipzig: Insel, 1933.

Briefe und Tagebücher aus der Frühzeit. Leipzig: Insel, 1933.

Briefwechsel mit Helene von Nostitz. Frankfurt am Main: Insel, 1976.

Briefwechsel Rainer Maria Rilke und Katharina Kippenberg. Wiesbaden: Insel, 1954.

Letters of Rainer Maria Rilke 1892–1910. Trans. Jane Bannard Greene and M. D. Herter Norton. New York: Norton, 1945.

Letters of Rainer Maria Rilke 1910–1926. Trans. Jane Bannard Greene and M. D. Herter Norton. New York: Norton, 1948.

Letters on Cézanne. Ed. Clara Rilke. Trans. Joel Agee. New York: Fromm International, 1985.

Letters to a Young Poet. Trans. Stephen Mitchell. New York: Random House, 1984.

"Lettres à Madonna." *Journal de Genève,* Jan. 21–22, 1961.

Lettres à une amie vénitienne. Paris: Gallimard, 1985.

The Notebooks of Malte Laurids Brigge. Trans. Stephen Mitchell. New York: Random House, 1983.

Rainer Maria Rilke Lou Andreas-Salomé Briefwechsel. Frankfurt am Main: Insel, 1975.

"Rainer Maria Rilke–Otto Modersohn: Briefwechsel." Stader Archiv Neue Folge Heft 31, 1941.

Rilke Archive, Gernsbach.

Sämtliche Werke. 6 vols. Wiesbaden: Insel, 1955–66.

Tagebücher aus der Frühzeit. Frankfurt am Main: Insel, 1973.

Secondary Sources

Albert-Lasard, Lou. *Wege mit Rilke.* Frankfurt am Main: S. Fischer, 1952.

Alpers, Ilse. *Clara Rilke-Westhoff und Rainer Maria Rilke.* Fischerhude: Galerie, 1987.

Berger, Renate. *Malerinnen auf dem Weg ins 20. Jahrhundert.* 2d enlarged ed. Cologne: DuMont, 1986.

Binion, Rudolf. *Frau Lou: Nietzsche's Wayward Disciple.* Princeton, N.J.: Princeton University Press, 1968.

Bohlmann-Modersohn, Marina. *Paula Modersohn-Becker: Eine Biografie mit Briefen.* Berlin: Albrecht Knaus, 1995.

Brahms, Karin. "'diese Künstlerin, nein, dieser grosse Künstler.'" In *Worpswede 1889–1989 Hundert Jahre Künstlerkolonie.* Worpswede: Worpsweder Verlag, 1989.

Buchheit, Gert, ed. *Rainer Maria Rilke: Stimmen der Freunde.* Freiburg im Breisgau: Urban, 1931.

Busch, Günter. *Paula Modersohn-Becker Malerin Zeichnerin.* Frankfurt am Main: Fischer, 1981.

Butler, Ruth. *Rodin: The Shape of Genius.* New Haven, Conn.: Yale University Press, 1993.

Casellato, Pietro. *La veneziana "misteriosa" di Rainer Maria Rilke.* Venice: Edizioni Helvetia, 1977.

Demetz, Peter. *René Rilkes Prager Jahre.* Düsseldorf: Eugen Diederichs, 1953.

Freedman, Ralph. *Life of a Poet: Rainer Maria Rilke.* New York: Farrar, Straus and Giroux, 1996.

Hauptmann, Carl. *Briefe mit Modersohn.* Leipzig: Paul List Verlag, 1928.

Heise, Carl Georg. *Paula Modersohn-Becker: Mutter und Kind.* Stuttgart: Reclam, 1961.

Hendry, J. F. *The Sacred Threshold.* Manchester: Carcanet New Press, 1983.

Hetsch, Rolf, ed. *Paula Modersohn-Becker Ein Buch der Freundschaft.* Berlin: Rembrandt Verlag, 1932.

Hindelang, Eduard, ed. *Die Bildhauerin Clara Rilke-Westhoff 1878–1954.* Museum Langenargen am Bodensee. Sigmaringen: Thorbecke, 1988.

Jacobsen, Jens Peter. *Niels Lyhne.* Trans. Hanna Astrup Larsen. New York: Twayne, 1967.

Kassner, Rudolf. *Rilke.* Pfullingen: Neske, 1976.

Kippenberg, Katherina. *Rainer Maria Rilke: Ein Beitrag.* Leipzig: Insel, 1942.

Kirsch, Hans-Christian. *Worpswede Die Geschichte einer deutschen Künstlerkolonie.* Munich: C. Bertelsmann, 1987.

Leppmann, Wolfgang. *Rilke: A Life.* Trans. Russell M. Stockman. New York: Fromm International, 1984.

Murken-Altrogge, Christa. *Paula Modersohn-Becker.* Cologne: DuMont, 1991.

Naumann, Helmut. *Rainer Maria Rilke und Worpswede.* Fischerhude: Galerie, 1990.

Nolde, Emil. *Mein Leben.* 2d. ed. Cologne: DuMont, 1977.

Pauli, Gustav. *Erinnerungen aus sieben Jahrzehnten.* Tübingen: Rainer Wunderlich, 1936.

Peters, H. F. *My Sister, My Spouse.* New York: Norton, 1962.

Pettit, Richard. *Rainer Maria Rilke in und nach Worpswede.* Worpswede: Worpsweder Verlag, 1983.

Petzet, Heinrich Wigand. *Das Bildnis des Dichters.* 2d ed. Frankfurt am Main: Insel, 1976.

Prater, Donald. *A Ringing Glass.* Oxford: Clarendon Press, 1994.

Russell, John. *Vuillard.* Greenwich, Conn.: New York Graphic Society Ltd., 1971.

Sauer, Marina. *Die Bildhauerin Clara Rilke-Westhoff 1878–1954.* Bremen: H. M. Hauschild, 1986.

Schmidt-Pauli, Elisabeth von. *Rainer Maria Rilke: Ein Gedenkbuch.* Basel: Benno Schwabe, 1940.

Schnack, Ingeborg. *Rainer Maria Rilke: Chronik seines Lebens und Werkes.* Frankfurt am Main: Insel, 1975.

Sieber, Carl. *René Rilke: Die Jugend Rainer Maria Rilkes.* Leipzig: Insel 1932.

————. "Rainer Maria Rilke in Worpswede." Stader Archiv Neue Folge Heft 31, 1941.

Stephan, Inge. *Das Schicksal der begabten Frau im Schatten berühmter Männer.* Stuttgart: Kreuz, 1989.

Uhde-Stahl, Brigitte. *Paula Modersohn-Becker: Frau Künstlerin Mensch.* Stuttgart and Zurich: Belser, 1989.

Vogeler, Heinrich. *Werden.* Fischerhude: Verlag Atelier im Bauernhaus, 1989.

von Reinken, Liselotte. *Paula Modersohn-Becker.* Reinbek bei Hamburg: Rowohlt, 1983.

Wohltmann, Hans. *Rainer Maria Rilke in Worpswede.* Hamburg: Deutscher Literatur-Verlag, 1949.

$\mathcal{A}ppendix$

Requiem for a Friend

I have my dead, and I have let them go
and been amazed to see them so accepting,
so quick to make themselves at home in death,
so satisfied, so unlike their reputation.
But you come back to haunt this place, you brush
against me, try to knock some thing so hard
the sound betrays you. O don't take away
the truth it's taken me so long to learn.
I am right and you are wrong if you've
grown homesick for some thing. We transform things;
they are not here, we only mirror them in
out of our own being when we sense them.

 I thought you'd gone much further. I'm bewildered
that *you've* got lost and come here, who transformed
so much more than any other woman.
That we were dumbstruck when you died; no,
that your fierce death broke darkly in upon us,
ripping the up-till-then from the ever-since,
is our concern; to make some sense of it
will be our task in everything we do.
But that you too were terrified, friend, even now
feel terror there where terror has no meaning,
that you could lose some piece of your eternity

and come back here where nothing truly *is* yet;
that out there for the first time in the All,
scattered and fragmented, you could not
grasp the rising of the eternal natures
half as firmly as you grasped each thing;
that the dull weight of some disquiet dragged you
back from circles that had welcomed you,
back down to the realm of counted time—
it wakes me up at night like a thief breaking in.
If I could only say, you deign to come,
come out of generosity or abundance,
as confident, at ease with your own nature
as a child that wanders freely, unafraid
of places where bad things are done to children—
but no. You're pleading. That's what pierces me
down to the bone and rips me like a sawblade.
Even some reproach, some grudge that you
might bear me as a ghost, would not appall me—
when at night I draw back to my lungs,
my guts, the last poor chamber of my heart—
like this pleading. What is it you want?

 Tell me: should I travel? Have you left
some thing behind that in its misery
longs to follow you there? Shall I journey
to some land you never saw, that nonetheless
was of such utter kinship as to be
the long lost other half of your own senses?

 I'll travel down the rivers, cross the land
to find out all I can about old customs,
speak to women standing in the doorways
and watch them as they call the children in.
I'll watch the way they put on the landscape there,
outdoors, as they ply the ancient labors
of field and meadow; ask to be brought before
the king, and bribe the priests to lay me down
before the most potent statues, leave me there
and go and shut the temple gates behind them.
But then, when I know enough, I'll simply watch
the animals there till some part of their grace
glides over into my own limbs; I'll live
one brief existence in their eyes that hold me
and slowly, peacefully leave me, without judgment.
I'll ask the gardeners to name the flowers

and in the shards of their lovely names bring back
some trace of all their hundred fragrances.
And I'll buy fruit, the fruit in which that land
is born again, unto its very skies.

For that is what you understood: ripe fruit.
You laid it down in bowls in front of you
and measured out, in colors, the weight of each.
Women too you saw as fruit, and children,
impelled from inside toward their destined forms.
At last you saw yourself as fruit, you took
yourself out of your clothes and brought yourself
before the mirror, then let yourself go in,
all but your gaze, so great it stayed outside
and said not: I am that; no, said: this is.
So free of curiosity at last,
your gaze, so free of owning, of such true
poverty, wanting not even yourself: holy.

So it is I'd keep you, as you placed
yourself inside the mirror, deep inside
beyond all things. Why come so differently?
Why disavow that, what would you have me believe:
that in the amber beads around your neck
some heaviness remained that has no place
in the mirror of a painting wholly at rest?
Why show me, by your bearing, some bad omen;
why display the contours of your body
as if they were the lines in the palm of a hand,
which I can see now only as your fate?

Come here, into the candlelight. I'm not
afraid to see the dead. They have the right
to come when they do and pause here for a time
inside our gaze like any other things.

Come here, and let's be still a little while.
Look at this rose on my desk. The light around it
hesitates, doesn't it, like the light around you,
because like you the rose is out of place here.
It should have lived or died out in the garden,
not here, caught up with me. Here it lives on,
but what is my awareness to a rose?

Don't be afraid if at last I understand,
o, it wells up in me, what choice have I?
I must grasp it, even if it kills me.

Grasp this: you are here. And I do grasp it;
as a blind man feels some thing on every side,
I feel your fate although I cannot name it.
Let us lament together that someone took you
back out of your mirror. Can you still weep?
You cannot. For you transformed all your tears'
power and pressure into your ripe way
of seeing, and were at work transforming all
your body's juices into one strong existence,
rising and circling, blindly, in equilibrium.
But some chance happening, the last in your life,
tore you back out of your furthest progress,
back into a world where juices *will*.
Only a part of you at first, but then
day by day the reality growing around
that part began to weigh you down, until
you needed all of yourself. And so you broke
yourself, in pieces, painfully free of the law.
You robbed yourself, you dug up from your heart's
night-warm soil the still green seeds from which
your death would grow, the one death for your life;
like all the rest, you ate the seeds of your death
and had in you an aftertaste of sweetness
not your own, and so you had sweet lips;
you whose senses, inside, were so sweet.

O let's lament. Do you know how haltingly,
unwillingly your blood returned from that
peerless circulation, when you called it?
How troubled it was to take up again the mere
circulation of the body, and with what
stunned mistrust it entered the placenta
and stopped, exhausted from the long way back?
You drove it on, you pushed it toward the front,
you dragged it to the hearth as one would drag
a herd of animals to the sacrifice
and even asked it to be happy there.
At last you had your way, and it was happy,
flowed, submitted to your will. You thought
because you'd grown accustomed to greater scale
that it would only take a little while.
But you were back in time again, and time
is long. And time goes on, and time expands,
and time is like an old sickness that comes back.

How brief it was, your life, measured against
those long hours in which you sat and bent
all the force of your long and varied future
silently back down toward that one child-seed
that was again your fate. O dreadful work.
O work beyond all strength. Day after day
you did that work, you dragged yourself to face it,
you tore the lovely weft out of the loom
and used each thread in service to that work.
You had, even then, the courage to celebrate.

For when it was done, you wanted some reward,
like children who have drunk a bittersweet tea
that might restore their health. And thus the gift
you gave yourself, because you were so far
beyond the others, yes, even now; no other
could have known which gift would serve you best.
But you knew which. You sat up in the bed
and there before you stood a mirror, giving
everything back to you. All was *you* again,
in front of it; inside was only deception,
a woman's sweet deception who puts on
pretty things and combs her hair and changes.

And so you died as women used to die,
died in that warm house the old-fashioned death
of women who, when they have given birth,
would close themselves up again but cannot do it
because the darkness they have borne as well
comes back to them and forces its way in.

Should we, after all, have found wailing-women?
Women who mourn for pay, whom one can hire
to wail the whole night long, when all is quiet.
Bring me customs! How bereft we are
of customs: they pass on, we let them go.
And so you must come back, and here with me
make up for the mourning that you missed.
Can you hear that I am wailing now?
I'd throw my voice as if it were a cloth
over all the fragments of your death,
tear at that cloth until it went to tatters,
and everything I said would have to go
in rags and freeze in order to go on
lamenting. But now, instead, I must accuse.

Not the man who pulled you from yourself
(I can't find him, he looks like all the others),
but in him I accuse them all: all men.
 If somewhere deep in me a child I've been
arises, one I've never known, perhaps
the purest child I was in all my childhood:
I don't want to know. I want to make
an angel of it, make it without looking
and hurl it all the way out to the first rank
of angels that cry out, reminding God.
 This suffering has gone on far too long,
no one can bear it, it is too heavy for us,
the all-too-senseless suffering of false love
that, built on mere persistence as on habit,
claims a right but profits from a wrong.
Where is the man that has the right to own?
Who can own what cannot hold on to itself,
only sometimes happily catches itself
and throws itself again as a child throws a ball.
No more than some commander may command
the Nike on the bowsprit of a warship
when the secret lightness of her godhead
suddenly bears her off on bright sea-winds:
no more can one of us call back the woman
so far away she can no longer see us,
gone off, wonder! on some narrow strip
of her being and miraculously unharmed;
even if guilt were his only wish and calling.
 For *that* is guilt, if anything is guilt:
not to multiply a loved one's freedom
by all the freedom we can find in ourselves.
We have, in loving, only this one task:
to let each other go. For holding on
is easy for us, nothing we need learn.

 Are you still here? In which corner now?
You knew so much of all that I have said,
your powers were so great as you passed on,
open to everything, like a breaking day.
Women suffer; to love is to be alone,
and artists sometimes glimpse this in their work,
that when we love we must transform ourselves.
You had begun both tasks: both dwelt in all

266

that your new fame distorts and takes away.
How far beyond all fame you'd gone. You were
so modest; you had taken in your beauty
as on some grey work-morning one takes in
a flag, and wanted nothing but that long
work that now will go undone. Undone.

If you're still here, if in this dark some place
remains in which your spirit resonates
with the dull sound waves a lonely voice calls up
in the currents of this high room in the night,
then listen: help me. You see, we fall back
unknowing from our furthest progress, into
something we never intended, and may be caught
as in a dream, and die there without waking.
No one has gone further. Anyone
who has lifted up his blood to some long task
may find that he cannot bear it any longer
and let it fall back, lost to gravity, worthless.
For somewhere an old enmity exists
between our life and that great work we do.
That I may understand and speak it: help me.

Do not come back. If you can bear it, stay
dead among the dead. The dead have tasks.
But help me in a way that does not distract you,
as what is farthest off may help: inside me.

ℐndex

Albert-Lasard, Loulou, 202, 238–39
Alcoforado, Marianna, 229
Allmers, Hermann, 41
All Souls' Day, 1, 13, 86, 224, 239
Am Ende, Hans, 34, 40, 98, 173–74
Andreas, F. C., 20, 25
Andreas-Salomé, Lou, 71, 80, 113,
 133, 188
 RMR and
 affair with, 15, 20–21, 24–26,
 61, 65, 81–82, 95–96, 107–9
 correspondence with, 140,
 156–60, 162
 influenced by, 10, 14, 20, 24,
 109, 124, 158, 211, 233
 journals for, 21, 60–61, 139
 renewed contact with, 156, 171
 CRW and, 211–12

Barkenhoff, the
 and the Family, 59, 61–64,
 65–66, 70–72, 74–76, 84–85
 RMR and, 23, 60, 62, 77, 84,
 132, 137, 158–59
 Vogeler and, 38, 59, 119, 174–75
Bashkirtseff, Marie, 44, 103
Bauck, Jeanna 30
Baumgartner, Frieda, 242

Beardsley, Aubrey, 38
Becker, Henry, 97
Becker, Herma, 97, 115–16, 150, 167,
 168, 169–70, 181, 214, 220
 and PMB in Paris, 182–83, 186,
 203, 204, 205
Becker, Kurt, 39, 178, 187, 220, 221,
 239–40
Becker, Mathilde
 and PMB, 28, 85, 106–7, 166,
 214–15, 220
 letters and journals, 239–40
 and OM, 148, 169, 178, 187, 206
 work of, 28, 45, 209
Becker, Milly, 62, 65, 66, 72, 107, 167,
 170, 186, 206, 210, 220, 223
Becker, Paula. See Modersohn-Becker,
 Paula
Becker, Woldemar, 27
 and PMB, 27–28, 32, 45, 48, 97,
 105, 110–11
 work of, 27–28, 30, 49
Beer-Hoffmann, Richard, 74
Benois, Alexander, 113
Bernard, Emile, 218, 224
Beuret, Auguste, 136
Beuret, Rose, 136, 172
Binion, Rudolf, 95, 247nn12, 19

268